Focus on Nature

Focus on Nature

Oxford Scientific Films

Gerald Thompson, George Bernard, John Cooke,
Stephen Dalton, Ian Moar, Sean Morris, John Paling,
Peter Parks, David Shale and David Thompson

Foreword by
David Attenborough

Faber and Faber
London · Boston

To our families

First published in 1981 by
Faber and Faber Ltd,
3 Queen Square, London WC1N 3AU

This book was designed and produced by
The Rainbird Publishing Group Ltd
36 Park Street, London W1Y 4DE

House editors: Karen Goldie-Morrison
and Valerie Noel-Finch
Designer: Martin Bristow
Indexer: Wendy Dickson

Text filmset by SX Composing Ltd,
Rayleigh, Essex
Colour originated by Bridge Graphics Ltd, Hull
Printed and bound by W. S. Cowell Ltd, Ipswich

British Library Cataloguing in Publication Data

Focus on Nature
 1. Photography, Biological
 I. Thompson, Gerald
 778.9'3 TR 721

ISBN 0-571-11810-0

Front and rear endpapers: Porpita is a surface-living relative of jellyfish and is found world-wide. The front endpapers show a close-up of an unusual yellow form which was collected by Peter Parks on the Great Barrier Reef. The *Porpita* photographed at a lower magnification on the rear endpapers is the usual colour. Both individuals measured about 5 cm across the umbrella.

Half-title page: A worker leaf-cutter ant, *Atta,* returns to its nest from a night-time forage, bearing a seed over its head.

Frontispiece: The dramatic quality of this photograph of a British beetle, *Endomychus coccineus,* comes largely from the method of lighting used on the stills optical bench. The beetle has been strongly back-lit by electronic flash and has had front lighting reflected onto it by a mirror system.

Contents

Foreword

Twenty years ago, an extraordinary image appeared on British television screens. A female ichneumon wasp stepped elegantly along the branch of an alder tree. She was so large in the screen that every detail of her body was clearly visible – her orange, hair-thin legs, her mosaic eyes, the delicate venation of her gauzy wings. She moved with an unnerving deliberation, searching the bark by tapping it with her long antennae. Abruptly, she stopped and brought the tips of her antennae together on one particular spot. Raising herself on tip-toe, she hoisted her abdomen high in the air and brought forward the long black ovipositor that was hinged to the end of her abdomen, so that its shaft was almost vertical and its tip rested between her two antennae. Then she began to drill.

This image itself was exceptional, but it was followed by a sequence that lifted the film to a quite new level of distinction. In the next slightly wider shot, we saw that inside the alder branch, directly beneath the ichneumon's drilling ovipositor, lay the grub of a wood-wasp. And then we seemed to be alongside the grub itself, within its chamber and looking upwards, for we could see the tip of the ichneumon's ovipositor breaking through the ceiling of the chamber. First she stung the grub, and then the ovipositor opened as the egg began to emerge. This she delicately placed on the body of the wasp grub so that the ichneumon grub, when it hatched, could eat the paralysed wood-wasp alive.

The film went on to chronicle the other almost unimaginable hazards that beset a wood-wasp. It showed how a second species of ichneumon uses the shaft drilled by the first to deposit its own egg in the chamber, and how the grub of the second, being larger, eventually eats the grub of the first; how another small wasp burrows through the wood of the alder branch, stings the wood-wasp grub and deposits some thirty of its eggs on it; and how yet another parasitic wasp lays its egg actually inside the wood-wasp's egg so that the wood-wasp grub, as it develops, will carry within it another creature feeding upon it from the inside.

This amazing film had been submitted for a competition run by the BBC and the Council for Nature. Not surprisingly it had won first prize. Those of us who were ourselves trying to make films about animals realized immediately that it had set a new standard which few of us could aspire to and against which all of us would be measured. Clearly, the person responsible for it had expert entomological knowledge and an uncanny ability to persuade insects to do what he wanted, where he wanted and when he wanted. But it seemed to me, at any rate, that the most remarkable thing about him was that he had had the imagination and sheer nerve to suppose that it was within the bounds of possibility to take such shots.

This man was Gerald Thompson, an entomologist working in the Forestry Department of Oxford University. The alder wood-wasp and its insect enemies had been the subject of his research for many years, so he had long experience in handling these creatures and, indeed, he had himself discovered many of the facts that his film documented. But he soon demonstrated that he was not just a wasp specialist. Next, he made a film about a beetle, and then a whole series about spiders. Since he was not himself an arachnologist, he recruited as consultant another Oxford zoologist, John Cooke. The techniques of photography they needed were, at that time, in a kind of optical no-man's-land. Wasps, beetles and spiders are too large to be filmed through the microscope and too small to be adequately

photographed with normal camera lenses. So new optical systems had to be developed. Gerald Thompson's son, David, helped him in tackling these problems.

Meanwhile, in the Oxford Zoology Department, Peter Parks and John Paling had also begun to film the small natural world, but they specialized in the life they observed down the microscope. In 1967, they were joined by Sean Morris, another zoologist who had recently graduated.

· Late in 1967, these two filming groups joined forces on an expedition to Jamaica. This had two purposes. The first was to make films for the BBC, and the second was to find out whether they could work together. In 1968, these five founded Oxford Scientific Films. They built a studio in Gerald Thompson's garden in a village outside Oxford, and very soon marvellous pictures carrying the now famous credit 'Oxford Scientific Films' began to appear both on television and in natural history books.

No doubt different people will have different opinions about which image caused their jaws to sag the farthest. Was it the sight of a little stickleback, apparently swallowed by a pike but revealed by OSF's camera to be still swimming valiantly within the pike's throat? Or was it, perhaps, the toothed leaves of a Venus fly trap plant snapping shut to imprison the unwary fly that had triggered them? Or maybe it was that most nightmarish of shots in which a rippling cloak of maggots enveloped a dead mouse and, in OSF's speeded-up shot, moved over the corpse, liquifying its flesh and stripping it down to its bones. I have my own special favourites, for OSF contributed many sequences to the television series *Life on Earth* and since I wrote the accompanying narration, they remain for me particularly memorable — those simple blobs of jelly, ribbed with cilia, drifting through the sea, that are known as comb jellies, which Peter Parks transformed by ingenious lighting into shimmering globes of ethereal loveliness; and a gruesome sequence in which a strange, floating sea-slug slowly, and with ghastly doggedness, munched its way through a living jellyfish.

Many of OSF's films have revealed facts that were new to science and for that alone,

they are valued in laboratories all over the world. I suspect, however, that the importance of the kind of work the organization has pioneered is more widespread and fundamental. The revelation of the alder woodwasp's tangled private life virtually coincided, by chance, with another extraordinary vision that came from a very different quarter. The date and time of the wasp film's television showing was publicly announced but at the very last moment, the transmission was cancelled to make way for other pictures. The Russians on that very day in 1961, released the news that they had sent the first man into space. Images of him were being sent back to earth and appeared live on our television screens. Cameras in space were eventually to give us the widest view of the world we had ever had, revealing it as a lonely blue globe spinning in the blackness of eternity. That picture has profoundly influenced our attitudes to ourselves and to the small and vulnerable planet that is our home. But so, too, have the insights at the other end of the scale of vision, of which the alder woodwasp was so spectacular a herald.

Since those days, OSF's team has grown a good deal. John Cooke, the early spider consultant, has become a permanent member. So too has stills photographer George Bernard, marine biologist David Shale, Ian Moar, who joined in the early days as an optical technician, and that specialist in astounding highspeed photography, Stephen Dalton. With their ingenious optical techniques, their scientific insights, and above all their imagination, they now, on our behalf, transcend both space and time. They give us an ant's view of a spider. They speed up the springing of a plant bud and slow down the beat of a hover-fly's wing. They show to millions of us wonders that no single human being has ever seen before. Because of what they have done, the rest of us now have a more complete and vivid view of the complexity and wonder of the web of life of which we are but one part. It is a privilege to introduce this book in which they explain how they do it.

David Attenborough.

The photographers of Oxford Scientific Films

Gerald Thompson

Born 1917. Founder member and senior director of OSF. Developed passionate interest in natural history at an early age while living in the concrete jungle of inner Glasgow. Read zoology and forestry at Oxford University and entomology at the Royal College of Science, London University. During war released from Royal Artillery to serve as district officer in Colonial Forest Service in Ghana. Spent spare time studying forest beetles. Returned to UK as lecturer in forest entomology at Oxford University until 1969. Pioneered techniques in photomacrography and started motion-picture filming of small animals in 1960. First film, *The Alder Woodwasp and Its Insect Enemies*, won top amateur awards in UK and rest of the world. Currently writing a book on pond life and filming tiger beetles.

George Bernard

Born 1949. Read biological sciences at Aston University. Fascination for the natural environment started at school and reached a degree of seriousness sitting in a wind-battered tent high up in the southern Swiss alps. There decided to collect butterflies in the Andes of Colombia and Venezuela. Armed with same tent and a Royal Society grant discovered many new species of butterfly. Joined OSF in 1977 to continue life looking at nature through the glass eye of a stills camera.

John Cooke

Born 1935. Director of OSF. Spent war years in USA and learnt to appreciate outdoor life and natural history. Spent 2 years of National Service in Royal Navy training to be a fleet air arm pilot. Read zoology at Oxford University. Spent a year in Africa and returned to do research on spiders. Lectured at Oxford University on invertebrate zoology, then moved to New York for 4 years as curator of arachnids at the American Museum of Natural History. Returned to Oxford in 1973 to join OSF. Dedicated traveller even before joining OSF, with zoological expeditions to Turkish Kurdistan, Tanganyika, North Africa and Mexico. Runs the expanding stills library and specializes in stills. Also mountaineer, caver, scuba diver and bon viveur.

Stephen Dalton

Born 1937. Director of OSF. First attempt at bird photography resulted in blurred image of a kingfisher. An avid photographer of nature from then onwards. Started career filming agricultural machinery. Decided to study photography at Regent Street Polytechnic, London. Breakthrough came when commissioned to work on *Borne on the Wind* and achieved dramatic high-speed stills of animals in flight. Joined OSF in 1980 to continue his unique brand of photography.

Ian Moar

Born 1945. Director of OSF. Spent early life in Scotland, developing an interest in natural history. Became senior technician in department of zoology, Oxford University, before joining OSF in 1970. Involved chiefly with special effects work and developing specialist filming equipment for feature films and TV commercials.

Sean Morris

Born 1944. Co-founder and director of OSF. Developed love of nature during childhood in the countryside. Read zoology at Oxford University. Fanatical sportsman. Rowed for Oxford in 1963 and 1965 Boat Races and for England in 1972. Has coached Oxford crews. Interests in design, construction and driving racing cars. Rebuilding Cotswold farmhouse.

Within OSF, specializes in birds, animal behaviour, high-speed and time-lapse techniques and company management. Currently completing a 7-year project on the sex life of plants.

John Paling
Born 1938. Co-founder and director of OSF. Read zoology at Birmingham University. Lecturer in biology at Oriel College, Oxford University, and erstwhile visiting professor at the University of California, Santa Cruz. Uses skills as natural light-hearted communicator to lecture throughout UK and USA. As fish specialist, involved in OSF's early freshwater photography. Present interest directed more towards animal behaviour, from elephant seals to pet dogs.

Peter Parks
Born 1942. Co-founder and director of OSF. From early age showed an obsession with 'squirmers' – especially those 'small and watery'. Read zoology at Oxford University. Started career in biological illustration. Surprising gift of 100-year-old Ross microscope led towards filming and photographing the natural world as if from the animal's own eye-line. Designs and constructs equipment needed to achieve difficult and entertaining vantage points. Has masterminded OSF's involvement in feature film special effects. Has overriding challenge in life to do justice to the exquisite and enigmatic planktonic communities of the oceans.

David Shale
Born 1946. Read zoology and entomology at University of London. Continued his studies and research into marine mollusc larvae at the Marine Biological Association at Plymouth. First film, *Ocean Life*, about deep sea life, made at the Institute of Oceanographic Sciences. Crossed paths with Peter Parks on RRS *Discovery* and joined OSF in 1979. Currently working on a TV programme on life between the tides.

David Thompson
Born 1945. Co-founder and director of OSF. Early life in Oxfordshire. Assisted his father Gerald Thompson in the early days of his

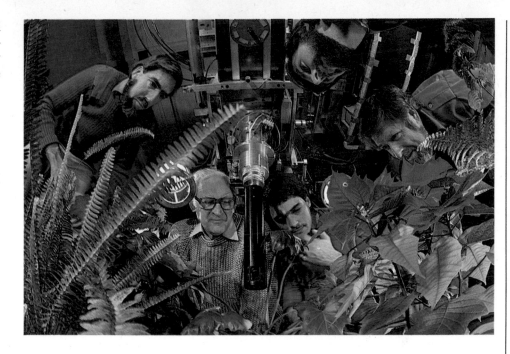

filming career. In OSF's infancy was chief designer of their realistic film sets. Has travelled widely from Central America to Australia, filming the full range of animal subjects in motion-picture and stills, although originally trained with insects. Currently filming ants in Costa Rica for Anglia TV's *Survival* programme.

A beetle's eye view of five members of Oxford Scientific Films and the Cosmoscope. *From left:* Peter Parks, Gerald Thompson, George Bernard, John Cooke and David Shale.

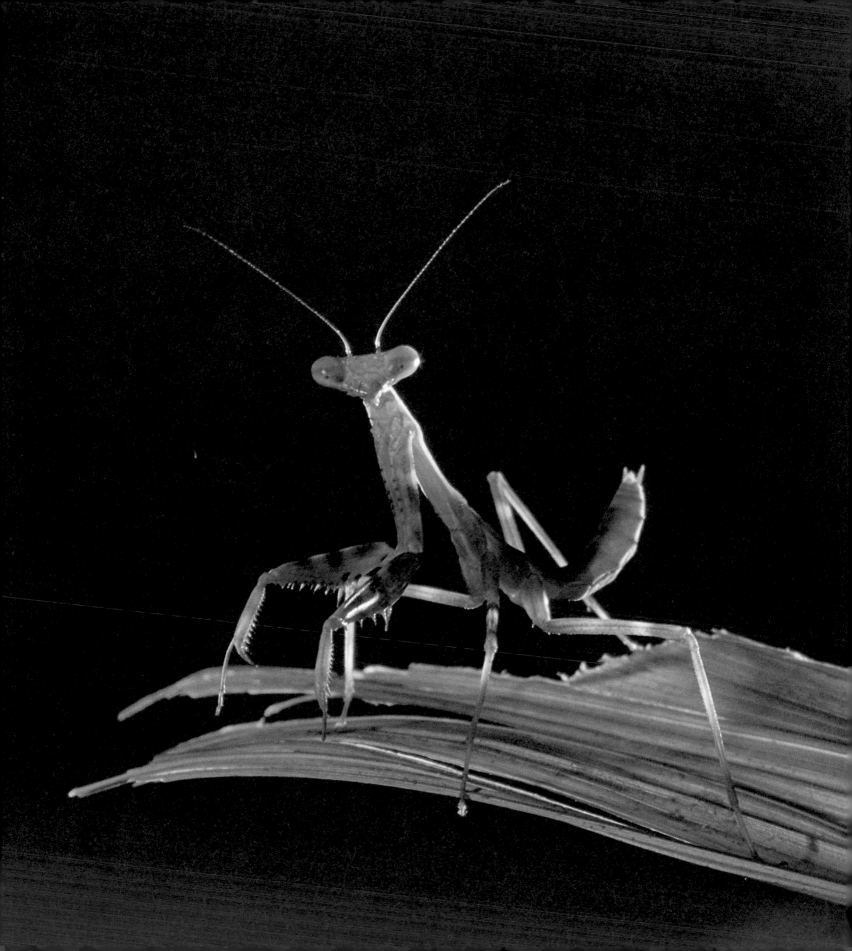

1 Nature at close range

GERALD THOMPSON

What is the connection between a pint of beer, a pile of sawdust, and the largest fly in the world? The fact that I am a biologist covers the fly. The other two items are more difficult to explain, but the key is photography. To find and photograph the largest fly in the world would be a thrilling event for any natural history photographer. But the odds against it happening are extremely high.

I was in Trinidad with my colleagues at Oxford Scientific Films photographing the wildlife of the tropical rain forest. While exploring a clear river that tumbled down through the foothills of the Northern Range, we came across a large pile of fresh sawdust under the bole of an enormous forest tree that had fallen along the river bank, its roots undercut by the wet-season floods. Being an entomologist, piles of sawdust interest me because they indicate that insect grubs are at work. This pile was of such a coarse texture, and there was so much of it, that I was certain that the culprit was a grub of mammoth proportions. In addition, the wood was riddled with tunnels one and a half centimetres in diameter. My curiosity was thoroughly aroused. I gingerly pushed a long grass stem into a fresh-looking tunnel until it would go no further. The tunnel's occupant reacted by pushing the stem part way out again. By using the instinctive behaviour of clearing its tunnel of obstructions, the grub had given itself away.

By dint of painstaking picking and prying with a sheath knife I succeeded in extricating a gigantic grub seven centimetres long. It was white and puffy, with a pair of large black jaws at the head end. I had come across grubs of this stature before, while studying wood-boring beetles in the forests of West Africa. But this was no beetle grub. Its lack of legs and the two breathing holes at the hind end told me this grub was destined to become a fly. But what sort of fly would hatch from such a long grub? My mind pictured a bluebottle the size of a hummingbird, and I knew instantly that I simply had to photograph the adult that my grub would turn into.

By carefully dismembering a portion of the fallen tree we managed to collect about half a dozen grubs and pupae. These I set up back in our studios, with the intention of photographing the moment of metamorphosis between pupa and adult – for me the moment of truth, so to speak.

Of course, it is one thing to be holding an insect pupa in your hand, and another matter entirely to be ready with a camera when that pupa turns into a winged adult. But that is what OSF and my life as a naturalist-cameraman is all about: photographing the seemingly impossible.

After weeks of patient observation, an amazing five centimetres of *Pantophthalmus tabaninus* emerged in front of my camera, and I became the first person ever to record the event on film. There only remains the pint of beer. This was bought for me by my colleagues who had bet that I would fail.

Early days

I made my first attempts at close-up stills photography in the high rain forests of Ghana where I had become daily more fascinated by the richness and variety of the West African forest insects. To record them I bought a twin lens reflex camera and adapted it for close-up work. I had only some spectacle lenses available and these I fitted in front of the two reflex lenses. One of the drawbacks of the twin lens reflex was that it had these two lenses: one for viewing the subject and the other for taking the picture. If the subject

OPPOSITE This immature mantis, about 3 cm long, was taken at night in the Big Bend National Park, Texas. The only light came from a single electronic flash angled partially behind the subject which picked out its contours in a ghost-like fashion.

was a landscape, the image seen through the viewing lens was almost identical to that recorded by the camera's lens in the final picture. But this was not the case in close-up work. The insect I had framed nicely through my viewing lens would often have only half its body in the picture. The real source of my failure, however, was being unable to afford a refrigerator to supply cool water for use in developing my films. I soon found that the high African temperatures were causing the film emulsion to disintegrate so that it either became perforated or slipped off the backing entirely. Despite all my efforts, I did not pro-duce a single acceptable negative.

Thirteen years later I became interested in a community of woodland insects, and again took up photography. This time I bought a single lens reflex camera, a wonderful technical advance since the same lens both viewed the subject and took the picture. The previous problem of picture shift was eliminated. Colour film was also available and the task of development rested with the manufacturer — a great weight off my shoulders.

There were other improvements as well, all of which were relevant to a close-up photographer. Extension rings or bellows

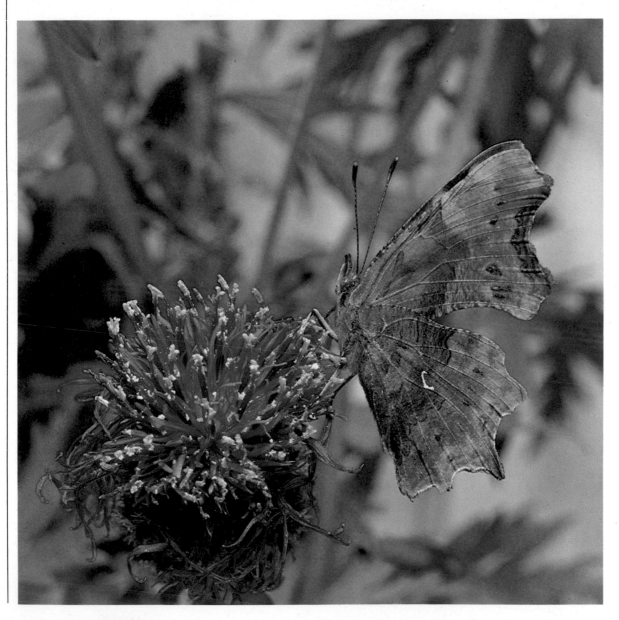

When stalking butterflies with a camera, the close-up limit for hand-holding the camera is usually achieved with a standard 55 mm macro-lens, which captures an image of half natural size (1:2). Before the 1930s, this picture of a comma would have been a rarity, since the butterfly was then confined to southern England. But it has subsequently spread northwards where its larvae continue to appear on gooseberry plants in gardens.

between the camera and the lens produced a wide range of close-up pictures; an extension equal to the focal length of the lens formed an image of natural size on the emulsion. In other words, the subject and camera image are in a ratio of 1:1, at which magnification we enter the realms of the photomacrographer. Unfortunately, using extension rings results in a loss of light. If, instead, a supplementary lens is placed in front of the prime lens, there is no loss of light but the additional layers of glass can reduce picture quality. Overall, the major developments in optics in recent years have vastly increased the range of lenses available and their performance, but no amount of camera hardware can substitute for filming technique.

Filming in the field

A comma butterfly feeding on a knapweed flower, for example, makes an irresistible picture. But how best to take it? A butterfly watcher knows that the comma will tend to visit flowers in sunshine and avoid those in the shade. As a photographer, I have a choice of two methods. The first is to set up a tripod with the camera aimed at a particular flower and wait, hoping that the comma will eventually visit the flower. If it does, I have then only to adjust the focus so that the butterfly's wings are sharp, since these and not the flower are the dominant feature. Perfect focusing is essential and it is better to risk the comma fluttering away than to omit this vital step. Patience is absolutely essential for the wildlife photographer and anyone who lacks it is unlikely to succeed.

The second method available to me is to stalk the comma, camera in hand. The risk of disturbing the butterfly is greater since I am on the move all the time and the insect may well decide to seek nectar elsewhere. A shutter speed of not less than 1/60 second or, if possible, 1/125 second avoids camera shake but even so I must remain as steady as possible. Since the insect eye is particularly well adapted to detect movement across its line of vision, I must make my approach towards the butterfly with the minimum of sideways motion. Precise focusing is always much harder with a hand-held camera and

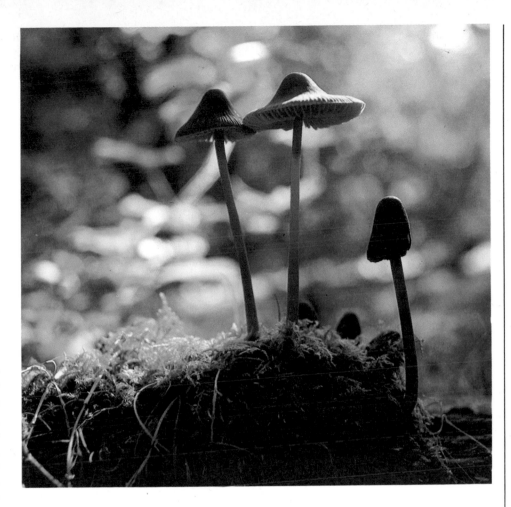

the failure rate is likely to be much greater than when a tripod is used. Whichever method I have decided to adopt, I usually restrict the butterfly's choice of flowers by covering some over with cloth or plastic.

Stalking butterflies on calm and sunny days may well be rewarding but in my experience the wind blows harder when the sun appears, creating less than ideal conditions for the photographer. But what can possibly be easier than a virtually static subject like a caterpillar of the large elephant hawk-moth quietly feeding on a tall rosebay willow-herb? The problem is that its tall foodplant gently sways in the breeze, in and out of focus. The odds against success are too great to persuade me to gamble on pressing the camera button at the right instant, even though I am using a tripod. So I reduce the odds by tying the plant to a stake, preferably fastening it above the subject, although this precaution often replaces the wide swaying

Natural light diffusing through the surrounding foliage was sufficient to photograph this group of toadstools growing on a rotting log in an Oxfordshire woodland during late summer. The beetle's eye view was enhanced by using a 35 mm wide-angle lens plus a thin extension ring.

movement by a short vibration. I have greater control over my subject if I cut the willow-herb, using secateurs to minimize the disturbance to the caterpillar, and insert a short length into a container of water, using cotton wool to keep the stem firmly in place: the field photographer carries more than just a camera and tripod.

A toadstool on the forest floor poses another problem. A picture taken from my own view-point, that is, looking down from above, will be dull and flat and devoid of visual impact. But what an improvement when my camera adopts the point of view of a beetle or mouse on the ground. If I arrange the exposure so that the subject is sharp while the background is in soft focus, the fungus will stand out against its background in a three-dimensional way. On those occasions when I want the background to be identifiable, I use a lens of short focal length, thereby increasing the depth of field. An ideal combination is a 35 mm or 20 mm lens used in conjunction with a short extension ring. While it is no longer possible to look horizontally into the viewfinder when working at ground level in the field, a right-angle viewer can be screwed into the eyepiece with no loss of through-the-lens metering. These pictures will be even more effective if the camera is tilted upwards so that the subject is viewed from below, but this may have to be done in a studio where the 'ground' can be raised above the camera.

Cheating with light

So far I have assumed that all our pictures are taken in bright sunlight using a small lens aperture, that is, with the iris diaphragm closed sufficiently to give a reasonable depth of field. In practice, sunlight is a rather mixed blessing: it varies a lot in quality during the day with sunrise and sunset at the extremes, it tends to disappear at the crucial moment, and because it is unidirectional it casts very hard shadows. Sometimes it is just not bright enough. For general photography a lightly obscured sun is preferable. But suppose that the sky is heavily overcast, the subject is in deep shade, or we need a greater depth of field than the available light permits. We could use a flash gun and flash bulbs, but for large scale

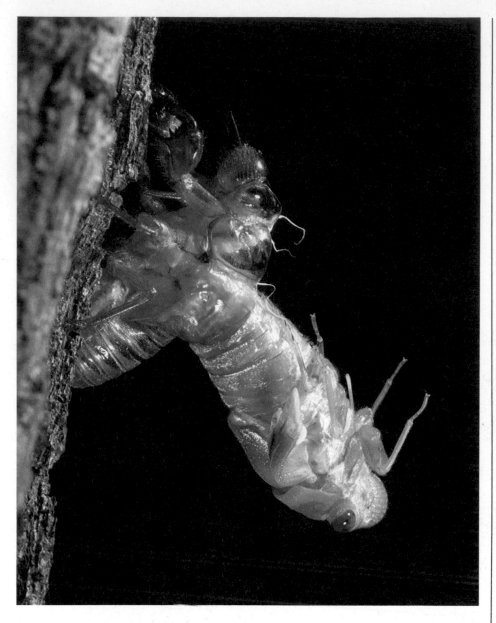

work the cost of new bulbs is prohibitive. Other disadvantages are the rather long flash duration, which will not freeze fast movement, the noise of explosion and the disturbance when a new bulb is inserted. Electronic flash or strobe light is the answer; it is no exaggeration to say that it has revolutionized photomacrography. The emission of intense light for a short period freezes movement, while the iris diaphragm of the lens can be closed down to give a greater depth of field. Electronic flash does not generate heat and does not disturb small animals unless the lamps are very close. The fact that the light

Electronic flash at midnight lit up an adult cicada emerging soft and vulnerable from its nymphal case. February 1978 was 'cicada year' on Lizard Island in the Great Barrier Reef. Hundreds of thousands were emerging in the eucalyptus rain forest to spend an all too brief life in the sun after living underground as a nymph for several years.

has the same colour balance as daylight is a bonus. Any insect resting close against its habitat is an ideal subject since both it and its background are fully illuminated. If instead the insect is resting on a twig against a distant background, the animal and twig will be correctly exposed but the background will be black. Black backgrounds usually look unnatural, as though the picture were taken at night, so to achieve a more natural effect a cut or prepared background is placed close behind the subject, though not so close that the subject then casts a shadow.

What if the weather is dull, you have stumbled across a rare sight and you are without flash? It is really tempting to use a long exposure. This may be successful provided the air is still and an exposure above 1/25 second is possible. But some cameras suffer from vibration caused by the movement of the shutter and the mirror at speeds slower than this. At such exposures, the part of the total exposure affected by vibration is proportionately large, and it will mar the picture quality. At exposures of 1/4 second

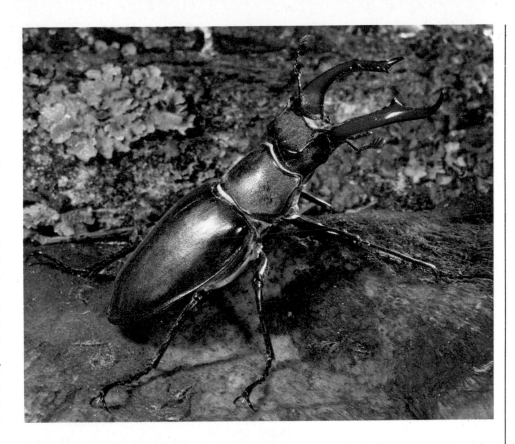

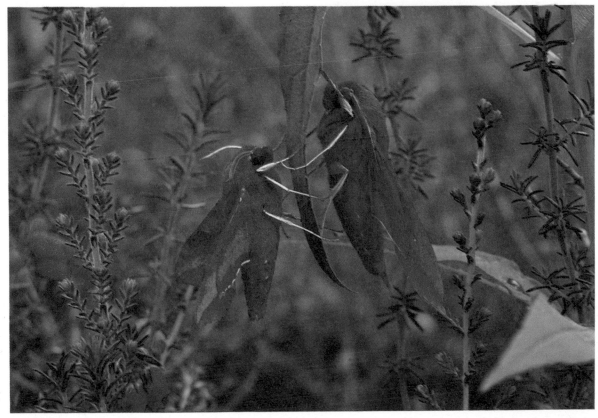

ABOVE Artificial light can be used to produce a clear and natural picture. For example, the high front flash used on the largest British stag beetle, *Lucanus cervus*, functioned like strong sunlight. A back light filled in the shadows under the beetle and rim lit his enormous gaping jaws, which he uses to wrestle with other males in competition for females. The females have jaws of normal size but can give a more severe bite.

LEFT The small elephant hawk-moth *Deilephila porcellus* is on the right and the large elephant hawk-moth *D. elpenor* is on the left of a stem of bell heather. Both moths have just emerged from purchased chrysalids; the chance of finding the two together in the wild is negligible and we wished to compare these two British species. These moths were not easily disturbed, so we could use a 55 mm macro-lens rather than a 105 mm lens, which allows a greater distance between camera and subject. A very heavily diffused continuous tungsten light originating in front of the moths gave the completely flat lighting. There are no shadows to provide modelling.

and longer, however, there will probably be no problem because the vibration takes up a small part of the exposure time. A precaution is to lock the mirror in the 'up' position and use the delayed action shutter; this removes one of the sources of vibration completely.

There are also many ways of using natural light. When the sun shines on to the wing of an insect from behind the camera, the range of contrast between high light and shadow is minimal. Structure, shape and colour emerge clearly but in such 'flat lighting', the resultant picture may be rather dull. On the other hand, if the sun shines from behind the insect, and therefore through the wings and towards the camera, this is known as 'back lighting' and can produce photographs of exceptional beauty. But the subject is seen mainly in silhouette and lacks detail, although surface hairs and sculpturing are often shown in striking relief. The photographer may choose to combine the two types of lighting, in which case he uses a reflector to throw light on to the dark side of the subject, from either the front or the back depending upon the position of the sun. Reflectors are easily made, even in the field, from aluminium baking foil taped to hardboard.

Wood-wasps – a favourite study

During the five years in which I studied the alder wood-wasp and its parasites, I accumulated a unique collection of colour transparencies of their life histories. But one thing was lacking. My great interest has always been in animal behaviour, but this is not static. The still photograph freezes a single moment and is a poor substitute for motion pictures portraying continuous action. I considered the possibility of making a movie but hesitated because of the cost. Then Sir Peter Scott, who in 1960 was presenting the *Look* programmes on BBC, told me that he would use the wood-wasp story if I put it on film. I took the plunge and bought my first equipment, woefully ignorant of what was involved and quite unaware that this action would change the course of my life completely.

My attempts to elicit information on suitable motion-picture techniques for insects soon revealed that I had wandered into

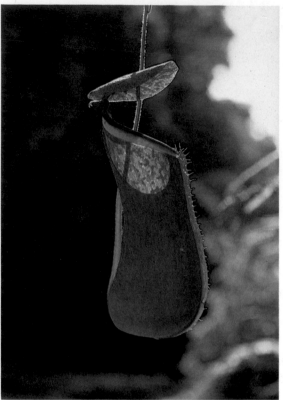

The pitcher plant, *Nepenthes*, is a creeper which covers trees and shrubs growing along rivers in the hills of Penang, Malaysia. Small animals, mainly insects, are lured to the pitcher by its colour and sweet secretions and may then fall into the digestive fluid which partially fills the pitcher. Natural back light and a dark background has enhanced its exotic shape.

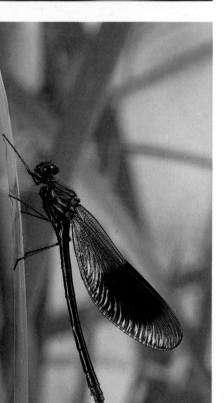

The male banded agrion *Agrion splendens* is one of the most attractive of British damselflies. Two electronic flashes, one from high up in front and one from the side, bring out the dark wing patch and the metallic blue and green of thorax and abdomen, while the highlights on the wings are achieved by illumination from behind. Perhaps such an interplay of light is also used in courtship, when the male opens and closes his wings in front of the somberly coloured female.

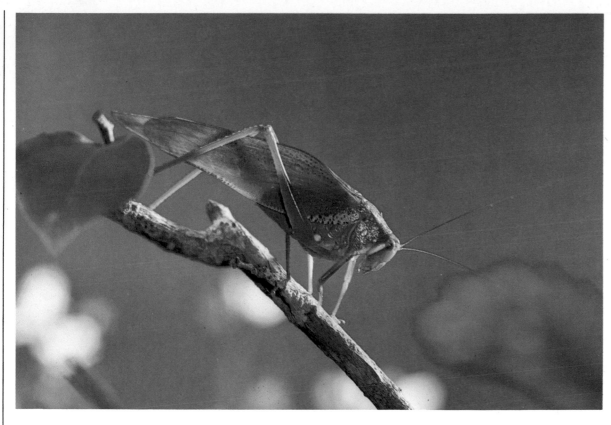

This Trinidadian katydid was one of a series of insects we took to illustrate camouflage during our stay at Simla in 1974. When among leaves it is very hard to see and to photograph. Back at base we directed four strobe lights at it: two lit the bushcricket from in front; one lit it from behind to produce 'rim lighting', and the fourth illuminated the background.

a sort of no-man's-land of photography. There were no established methods for motion-picture photomacrography – that is for animals that were too small to film by conventional studio methods, and too large to film down the microscope. So I became an unintentional pioneer. Today, twenty years later, there is a worldwide scattering of competent photographers in this specialized field. In 1960 the challenge was complete.

The first decision was 'field versus studio'. I had only to stand in my study area on the outskirts of Oxford and look up at a wood-wasp laying eggs in a dead tree two metres above my head to realize that working in the field was not likely to be rewarding. It was obvious that most of the filming would have to be done under controlled conditions. Luckily, my studies had shown that the insects would behave normally in my laboratory.

The main photographic requirements were that the subject should be accessible to the camera and that picture size and angle of view could be readily changed. The picture must be perfectly steady. The light must be sufficiently intense to permit close-ups in colour but not so warm as to cause the animals discomfort or to behave abnormally.

I mounted the camera on a wheeled gantry with a rise and fall pillar incorporating a fine focus rack-and-pinion, and placed the subject on the basal platform of a large pedestal drill so that it too could be raised and lowered.

There are two sources of vibration; from the floor and from the camera motor. The likelihood of apparent vibration is directly proportional to the size of the image; at natural size and larger, the problem may become acute. The greater the mass, the more it absorbs vibration and so I made sure that the camera gantry and subject stands were heavy. Indeed, the university surveyor accused me of grossly overloading the floor of my upstairs room in the Department of Forestry and I was banished to the basement, where I was given a larger and better room in every respect. Here I was on a solid concrete floor which helped reduce vibration coming upwards. Even so, when attempting high magnification of a little chalcid fly I found that the camera registered vibration whenever a

car went along the road, although the Department of Forestry is a massive stone edifice.

I obtained intense illumination by passing the light from a 500 watt internal reflector tungsten lamp through a three litre flask filled with water. The flask acted as a primitive condenser giving ten times as much light at the point of focus. But the temperature quickly rose to 70°C, by which time any insect was quite dead. By incorporating two discs of special heat-absorbing glass between the lamp and flask, I managed to keep the temperature below 30°C. On occasions, I even had to provide additional heat. For example, when I tried to film the courtship of some jumping spiders I had no success until I remembered that stones on the ground in the sun, where the spiders would normally perform, would heat up greatly in excess of 30°C. Adding a naked tungsten lamp produced the desired effect.

One problem remained; that of the sheer intensity of the light. At first, insects that are normally active by day appeared to be unaffected, but if the lights remained at full intensity they usually moved into shade. The answer was to have the lights full on only while the camera was running. Most shots in a film are quite short, rarely longer than ten seconds (the wood-wasp film averaged seven seconds per shot when it had been edited), so I operated the lights through a variable resistance while I was setting up a shot or waiting for action. I turned a wheel to set the resistance to give 100 volts allowing sufficient light to see through the camera reflex system without in any way disturbing the insect. When the desired action started, I turned the power full on to 240 volts using my right hand, while I started the camera motor with my right foot. In order to avoid having to use a hand to start and stop the camera — both hands were already needed for focusing and panning — I modified a dip switch such as used to be fitted on the floor of cars to dip the headlights. One depression with the foot started the camera and another depression stopped it. The device may sound primitive yet it has the great merit of being simple and effective.

On the other hand, I found small nocturnal animals were difficult to film because they would flee at once when the lights were turned full on. Before we could film the life history of cockroaches, they had to become acclimatized to light. To do this we kept them in containers under constant light, steadily increasing its intensity until they would eat and lay their eggs under high light levels. It took several weeks before the insects were ready and advance planning was obviously important.

The art of building up a motion-picture sequence relies on frequent contrast of viewpoint and picture size. No viewer's attention is held by a constant diet of big close-ups. A pull back to a wider angle offers relief from the last close-up and enhances the impact of the one following. One very convenient way to change the field size quickly is to use a lens such as the Nikon Micro Nikkor. This lens is made for a 35 mm stills camera but with a suitable adaptor it can be fitted to a 16 mm motion-picture camera to give a wide range of field size. For bigger close-ups to 1:1 I use a Switar 75 mm lens plus extension rings, and for higher magnifications, I graduate to the Zeiss Luminar lenses which are also used in still photography.

It often seems that the film runs out just as the best action begins. This is understandable since a thirty metre roll of film exposed at 24 frames per second only lasts for two minutes

For us to obtain a series of behaviour photographs, this female American cockroach *Periplaneta americana* was kept for three weeks under permanent tungsten lights. Even so, she seldom stood still and her antennae were constantly on the move. We therefore used a short exposure and opened the lens aperture to f/5.6. As a result the depth of field is rather narrow. Had we used electronic flash, we could have closed the lens aperture to f/22 and obtained a wider depth of field. But the firing of the strobe disturbed her considerably and we would never have achieved a sequence. Here, an egg cocoon at an advanced stage of development projects from her abdomen. Soon the roach will glue the cocoon to the substratum in some crack or crevice and finally she will cover it with saliva and dirt.

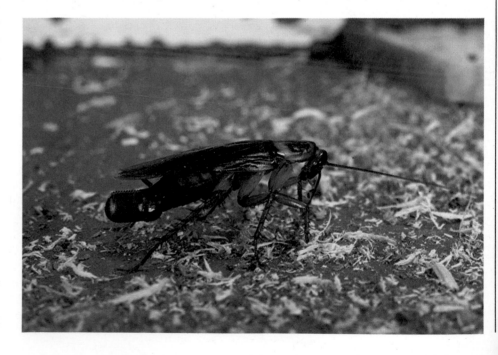

and forty six seconds, but all the same it is intensely annoying. Under these circumstances I find it far quicker to change the camera than to empty and reload, assuming, of course, that all fittings are of the quick release type. In this way, a fairly slow event, like the expansion of a butterfly's wings, can be captured despite the interruption.

Rapid events pose other problems. A hawker dragonfly shedding its nymphal case emerges until it hangs head down with only the tip of its abdomen held by the case. For about twenty minutes the insect remains completely still, and then, suddenly, it flicks up and grasps the case with its legs, at the same time extracting the last portion of its abdomen. The sudden change in orientation from head down to head up is disconcerting in a film sequence and the viewer may well feel cheated. Yet the camera cannot be run continuously; this would consume more than two hundred and twelve metres of film, which is in any case greater than the capacity of an ordinary 16 mm camera. One approach is to determine from experiment whether the length of the dragonfly's quiescent period is more or less constant, then start the camera just before the body's change in orientation is due to occur and hope that it is over before the film is exhausted. Rather than doing this, I decided to place a thin wire barrier beside the abdomen of the dragonfly to impede it as it began to swing upwards. At this point the camera was started and the barrier removed. Fortunately the insect made another attempt without delay.

One of the most interesting aspects of this type of filming is the constant challenge to devise suitable techniques for the unending difficulties that arise. The problem of the emerging dragonfly was one. And there were others. For example, could a female locust be persuaded to lay her eggs between glass plates so that the whole egg pod would be visible? What were the chances of filming a tropical fish giving birth to live young? I got my sequence after several months, but in this case patience was the key to success. Could the emergence of a silk-moth be filmed from inside its cocoon? Yes, a window was cut in the side of the cocoon and the moth emerged through the intact roof.

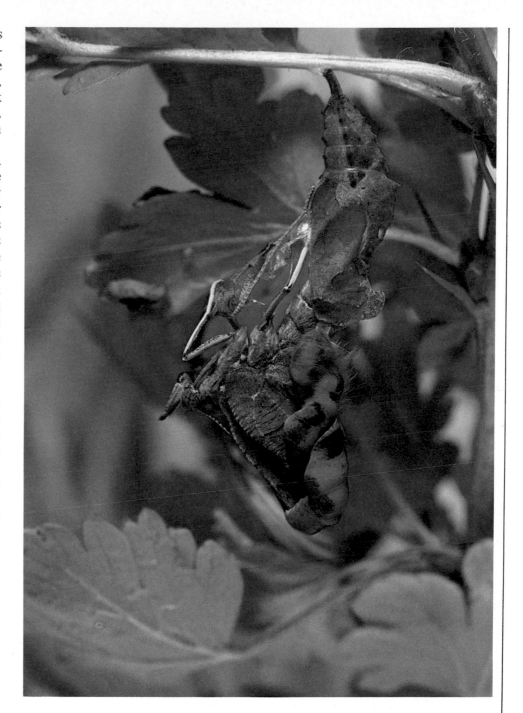

But the subject that had motivated my venture into motion-picture photography in fact presented me with one of my most difficult shots: how to show the alder wood-wasp laying her group of eggs between the bark and the wood of a dying alder tree. The female uses her tough tripartite ovipositor to drill a channel through the bark, but she will never start to drill through bark which has

One of a series of 20 pictures of the emergence of a comma butterfly. We were given twelve hours' warning of the start of this event by the deepening colour and pattern of the wings seen through the pupal case.

become detached from the wood. Luckily, once she had started work, she was not then disturbed by my fingers or scalpel provided my movements were slow and cautious. So I decided to try to cut through the bark around the wood-wasp and pull it away from the wood in the hope that she would continue to drill and deposit her eggs. The problem was that any alteration to the natural curvature of the bark would pinch her ovipositor and she would withdraw. At the thirty second attempt I managed to remove the bark with the insect still at work. With bated breath, I fixed the fragment in a small clamp in front of the camera and watched as the ovipositor came through the inner surface and gaped as the eggs began to emerge one after another. I had become the first to witness a phenomenon which had seemed safe from human sight. Such moments of privilege are infrequent, but when they occur they more than compensate for the tedium that is part of any job, even filming nature.

The proper care of the animal performers is important; they must be fed and watered regularly. When the filming lamps are on for

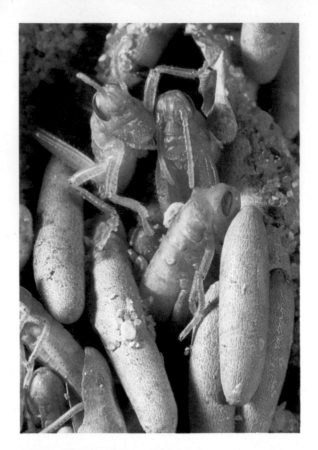

LEFT We had to overcome two problems in order to succeed with this picture. First, the desert locust had to lay its eggs in sand between two plates of glass so that they were visible. Secondly, the cameraman had to be present at the precise moment of hatching. Luckily, a locust eager to lay her eggs is rather amenable and, if provided with sand moistened to her liking, she will thrust her abdomen into any crevice wide enough to accommodate it. We reduced the development time to the minimum by incubating the eggs at 32°C.

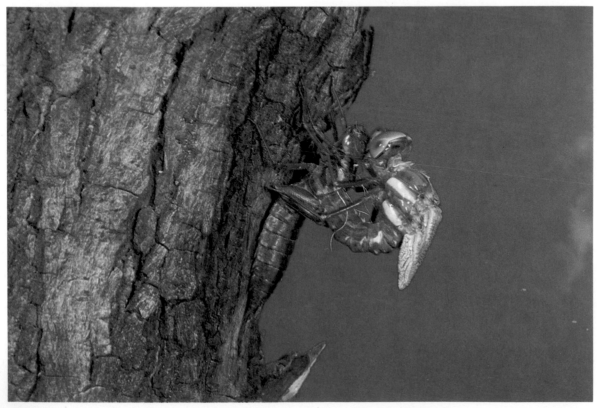

LEFT Halfway through its emergence an adult dragonfly hangs head downwards from its nymphal case, having extricated its abdomen as far as it can without falling down. It takes a break from its exertions, lasting between 15 and 20 minutes, then suddenly flicks its body up so that it can grasp the case with its legs and free the end of its abdomen. This picture was taken during the very short interval between grasping the case and removing the abdomen.

a long time, heat builds up on the set despite the filters, and wet cotton wool held in forceps is offered to the insects and spiders every half an hour to prevent their desiccation. Many insects get all the food they need from a five per cent sugar solution. A male parasitic ichneumon wasp, *Rhyssella curvipes*, would live on average only three days without water or food. Water increased its life expectation to five days, while with sugar solution the average life became twenty eight days. An adult tiger beetle, *Cicindela*, lived for four months provided with water and a regular diet of ants and caterpillars. The spiders in our laboratories are fed on fruit-flies, house-flies or blow-flies, according to size, or in the case of tarantulas, on locusts. An elementary precaution is not to keep small predators together — in a short time you will be left with only a single bloated individual.

Some individuals are better 'performers' than others. When filming tiger beetles capturing meadow ants, I found that one beetle from the dozen available was consistently more likely to give me what I wanted. He was awarded a name and became the star of the film. I have noticed the same variation in usefulness on other occasions and my heart sinks if I am offered only one or two specimens for a difficult sequence.

In Britain, the adult garden spider, *Araneus diadematus*, varies in colour from nearly white through all shades of brown to almost black. But except when there are such obvious differences between individuals, the human eye does not distinguish between one small animal and another of the same species. This is fortunate, because it is often necessary to use several animals for any sequence. Any that die obviously need replacing, but there are other situations. For example, we were filming the female of a species of spider which mates only once. The action was over so quickly that several matings were necessary in order to obtain a selection of angles and magnifications. It is in the adult that continuity is most easily lost and we have always to be careful to watch for basic structural differences in the actors and their understudies. For example, an insect may be missing an antenna or leg without being inconvenienced, and spiders frequently have fewer than

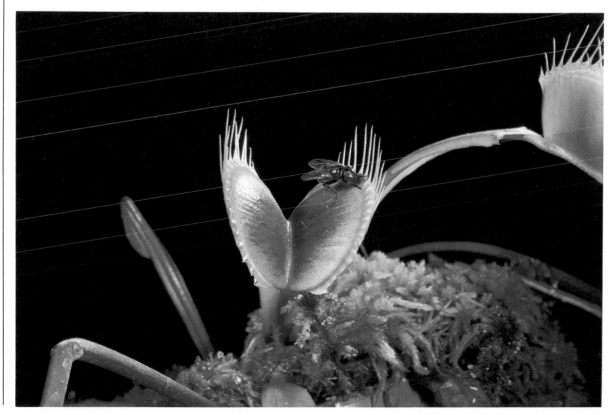

Each of the Venus flytrap's leaves is modified to attract and trap small animals. The livid red valves, the colour of raw meat, attract carrion-feeding flies, while nectar secreted around the edge of the trap attracts nectar-feeders. When one trigger hair — there are three on each valve — is touched twice within about 20 seconds, or two hairs are touched at the same time, the trap is sprung. The valves close so that their spines interlock, leaving space between them for very small insects to escape. But something worth digesting, such as a large fly, cannot escape and the valves then squeeze together until they are flattened against each other. Enzymes are secreted, the fly is digested, and the nutritious products are absorbed. A day or so later, when the valves re-open, the chitinous skeleton will be all that remains. Each trap can consume about three large flies or one animal the size of an earthworm. It then dies.

their full complement of eight legs. The membranous wings of insects easily become torn, and scales, when present, are frequently rubbed off leaving recognizable bald patches. This is another reason why we never pick up scaly winged insects with our fingers, and handle them instead with small paintbrushes or glass tubes if they are fliers. A well-fed spider has an obviously distended abdomen and is quite different in shape to a hungry one. Similarly, pregnant females have vastly larger abdomens when compared to ones that have laid their eggs. Relative size is particularly important in sequences on courtship and mating. For instance, the body length of the female alder wood-wasp varies from 7 to 21 mm and that of the male from 6 to 17 mm. The female can thus be up to three and a half times the length of the male, or the male may be as much as two and a half times the length of the female.

A film sequence showing how an orb web spider catches, wraps and transports its prey took about two weeks to complete, not an hour or two as some may imagine. This is

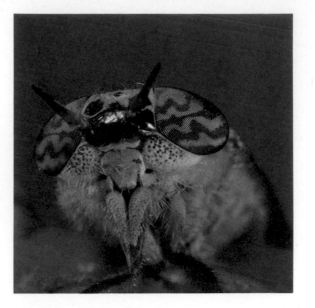

Horseflies and clegs are major irritants of man during the heat of summer because the females are blood-suckers. But the hated horsefly has one item of beauty to counter the drabness of its flattened body. In life, the eyes are among the most beautiful in the world of insects. Iridescent and changing in colour according to the angle of the lights, they exhibit brilliant colours exaggerated here by using two strobe lights and magnifying 5 times using a 25 mm Luminar lens.

because the action was quick and had to be repeated at least six times to obtain a sufficient variety of angle and field size. Each time an insect was caught part of the web was destroyed and a new web had to be constructed before filming could proceed. In

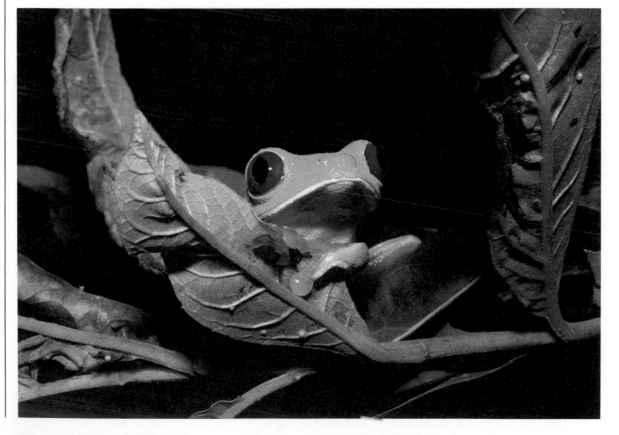

This picture was taken at night with a hand-held camera using a 55 mm macro-lens and a single strobe light mounted on the camera. The cameraman noticed the frog sitting quietly in a bush on the island of Barro Colorado in the Panama Canal. Apart from its beautiful eyes, its colouring was cryptic. There was no use him setting up a tripod; the frog would doubtless have leapt away during the inevitable disturbance to its bush.

short, the sequence required twenty one shots of which six were midshots, nine were close-ups and six were big close-ups. The spider needed five identical prey insects. In contrast to these rapid-action shots, the mating of the beautiful spider, *Micrommata virescens*, is slow and repetitive and one pair of individuals and one mating was enough for me to film the complete behaviour within three hours.

Studio filming is no easy option compared with field filming, but it is the only way to obtain big close-ups of small animals under conditions free from wind, inadequate light and difficult access. But to get the best from the subjects under these 'artificial' conditions, we take care that the 'set' or natural setting always provides the correct environment for the animal. When filming spiders I have had to construct portions of a garden shed, a greenhouse window, a greenhouse bench with plant pots, a slate roof, a brick wall, a wooden fence and the ceiling of a living room. Natural spider sets replicated in the studio have included sand dune, acid bog, alkaline grassland, tree trunks and tree foliage and a variety of shrubs such as gorse. Sets that include living plants present problems when they have to be maintained for more than a few days. If the sets can be moved they are kept in full daylight when not in use; if too heavy they are illuminated with plenty of light of the right quality. We use strip lights containing ultraviolet and these prevent the plants becoming etiolated or turning yellow. We use a time clock to provide the correct day length for the time of year. Provision for watering involves drainage and catchment vessels. We retain animals on their sets by various methods, for example, water barriers, netting, miniature electric fences or glass walls. It is not difficult to see that a studio set

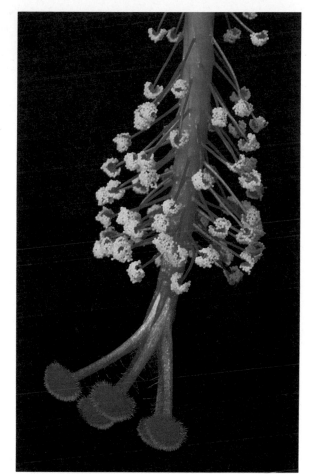

The sexual organs of a coral hibiscus hang down below the large red showy petals, not included here. The flash has picked up all details of colour and texture because of the good depth of field. The petals form a tube with nectar at its tip, and a hummingbird must hover against the sexual organs as it reaches to drink. As it quarters its territory it, therefore, picks up pollen from many laden anthers and brushes it off onto any sticky, hairy, red stigma. The flower closes at night when the birds are inactive.

may be both cumbersome and complicated.

I have always regarded the camera, whether for stills or motion pictures, as a means of conveying information. The prime requirement of the wildlife cameraman is a sound knowledge of biology rather than an expert knowledge of the art of photography. It is much easier for a biologist to learn to take photographs than for the reverse to occur, and the history of Oxford Scientific Films supports this view.

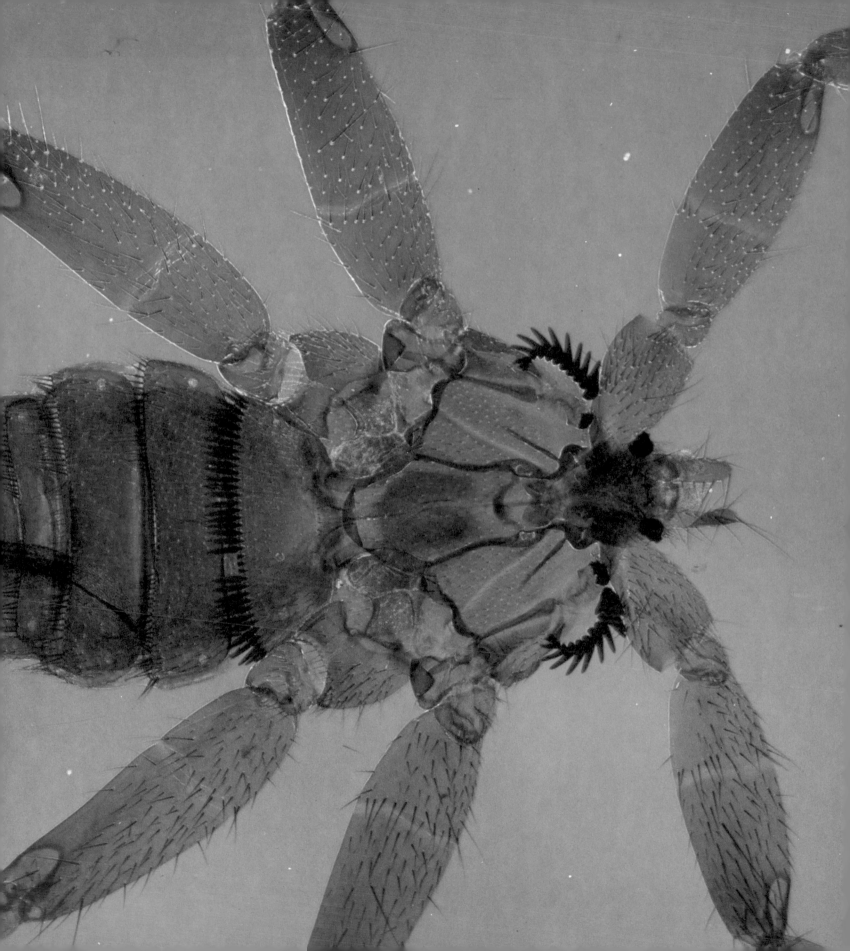

2 Filming microlife

JOHN COOKE and PETER PARKS

After the return of our 1967 expedition to Jamaica, when the seeds that were to become Oxford Scientific Films began to germinate, I [John Cooke] was still firmly wedded to a career as an academic zoologist. My particular interest was, and still is, the study of spiders. Indeed, since I was about fourteen, spiders have provided me with not only an absorbing hobby but a valuable focus for all my zoological interests and a perfect excuse for travel to foreign parts.

The identification of spider species, the first step in any scientific investigation, requires that the preserved corpses be examined under a microscope as they lie in alcohol. As with many kinds of animal, the ultimate characters for separating species are to be found in the reproductive organs, which in spiders are particularly complicated and difficult to observe. Traditionally, spider taxonomists have relied on detailed and time-consuming pen and ink drawings of these structures, but during the 1960s I became interested in recording this information photographically in the belief that it would prove both quicker and more accurate. It is from such esoteric and improbable beginnings that several of OSF's specialized photographic techniques have evolved. Foremost among these is the stills optical bench.

Spiders and the stills optical bench

One of the main objectives of photomacrography is to show the subject in more detail than can be seen with the human eye unaided. Although photography at natural size — a reproduction ratio of 1:1 — can be done in the field, when magnifications beyond this are required, a number of special problems arise. Foremost of these is the progressively reduced depth of field. Normally the depth of field can be improved by stopping down the iris diaphragm within the lens, but with small subjects other laws of physics begin to intervene and increase in depth of field is offset by an overall degradation in quality through a general loss of resolution. The stills optical bench, like its motion-picture counterpart (which Peter Parks will describe later), was designed to facilitate photography at magnifications greater than 1:1 and so bridge the no-man's-land between photomacrography (at 1:1) and photomicrography (at 10:1). Both optical benches rely on the subject being moved relative to a static camera for focusing, and both link subject and camera mechanically thereby overcoming the problem of vibration.

Originally the stills bench was designed as a wall-mounted unit to photograph vertically downwards on spiders lying in preserving fluid. From dead spiders in alcohol, my

OPPOSITE A wingless fly, an external parasite of bats, was photographed from a slide 110 years old inherited by Peter Parks along with the Ross microscope and optics that he has used so extensively for photographing microlife. The lighting, a combination of blue dark field and oblique, is used to offset the natural brown colour of the fly and give sparkling highlights to its bristles.

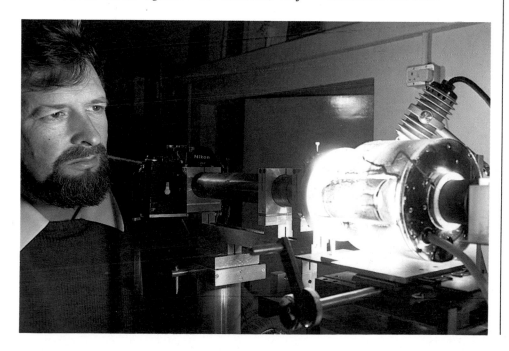

BELOW In this picture, John Cooke is being illuminated by stray light emanating from the stills optical bench as the camera fires. The specimen sits on the platform projecting from beneath the glowing lamp unit and is moved relative to the camera and illumination, which are rigidly fixed. The stills bench is designed to work at magnifications between 2:1 and 36:1.

interest turned to the general problems of photographing small living organisms, particularly those in water. The bench quickly evolved into a free-standing, transportable unit that could be used wherever there was an external supply of electricity. My first subjects came from our small lake and consisted of a variety of molluscs, worms, insects and crustaceans ranging in size from about one centimetre to less than a quarter of a millimetre. I then turned my attention to various parasites – including the developmental stages of the liver-fluke, *Fasciola*, being used for teaching in undergraduate biology courses at Oxford. Eventually it was possible to take the equipment on marine biology courses to places like Swansea and explore the diversity of minute tidepool life and the limitless marvels of plankton.

The stills bench, which is designed for use with a 35 mm single lens reflex camera, is constructed on the principle of the large-format monobar camera but uses fixed-interval extension tubes instead of infinitely variable bellows. Although for conventional photography there are an enormous number of lenses to choose between, as soon as you start to work at magnifications greater than 2:1 the field of choice is greatly reduced. By good luck rather than good management, we decided at the outset to use Zeiss Luminar lenses, a choice which even with the wisdom of hindsight could not be bettered. The Luminars are essentially microscope objectives with an integral iris diaphragm. They come in four focal lengths and are designed to be used when the distance from lens to subject is less than the distance from lens to film. By using the 16 mm, 25 mm and 40 mm Luminars with extensions up to 500 mm it is possible to cover a range of magnifications from ×2 to ×36. On the relatively rare occasions we need to work at magnifications greater than this we use either the motion-picture optical bench or a conventional, commercially available photomicroscope. When working with living animals, however, the Luminar lenses present one very serious drawback. The iris diaphragm is controlled manually so that an appreciable amount of time is lost in stopping down the lens after focusing the subject, during which time, more likely than

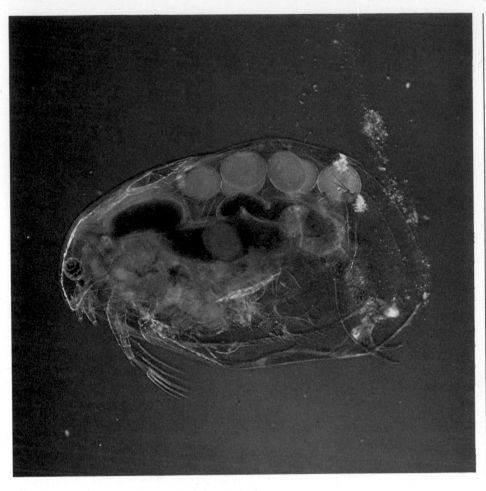

not, the subject has moved out of the field of view. As a result we had to devise an automatic aperture control system. After a couple of false starts, we constructed a rather Heath Robinson spring-operated mechanism which operated perfectly. Despite plans to refine the system and make it more compact and elegant, the original device is still in use. Its most important feature is a microswitch which is operated when the diaphragm closes to a preselected aperture. This switch is connected to the motor drive of the camera, which is thus fired electrically rather than manually, so minimizing the delay.

The original subjects for the stills bench were small aquatic creatures, such as brine shrimps, mosquito larvae and water fleas, and to photograph them effectively meant that they should be swimming free but nevertheless confined within a small area. This was achieved by building small tanks of extremely thin glass and then confining the subject close

This picture of the water flea, *Daphnia*, was one of the first to be taken on the stills optical bench using a projected blue background as an alternative to the blackness of conventional dark field illumination. During the summer months female water fleas produce large numbers of eggs, which are clearly visible in this specimen, without being fertilized. The eggs hatch within a brood pouch so that the water flea in fact gives birth to live young. In winter, or when conditions become hard, males are produced. The resulting fertilized eggs are protected within a brood pouch which is moulted by the mother. Pouch and eggs settle in the mud and hatch only when conditions improve.

to the front by a second, moveable piece of glass. This was not satisfactory. Small subjects were effectively lost because they still had too great a space to swim in. Even when they were eventually located the pictures were frequently marred by a ghost reflection produced by the second sheet of glass behind. The solution was to have made a series of optically polished glass slides in which were hollowed out a series of depressions of varying depth and diameter. These were invisible through the camera, yet confined the specimen to an area just big enough for it to move naturally but not so large that it took half an hour or more of searching to locate it through the eye-piece.

Illuminating the microworld

More interesting were the problems of lighting, particularly because I wanted to use the technique of dark field or dark ground illumination. Much favoured by the Victorian microscopists, this type of lighting is wonderfully suited to revealing the complex internal structure of small, translucent aquatic organisms. Although it was quite possible to use a conventional light source and dark field condenser, this did not provide all that I wanted. To get the optimum depth of field without the loss of resolution mentioned above, the iris diaphragm must still be closed well down and this necessitates a powerful light source. Rapid movements of, for example, the limbs of a water flea are magnified as the creature is magnified, so very high shutter speeds are needed to freeze the activities of such subjects. High shutter speeds also require powerful light sources. But fortunately conventional tungsten filament bulbs are not the only lamps available. Xenon discharge tubes, more familiarly known as electronic flash, or strobe lights, are not only immensely powerful, but produce their light in very short bursts that can freeze the most rapidly moving limb. The difficulty lay in using a strobe lamp efficiently for dark field illumination because the conventional dark field condenser requires a small, compact source that can be focused, whereas xenon discharge

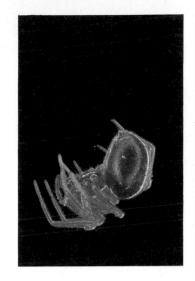

ABOVE Money spiders, like this *Gonatium rubens*, undertake dispersal flights in autumn suspended from silken threads. This specimen was filmed on the stills optical bench, and the dark field illumination makes the fine silk strand and the surface hairs stand out very clearly.

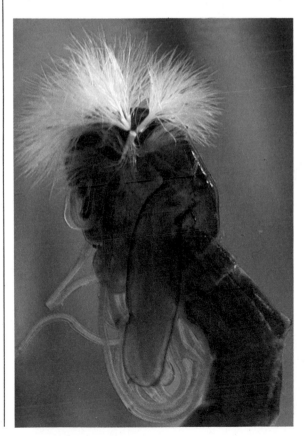

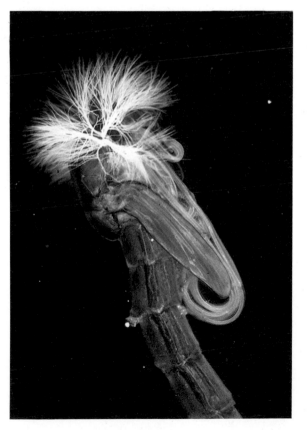

FAR LEFT AND LEFT These two pictures demonstrate conventional dark field illumination and the effect of projecting in a hint of natural background, using the aerial image relay system. Both pictures were taken on the stills optical bench using electronic flash. The larval stages of midges live in mud at the bottom of ponds and rainwater butts, where there is little dissolved oxygen. As an adaptation to this environment they possess haemoglobin, the same red pigment that we ourselves possess in our blood, to help extract as much oxygen as possible. The pupal stage, illustrated here, swims actively and obtains its oxygen through the branched and very decorative gills on its head.

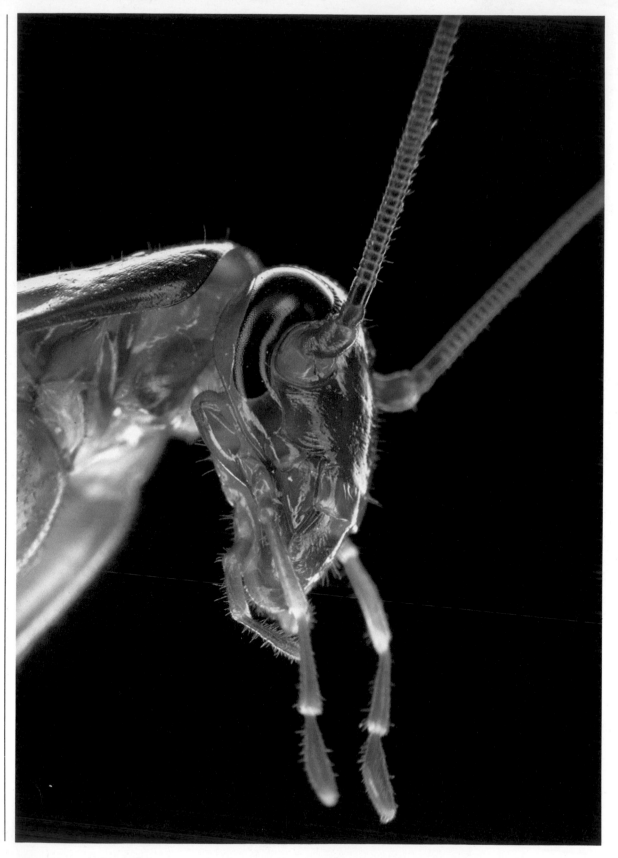

The head of this American cockroach, *Periplaneta americana*, was photographed on the stills optical bench using the same type of illumination as for the money spider on the previous page. However, because the cockroach is larger and far denser than the little spider, the backlighting of the dark field system only emphasizes the outline and surface sculpturing of the head. The necessary front lighting comes from the same lamp but is reflected off an annular parabolic mirror.

tubes are relatively large and diffuse. While pondering this problem a solution suddenly dawned, simultaneously overcoming another, more daunting problem of how to achieve the brilliant, glowing illumination of the dark field technique against a more natural and colourful background than plain black.

By using an annular light source, I argued, it should be possible not only to back-light the subject in the same way, without the need for a condenser, but also project in any background through the centre of the light source. By good fortune, many commercial strobe lamps use annular flash tubes about eight centimetres in diameter, and before long a prototype unit for the optical bench was constructed. After a series of tests the principle was found to work. Nevertheless I remained unsatisfied. When larger or more dense subjects, such as a water louse, were photographed by this method, the central areas were underlit and clearly a simultaneous source of front lighting was required. This immediately presented difficulties in the form of unwanted reflections, particularly off the front glass, and some complicated calculations were necessary before an angled annular parabolic reflector was built which could use light from the same source as that supplying the dark field back lighting. The first tests were done with black and white film so that the results would be available for analysis without delay. The excitement in the dark room as I waited for the first images to reveal themselves was electric, and when the pictures appeared they confirmed that the embryo idea which had loomed out of the steam as I lay in the bath had indeed been worth following up. Since then the original bench has been slowly refined and improved in various ways. When an annular light source is used on non-aquatic subjects, such as small insects or spiders, the lighting can give particularly dramatic effects, making hairs and surface sculpturing stand out with great clarity and brilliance. Used with polarizing and interference filters quite mundane subjects like fish scales, crystals or even the teeth of a snail can be made to look colourful and attractive. Moreover the principles used to

project a more natural background through the centre of the annular light source have also been applied in one of OSF's most sophisticated special effects techniques, the aerial image relay system.

Although the stills bench is far smaller and altogether less impressive than Peter Parks' later and more elaborate motion-picture benches, it has now become a routine weapon in the OSF armoury. Nevertheless, when

ABOVE Most snails feed by scraping up fragments of plant material with a rasp-like tongue called a radula. This specimen and the volcanic mineral, picrite (below), were photographed on the stills optical bench using polarized light. The dramatic colours are the result of introducing a quartz interference filter, which converts the light and dark of polarized light into different shades.

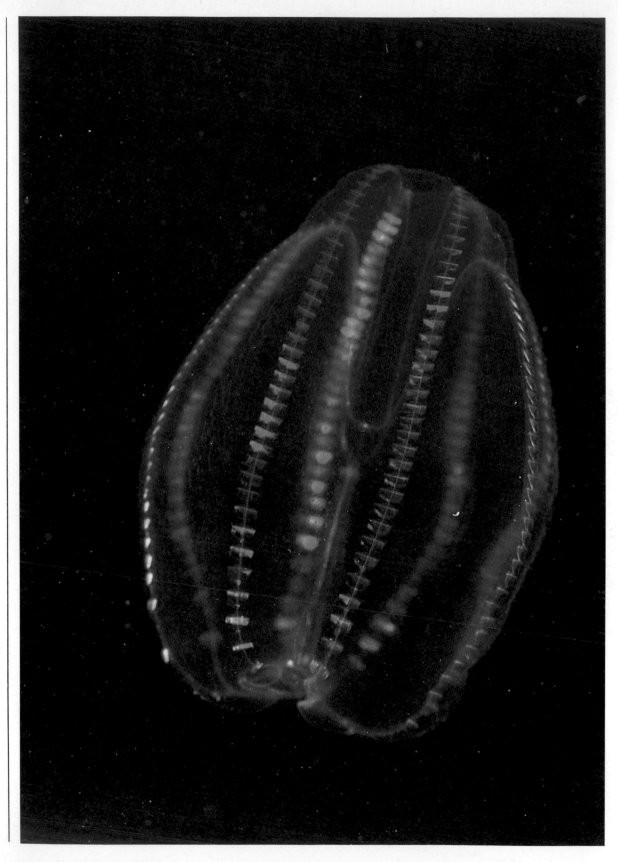

A comb jelly, 3 cm across, is lit up with the superb interference colours it is only possible to capture with carefully directed light. Much of microlife photography is concerned with extremely careful lighting.

using the stills bench we must remember to treat the electronic components with some degree of respect because the energy stored in the condensers that power the flash tube can be devastating if allowed to escape accidentally. The control panel still displays ominous burn marks from an unforgetable occasion some years ago when I was photographing marine life and carelessly allowed salt spray to drift on to the power unit. I was jerked back to reality from the hypnotic world of plankton by a blinding flash and massive explosions that devastated the circuitry and, had I been less fortunate, might well have killed me. It is sometimes hard to convince friends that photographing microscopic plants and animals can really be as dangerous as photographing charging rhino or buffalo!

Argulus and the optical bench

At the Zoology Department in Oxford, John Paling and I [Peter Parks] had a great desire to portray on moving film the wild life behaviour we both watched with fascination down our microscopes. Most of the minute animals that interested us were aquatic or parasitic, and John Paling's training as a fish parasitologist stood us in good stead for the behavioural stories we wished to record. But how were we to tell these stories on film? That was our problem.

I had inherited from a master at my old school a Ross Microscope that was eventually to become worth its weight in gold to Oxford Scientific Films. This masterpiece was built around 1870, and came to me with an extraordinary assemblage of eyepieces, objectives and condensers as well as some intriguing optics of ill-defined purpose — ill-defined to me, that is. John Paling and I perused the system, and bit by bit came to grips with the applications of the accessories and how to get the best results from them. From the start, the objectives, ranging from 10 cm to 0.2 cm, gave us great scope for a thorough study of our aquatic microlife, and though we did not know it at the time, this 110—year-old piece of optical equipment was to be the route on which John Paling and I based our careers.

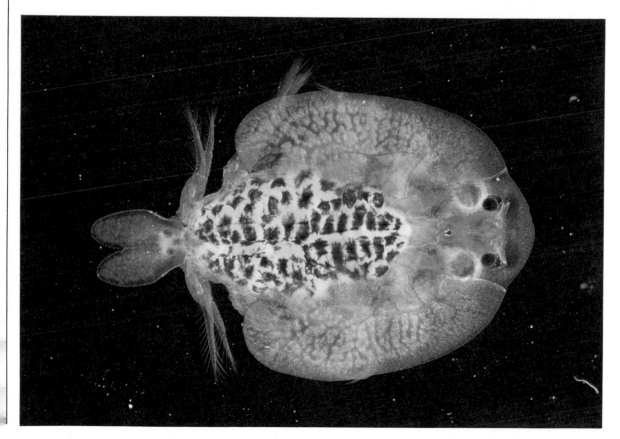

Fish lice are parasites found on many an angler's prize catch. *Argulus*, with its dramatic life style, was one of our first film subjects. The two enormous suckers behind its eyes enable this flat animal to grip on to smooth and slippery fishes — even to their eyes. Because the louse was so flat and transparent, we were able to make effective use of the old Ross microscope's dark field condenser and show not only the appearance of the louse but also what was going on inside it. Unlike light transmitted through an animal, dark field illumination retains the animal's colour and allows a very high intensity to reach the camera.

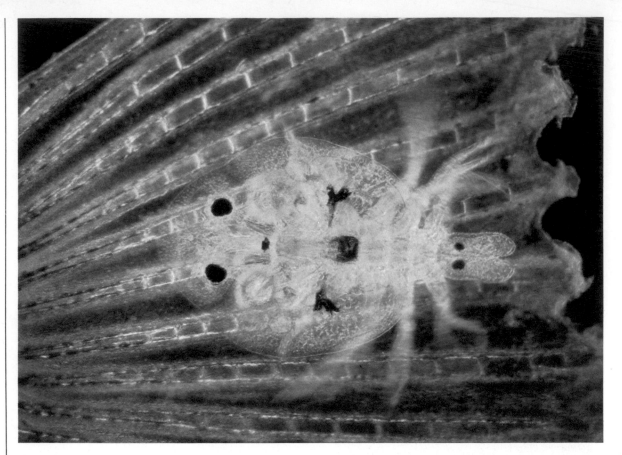

A juvenile *Argulus* on the tail fin of a stickleback. This high magnification shot of a 2 mm long louse was filmed on a live fish as part of the study of its life history. This juvenile has spent most of its time siphoning off the body fluids from the soft fin membranes. Its central stomach is darkened by fish blood. This young female will then develop eggs and move to the fish's body.

The item that intrigued me most was the simplest. It was a perfectly plain but effective, low power, dark field condenser. By continued experimentation with that condenser we eventually produced one or two fairly notable shots of what was going on inside the body of a parasitic crustacean, *Argulus*, found on many freshwater fish, and particularly on sticklebacks. Early on, we even found that this dark field technique was giving us remarkable views of the blood flowing round within the blood vessels of the fish's tail on which the fish lice were attached. Already we were both beginning to realize the vast potential that this system held in store.

Those first few sparkling dark field shots of *Argulus*, together with a varied assemblage of parasitic mites and lice, eventually found their way into a short assembly of shots that in those days we called our 'show' reel. This reel had some very important ingredients. It showed not only what those animals were doing but also what was going on inside the animals. Furthermore it contained some of

the shots that are so important in a detailed film: those that link the close-ups with the wider view and so help the audience to appreciate size and magnification more easily. Mites and ticks on lizards were seen to crawl into the ear cavity and lodge in the corner of the eye; fish lice attached to the tail of a living stickleback were illuminated in such a way that the blood corpuscles in the fish's tail looked like an aerial view of headlights moving along a street at night; feather lice scuttled between the barbs of a pigeon's feather to become flush with its surface; *Argulus* was seen to walk across the eye of a three-spined stickleback.

Nose-diving rabbit fleas

One day a few months later, we took that 'show' reel to Richard Brock at the BBC Natural History Unit, and while looking through it he was especially attracted by a shot of a live blue tit flea. This was a happy coincidence for us, because at that time Barry

Paine, a colleague of Brock's, was about to embark upon an intriguing programme about Miriam Rothschild's study of fleas at Oundle. She had found spectacular evidence that the life cycles of the blood-sucking fleas found on rabbits were regulated by the hormones and temperature changes within the rabbit's bloodstream – the first example of an invertebrate's life cycle being controlled by vertebrate hormones. The hormone fluctuations that dominate the rabbit's behaviour in reproduction were controlling not only the reproductive behaviour of the rabbit, but also the reproductive behaviour of the fleas. Both male and female rabbits played their part. For instance, when the buck approached the doe before copulation, his blood temperature rose half a degree. In response to this, the fleas in their summer feeding position on his ears, released their hold and migrated to his nose, and while he mated they hopped on to the female. In response to the hormone changes associated with rabbit birth, those fleas, and others already on the female, migrated from her ears on to her nose and while she licked the new born young, hopped on to them – there, it was found, to mate and lay eggs. This is only part of an extremely complex story, and our job was to film as much of it as we could.

First we had to overcome the technical problem of filming a microscopic flea feeding upon a live rabbit. It was impossible to get a fully grown, live rabbit on to the subject stage of a microscope (as the viewing platform is known), and the fleas would feed only on live rabbit. So we had to reconstruct the principle of a microscope that retained sufficient space and access for lighting and manipulation of such small subjects on such large hosts. We also chose to build it horizontally for greater comfort. From this humble start there evolved over the succeeding five years a succession of optical benches on which so much of our subsequent work has been done.

The first step in the evolution of the motion-picture optical bench was the dark field illumination system developed for *Argulus*, similar to the one which John Cooke later developed for his stills bench. The second step

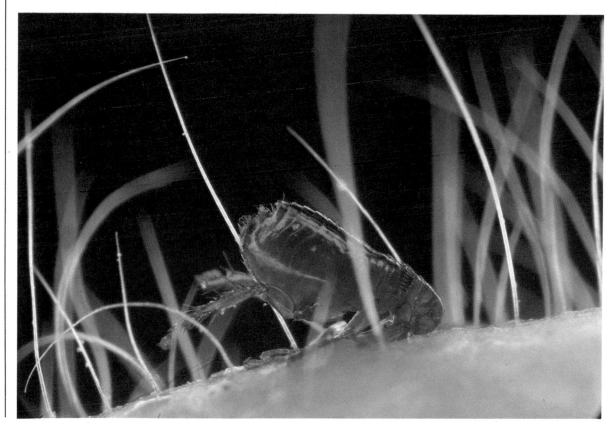

An adult female rabbit flea sucks blood from the ear of an unsuspecting host. The flea hangs on with its barbed mouthparts, its legs free to clamp on to any hairs that come within its grasp. It eats more blood than it can digest and it actively defaecates the excess. In the rabbit's burrow, the young fleas feed on these dry blood droplets.

While filming the flea's life cycle we had to solve the problem of getting a live rabbit under a microscope to film its fleas. Our solutions led to the evolution of a series of optical benches.

involved removing the vibration, which was a real problem when using magnifications of over ×5. We realized that if both the subject and the camera were held on the same rigid framework, the camera motor vibrations would move the specimen as well, and no resulting movement would be detected on the final film. Even our first step in this direction, that of linking the camera stand and the subject stand with two 'G' cramps, helped us double our magnifications without vibration. The system resembled a cake stand, the subject under scrutiny being the 'cake'. The platform upon which the subject stood was attached firmly to a steel bed in turn clamped firmly to the camera.

Such a rigid system obviously precluded movement of either the camera or the subject. No longer could the camera pan and tilt. Yet what was to happen every time the animal being filmed moved left or right or up or down? Because the animals and plants we were observing at these magnifications were relatively small, it was essential that the subject was moved at right angles to the photographic axis; otherwise a move made to track a progressing animal would soon come to a sticky end because the animal would be completely out of focus.

For similar reasons, the focus movement was also built into the subject stage but this was of course along the photographic axis. The subject stage or platform was therefore constructed in such a way that three-way multiaxial moves were possible. The whole cake stand was then built so that subjects could be filmed horizontally, vertically up or vertically down. Five years after the creation of the simple 'G' cramp system, we had constructed two three hundred and eighty kilogram systems with precision multiaxial movements and dual, horizontal and vertical modes of operation, complete with micro-zoom lens systems.

The principles used in constructing the successive optical benches, however, were fundamentally those we grappled with on the flea film. Even in those early days the simple system had some success. We actually managed to film parasitic hypopus mite larvae on the rabbit fleas, nicely illustrating Swift's line 'bigger fleas have lesser fleas upon their

backs to bite 'em'! Since the size difference between a young rabbit and its flea is similar to the difference between the flea and its larval mites, we had to achieve magnifications of ×20 or ×30 just to make these minute creatures fill half the frame. We also successfully filmed full-frame the fleas feeding on adult rabbits and mating on new born rabbits,

The prototype optical bench was made from a flat steel bed and an old brass microscope. The camera tripod is clamped with blue G-cramps to the table on which the optical bench stands. It was this joining of camera and specimen which allowed us to achieve magnifications up to 40:1. Our later benches can magnify to 400:1.

as well as the spectacular migration of the fleas from adult to youngsters at parturition.

The rabbit flea story not only relates an important stepping stone in the evolution of the optical bench but also underlines something which has been part and parcel of the fascination of using this equipment: almost every time we have ever filmed with this system we have seen hitherto seldom witnessed events, been able to share someone's brilliant research work and, perhaps most exciting of all, have shown the behaviour of animals that has never been seen before. It is this aspect of our work in general that acts as a great driving force when we explore further developments of equipment and techniques.

Filming down the microscope

Although the optical bench does not make the photomicroscope redundant, it can certainly do most of its work. For example, it can attain magnifications up to 400:1, and on one occasion we successfully doubled that to take a close look at blood corpuscles in vivo. But one unusual product of our research

upon microfilming systems has led to a useful and valuable advance with the regular photomicroscope. By battling away for many months with high-power dark-field illumination and condenser systems we developed

ABOVE The network of blood vessels transporting food material from the yolk to a five day old chick embryo. Had more traditional transmitted illumination been used, the blood corpuscles would not have sparkled like they do here. This picture is magnified only to 50:1, but without further modification to the lighting or preparation, we could zoom in to show blood corpuscles passing along the capillaries like coins cascading out of a one-armed bandit.

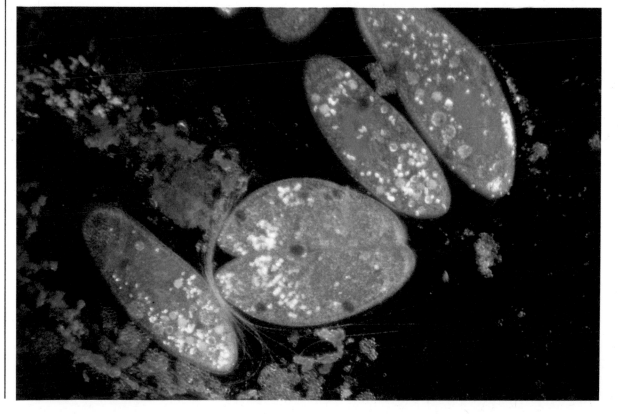

LEFT Several ciliated protozoans called *Paramecium* were filmed at 200:1, although on the page they appear at 900:1. Two of them are joined and are swapping nuclear material. The meganucleus, the nucleus not involved in conjugation, is bright Cambridge blue. Congo red stains the yeast which the single *Paramecia* are eating and records its progress from yeast (red) to digested yeast (blue). The conjugating *Paramecia* have few granules of either colour which indicates that they have not eaten for several hours.

a system which gave us surprising results. We were able to make an event like cell division not only visible but attractive and still lit to match lower power scenes. Under normal lighting, the two nuclei in ciliated protozoans are indistinguishable. Using the new system, the larger meganucleus of all ciliates so far studied turns a bright Cambridge blue. The smaller micronucleus is rendered Oxford blue – an exciting distinction as it is this nucleus that controls many of the detailed changes which take place in sexual reproduction. There is as yet no complete explanation of this phenomenon but it is likely that the blue colour is a result of the scattering of light, similar to the Tyndall effect seen in colloids and particles in suspension, and allied to the scattering effect of sunlight in our own atmosphere.

The condenser that we use to produce this effect is a high power, double reflecting, dark field condenser. That is to say, the light is bounced twice within the material thickness of the condenser so as to produce an exit angle sharp enough to avoid the front element of the high power objective with which this sort of condenser must be used. It is the sort of condenser that when you look into its exit face there is no clear glass to be seen. Only by light entering the back of the slide at this extreme glancing angle can dark field be produced, but because of the extreme angle the condensor must be oil immersed with the back face of the slide and that slide must be of the correct thickness.

We have found that the light source within a photomicroscope is nothing like powerful enough for motion-picture filming using this dark field technique. So some years ago we built up our own light source system using a Leitz Pradovit projector, with its built-in power-cooling, as the basic unit. With this system we achieved some beautiful results and we wish that the excuse existed for us to perfect this system further and research the whole technique.

Many small animals move rapidly, but watched down a microscope their movements seem even more frantic. This is because lenses and optics can only magnify length and breadth (or space) and not time. In order to slow these movements, the camera can be

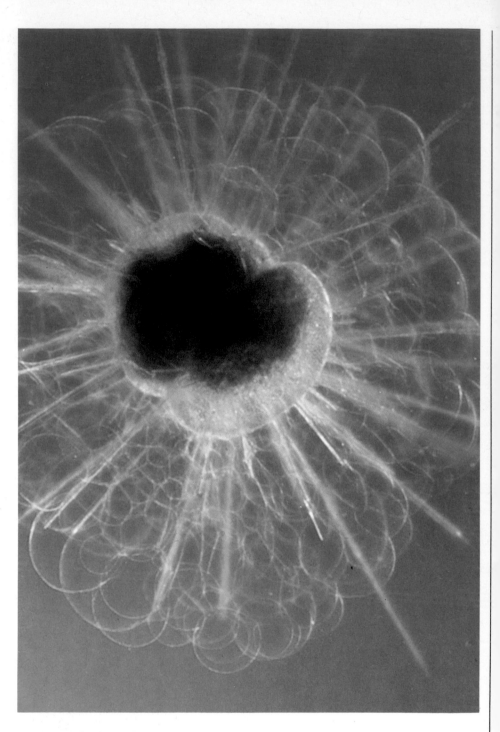

'over-cranked' and made to run faster than usual. To run faster it needs more light, and the most important single factor in motion-picture photomicrography is, therefore, adequate heat-free illumination. Few standard cameras run at rates above 75 frames per second, so it is not necessary to provide a light level more than two or three times that

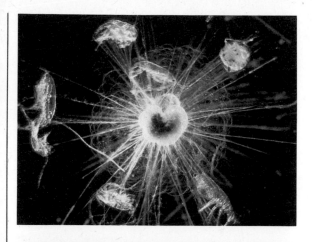

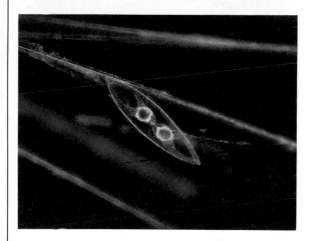

required for 24 frames per second. But to have this extra reserve of light is an enormous advantage. The finished film is more controlled, and the viewer is less likely to suffer a splitting headache as his eyes cope with jerky movements and rapid focus adjustments.

If we wish to incorporate the ability to zoom at magnifications between 5:1 and 400:1, a prodigious amount of light is required. Unlike standard zoom systems, microzooms utilize approximately one stop more light per order of magnification. A five-to-one zoom uses five stops more light at the long focal length end of the range than it does at its wide angle, short focal length end. On top of this, the system is a slow (or light costly) lens system and, compared to one providing equivalent magnification with micro- or macro-lenses on extension tubes, as much as four stops of light may be sacrificed at the outset. To overcrank with a microzoom system requires enormous quantities of light. To achieve this sort of intensity is not too difficult if the operator is careful. The secret is efficient condensing. This is far more likely to achieve success than to wheel in ever bigger and bigger lamp heads.

Is all this trouble worth while when good results can be obtained with the use of far less light? We think it is. The depth of field at high magnification is pitiably shallow, and anything that improves the situation is of great advantage.

FAR LEFT *Globigerinella* and its relatives are single-celled giants, 2.5 cm across. These foraminiferans float in the Atlantic waters of the Gulf Stream where they ambush active multicellular crustaceans (*left*) by extending strands of cellular material and skeletal spines into the surrounding water. The ensnared crustaceans seem to become paralysed and are then drawn towards the cumulus layer surrounding the nuclear capsule, where they are digested. The blue dark field illumination retains the roundness of this small predator, particularly its cumulus layer. The final act in this marine drama stars a simple dinoflagellate, *Pyrocystis* (*bottom left*), which can attach itself to the outer spines without being captured, and then feed on the nutrient-rich remains of the crustaceans. The magnifications of the three smaller pictures range between 200:1 and 400:1.

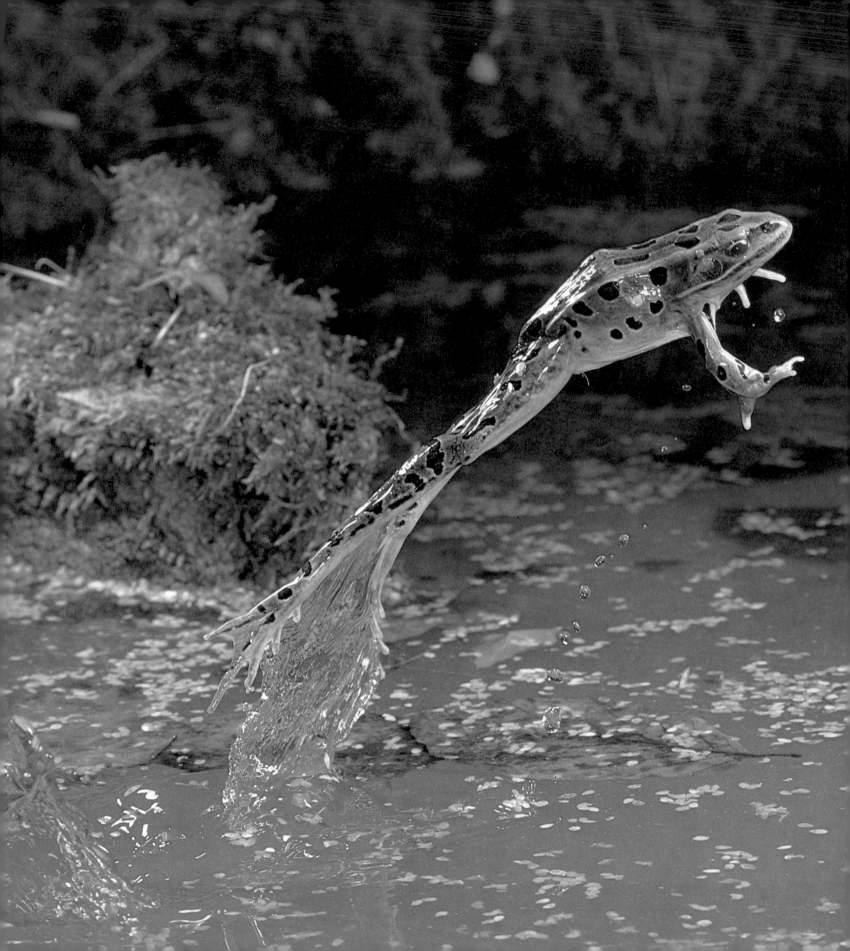

3 Time-warp photography

SEAN MORRIS and STEPHEN DALTON

In all the fascinating photography involving Oxford Scientific Films, nothing is more technically demanding and exciting than the filming of events that cannot be observed by the human eye. These events happen either too rapidly or too slowly for the human eye and brain to register and are in many cases witnessed for the first time in the projection room itself. The 'time-warp' camera has become the instrument of original observation.

Only when we see, in a few precious seconds on film, the contortions of a growing seedling or the balletic precision of a hawk-moth's split-second visit to a flower, do we fully realize how limited is the selection of natural events that can be observed by the human eye unaided. In the world of nature, vastly more happens outside the range of human observation than within it. For instance, most processes of growth and decay are too slow for us to observe as continuous events. We see them as a series of still-life portraits and rely upon the memory of past portraits to tell us that things are actually happening: that the mushrooms on the lawn are larger and more numerous today than yesterday, or that the dead mouse left by the cat is becoming less like a mouse and more like a mass of seething maggots as time progresses.

In order to convert these separate images into continuous motion, we use a photographic technique that in effect shrinks the time interval between successive images until they merge into each other. We can now watch, on film, as the mushrooms burst up through the lawn like expanding white bubbles, and can witness the gruesome and stomach-churning spectacle of several hundred maggots as they strip a dead mouse of every morsel of flesh and leave it a disjointed assemblage of delicate white bones.

The technique used to shrink time in this way is called time-lapse, and is based upon a camera that exposes single frames of a length of motion-picture film at predetermined intervals, thereby providing a series of still portraits of the subject. This length of film is then projected at the normal projection speed of 24 frames per second so that the still portraits merge into each other to give continuous action. If, in the case of the mushrooms, one frame is exposed every five minutes, their growth over a period of a week will be seen in roughly one and a quarter minutes of film. The effect is truly magical and, in many cases, absolutely astounding, as we are suddenly confronted with activities and details that are normally unrecognizable. Plants spiral and twist as they grow. Leaves flop up and down like an army of green wings – up during daytime, down at night – giving the impression that the plant is about to heave itself out of the soil and fly off, roots and all. Flowers unexpectedly become highly animated, waving their sexual organs seductively and, in many cases, changing shape and colour from day to day.

At the other end of the spectrum, when activities happen too rapidly for the eye to analyse, we need a method of expanding rather than shrinking time. For instance, the split-second in-flight corrections made by a hummingbird as it sucks nectar from a flower swaying in the breeze involve subtle and precise corrections to the angles of the wingbeats and the position of the tail. In reality, all we see is a flash of iridescence as the bird darts into view, hovers momentarily in front of the flower, and darts away again, the whole experience lasting but a second or two. By using a high-speed camera we can expand that experience to last a whole minute, if we choose, and only then do we notice that the

OPPOSITE Caught in mid-leap, the leopard frog shows off the explosive power of its hind legs. Used for escaping predators, capturing prey, and just plain getting about, this asset is the outstanding feature that distinguishes frogs and toads from other amphibians. At the moment of take off the eyes are withdrawn into their sockets, perhaps to protect them from damage or to improve the frog's aerodynamic profile. Actually, they bulge down into the roof of the mouth cavity, an action also used when a frog swallows, to help push the food down its throat. The leopard frog extends its hind legs totally in 1/10 second reaching a maximum speed of 2.5 m per second (90 km per hour). The leap may propel it one metre or 12 times its own body length. To film the leap in slow motion, a motion-picture camera must be running between 300 and 500 frames per second. On stills, the frog took its own picture, by breaking a light beam that triggered a 1/25,000 second flash.

bird's bill is held in perfect register with the flower, giving the impression that the two are joined together by an invisible but rigid thread while the rest of the bird's body is a symphony of continuous motion, the wingbeats constantly altering in order to hold the bird's body in the correct position. It is the remarkable performance of a hummingbird's wings, which in the smaller species beat at rates of up to sixty times a second, that enables it to hover with such precision, to fly backwards, even sideways, and to execute manoeuvres that no stunt pilot would dare to copy. The high-speed camera is the magician's wand that transports us into a world of dramatic beauty, by the simple process of exposing a greater length of film than would a normal camera in the two seconds it takes for the bird to visit the flower. When projected at normal speeds, the greater length of film provides us with our minute-long record of the bird's behaviour. We have expanded two seconds into a minute, and the action is slowed down proportionately.

Both techniques, time-lapse and high-speed photography, are methods of distorting apparent time. Hence the overall title of time-warp photography. As techniques, they are as different as chalk from cheese. They are in fact complete opposites, save for one attribute held in common — they take the photographer on a fascinating adventure into the unknown, unsure until he sees the film of what his camera had recorded.

High-speed bats, birds and butterflies

In a normal 16 mm motion-picture camera, the film progresses past the lens at a rate of 24 frames per second, not smoothly but in intermittent steps. Each frame is held stationary behind the lens for a precise and predetermined fraction of a second. It has always seemed to me to be a minor miracle that the film itself, and the mechanisms inside the camera that produce this jerky motion past the lens, can do so with such precision and reliability.

Imagine the attendant stresses and strains when a filming speed of 500 frames per second is used, the current limit for high-speed inter-mittent-action 16 mm cameras. At frame

Attracted by the stench of decaying flesh, female flies assemble to lay their eggs and larvae on a dead wood mouse. The slate-coloured flesh-fly *Sarcophaga* deposits live young, so giving them a head start in the competition for food. The larvae of the greenbottle *Lucilia* hatch 24 hours after the eggs are laid. Eggs and larvae are deposited in shaded, moist areas of the carcass — in the mouth, ears, around the anus, and sandwiched between the carcass and the soil.

The maggots disgorge a liquefying agent that reduces the tissues of the mouse to a soupy consistency. By the third day, the skin has begun to collapse into the emptying carcass.

A time-lapse motion-picture sequence would have something to add to this still life portrait on the fifth day. It would show that the maggots move around the carcass as a single clump.

The maggots feeding on their revolting soup mature in a matter of days, and by the thirteenth have crawled off to pupate under-ground. Adult flies emerge a few days later — a rapid turn around. To photograph this sequence, the dead mouse was kept in the dark to encourage the maggots to work in the open. In natural conditions, the maggots would have remained hidden beneath the skin.

rates above 500, it is no longer possible to move the film in separate jerks, and it is simply wound rapidly and continuously past the lens at the selected speed. The problems are now to ensure that the film accurately follows its complex and tortuous path over the various rollers and sprockets that control its destiny, and to accelerate the whole box of tricks rapidly enough to ensure that you do not waste several hundred metres of film merely getting up speed. The upper limit for 16 mm cameras is in the region of 11,000 frames per second, at which rate the film is moving past the lens at 305 kilometres per hour, with the film spool turning at 33,000 revolutions per minute.

It is hardly surprising, then, that high-speed cameras have their good days and their bad days. And if disaster should strike, at, say, 7,000 frames per second, one should be eternally grateful that the lid was on the camera when things got out of step. When the camera malfunctions it is not unusual to find thirty thicknesses of film jammed into a space designed for one, and sufficient celluloid confetti for twenty weddings. In polite jargon, this is referred to as a 'jam up', and a bad one can take several hours to put right.

With the choice of filming at any rate between 24 and 11,000 frames per second, the cameraman must decide which is the appropriate speed for each occasion. The choice is crucial, for even the most rivetting spectacle — a frog erupting through the surface of a pond like an amphibian Polaris missile, trailing a cascade of water droplets as it leaps for the bank — becomes utterly boring if slowed down too much.

To get slow-motion shots of large animals running and leaping, we can make do with speeds of up to 200 frames per second. The best-known example of this category is the cheetah. Although I have lost count of the number of times I have seen cheetahs in slow-

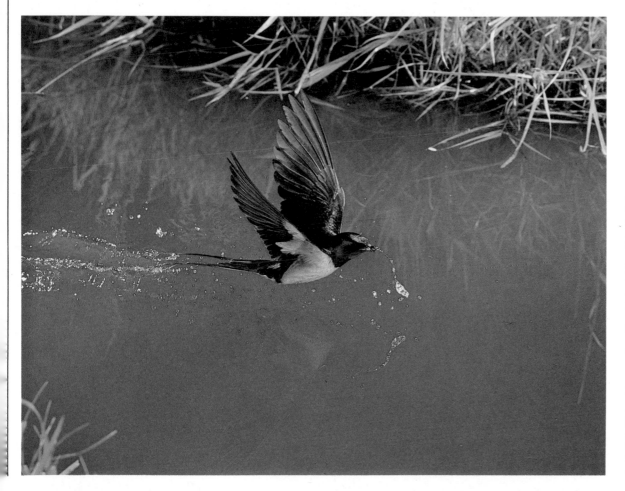

Superbly designed for catching flying insects, swallows also drink and bathe on the wing. Sweeping low over the surface of ponds and rivers, the swallow dips its beak into the water, cutting a channel in its surface. This magical effect, visible to the naked eye as a flash of blue, a splash and a ring of ripples, is captured on stills with a 1/12,000 second flash, or with a motion-picture camera turning at 500 frames per second.
To obtain this photograph, swallows were trained to visit a garden pond, and their flight path past the camera encouraged with wire netting guides. The sound-proofed camera took three weeks to set up and countless tests were run before the correct settings for the photo—electric trigger beam and the delayed action flash were obtained.

motion pursuit of their prey, I will never tire of that six metre stride, the elastic flexing of the back as the hind paws reach forwards past the front shoulders for the next contact with the ground, and the way the long tail is used as a counterbalance to maintain the animal's poise as it accelerates up to speeds of 112 kilometres per hour. In the same category are such contrasting examples as salmon leaping and the larger birds like owls, hawks, gulls and herons flying.

Smaller birds, bats and most insects require speeds of up to 500 frames per second, but rarely is it necessary to exceed this rate. There is a limit to the speed at which animals can move, and only if we wish to slow down the wingbeats of small insects like hover-flies and midges, or to analyse how fleas jump, is it necessary to film at 1,000 frames per second or more. Physical events, such as the impact of rain drops upon a water surface, or the bursting of a bubble, require frame rates in the thousands. The results can be very beautiful, but this sort of photography is really in the same category as equally dramatic but contrived demonstrations of bullets shattering apples and golf clubs hitting golf balls, both of which require 11,000 frames per second.

While it is possible to pan with the larger and slower animals, the smaller subjects have to be filmed with a static camera, partly because they move so fast, and partly because their flight is so erratic. Butterflies are particularly trying in this respect; they are tantalizingly beautiful and maddeningly unpredictable. In fact, they seem incapable of flying in a straight line; some species that glide are easier to film, but the results are then less interesting.

Among the insects, dragonflies are the easiest to film in slow motion. Dragonflies are voracious carnivores, catching other insects in mid-flight with their spiny legs. Each dragonfly hunts from a preferred vantage point, such as a twig or a bulrush stem, to which it returns to devour its prey. So it is relatively easy to obtain slow-motion film of dragonflies taking off and landing but, of course, once in flight they are as unpredictable as the rest. The best way to film these erratic movers is to train the camera on an

area through which the subject is likely to fly. The only way to film wild bats, for instance, is to lie in wait for them at the entrance to their roost, where they sleep during the daytime. At dusk the bats fly out to feed, returning again at dawn.

On one occasion we were making a documentary film about the various animals that inhabit Tamana Cave in Trinidad. The entrance to the cave itself was a vertical shaft of some three metres in diameter leading into a system of branching tunnels formed in the heart of the limestone hill by underground streams. The caves harboured at least a dozen species of bat, several million individuals in all. Every evening, the bats poured from the cave in a continuous brown tide, spiralling upwards and outwards into the warm tropical night. It is a memorable experience to be enveloped by a whirling avalanche of bats and to feel nothing more solid than the buffeting of the night air and the occasional flick of a wing against your face.

We decided to film the bats deep down in the cave where the passage narrowed to a bottleneck half a metre across. When the bats flew through this constriction, they created a wind that roared like a tropical gale. With no choice but to fly past our camera and lights, we felt sure that the bats would provide us with good slow-motion film.

The surface of water is an interface between two media — air and water. The tendency for water molecules to cling to each other produces a surface 'skin' of remarkable strength and elasticity, strong enough to carry the weight of an insect or to hold a drop of water from falling apart, and yet elastic enough to allow the surface contours to change constantly. Photographed at 1/25,000 second, the drop shown here is moving *upwards*, a reaction to the impact of a raindrop on the surface a few milliseconds earlier. The initial impact also created the outermost ripple. To film this action on motion picture, a frame rate of 3,000 frames per second would be necessary.

We were to pay dearly for our sequence. The paraphernalia of cave photography — lights, cables, generator, tripods, cameras, ropes and the inevitable vacuum flask of tea — were manhandled up Tamana hill to the entrance of the cave, and all but the generator lowered on ropes into the main gallery. Conditions in the cave were not to everyone's liking. From the bats hanging in clusters above, there fell a fine mist of urine and the occasional dropping. Underfoot was a mulch of rotting excrement that seethed with cockroaches, ticks and an assortment of other creatures. The air was stale with the products of decomposition and carbon dioxide breathed out by the bats. It was humid and very hot. What a contrast with my other work in Trinidad which had been filming hummingbirds in Peter Rapsey's enchanting estate garden, surrounded by hibiscus, bougainvillea, tinkling streams and citrus orchards! There, my only problem had been a particularly savage jam-up. In the process of mending the camera I had taken great care to align correctly all the cogwheels, which had been marked with dots of paint by the manu-

A greater horseshoe bat closes in for the kill. The prey is a yellow underwing moth, *Noctua pronuba*. Most bats hunt at night, their prey being the thousands of species of moths, beetles and flies that have evolved a nocturnal activity pattern to avoid predatory birds such as swallows and swifts. With little or no light, and poorly developed eyes, the bats rely upon a system of echo-location to navigate and to detect and catch their prey. Bats produce a beam of high-pitched squeaks or clicks, then listen for the echo from surrounding objects.

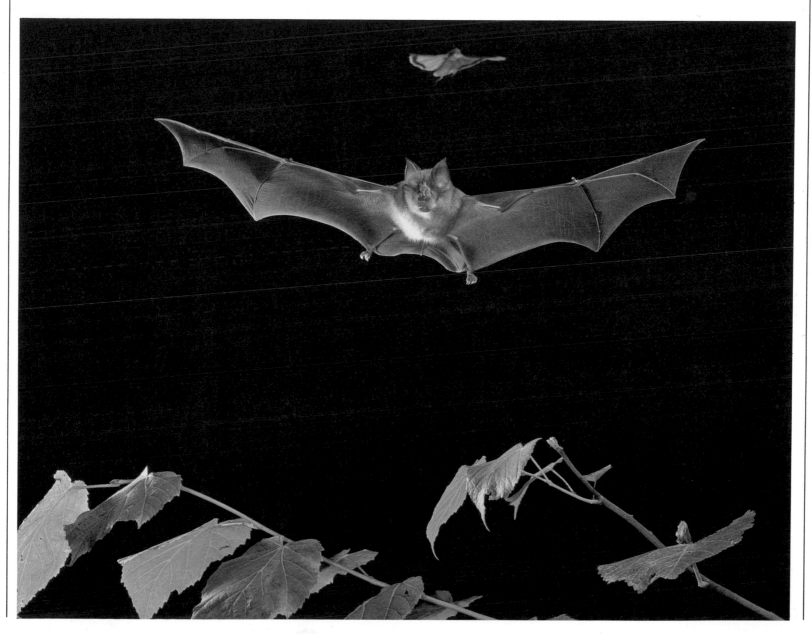

facturer for that purpose. So it was with some trepidation that we let the camera loose at 500 frames per second in the face of the torrent of bats, half expecting it to grind to a halt with a screech of tortured film and jammed sprockets. In fact it ran without any sign of distress. Having extricated ourselves from the caves, we hauled ourselves and our equipment down Tamana hill in the darkness for the last time with pleasant thoughts of showers and glasses of iced 'sundowners'. The three month expedition to Trinidad was nearing its end, and we were all becoming somewhat jaded and travel weary.

The following two weeks were spent crating up all our belongings for the homeward journey and filming a few final sequences — light work really, compared to the hard slog of the previous months. Three days before D-day, with all the crates packed and securely fastened, I received a telegram from England stating that all the slow-motion bat film was unusable. There was, apparently, a blurring of the image, caused by a misalignment of the drive sprockets. On checking the camera, I discovered that the alignment dots painted on to the sprockets by the manufacturers had been incorrectly positioned.

The expedition had already come to an end. My colleagues were relaxing for the first time in three months, sprucing up the estate house in which we had stayed and preparing themselves for departure. With their thoughts already firmly ashore in England, I wondered how they would take to my suggestion that the crates be unpacked and the generator, lights and cables be taken back to Tamana for a spot of bat filming. In the event, they greeted the bad news with a torrent of good-humoured abuse directed towards the makers of the camera and the unknown employee who painted the dots in the wrong position, and set to removing the Tamana equipment from the crates once again.

Back in England, as we viewed the film taken on our last-ditch assault on the bats of Tamana, you could have cut the air with a knife so great was the suspense. Then came the whoops of joy and relief, as we watched a slow-motion ballet of bats materialize out of the dark depths of the cave and wing their way towards and past the camera.

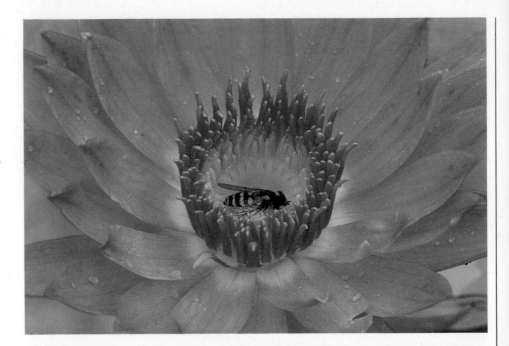

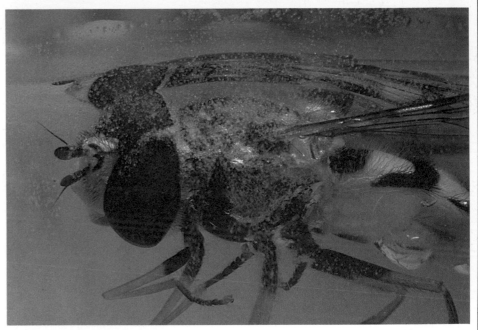

Time-lapse plant assassins

In contrast to the high-speed camera's mechanical frenzy, the time-lapse camera seems almost fossilized by its inactivity. In order to record the first week's growth of a seedling in one and a half metres, or eight seconds, of projected film, the interval between successive exposures has to be 51 minutes. During each interval, the camera

TOP The first day this tropical water-lily opens, it contains neither nectar nor pollen, but insects visit it nonetheless.

ABOVE As the hapless visitor struggles and eventually drowns, pollen adhering to its body washes off, sinks to the bottom of the central pool and fertilizes the ovaries below. In the evening the flower closes over the dead corpse.

sits motionless. Even when it is required to expose a single frame, the movement of the film is a leisurely affair. However, what it lacks in raw speed, the time-lapse camera makes up for in complexity. It needs a supporting host of electrical and mechanical accessories: a timer to actuate the camera at preset intervals, a special motor to advance the film exactly one frame at a time, and a device for turning on the filming lights just before each frame is exposed and turning them off again afterwards, or a trigger mechanism for firing the strobe lights if electronic flash is the chosen type of illumination. All this potentially fallible equipment is often held in suspended animation for long periods of time, and although most of the time all the components of this electromechanical web function perfectly, there is a chance that one of the elements will malfunction at some stage during the period of the shot, so ruining the whole sequence. And in many instances this is not evident until the film is viewed.

For example, I have recently been filming the pollination of tropical water-lilies. From their fragrance and delicacy, you would not expect these exotic flowers to be murderous assassins but that is just what they are. They attract their hapless victims with an irresistible combination of scent and colour. The victims, various species of insect, land on the flower in search of nectar and pollen, but instead find death. The flower is a trap: in its centre is a circular pool of clear liquid and around the pool stands a circle of smooth rods, the flower's stamens, outside which are the petals. An insect, from its experiences of foraging in other flowers, will land as near to the centre as possible, probably on the stamens. At this stage in its life cycle the flower holds neither nectar nor pollen, but the insect does not realize this and will clamber about on the glassy smooth stamens in search of food. Inevitably, it loses its footing and tumbles into the central pool of liquid. For a brief moment it struggles desperately to escape, but in vain. The liquid contains a wetting agent and the insect is immediately waterlogged. It sinks beneath the surface. Poisonous substances quickly subdue it, and it drowns. Any pollen adhering to its body washes off and sinks to the bottom of the pool. There the

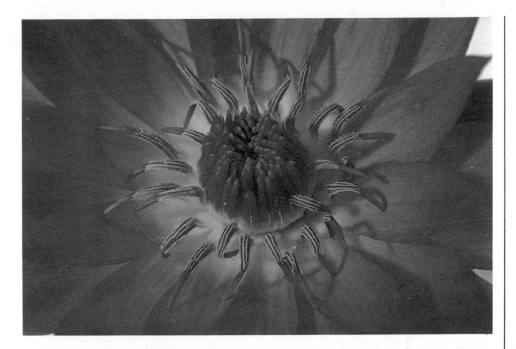

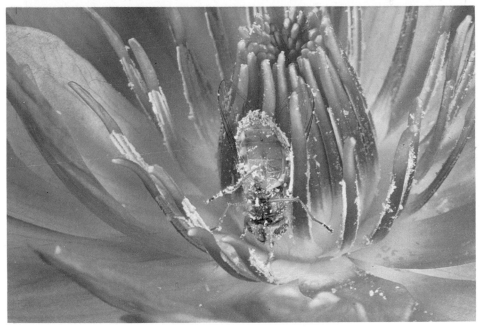

pollen germinates, sending tubes down into the water-lily's ovaries to fertilize the embryo seeds. That night, the water-lily flower closes its petals encasing the body of its victim in the most exotic of tombs.

It was this strange and macabre story that I was filming and I particularly wanted time-lapse sequences of the flower opening and, having captured a pollinator, closing again. The lilies I was using as my subjects grow

TOP The next morning the flower opens to present a very different face to the world. The stamens have bent over to cover the central pool and some of them have begun to produce pollen.

ABOVE Insects can now come and go without risk. Sticky pollen is produced in abundance, some of it consumed by the visitors, some adhering to their bodies.

in an enormous tropical greenhouse in the Botanic Gardens in Oxford and it was there that much of the filming was carried out.

The time-lapse photography, however, had to be done at our studios thirteen kilometres north of the city. It is an unfortunate and frustrating fact that tropical water-lily flowers shut if the temperature drops more than a few degrees, even if this occurs during the day. Perhaps this response is designed to prevent the flowers being flooded and battered by tropical rainstorms. Whatever its use to water-lilies growing in the wild, this behaviour caused me enormous problems. Having cut my chosen flower, I was forced to sprint from the heated greenhouse to my car, drive at frantic speed through the congested city centre and out to our studios – the car's heater working flat out to maintain the flower at its preferred temperature – and rush the flower into an already prepared time-lapse studio. If I was lucky, I arrived with the flower still open. Sometimes, if I hit red traffic lights in Oxford or was held up behind a slow truck, the flower would close during the journey. At the end of a week of hairbrained driving I reckoned I had a couple of good shots in the camera. As I removed the camera door to unload the film, a cascade of crinkled celluloid poured on to my lap. The camera had evidently jammed at the beginning of the week, and all my efforts had been a complete waste of time.

Lighting, timing and noise

For an image to be recorded on film, the sensitive chemicals of the emulsion must receive exactly the right quantity of light – either brilliant illumination for a short duration, or weaker illumination for a longer period. The duration of the exposure determines the strength of illumination needed for a correct exposure.

At the higher frame rates attained by high-speed cameras the exposure time is extremely brief – one thousandth of a second at 500 frames per second, for instance. The higher the frame rate, therefore, the stronger the illumination required. For frame rates up to 500 per second, the problems are not too taxing. Strong sunlight or an equivalent artificial source are sufficient. Of course, the sun does not shine to order. I have sat for countless hours in the tropics with humming-birds obligingly visiting the flowers I have placed within the range of the camera but unable to film for want of a shaft of sunlight. At times it seems as if a personal cloud is in constant attendance, with the sun shining everywhere else.

At frame rates of 1,000 per second and more, even the fiercest of equatorial sunshine is too weak. We have to provide our own sunshine which means lamps, cables, stands and generators. Worst of all, light means heat. Most high-power lights produce prodigious quantities of heat, and for the unfortunate subject of the photography itself the effect of all this heat can be catastrophic. Even with special heat-absorbing filters, the lights we employed to film the effects of rain drops hitting vegetation at 3,000 frames per second, caused the water to evaporate and the leaves to burst into flames within seconds. With animal behaviour, the problems are even more acute: although the levels of heat can be reduced sufficiently to prevent the subjects from coming to any harm, they may understandably decide not to behave at all. Stephen Dalton spent several days constructing a special chamber in which to film flies landing on a ceiling, and the flies rewarded his ingenuity by doing just that. Until the lights were turned on; then all he got for his troubles were some fascinating sequences of flies in constant slow-motion flight.

With time-lapse photography, the problems are exactly opposite. Often the light sources are too powerful and their intensity has to be reduced. The focus of the time-lapse camera is frequently botanical and plants need light if they are to grow and behave normally. So there are lighting problems unique to time-lapse photography. It is an unfortunate fact that the wavelengths of light required by the photosensitive elements in colour film and the energy-absorbing mechanisms of the plant's chlorophyll are not the same. If they were, one type of light would be sufficient both for exposing the film and keeping the plants healthy. As it is, special growing lights must be set up, with a time clock to govern the ratio of 'night' to 'day'. These

OPPOSITE The bumble-bee *Bombus lucorum* takes off, having foraged for nectar at a cinquefoil. Some pollen has adhered to the hair on the bee's back. Its hairy covering and large size enables a bumble to forage in colder temperatures than a honey-bee, for instance, and it works longer hours, often being active at dusk and dawn. To fly, the bumble's powerful thoracic flight muscles must be between 30°C and 44°C. In order to forage in low temperature, it must first 'warm up' these muscles by 'shivering'. Once in flight, the heat produced by the muscles can maintain them at the required temperature even if the air temperature is as low as 0°C. A bumble has two wings on each side, but they are 'zipped' together to form a single flexible flight surface. With a wing beat frequency of up to 200 per second, 1/25,000 second flash is sufficient to freeze the action. For a motion-picture sequence, 500 frames per second and some strong sunlight would be required.

growth lights must be switched off a few seconds before each frame is exposed and on again immediately afterwards. Plants are particular about the quality and quantity of light they are offered and also about the temperature of their environment. Consequently, the time-lapse rooms are the only ones at our laboratories provided with air conditioning, and for sensitive subjects like slime moulds, fungi and liverworts we also install automatic humidifiers.

One very important aspect of time-warp photography is timing: when to start filming and when to stop. Imagine that you are attempting to film a honey-bee visiting a flower. You wish to produce a lyrical slow-motion effect and you have set up a high-speed camera in your garden, alongside a small apple tree in full bloom.

For once the sun is shining, breakfast is but an hour behind you, and your beehive is buzzing with activity. There is steady flight of bees back and forth between hive and apple tree. There are twenty to thirty bees at work on the blossoms and at least seven of these are within the focusing range of your lens. A pleasant hour or two and your shot will be made. By coffee time you will be back at the studios with your film, free to set up a re-run of that time-lapse shot that went wrong again last week. If this is your plan, I am afraid you are in for a succession of unpleasant surprises.

The camera takes one and a half seconds to reach full speed. It takes you at least three times as long to train and focus the camera on a bee after you have seen it land on a flower. A bee, unless she is lazy or unwell, rarely spends more than three seconds at an apple blossom. By the time you are framed up and running at full speed, the industrious bee is well on her way back to the hive. So there seems no alternative but to put all your money on one blossom, and train your camera on that with the intention of anticipating the arrival of the next visitor. But, how many blossoms are there on your tree? And which one do you think a bee will find most irresistible? The odds start to lengthen alarmingly. You examine all the flowers on the sunlit side of the tree and eventually choose one that seems particularly fragrant and fresh. Your choice is immediately rewarded when two

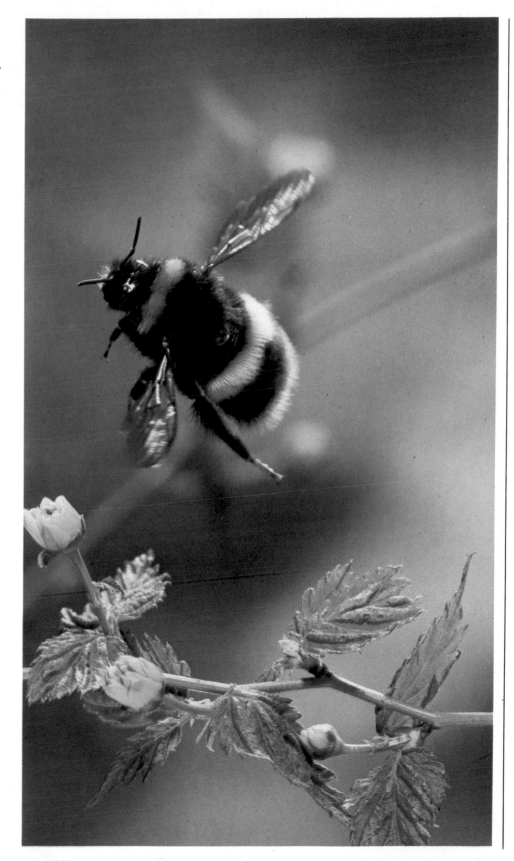

bees visit the flower in quick succession — while you were setting up the camera. Never mind, you feel proud to be as good a judge of blossoms as these two hardened professionals.

Eager and alert you await the approach of the next bee, your thumb poised over the camera switch. Knowing how long the camera takes to reach full speed, you try to work out how far a lightly laden bee can fly in one and a half seconds. With horror you realize that every bee within three feet of your chosen blossom is a potential visitor. As best you can, you keep several bees under close scrutiny at once, reacting to any movement towards your flower. Unfortunately, bees do not travel in straight lines while foraging and you waste half a roll of film with false starts. After three-quarters of an hour, several false starts and no visits, you begin to wonder if those two initial visitors might have drained the flower of all its nectar, and whether bees can tell from a distance if a flower is worth visiting or not. Or perhaps a bee leaves a slowly decaying marker on a flower it has exhausted, as a warning to its hive mates not to bother with the flower until later in the day.

While deeply engrossed in the speculations about the foraging behaviour of honey-bees, a bee lands on your flower. Instinctively but one and a half seconds too late, you stab at the camera switch with your aching thumb. Just as the camera reaches full speed, the bee departs fully laden. Four hours later, with two hundred metres of false starts and bees leaving flowers in slow-motion, you finally strike gold. You start the camera in response to a bee that shows some imperceptible sign of heading in the desired direction, but it veers off at the last moment. Before you have time to switch off the camera, another bee, hitherto unnoticed, swoops into the field of view, hovers for a moment, and lands on the flower. Afterwards you check: the sun was shining, there was plenty of film in the camera and the timing was perfect. This is not as fanciful a tale as you might think. It is a perfectly normal account of a day with an apple tree, some bees and a high-speed camera.

At higher frame rates, the problems of timing are even more acute. The camera's acceleration time is even longer, and, in

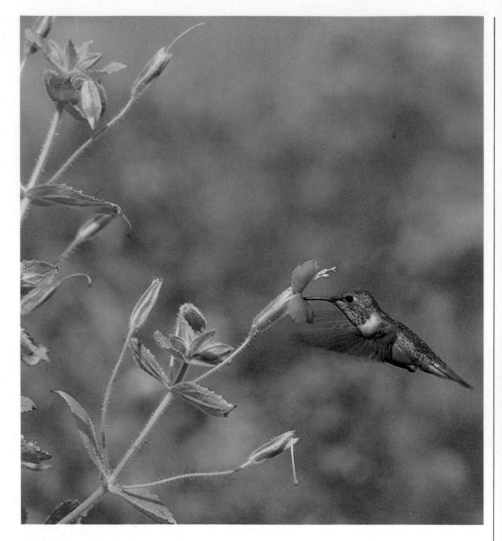

addition, a two or more man crew is required to switch on the lights, set off the rain maker, fire the camera, and so on. The crew must work with split-second precision. If the lights are mistimed by so much as one second, you have perhaps four thousand frames of black film, or a smouldering set.

Time-lapse has none of these problems, but one peculiar to itself. It is not the starting that needs skill and judgement, but the stopping. If all systems are functioning correctly, the camera is recording events that are invisibly slow. There have been countless occasions when I have looked at a roll of film after it has returned from processing to find that I have unwittingly stopped filming in the middle of some remarkable and hitherto unnoticed biological happening. Mainly these consist of strange plant movements, such as

Selasphorus rufus sips nectar from *Mimulus cardinalis*. Hummingbirds are adapted to a high-energy diet — the nectar they collect from flowers. With a unique wing joint, hummers produce power on both up and down beats, so enabling them to hover. This method of foraging and their small size results in their having the highest metabolic rate of all vertebrates. They must feed frequently to survive.

The smaller hummers beat their wings up to 40 times a second and frame rates between 300 and 500 are required. For stills of a bird hovering, a shutter speed of 1/500 will freeze its body but 1/12,000 second is needed to freeze its wings.

leaves waving up and down, petals twisting and turning and flowers rotating on their stems. Occasionally there is something happening in a corner of the frame, beside or behind the main point of interest, that is becoming more absorbing than the main point of interest itself. A seed germinates, or a snail starts devouring a leaf, or the soil dries out and cracks in a symmetrical honeycomb pattern. The answer is to leave the camera running until the last possible moment.

Another hazard is noise. Time-lapse photography is a tranquil affair, the loudest sounds being the humming of the air-conditioner and the buzzing of the fluorescent lights. With high-speed photography, noise is an unavoidable and troublesome enemy. The high-frequency electromechanical wail produced by all those tortured sprockets, motors and register pins flogging the unfortunate film-stock through the camera at 500 frames per second is more than most of nature's delicate ears can stand. Many of the mammals and birds we have attempted to film have been acutely disturbed by the frequency and the intensity of this sound. Our initial efforts were invariably rewarded by shots of the rear ends of startled animals heading for cover, albeit in slow motion.

When I filmed hummingbirds, they seemed not to like the noise initially, but I was able to train them in an hour or so by running the camera without film in it. Bats do not much care for it either. I think it must overlap their echo-location frequencies and with such a delicate and finely tuned sense of hearing, I often wonder if they might be deafened for life. However, we managed to film the bats leaving their roosts deep in Tamana cave by positioning the camera and lights in a narrow constriction through which they had to pass on their way out for their skirmishes with the night-flying insects. Temporarily blinded and deafened they may have been, but those bats still successfully negotiated the tortuous path to the entrance of the cave a hundred metres further on.

Some cats and dogs simply will not tolerate the noise and no amount of training with empty cameras will make them change their minds. A local black labrador becomes a nervous wreck the moment the camera starts running, which is a pity because he is the most impeccably trained dog I have met, and has lost the chance to appear in numerous films as a result.

High-speed stills and insect life

The photograph of a damselfly flying over some stones at the water's edge represents a mere 1/25,000 second in the creature's life. But for me [Stephen Dalton], it is the result of three weeks spent in the field and studio, and is just one successful frame from many rolls of film. Furthermore, the picture represents the fulfilment of half a lifetime's ambition, and is the culmination of three years spent developing techniques to photograph in full colour and detail insects flying free.

Considerable differences in techniques

The green lestes damselfly *Lestes sponsa* haunts the edges of ponds and ditches where it catches small flying insects on the wing. The forewings are halfway through the upward stroke and the hindwings have just started the downward beat. It is obvious that the two pairs of shimmering net-like wings move quite independently.

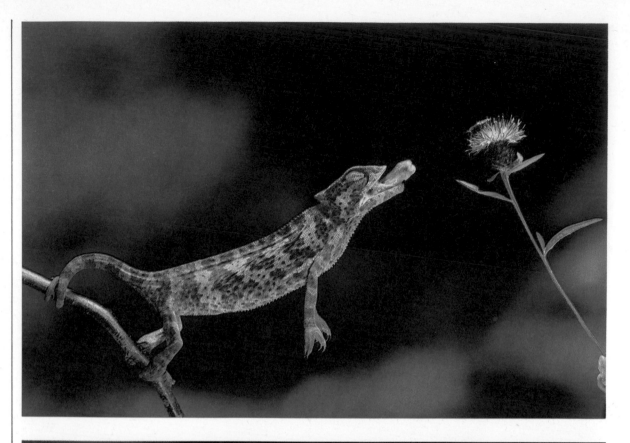

There are almost a hundred known species of chamaeleon, the majority occurring in Africa and Madagascar. The common chamaeleon *Chamaeleo chamaeleon* exhibits many of the characteristics that make these animals so well adapted to their mode of life. The highly mobile eyes can work independently to provide the animal with all round vision, and enable it to judge distances accurately. This is particularly important in feeding, when the tongue is used to capture insects at a distance. The tongue, which can extend to over 20 cm, lies coiled within the mouth at rest but can be straightened by a sudden inrush of blood. The terminal sucker is very sticky and normally holds the prey firmly. However, the butterfly in the lower picture has been saved by its loose scales, which stick to the tongue but separate easily from the insect's body.

Chamaeleons are renowned for their ability to change colour so that they remain camouflaged amongst the surrounding vegetation. However, as the chamaeleon starts to stalk prey its coloration and patterning become more intense as if heightened by the excitement of the chase.

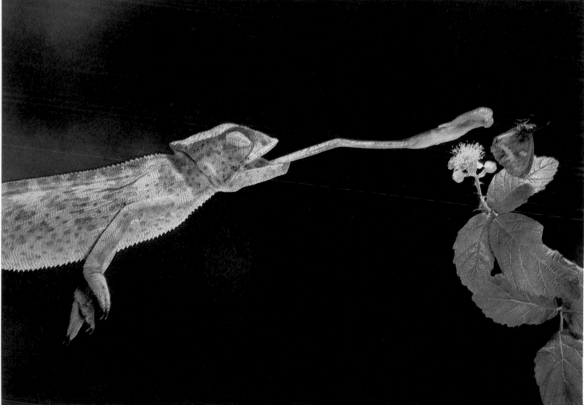

and approach exist between high-speed movie and still photography. Expense is the greatest drawback to high-speed motion-picture photography. The quantity of film consumed is nothing less than prolific: up to 11,000 frames a second are driven past the camera gate. With still photography on the other hand, there is only a single frame of film to play with, but arranging for this frame to be exposed at exactly the right moment is the major preoccupation of the photographer. It can be a particularly frustrating performance since living creatures are involved. And, unlike motion-picture film, a good still photograph has to withstand close scrutiny and hold the viewer's interest over a period of time. To this end, a photograph should contain many times more detail than a single frame of motion-picture film, and have lasting aesthetic qualities.

Photographs taken at high speed frequently reveal flight behaviour or other animal activities which have never been observed before. Imagine my excitement while thumbing through freshly processed Kodachromes, at seeing that a lacewing has performed a complete loop, that the fangs of a rattlesnake have ejected venom well before they strike their target, and that the twisting of a fly's wings during rapid manoeuvres is so extensive that the trailing edge faces forwards. It is these sorts of mini-discoveries that make all the expenditure of time, effort and film a tiny price to pay.

It is hard to say exactly where normal-speed photography ends and high-speed begins. Conventional camera and flash equipment have a limiting speed of about 1/2,000 second, so anything much faster than 1/2,000 could be classed as high speed. But it is certainly impossible to stop the wing tip movement of many birds at speeds slower than 1/2,000 second; in fact, most small birds require at least 1/5,000 second, and insects may beat their wings up to one thousand times a second, demanding speeds of 1/10,000 or 1/20,000 second.

Clearly, the first essential item of equipment is a flash unit of sufficient power to provide at least 1/5,000 second. But unfortunately speed and power are in direct conflict; high flash speed generally means low light output. Choice of equipment depends upon the qualities desired in the result. For example, if a compromise is made with flash duration, then image definition will suffer owing to subject movement. If, on the other hand, flash speed is maintained at the expense of power, then either a faster film has to be used, which reduces image quality, or the lens aperture has to be opened thereby narrowing the depth of field. Insufficient power can also cramp your style as far as lighting is concerned, because as the lights have to be moved closer to the subject, it becomes increasingly difficult to illuminate the scene evenly or to use back lighting effectively. What is more important, our subject may well object to the closeness of the flash heads.

The so-called computerized flash units,

A ladybird caught with 1/25,000 second flash as it began to fly away, leaving behind it a shower of yellow pollen. The red structures are the wing covers, common to all beetles. They are held up out of the way while the long membranous hind wings do the real work. Ladybirds are among the most beneficial of all insects to man since they feed avidly, both as adults and larvae, on the greenfly hordes that ravage crops.

although capable of short durations, are nothing like powerful enough for serious work as they need to be switched down to one-eighth power or less before operating at useful 'freezing' speeds. To increase the power it is possible to combine several switched down units into a single flash head but, apart from being clumsy, this is an expensive solution. The only really satisfactory way of maintaining power and speed is to use high-voltage units with paper capacitors; some of the early apparatus was of this type, but it is difficult to find and, being old, tends to be unreliable and sometimes dangerous. I found the best answer was to have a flash unit made to my own specifications.

It is not always easy to capture the exact moment of interest on a single frame of film. Imagine trying to photograph a small rapidly moving insect that is constantly changing its speed and direction. I remember seeing a Brazilian skipper butterfly flying towards me over some mangroves in the Everglades at a speed I would never have thought possible. It flew straight past me like a miniature supersonic jet, then suddenly turned about and with a series of zig-zag rapid manoeuvres landed on a flower at my feet where it calmly fed on the nectar. It would be utterly impractical to attempt photography of this butterfly on the wing in the wild. Even under 'controlled' conditions, persuading this insect, or any other for that matter, to fly along a predetermined flight path and through the exact point of focus can prove irksome to say the least. But assuming that our subject does fly in the right place, then we still have to fire the camera at the critical moment, and this depends on two factors. First, the animal has to be detected at the right point, and second, once detected, the shutter and flash have to be fired after a minimal delay, otherwise the creature will be out of focus or out of the picture entirely. It is rarely possible to rely on our reflexes to fire the camera manually, as the lively subject will probably be moving too rapidly to be clearly seen, and even if it can be seen, by the time the button is pressed and the shutter opens it may well have vanished altogether. So we have to rely on more precise and rapid mechanisms than our eyesight and finger.

Various kinds of trip can be used for detection, either mechanical, optical or acoustic, but the optical type is by far the most versatile. Its principle is simple. A narrow beam of visible light or infrared is focused on to a photoelectric cell, and an amplifier senses the moment the beam is broken. With suitable optics and electronics, anything from an elephant to a midge can be detected. The amplifier operates a switching device which opens the camera shutter via an electromagnetic release, either externally or inside the camera, and fires the flash. A problem arises in getting the camera shutter to open quickly enough. Focal plane shutters take about one-tenth of a second to open and blade shutters about one-twentieth of a second, during which time an insect may have flown thirty times its own length. In the case of those animals which move at a predictable speed and direction this long shutter delay can be compensated by locating the beam some distance from the plane of focus, the exact distance being found by trial and error. But it is far more difficult to cope with erratic creatures such as insects which frequently adopt lunatic flight paths; almost anything can happen in one-tenth of a second. One simple solution is not to use a shutter at all and work in the dark with open flash technique. This is fine for bats and owls

The Brazilian skipper is one of the largest skipper butterflies in the United States. It shows great acceleration and aerial manoeuvrability and is capable of sustained high speed. Its wings beat approximately 50 times per second and need a 1/25,000 flash to freeze them.

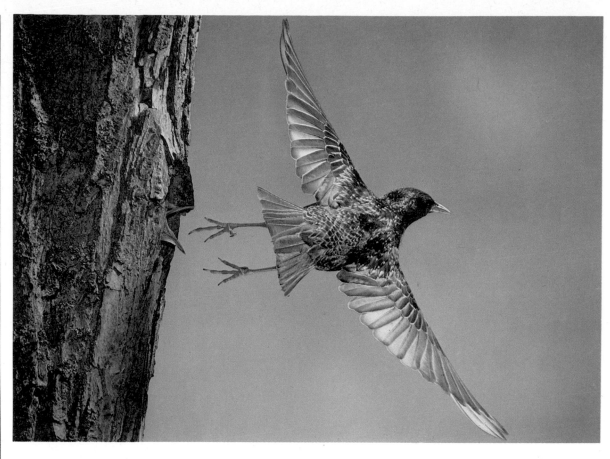

Photographed leaving its nest hole, this adult starling shows off the brilliantly glossy and spangled plumage of one of Europe's most common birds. It is an extremely tough and adaptable bird, and is one of the few animals to have profited from man's exploitation of nature. Its natural range is throughout temperate Europe and Asia. Introduced to North America in 1872, it has colonized the whole of the continent east of the Rockies from the St Lawrence to the Gulf of Mexico. The starling is now successfully established in Australia, New Zealand and other areas of the southern hemisphere.

but when working in bright light it is out of the question. The ideal answer is to bypass the camera shutter by leaving it open and to use a special rapid-opening shutter clamped in front of the lens.

Birds in the field

Ideally animals should be photographed outside in their natural surroundings rather than captured and brought inside. Flying birds are most easily photographed as they approach their nest and young, which act as an irresistible attraction to them; alternatively they can be tempted to bait. In either case they usually fly in straight lines and along regular flight paths. Knowing exactly where the bird is likely to fly, or persuading it to use a route to suit the camera is one of the keys to success. Several days can be spent setting up complex equipment at, for example, an owl's nest at the top of a tree, only to discover that the bird's flight path is not what was expected, or that the bird has changed

its approach pattern as a result of all the paraphernalia around its doorstep. A kestrel that I attempted to photograph near Bridgnorth serves as a memorable example, even if not a successful one.

The bird had selected a nesting hole some six metres up in an isolated ash tree. It was an attractive setting and had all the ingredients to provide me with a dramatic shot. Peter Bale was making a film about my work for a BBC *World About Us* programme, so the project would also present him with an opportunity to get some worthwhile footage. This in turn gave me added incentive to ensure that the operation reached a successful conclusion.

The placing of the scaffolding to support the hide was critical. It had to be at the correct distance and at the right angle, because it would be a major operation to move it. With this in mind I spent a day or two watching the activities of the birds, noting such things as feeding behaviour and flight paths. These observations enabled me to establish

the ideal camera viewpoint and approximate position of the light beam — the two cornerstones of such a set-up. I noted that the hen's visits were not as frequent as they might have been, and that her flight path was somewhat inconsistent, while the cock bird never appeared on the scene at all. In spite of these danger signs I decided to see the project through, particularly because Peter Bale had by this stage made his plans for filming.

A golden rule in nature photography is to avoid subjecting any creature to more stress than is absolutely necessary, so the scaffolding and hide were erected over about ten days. Then the flash heads and associated equipment were gradually introduced; if the bird showed any signs of distress I had to be prepared to go back a stage or, if necessary, to abandon the project altogether.

Once everything was in place and lined up I was ready to expose the first test photographs. I knew that my chance of obtaining instant perfection was extremely slim, but I never expected to spend the following ten days of that exceptionally cold, wet and windy July cooped up in a poky hide with so little to show for it at the end. The trouble was that the hen visited the nest only once or at the most twice a day. This, coupled with her unpredictable approach behaviour, meant that the success of the project depended on a factor which can rarely be relied upon — luck. The root of the problem was that there were only two youngsters in the nest instead of the usual four or five, and they were being fed on large fledgling starlings instead of small voles and mice. One starling provided them ·with enough food to last a day or more. As the visits were so infrequent, I had desperately hoped that the parent would fly in from the side, but instead she usually approached from the back or front, frequently missing the light beam altogether. Consequently the camera fired only every day or two, and I finished up with a handful of transparencies of dubious quality. But at least Peter Bale got some interesting sequences for his film.

The whole exercise underlines the differences between high-speed still and motion-picture photography. I had spent ten days up in the hide surrounded by sophisticated electronic equipment and had little to show

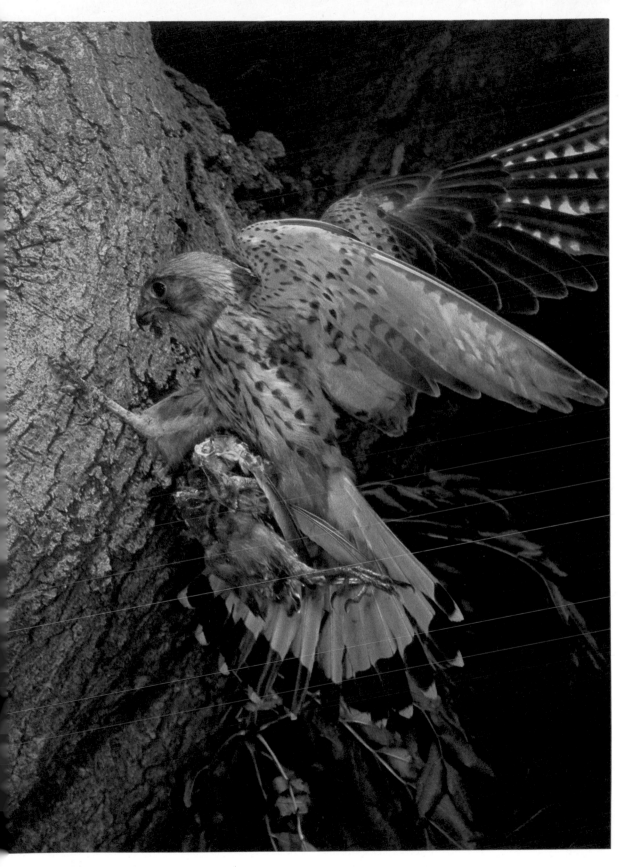

The kestrel is a widely distributed European and Asian species. A varied diet, allied with its ability to nest in cliffs, old crow's nests, hollows in trees and on ledges of buildings, makes it one of Europe's most common birds of prey. It feeds mainly on voles and mice but will also take small birds, insects and earthworms. Usually found in wooded countryside, kestrels are also at home in towns and cities. A pair once nested on Nelson's Column in London. With the expansion of the motorway system, kestrels are a common sight, hovering over the motorway embankments – an extensive grassland ecosystem winding its way through the countryside – a perfect kestrel hunting ground.

for my troubles, when Martin Saunders, the BBC cameraman, had spent two days armed with no more than a motion-picture camera and tripod, but had shot several thousand frames of quite dramatic slow-motion film of kestrels.

One worry about photography in the field is the problem of vandals and thieves. After sessions in the hide it is quite impractical to take down equipment which may have taken several days or even weeks to position and adjust accurately. What I often do is to pin a note on the back of the hide that reads 'Danger High Voltages', which indeed there are – some 3,000 of them. As the set-ups are often more reminiscent of Battersea power station than an in-field photographic studio, perhaps it is not surprising that so far the warning has been taken seriously.

Another potential enemy is the weather. In order to keep rain and condensation at bay, power packs, flash heads and junction boxes should be well protected by plastic bags. I have sat up in hides in driving rain and thunderstorms for hours on end with no ill

effects to the equipment, though being surrounded by 3,000 volts can be intimidating in these conditions.

Snakes and flies in the studio

There are many subjects which are best handled inside, away from thunderstorms and human interference. It is far easier to film an example of behaviour under controlled conditions. The mind boggles at the thought of attempting to photograph in the field a flea leaping or a rattlesnake striking.

The rattlesnake was not shot in the wilds of Texas but in the studios of OSF. In my efforts to capture this fleeting moment I employed the services of one European viper, two puff adders and a pair of rattlesnakes before succeeding. The puff adders were borrowed from a local wildlife park, and as they made no attempt whatsoever to strike, they were returned forthwith. I then tracked down a dealer in venomous snakes, vampires and scorpions and selected a particularly mean-looking tiger rattler. In due course I

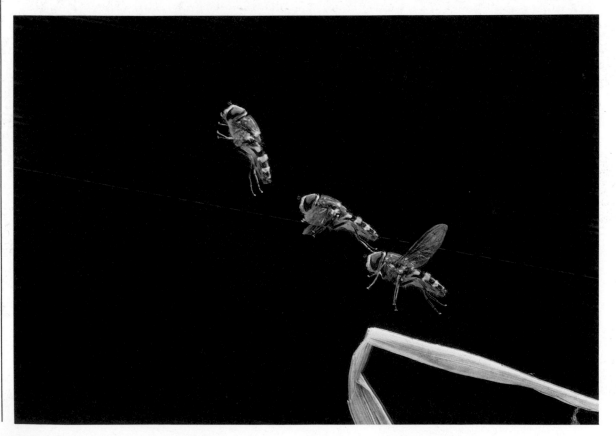

The hover-fly, *Syrphus ribesii*, is an abundant species whose larvae devour untold millions of greenfly, those ubiquitous pests of flowers, fruits and vegetables. Because of their livery of black and yellow, adult hover-flies may be mistaken for wasps. But, like all the true flies, they have two, not four wings, and are stingless and completely harmless to man. For this triple exposure, the flash was fired consecutively at intervals of approximately 1/25 second, at a speed of 1/25,000 second. In the first image the fly's wings are at the top of the upbeat, in the second the wings are on the way up and in the third the wings are on the downbeat.

prepared a suitably snake-proof set using a couple of hundredweight of sand and carefully set up the photographic and electronic hardware. In theory, the snake had to strike exactly the right spot and so intersect a two millimetre beam of light with its nose. After making a few half-hearted attempts it never tried again.

Determined not to be defeated, I exchanged the tiger rattler for an ill-tempered diamondback rattler. All sorts of devious means were employed to induce this creature to strike in the right place, but it would lunge out only if the object of its attack (a human hand was best) was within its comparatively short striking range. If too close, the object appeared in the picture area, if too far, the reptile simply huffed and puffed, hissed and rattled, but rarely struck. On the few occasions the creature did so, it occurred so unexpectedly and with such awesome speed that it certainly got the adrenalin going. In all, the whole operation took some three weeks to complete, during which time I managed to get about four acceptable photographs.

Insects too are far easier to cope with in a studio. Unlike birds their flight is erratic and unpredictable, they do not respond well to bait, and few insects return to their nest and young. The best way to persuade an insect to fly approximately where you want it is to enclose it in a dark box or tunnel which has a single exit towards the light. By locating the light beam in the right place, the insect can be photographed as it leaves. Needless to say, some insects totally ignore the exit and buzz around the box indefinitely. The camera axis relative to the flight tunnel axis will determine the view of the insect.

In spite of the assortment of optical and electronic aids, and the infinite care taken in setting up the equipment, all manner of things can go wrong. The chance that the insect will end up in the right place with its wings in the 'right' position and in critical focus is remote. Depth of field is always restricted in close-up photography, but its limitations become more apparent when dealing with flying insects. There are three main reasons for this. First, a flying insect has much more breadth and depth than a sitting one. Secondly, it is difficult to anticipate which

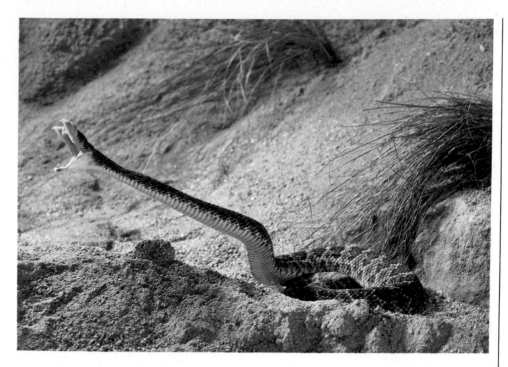

part of the insect's anatomy is likely to intersect the beam first and, thirdly, there is the problem of shutter delay relative to the insect's speed. Closing down the lens aperture, even supposing there is sufficient light available, which is unlikely, is not a satisfactory solution owing to the reduction of overall image quality as a result of diffraction. The only real remedy is to make the image smaller and thereby include more of the insect's surroundings. Additionally, by taking dozens or hundreds of exposures one hopes for the best.

As in all nature photography, there is no substitute for a sound knowledge of the subject. Not only is it invaluable to be able to anticipate an animal's next move, but in studio work it is essential to select a suitably natural setting Insects and other creatures spend their lives crawling, jumping and flying around vegetation, so any plants selected must be biologically appropriate. Furthermore, once picture elements other than the subject are included in the overall scene, the pictorial potential of the final result is increased. To this end, a sense of design is as important to a nature photographer as a knowledge of natural history and photographic technique.

The western diamondback rattlesnake *Crotalus atrox* is perhaps the most dangerous North American serpent. Rattlesnakes belong to the group known as pit vipers, so called because they detect the location of their prey by means of temperature-sensitive pits on either side of the face between the eye and nostril. In this picture, frozen by 1/12,000 second flash, the drops of venom may be seen flowing from the tips of the fully erected hollow fangs. The snake took its own picture when, in striking at the hand of technician Philip Sharpe, held just out of range, it cut a fine light beam which triggered the camera.

4 Hidden worlds

GEORGE BERNARD and JOHN COOKE

It all started in March. The mechanical diggers had been levelling one of the earth ramparts that surround Oxford Scientific Films to allow space to build an extension to the special effects studio. Apparently ignorant of the earth-gouging bucket that would soon destroy her offspring, a rabbit had carefully earthed up the entrance hole to her nesting burrow. It was this tell-tale sign that caught the eye of Ian Moar as he inspected the work in progress from the vantage point of the bank.

Invading nests and burrows

We excavated the stop, as nesting burrows are called, and transferred the three ten-day-old baby rabbits, called kittens, to a cardboard box. For the next few days at intervals of five hours, the kittens were fed on tepid cow's milk through a pipette. Meanwhile, with accurate measurements of the stop, Philip Sharpe and I [George Bernard] were able to construct a replica in fibreglass. Within the week the sectioned nesting burrow was finished. Dry earth, stones and roots were thrown on to the final tacky layer of resin and, once dry, we inserted an observation window made of clear perspex.

While the fibreglass was setting, and the noxious vapours were evaporating, we erected a lean-to shed in the enclosed quadrangle within OSF, the site chosen for the new nesting set.

Laboriously, Philip and I transported in, wheel barrow by wheel barrow, several tons of earth and vegetation, and slowly but surely a grassland habitat emerged. On one side of the set we created a miniature hedgerow by planting lots of ivy and cow parsley, and other such plants associated with hedges.

A month later, we placed the stop inside the lean-to with its entrance hole leading out on to the now stabilized grassland. It may appear that we had gone to extraordinary lengths to photograph the private life of a few rabbits. But for the rabbits to behave as they would in the wild their territory had to be as natural as possible. But how do rabbits behave in the wild? The relevant literature gave me a basic understanding of their requirements and behaviour, but no amount of reading was a substitute for my own observations.

So, armed with camera, telephoto lens and the accompanying paraphernalia of a stills photographer I found an accessible rabbit warren. I had to use a 600 mm lens because of the 30 metres' distance between me and the rabbits. There is always the problem of vibration as the shutter is released, but this is more acute with a long lens so you have to use either a very sturdy tripod or a beanbag

OPPOSITE An 18-day-old rabbit sitting in a tunnel leading from the birth cell. At this age, the young spend a lot of time investigating their home, almost as if they are plucking up courage for their first peep at the world outside. All the nesting burrow shots were taken with electronic flash and a 55 mm macro-lens.

BELOW Although lying low in fear, this young rabbit is still inquisitive as it watches the antics of the cameraman. If it were truly fearful, it would lay its ears typically along its back.
As soon as I approached within the critical distance, the rabbit bolted for safety.

into which the barrel of the lens is pushed like a chicken settling down on to her nest. A useful rule of thumb is to use a shutter speed no longer than the focal length of the lens, in this case 1/600 second.

The next requirement was patience of the quality attributed to the prophet Job. Rabbits have survived by being alert and secretive. Any movement or strange smell, such as caused by a sudden attack of 'photographer's cramp' or the lighting of a cigarette, and the area is suddenly dotted with white, receding rumps.

The ability of any natural history photographer to isolate an incident of behaviour depends on three factors. First, the more intimately I know the creature, the more accurately I can predict the probability that a certain behavioural stance will appear. I say predict because there are two inherent delays: it takes my mind a finite time to react and the camera mechanism also has an irreducable delay. For instance, during the courtship of two tropical butterflies, the male briefly flaps above the receptive female before landing to copulate. The female flattening out her wings and lifting her abdomen would be my signal.

The second factor is the quality of light, whether natural or artificial, falling on the subject. In natural history photography strobe light is often used to simulate sunlight: from the warm morning or evening light achieved by using reddish or orange filters, to the contrasting light of sunny days by using a unidirectional light source, and the even illumination of hazy days. The type of lighting is important: it suggests the time of day the subject is to be seen.

The last factor, though closely related to the problems of lighting, is my mood, because that also affects the final outcome. But one rule I try to abide by, whatever the mood, is never to patronize the subject — I always try to get down to its level, as if the world is being seen from its point of view.

Five months had passed since the almost forgotten, blister-inducing and grimy work of set building. The rabbits, two bucks and a doe, were now sexually mature. One of the bucks had become king of the patch and, since the area was only adequate for two full-grown

The ability to stand on hind legs may also be used to investigate low hanging foliage. The nostrils are flared exposing two highly sensitive smell pads. Electronic flash shows off the ancient bark of the oak tree and the fine whiskers of this adult buck.

rabbits, the submissive male was taken along to the vet, injected against myxomatosis and released near a small warren as far from gun and ferret as possible. Although the main breeding season of the rabbit is from January to August, sporadic breeding does occur throughout the year. With ample food, provided in the form of pet rabbit feed, I was hoping to encourage our pair to mate, although the breeding season had finished as far as wild populations were concerned. But for one reason or another, the doe rejected the amorous advances of her brother, indubitably not on moral grounds, but more probably because her reproductive biological clock had been turned off for the season. Winter must be a grim time for wild herbivores. It makes sense for survival that any system which is energy intensive, such as breeding, can be suspended. Another obvious energy-saving strategy is to hibernate.

Once they had investigated my appearance on their domain, they would become less interested. The buck usually took a little longer to do so than the doe, taking time to sniff and then rub his lower jaw across the toe of my shoe. Rabbits live in a hierarchical

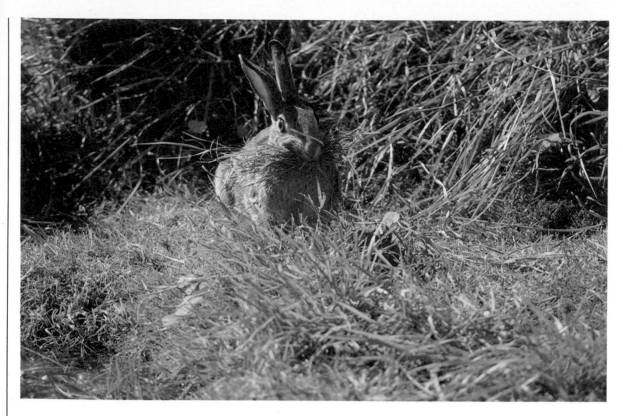

Unlike her usual dainty method of feeding on blade by blade of favoured grass, the nest-building doe gathers up great mouthfuls. These bundles she holds in the gap, called the diastema, between the front teeth and the cheek teeth at the back of the jaw. This behaviour takes place some 24 hours before birth.

society; to let other rabbits know that they are encroaching on an established territory the occupier scent-marks his boundaries with faeces, urine and scent from his chin gland. I was now included in his territory. To photograph the buck chinning was therefore a straightforward matter. I would take him away from the set for a couple of days at a time, and on replacing him, he would bound around renewing the attenuated scent and thus re-establish his rights of tenure.

Because our rabbits were as good as tame, photographing their antics could be done with a 105 mm macro-lens. What a contrast to photographing the wild rabbits. And having spent quite some time watching the deportment of rabbits in the wild, I was able to compare it with the captive pair. I was happy to see similar behaviour patterns, such as sunbathing and standing up on their hind legs to investigate their surroundings.

About a week into February, the doe had started to reciprocate some of the attention the patient buck had been lavishing on her since the beginning of the new breeding season in January. By the end of that week courtship had reached its climax. Twenty-eight days after mating, the day before parturition, the doe collected up great mouthfuls of grass and with this Franz Joseph moustache of vegetation disappeared down the stop. After several such collections the cell at the end of the tunnel was full. From her upper chest she pulled out great clumps of fur and, burrowing her head into the ball of grass, deposited these into the centre.

Needless to say I was overjoyed that she had accepted the stop. She could just as easily have burrowed into the bank overnight and negated all our hard work. In the wild it is the doe that undertakes all the major earth shifting, while the buck seems to lose interest very quickly after a perfunctory scratch.

I was not going to push my luck, however, by photographing her during her first birth because anxious rabbits have the macabre habit of devouring their young. But the next morning, trembling with anticipation, I quietly opened the perspex window, carefully parted the grass and peeped into the ball of fur. Ensconced in the warmth were five hairless, mauve, hippo-like bodies, their bulging eyes covered with still unopened lids. Though blind and helpless, my disturbance made them

jump several centimetres into the air and make little kissing noises with hungry mouths as they searched for what would normally have been the doe's nipples.

Their development was recorded on film. At first the sudden noise of the shutter troubled the kittens, but they soon grew accustomed to it. Because of its short duration the flash of the home-made strobe does not normally disturb animals. One of the great advantages that stills photography has over movie is the use of these short flashes of light that can both freeze motion and catch the dweller in dark places unawares. But when using a portable flash system, there is no continuous light and when working on a set one needs a dim lightbulb by which to focus. In the wild, a coal-miner's headlight is extremely useful.

Whereas the two rabbits were to a great degree tame and tolerant of a good deal of disturbance, the harvest mice, the stars of another project, would at the slightest sound dive headlong into the vegetation. The higher the pitch and the closer the sound

ABOVE New-born rabbit kittens weigh in at about 30 g. The doe leaves them in this bundle of fur and grass, giving them milk once a night. By the time they leave the nest 20 days later, they will have gained 220 g.

The same five kittens at 11 days. Each now weighs about 150 g. They spend most of their time asleep, but now and again they attempt a few unsteady hops. Four days ago they started to use their eyes.

resembled the hiss of rustling grass, the more violent was their reaction. In the wild, these sounds give a mouse an early warning of the approach of possible danger. The best strategy is to run first and watch later. So I used a 105 mm macro-lens, which allowed me to photograph their antics beyond the critical distance of fright and flight.

A set had to be made that gave the appearance of depth, but which, in fact, restricted the mice to a filmable zone in front of the camera. This trompe-l'oeil was achieved by positioning a clean glass sheet across the set, thereby giving the mice a depth of twenty centimetres in which to perform. After a week of patient waiting I caught the frenzied act of mating. The filmable zone now became known as the erogenous zone. Seventeen days later I started an all night vigil at the breeding nest. The next morning I was relieved by Sean Morris who photographed the birth at two o'clock in the afternoon. With both rabbit and harvest mouse, birth takes place away from prying eyes. In the case of the mouse she accepted a disused wren's nest for her

ABOVE At 14 days old, the kittens are hopping up and down the nesting burrow with confidence. Self-grooming starts up as if a switch has been turned on and, except for the obviously cute features and sexual immaturity, they now behave like adults.

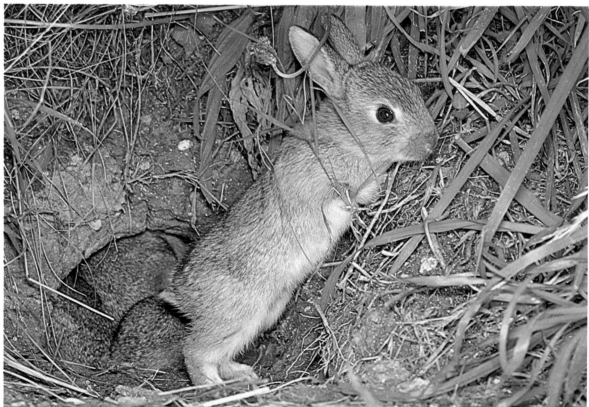

A camera with a 105 mm macro-lens mounted on a tripod and under remote control lit up this night-time scene of 18-day-old rabbits investigating the world outside the warmth and safety of their stop for the first time. Within the next few days these young will be on their own — left to survive or die. Their average life expectancy is about 18 months.

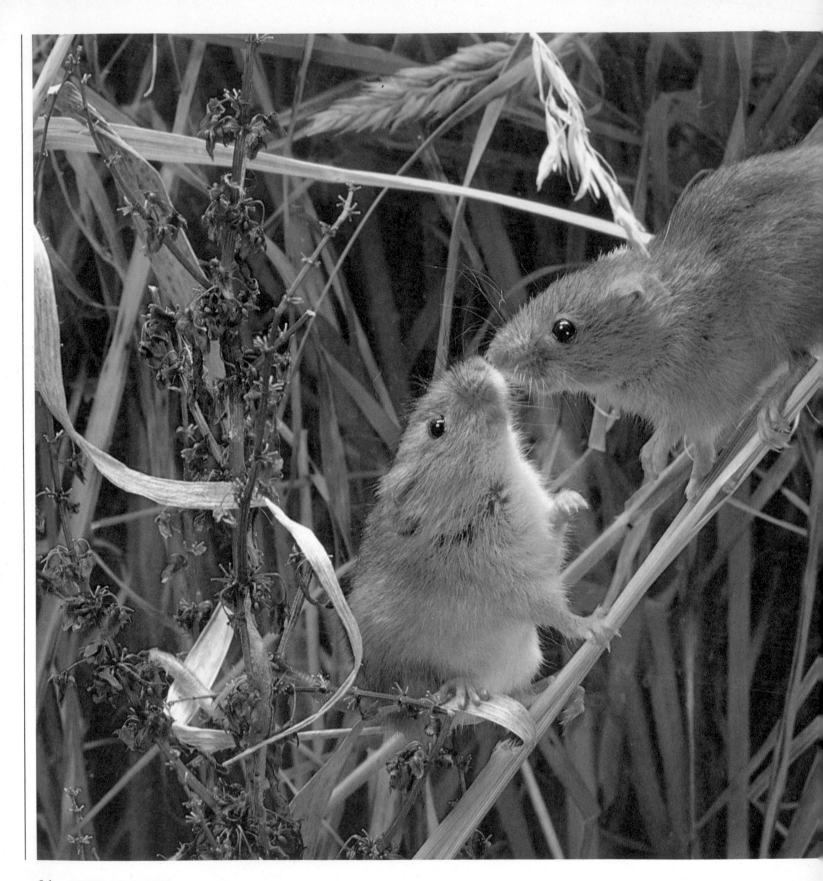

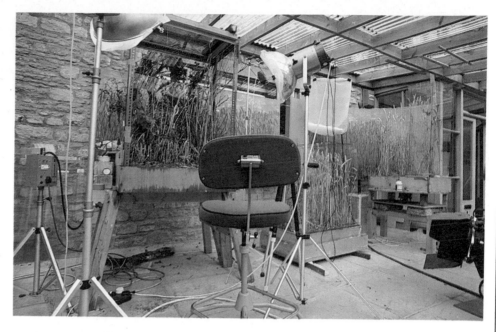

maternity ward. Although harvest mice make intricately interwoven nests of grasses, they will quite happily take over a wren's nest found in a hedgerow. But this was a wren's nest with a difference: three small windows had been carefully cut out of the nest wall, two for the flash guns and one for the vitreous eye of the camera.

Imagination and care must be used to show any animal in its environment. This also applies to other creatures who live hidden from the human eye within the sanctuary of darkness, in caves or underground.

ABOVE Here we have the various harvest mouse sets. The one on the left is an autumnal set. On the floor is the summer set — while it was still green we could photograph and film the mice's acrobatic antics during breeding and nest building. In the precariously balanced right hand set, full of ripe wheat, we filmed the mice chasing grasshoppers. The painting of a field of wheat on the curved hardboard was executed by our resident da Vinci, Philip Sharpe.

FAR LEFT Harvest mouse courtship is a noisy and fearsome spectacle. The male gingerly approaches the female while she clings to a stem, with her head back and her teeth exposed ready to bite her suitor. He nervously sniffs her genitalia and, with no apparent warning, the two mice rush through the vegetation at break-neck speed. They soon tumble to the ground whereupon the male chases the retreating female into the undergrowth where they mate. To catch courtship and mating I restricted the pair to a narrow glass-bounded territory at the front of the set.

LEFT The first born mouse slips out in its amniotic sac. There was no noise from the mother but she appeared a little nervous. She gave birth to all five mice in less than 15 minutes, by which time the candy-pink blobs had all become animated.

The perpetual darkness of Tamana cave

Dominating Trinidad's central range is Mount Tamana, and deep within its limestone rocks lie the chambers and passageways of Tamana Cave, whose further reaches are still unexplored. Home to at least a dozen species of bat and numerous other creatures, Tamana had been the subject of several detailed studies by biologists from the University of the West Indies at St Augustine. I [John Cooke] had previously worked on the ecology of temperate cave systems in northern Mexico and was particularly interested in comparing these with a tropical cave. We knew that filming in this strange, hot and humid world of perpetual darkness would be difficult, but it proved to be even harder than we had feared.

To biologists interested in the evolutionary forces that mould the form and behaviour of species, caves provide valuable field laboratories in which these influences may be studied. Absence of light makes eyes useless and necessitates the development of other sensory systems, particularly those of touch. Well-adapted cave dwellers, or troglodytes, tend to lack pigmentation and have unusually long antennae and sensory hairs, while bats have evolved extremely refined echo-location systems to enable them to navigate and find prey within their subterranean world. In many caves, particularly those not inhabited by bats, the most powerful evolutionary pressures result from intense competition for limited supplies of food, for little energy flows into the system from the outside. Tamana, however, with its huge bat populations foraging nightly in the surrounding forests, provided an interesting contrast.

Tamana cave is reached by a strenuous uphill hike, the path winding its way up through derelict coffee plantations and dense forest, and including all the usual tropical hazards of slippery logs, mud, army ants on the march and the constant possibility of poisonous snakes. Day after day, heaving cameras, lamps, battery packs and caving gear up to the entrance drop became an accepted form of purgatory from which we knew there was no escape. But this was nothing compared to carrying the generator. Four times we experienced the nightmare

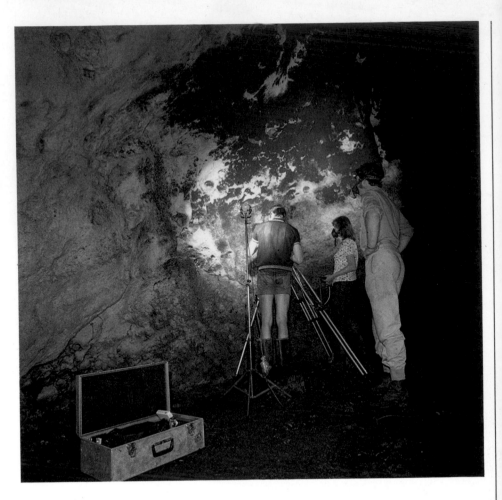

of carrying one hundred kilograms of generator, slung between large poles, up the narrow, winding, slippery trail — and down again. Seldom, if ever, can the Tamana mosquitoes have enjoyed such a feast.

The main cave entrance was a vertical shaft of some three metres in diameter through the roof of an old chamber that had long ago collapsed. It dropped into a system of tunnels carved out of the soluble limestone by underground streams. The series of beautifully sculptured rooms and passageways that led away from the entrance drop were hung with stalactites and limestone curtains. In the roof were deeply incised domes occupied by fruit-eating bats of the genus *Phyllostomus*. These bats were the starting point for our story, because through them energy is brought into the cave, to be dispersed in the form of guano which in turn supports a diverse and characteristic fauna. Even before we had time to identify the bats in these

David Thompson, Ian Moar and Carol Naylor preparing to film in Tamana Cave. The large brown patch on the cave wall is caused by millions of strebilid fly pupae. These flies are parasites on bats but their larvae live in guano — their story was just one of the sequences in our film on the ecology of Tamana for an Anglia TV *Survival* programme. The lights were powered from a generator carried up to the cave entrance. We all wore face masks as a precaution against histoplasmosis, a fungal infection of the lungs.

upper chambers, we knew that they were fruit rather than insect eaters, because sprouting from the guano beneath their roosts were the pale, etiolated stems growing from seeds that had been brought in and struggled upwards towards the non-existent light without hope of surviving.

In such a setting, the biologist cannot afford to be squeamish, and we were soon crawling on our hands and knees to see what else flourished in this unattractive habitat. The list proved quite impressive. A large number of beetles, springtails, woodlice, worms, fly larvae and assassin bugs made their homes here, feeding on the guano and each other. There was also a curious tineid moth, whose caterpillars live in little guano-covered cases like those made by caddisfly larvae. These small, pale moths seldom fly but crawl on the guano, the female attracting males by periodically extruding scent-dispersing brushes from the tip of her abdomen. Most conspicuous, however, were the large and abundant cockroaches. The cave walls, altogether more wholesome, were a danger-

ous place for any invertebrate to live because they were inhabited by a number of predators, including the spitting spider, *Scytodes*, several web-spinning spiders and two species of large, fast-moving centipede. The most interesting inhabitant of the cave walls in this upper area was the pupa of a strebilid fly. The adults are parasitic on bats, and were frequently seen crawling among their fur. But the larvae live in the guano on the cave floor and, when they are ready to pupate, crawl up on to the walls. For some reason, they all congregate in one area which was therefore covered in millions of empty pupal skins from untold generations of flies.

Filming in this environment clearly presented difficulties and getting the equipment to the cave was only part of the battle. There was moisture everywhere, if not dripping off the roof, certainly falling freely from our faces in the 30°C temperature and 100 per cent humidity. Trying to change film or operate a delicate tape recorder with wet, guano-covered hands, without ruining the mechanisms, calls for considerable skill and a lot of

Bats in flight. To take this picture we sat the camera on a tripod at a point where the Tamana Cave narrows to a bottleneck. The wide-angled lens was focused at about 1 m and stopped well down so that everything between 0.5 m and 5 m would be in focus. To freeze the movement of the bats, the scene was lit by electronic flash of short duration. The camera was fired at about 6.15 in the evening as the bats started to leave the cave to forage in the surrounding forest. Many exposures were needed to ensure that, in at least some pictures, the bats were correctly positioned.

luck. Then, too, there was the problem of lighting. There was a limit to the length of cable we could carry, and every junction was liable to become saturated and emit fearful sparks or, worse still, bone-breaking shocks despite being sealed in plastic bags. Further down the cave we had to rely on heavy, battery-operated lights.

It may perhaps come as a surprise to the uninitiated to learn that in making a film of this sort not all the photography is actually done on location. For close-up work especially, it is not only more convenient but technically necessary to remove the subjects to a more controlled environment. This is particularly true of aquatic creatures, which have to be filmed in relatively clear water if the results are to be acceptable. Clearly, also, it would be absurd to carry a large optical bench, with its numerous accessories, into a cave in order to get close-ups of crab eggs or tadpole jaws, when the subjects themselves can be carried out in a small bottle in a trouser pocket.

Another problem, and one we encounter continually, was the incompatability of stills photography with motion-picture work. Because a still picture will be viewed repeatedly it must have a greater clarity and depth of field than is necessary in a motion-picture frame, which cannot be contemplated and in which action can conceal technical inadequacies. For these and other reasons electronic flash is often the preferred form of illumination, whereas motion-picture filming obviously requires continuous lighting. Nothing shortens the temper of a movie cameraman faster than the blinding flashes of an over-enthusiastic stills photographer intruding upon his film sequence. With all the difficulties involved in fulfilling our primary obligations to motion-picture filming in Tamana, we usually refused to add to our burdens by attempting to cover events in stills as well, except when it could be done back in base. For this purpose, we would carefully gather rocks and guano and re-create in small sets the scenes witnessed underground. One such set was a replica of one of the pools formed by the stream running through the length of the cave. Here we filmed, for example, the large

freshwater land crab, *Pseudothelphusia garmani*. Unlike the more familiar marine crabs, whose eggs hatch into larvae which are distributed by drifting in the plankton, *Pseudothelphusia* eggs hatch directly into miniature crablets, which are carried in a cluster beneath the tail. Although they prefer moist habitats like Tamana, the suppression of the planktonic larval stage in their life history allows them to survive far from standing bodies of water.

Pseudothelphusia is not a troglodyte – that is a creature exclusively confined to the dark part of the cave – but rather a troglophile: it exploits the cave but can also survive in similar habitats above ground. Many of the inhabitants of the twilight zone near the cave mouth belong to this category, including a variety of snakes, lizards and geckos and also the manicou, an ill-tempered opossum that climbs the cave walls to prey on roosting bats. Another troglophile was the frog, *Phyllobates*,

Newly hatched tadpoles of the tree frog *Phyllobates* on a leaf. The moist rain forests of Mount Tamana are home to several frog species, each displaying characteristic breeding strategies. *Phyllobates* is a diurnal ground-living species living both by heavily shaded streams and around the mouths of caves. After the eggs are laid, either on leaves or in rock crevices, they are guarded by the male frog for about 3 weeks, until they hatch into pale little tadpoles.

which enters the cave to feed on the moths and other insects inhabiting the guano. The female frog lays her eggs either on leaves around the cave entrance or on the rock walls beneath. When the eggs hatch, the tadpoles wriggle on to the back of the male and he then carries them down to the stream trickling through the guano. Here they feed on bacteria and the occasional cockroach corpse that drifts by. But the tadpoles are not without their predators. Another casual inhabitant is the high woods coral snake. *Leimadophis*, a brilliant green snake that has so far been found nowhere in Trinidad but Tamana cave. It has the startling habit of spreading its neck rather like a cobra when alarmed – although it is totally harmless, except to tadpoles. Coming to the edge of the pool the snake lowers the front part of its body into the water and slowly waves back and forth until it finds a tadpole, which it immediately swallows whole.

So far I have described only the upper parts of the cave where the filming problems were relatively small when compared to the difficulties we encountered in the deeper passages. Why, it may well be asked, bother with the remote parts. Surely they cannot be so different? But they are. Deep within the cave lives a quite distinct fauna and a far less welcoming environment. Stumbling downwards from the entrance we soon found ourselves at the top of a waterfall, with a narrow passage dropping below into utter blackness beyond the probing beam of our caving lamps. Suddenly we became aware that the whole cave below the falls was seething with millions upon millions of enormous cockroaches which rejoice in the name *Eublaberus*. To reach this zone there was no alternative to a good soaking as we slowly negotiated the guano-impregnated falls. Working downwards from chamber to chamber, the sharp-nosed connoisseur can detect a change in the

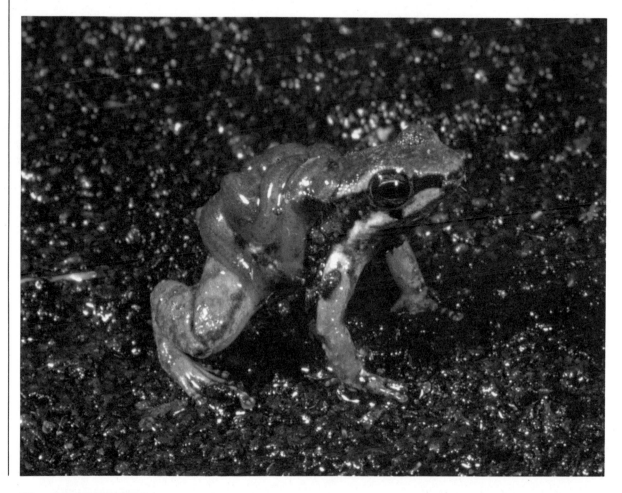

After the eggs of *Phyllobates* have hatched the tadpoles attach themselves to the back of the male frog. He then carries his offspring to a suitable pond, where they live for about two months before emerging as little froglets. Tamana Cave, with its constantly flowing streams, provides an ideal habitat for *Phyllobates*.

The high woods coral snake *Leimadophis reginae* is found very rarely. In Trinidad it only occurs in Tamana Cave, where it feeds on tadpoles. Despite its common name, *Leimadophis* is not a true coral snake, which are highly poisonous relatives of the cobra, and is completely harmless to man.

The tadpoles of the ground-living tree frog *Phyllobates* live in huge numbers in the rock pools of the cave. Often several thousand live in a square metre, barely covered by the shallow water. Their principle diet is bacteria and organic matter washed out of the surrounding guano.

sweet cloying odour of the guano, which upon inspection also proves to have a different consistency. This was the guano of insectivorous bats and, not surprisingly, we discovered that it supports a different fauna to the guano of the fruit eaters. Quite the most alarming inhabitants were ticks belonging to the genus *Antricola*. Ticks are generally parasitic and require at least three blood meals in order to complete their life cycle. Many are also vectors of diseases such as Rocky Mountain spotted fever and relapsing fevers. So it was

a daunting prospect when I came to a chamber filled to within forty five centimetres of the roof with guano that was seething with innumerable large ticks. A tempting passageway led out from the far side and the only way to get there was to wriggle through the ticks. To my amazement I did not receive a single bite. Indeed the ticks quite ignored me, despite the fact that such large and juicy meals could seldom be found at such depths. Apparently *Antricola* is unique amongst ticks in preferring guano to blood, a sensitivity for which I have ever since been extremely thankful. But ticks are not the only barrier to Tamana's depths. The prudent visitor must add to his burden by wearing a face mask, for the cave is renowned for a particularly nasty respiratory condition called histoplasmosis. This is caused by a fungal infection of the lungs which is often serious and can, on occasion, prove fatal. There is also the risk of picking up rabies from the bats, not by being bitten but by droplet infection, from which the masks provide but limited protection and innoculation before departure only slightly more. But even this is not the final bar to exploring Tamana's deepest recesses. The honour of guarding the innermost secrets from prying eyes must go to an invisible and quite unexpected foe — carbon dioxide gas.

As determined explorers we forced ourselves deeper and deeper underground but gradually became aware of a curious lassitude, a need to pause more and more frequently to try to catch breath, which grew ever more elusive. By the time this shortness of breath became obtrusive, the density of roosting bats on the walls and ceiling had grown to unbelievable proportions. Not a square centimetre of bare rock remained — everywhere, we saw a shimmering curtain of fur and the air was filled with squeaks and periodic flapping as one of the dislodged inhabitants tried to find a fresh spot on which to continue its slumbers. Eventually we reached a point, at the end of a long and seemingly bottomless descent, where it became physically impossible to proceed further. With splitting head, heaving chest and half blinded by sweat even the most resolute caver is forced to turn and drag himself back towards the surface. It was only at this point that we realized just how far we had penetrated. Climbing back was far, far harder than descending. Only once did David Thompson and I bring cameras down to this hellish spot. But it was not bravado that drove us here. We had set out to make a film on the ecology of the cave and the high density of roosting bats in the deeper chambers was a vital ingredient. Had we realized that the film editors of *Survival* at Anglia TV, sitting comfortably in their Park Lane offices, were going to simplify the story for their viewers and make no distinction between the two very different chains of life in the upper and lower parts of Tamana, we might not have struggled quite so hard for scientific accuracy. Perhaps we should have realized, for it is not the first time that such endeavours have subsequently been wasted on the editing room floor.

Eventually, after nearly three months of fairly regular visits, we felt that the work was nearing completion. Just one sequence, albeit a very important one, remained to be shot. Each evening at 6.15, the millions of bats in Tamana start to emerge into the surrounding forests to feed. For fully three hours, a seemingly endless vortex of bats pour upwards from the entrance and disperse through the trees into the noisy tropical night. We needed to capture this mass exodus in slow motion and so called in Sean Morris with the camera he was using to film hummingbirds, a sequence he describes in chapter 3.

Bats are sensitive creatures; they dislike disturbance and soon move on to fresh roosts if persecuted. To film them in slow motion necessitated the use of exceptionally bright lights and also involved an OSF team of six people. So we were anxious to shoot as quickly as possible and then to move out to leave the bats in peace. Little did we know that, because of technical problems, we were going to have to re-shoot the subject two more times, and each time we had to heave the generator and all the other equipment up the mountain.

With the passing of time, memories of the dirt, smell and the sheer physical labour have faded and only the excitement of new discoveries and successful sequences remain.

5 Freshwater filming

DAVID THOMPSON

Freshwater subjects, such as dragonflies, newts or fish may conjure up pictures of outdoor filming on idyllic summer days beside a meandering river or shady lake. But freshwater filming is not quite like that. For one thing, in Britain it is impossible to rely on the weather. Good sunlight is essential for periscope work on underwater subjects as light does not easily penetrate those murky corners where the action inevitably occurs. A round-the-clock riverside watch, which might be required for a fish spawning sequence, would be fraught with almost insurmountable difficulties and discomfort, and the colder months of the year are torture for wet hands attempting to operate the controls of a camera. So generally speaking, when filming freshwater life, only a very small percentage of work is done outside. We do, of course, take the wide-angle views which establish the habitat of our subject.

The periscope we use for outdoor filming in water is a square tube, about one metre long with a glass bottom, behind which a mirror is set at an angle of 45°. The camera, which is firmly attached directly above the tube, looks down at the angled mirror and so sees ahead of the apparatus. A seat built behind the periscope accommodates the cameraman, and the whole thing is stabilized on three legs. The buoyancy of this large tube is an obvious problem, but two bags attached either side of it can be filled with sand or rocks to weight it down. To prevent light entering the tube from above, the cameraman usually has to sit with a black cloth draped over his head and the top of the periscope. Although a periscope can be used very successfully on many tropical expeditions, in Britain most waters other than some mountain streams are so full of microscopic life and debris that the view seen by the camera is too cloudy for

successful filming. So, wherever possible, we bring the subject indoors, to the purpose-built tank in our studios.

Tanks and trout

In the very early days of Oxford Scientific Films, when we were asked to film the life of the trout, it was suggested that we build a large indoor tank set. This was the brain-child of our fish expert, John Paling. The advantages were obvious: opening up before us were the possibilities of capturing behaviour, such as spawning, never before filmed in close-up in the difficult underwater conditions of river and lake. Although we were apprehensive that the need for such a tank in the future would never justify the expenditure involved, the vote went in favour of the project, and the tank has been in almost continuous use over the past ten years.

OPPOSITE It would be difficult to achieve such sparkling clarity in the field where there is debris floating around, and it would be hard to get close enough to the froglet for a macro shot. So we prepared a small tank 15 cm long, 10 cm wide and 12 cm high, thus restricting its movement. The tank was lit from the sides with electronic flash. Just enough weed created a background without casting shadows.

BELOW The River Guanapo in Trinidad was very clear, silt-free and fast-flowing so Ian Moar was able to use the periscope to film a motion-picture sequence of tadpoles. Even these idyllic filming conditions have their drawbacks; a constant watch was necessary for the very poisonous fer de lance snake which lived near the water and at times swam around.

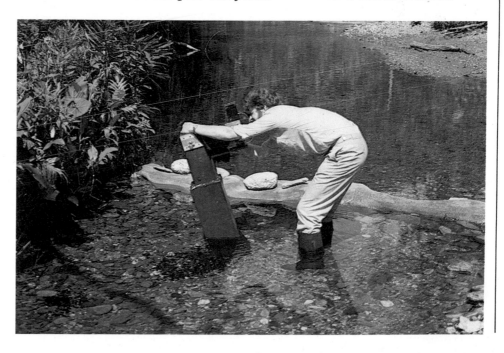

The life of the trout was filmed very successfully in the new tank, and a delightful and unusual subplot was the activity of a bird, the dipper, included in this story because it was known to feed on trout eggs. The water level in the tank was lowered, a grassy bank constructed and a cage was built over the top. The dipper adapted to its strange surroundings almost immediately. It virtually 'flew' when under the water in search of eggs, its dark plumage taking on a silver sheen owing to air trapped in its feathers. It would pick up quite large stones and move them about, and on one occasion, dropped one on a passing crayfish which immediately scuttled off to a safer spot.

The prototype tank built for the trout film measured 3 metres long by 0.4 metres wide and 0.6 metres high, but the width has since been doubled to give a depth of view of one metre. The tank room is specially equipped with floor drainage against floods because the total system, including the outside reservoir section, holds 4,500 litres which at full speed can be circulated in one minute. This flow is regulated by means of a gate valve or by having less water in the system, so we

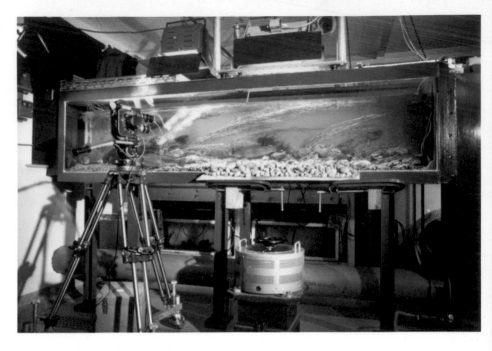

can simulate the conditions of any environment from the muddy bottom of a slow-running river to the clear waters of a fast-flowing salmon stream. Filters placed at each end of the tank ensure that the same leaf does not make a repeat appearance at regular

ABOVE The freshwater tank is prepared, decorated and stocked — ready to film the life of the trout. We leave all sets for a month to become established. Ultraviolet lights positioned around the filming lights ensure that the plant life will survive for the period of filming. Algae of course also grow on the front of the tank and the glass has to be carefully cleaned throughout filming; any scratch immediately destroys the illusion of the underwater scene. An extra bed of gravel outside the tank provides additional foreground and therefore greater distance to the river scene.

LEFT One of the subplots in the life of the trout: the dipper on an underwater search for trout eggs. It took us three weeks to get the full sequence in both stills and movie.

intervals, and a fan directed at the surface of the water produces the effect of dappled light. We normally use 10 kilowatts of light to illuminate the tank adequately, and these lamps have their own fans and heat absorbing glass to prevent them heating up the water. We also have aeration pumps below the tank, supplying essential oxygen to the water.

Spawning salmon

When asked to film salmon spawning we took on the work with no guarantee of success, but were excited by the challenge of filming something that had never been done under artificial conditions or in the detail now required. The building of the set was even more important than usual; in natural surroundings the conditions have to be exactly right before the salmon will spawn, and we had to reproduce this environment in a tank.

The underwater environment into which we place our 'film stars' is always important, and whether it is a small aquarium or the large tank which is being used, a great deal of time and effort goes into achieving a natural effect. This is not just to ensure that other experts will not catch us out; if the environment is wrong, the subject will very often not behave naturally. It takes about a week to build a set: to provide appropriate basc cover, devise a suitable background, sometimes with the assistance of back projection, and to collect and plant weeds.

The sequence on salmon spawning was to be part of a BBC film by Hugh Falkus. It required an entirely different set to that in which we filmed the trout. The first consideration was to ensure that our studio shots matched the outdoor filming in the countryside around his Cumbria home. After a round trip of some eight hundred kilometres and a couple of hours spent up to our knees in the freezing cold water of a Cumbrian salmon stream in October, technician Ian Hendry and I arrived back at the studios with the car full of dustbins containing gravel scooped from a known redd — the area where salmon choose to spawn. The size of the gravel was important; too large and the salmon would be unable to dig, too small and it would cave in on the eggs.

The biggest problem was how to produce an adequate supply of oxygen. Salmon spawn in water which filters well through the river-bed material, so that there is always plenty of oxygen for the development of the eggs. We came up with the idea of making a fibreglass base which was perforated and raised eight centimetres off the bottom of the tank. On to this base we tipped our half ton of Cumbrian gravel.

Another problem we faced was that the predominantly dark background of a water scene, if not organized properly, results in a reflection of the action outside the tank appearing on film. This can be overcome by draping the cameraman in black velvet and even painting the shiny parts on the camera black. But we find it preferable to erect a hessian screen, into which appropriate slits have been cut, between camera and tank. The camera, which is mounted on a wheeled tripod, can then move easily and smoothly to that part of the tank where the action is. This reduces the disturbance to any subject, and fish in particular are easily put off by vibration and movement. It proved to be the solution for the filming of salmon.

While filming outdoors I often watched common blue damselflies, linked in tandem, fly gently over the water in search for a suitable spot for egg laying. If I am lucky I see them land on some fine filamentous weed and watch the male as he pushes his mate under the surface.

The male releases his grasp, and she climbs down a stem and starts to lay her eggs, as illustrated below. First, she cuts a slit in the stem with the sharp cutter at the end of her abdomen and then slips a minute egg into the slit before moving further down to repeat the operation. Often as many as 20 eggs are laid during an underwater stay of up to 20 minutes. Enough air is apparently trapped around her body for her to breathe.

The fish were supplied to us by the Wye River Authority from one of their sample nettings. We wanted two hen salmon and a cock, preferably in the three and a half to four and a half kilogram range. The consignment arrived one dark and wild November evening, but when we shone a torch into the delivery tank to check that our precious salmon had survived the journey, we were confronted by three immense fish, each between seven and eight kilograms. Even in the filming tank they looked huge.

So we waited – and the fish did nothing. What was the problem? Was the temperature wrong, had the journey upset them, or was it the chlorine in the Oxfordshire tap water we had been forced to use in the short time available to build the set? Were they simply too big? Feeding at least was no problem, as salmon do not feed in fresh water. We decided to lower the temperature from 8°C to 3°C, and freezing units were put in the reservoir tank. Almost immediately one of the hens made a half-hearted attempt at digging a redd, and raised our hopes considerably. But after five days the fish developed a fungus disease. This was probably as a result of our difficulties in handling such large specimens, for the mucus that prevents the growth of fungal spores can so easily be rubbed off.

With the end of the spawning period rapidly approaching, and the problems of finding fish of the right size and condition growing daily, an urgent request to the Wye River Authority brought a second consignment. Again nothing happened.

We were on our third group of fish when, for no obvious reason, one of the hens started to dig in earnest, throwing quite large stones up against the glass front of the tank with horrifying force. The cock fish began to show interest, coming alongside the female and making the shuddering movements consistent with courtship behaviour. But there were still problems. In the tank there were also a few male parr – young salmon, about fifteen centimetres long, that are mature enough to fertilize the eggs. The parr kept getting in the way of the big male which, understandably, got very fed up with the interference. Lunging at one of the young males, he grabbed it in his mouth and gave it a gentle squeeze before releasing it unharmed. But the parr heeded the warning.

Throughout this time we were able to make occasional use of a periscope specially designed for use in the tank. Because of the format of the long narrow tank, we rarely get a head- or tail-on view of a fish, and the periscope is particularly useful for this. It is supported from the top of the tank on castors, and can easily be moved along to the spot required. The use of a periscope can have an unexpected advantage, particularly with shoal fish, which are so fascinated by the sight of themselves in the mirror at the base of the apparatus that they frequently stop and pose in front of the camera. But the movement of the periscope and the presence of the cameraman above the tank can so easily disturb the subjects in the water below that it is used only sparingly for very special shots.

The salmon were becoming more active in the evenings, when there is less disturbance in the laboratories, and we began to take turns to watch into the early hours. At last, in mid December we succeeded in capturing salmon spawning on film. But that was not the end of the story. There is always a limited amount of time to film any action, and parts of it can be missed while changing the lens or the camera angle, or when the film runs out. We invariably have to try to repeat the whole sequence to get the bits we missed the first time around and to give the film editor a good choice of shots with which to work. So we had to film it all over again, with yet another group of fish, to get those all important 'cut-ins'.

The last footage on salmon spawning was completed on Christmas Eve, with John Paling, the cameraman on that occasion, in full evening dress, having come straight to the studios from seasonal festivities. At least that was a change from the wetsuit he had donned early in the filming to enter the tank and unblock a filter.

Our experiences with the salmon showed not only how differently individuals within a group may behave, but also the problems of persuading animals to perform. There are, of course, physical difficulties. For example, a salmon may simply not be ready to spawn.

OPPOSITE TOP Pike usually swallow their prey head first. This time its prey was a smaller pike and it grasped it tail first instead. This prey was lucky because it was disgorged a few minutes later. But I have watched a three-year-old pike, 45 cm long, successfully eat an 18 month old pike half its length. Digestion took five days by which time its stomach bulge had disappeared.
The continuous tungsten light used for the motion-picture sequence I had been taking was just bright enough for this still.

OPPOSITE BELOW Perch are very common shoal fish. Even though the rest of the shoal darted away as I approached the tank, this fish remained vertical and static and presumedly asleep. Many minutes passed while it made only very slight movement with its fins.

But while some animals settle down immediately in their new and, admittedly, strange environment, others never adapt. Perhaps, as with the human race, some can cope with stress more easily than others.

Cannibalism

We were once asked to film pike for a sequence on the natural history of gravel pits. I had several times seen a large pike attack a smaller members of its own species in the tank, and so decided that I would try to film this if the opportunity arose. One morning when I checked the tank, I noticed that a pike of around thirty centimetres long appeared to be stalking one that measured about eighteen centimetres. The camera was set up, but as soon as the lights went up, the fish were disturbed and all activity stopped. Once the lights were turned down, however, the stalking began again. This time the fish were so absorbed in their life-or-death drama that I was able to switch the lights up to full power.

The smaller fish backed slowly away from its would-be predator. By arching its spine, lowering its jaw and extending its gill covers, the smaller fish tried to make itself look big and ferocious. Suddenly the large pike struck and the victim was seized sideways across the body. After swimming around for several minutes, the captor began the difficult task of turning the helpless fish round to swallow it head first. The pike's vast array of small needle-like teeth point backwards and so make it easy to push something into its mouth, but almost impossible to pull it out. The fish was soon on its way down the other's throat, but after twenty minutes the captor's stomach was obviously full up, while the victim's tail was still sticking out of its mouth. By now, no doubt, the pike was regretting the fact that it had bitten off considerably more than it could chew. Whatever was going to be the outcome, it would obviously be too long a sequence to film, so I turned down the lights. The big pike went into a frenzy at this new disturbance and regurgitated the smaller fish, which then swam away. Badly slashed as it was, it survived this horrific experience and left me very frustrated at having missed such a wonderful shot.

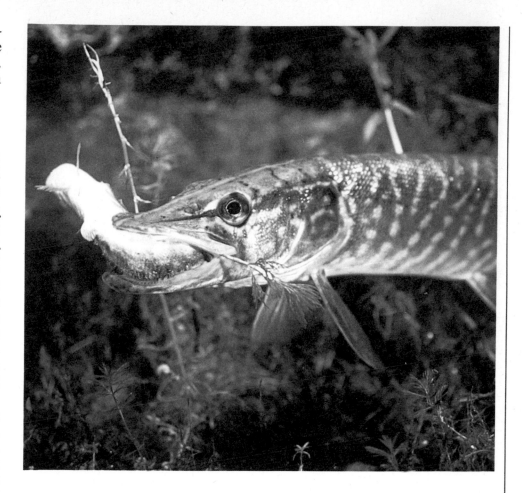

Fishy facts

One of the questions most frequently asked about fish is whether they feel pain — an emotive subject and one which causes considerable argument. A sixty centimetre pike had been in the big tank for some time and was quite familiar with its surroundings. One morning I noticed that it was lying in one corner of the tank with its side against the water heater, which is turned on to help keep up the temperature in winter. The fish was badly burned, the scar measuring about ten by two and a half centimetres, but it had made no attempt to move away from the cause. When it eventually did, its swimming action appeared unimpaired.

There is also the question of whether or not fish sleep. Obviously, since they have no eyelids they cannot close their eyes, but they do rest in a comatose state. I have observed a perch stationary in a vertical position, head

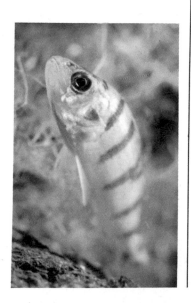

upwards and completely unaware of events going on around it for nearly half an hour.

On one occasion we had to film some underwater scenes of roach being caught. We obtained fifteen fish, all caught on a line from the same shoal, and so immediately had a problem — they would be shy of bait. For expert assistance with the sequence I called upon the services of a well-known local angler, Roger Danbury. A rod was essential to achieve a natural striking action, but only the top section could be used because of the lack of space between the top of the tank and the ceiling. So with the line tied through the rings to give some control over the maggot bait, our fisherman had to operate 'blind' from behind a screen, taking instructions from me to strike whenever a fish was about to take the bait. His fast reactions as an experienced angler paid off and he did not miss a bite. This was very important since any fish nicked but not taken would have

given off a chemical alarm signal that might have put the whole shoal off feeding for several days.

While filming these roach we were able to observe some interesting shoal behaviour. Usually the fish stayed together as a group; one fish would be the leader for a while, and then another would replace it. During this time, any movement by the leader was repeated by the others as they streamed off in pursuit, like a flock of sheep. As the shoal moved from one end of the tank to the other, a single fish would dart out and take or examine the bait before returning to the safety of the group, exhibiting, at the time, a remarkable ability to stop dead in mid-swim. It was interesting to see that the largest fish was caught first, then the second largest, and so on in descending order of size. This could have been a coincidence, but we caught a third of the shoal, and this pattern was maintained.

Roach are highly sought after by anglers because of the density of their shoals. This small group caught pointing in the same direction, were just about to dart off like a flock of sheep after their leader. They were filmed on gravel so that the top lighting would reflect off the gravel and highlight their bellies. This obviated the need for side lights which would have got in the way of the camera as it tracked the shoal as they moved up and down the tank.

Turtle traps

Besides man, expert fishermen are to be found elsewhere in the animal kingdom. The best known are probably the angler fish which sit motionless on the sea bed waving brightly coloured or glowing lures near or actually inside their capacious mouths. But a more unusual animal using such a snare is the alligator snapping turtle. Its home is the swampy waters of the southern states of North America where its long low profile provides perfect camouflage when lurking motionless in shady corners. It sits with its mouth wide open, and on its lower jaw is a red and fleshy protruberance which it wriggles. If a fish investigating the 'worm' comes in too close, the jaws slam shut.

We needed such a sequence to illustrate yet another of the strange methods used by animals to catch prey for the OSF American TV special *Death Trap*, narrated by master of horror Vincent Price.

John Cooke is a keen collector of interesting animals, and eighteen months earlier he had brought back a snapping turtle from Florida. It was then ten centimetres long. During its stay at the Burford Wildlife Park in Oxfordshire, it had grown to thirty centimetres. Even this comparatively small specimen —

they grow to seventy centimetres in the wild — is capable of doing severe damage to passing fingers. So we were extremely careful when cleaning its tank or manoeuvring it for filming. All our fingers remained intact although it obligingly performed the snapping sequence again and again on the small fish we proffered.

A tank of about 100 cm long and 50 cm wide decorated with leaves and branches simulated the murky waters in which this alligator snapping turtle normally lives. It is sitting in its characteristic posture, mouth agape, its fleshy 'bait' exposed.

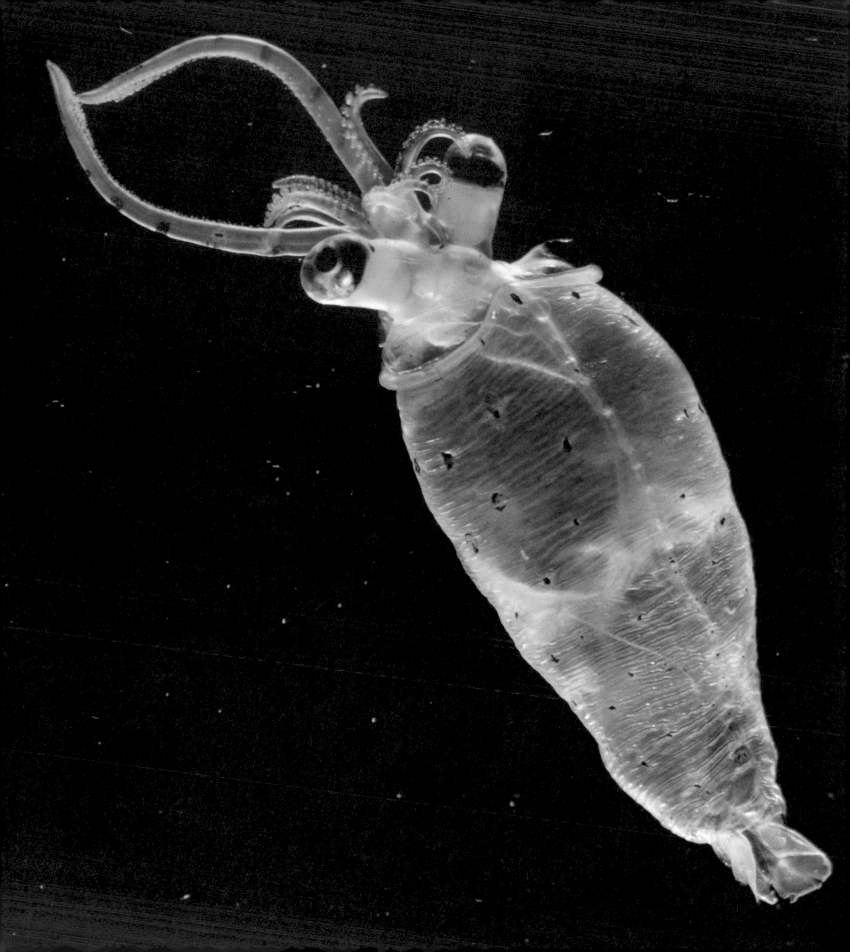

6 Sea animals of the deep

DAVID SHALE and PETER PARKS

The deep sea is probably the least understood environment on this earth. Three-quarters of the world's oceans are between 3,000 and 6,000 metres deep. Whereas Mount Everest reaches a mere 8,800 metres above sea level, the deepest ocean trench plunges to 11,500 metres. It is a vast and varied environment inhabited by few animals. Although there are twice as many animal species inhabiting the sea as there are on land, if one excludes the insects, only five per cent of these animals are found in the deep sea. In fact, the ocean as a whole does not team with life and the deep is probably one of the world's environments most devoid of life forms.

As light enters the ocean it is scattered and absorbed. All the ultraviolet light is absorbed in the first metre of depth. At ten metres most of the red light has been absorbed and all the light that remains is in the blue-green part of the spectrum. Only five per cent of the sunlight falling on the surface extends below fifty metres. The average depth to which the last vestiges of daylight reach is about a thousand metres. The water between five hundred and one thousand metres is aptly called the twilight zone and it is this zone which contains some of the most interesting animals.

A twilight world

Adaptations in the deep sea relate primarily to remaining unseen. The animals live in a world with only two boundaries, the sea bed and the surface, and the majority will never encounter either. There are no weeds to hide among or rock crevices to dart into. With the exceptions of reproduction and prey contact, the total avoidance of all other animals is the order for survival. Throughout the animal world, colours and shapes are adaptations for camouflage. In the deep, all groups of sea animals also exploit colour and light in ingenious ways.

The colour that any animal appears is actually the colour of the light reflected from its body. This, of course, relies on all the colours of the spectrum being available. Descend to five hundred metres and colour takes on a whole new look. Many of the crustaceans — prawns, shrimps and copepods — are red, a really vivid red, that in a terrestrial animal would be a dramatic warning colour. But no red component of daylight penetrates into the twilight of the ocean: no red can be reflected from their bodies and so they appear black — a perfect camouflage.

The major problem with deep-sea photography is not so much a technical one as one of accuracy and factual representation. Microscopic animals present no real problem apart from their size, but the larger animals do. Accuracy in lighting and surroundings for a large terrestrial subject is particularly important. In the same way that a tree frog photographed on a sandy bank looks out of place, an animal hauled up from the deep is bound not to be represented the way it really is. To obtain any degree of accuracy is extremely difficult and all we can do is to try to exemplify the special characteristics and adaptations of these animals.

Fish in the deep sea are masters of deceit when it comes to camouflage and the methods they use to counter it. For example, viewed from any angle in this dim world, the common hatchet fish, *Argyropelecus*, should not be visible. Exposed to full daylight or the harshness of flash it appears not unlike any ordinary fish, looking only slightly odd with its upturned jaw and upward-looking tubular eyes. But daylight betrays its method of deceit: a complex system of countershading, mirrors,

OPPOSITE The colouring of this cranchid squid is typical of many invertebrates living in the upper two hundred metres of the sea, just above the twilight zone. A translucent body is less visible in water in which there is light of many wavelengths.
This squid is about 4 cm long. Its eyes are large and situated on short stalks. The tail fin is small and probably used only to make minor adjustments to position.

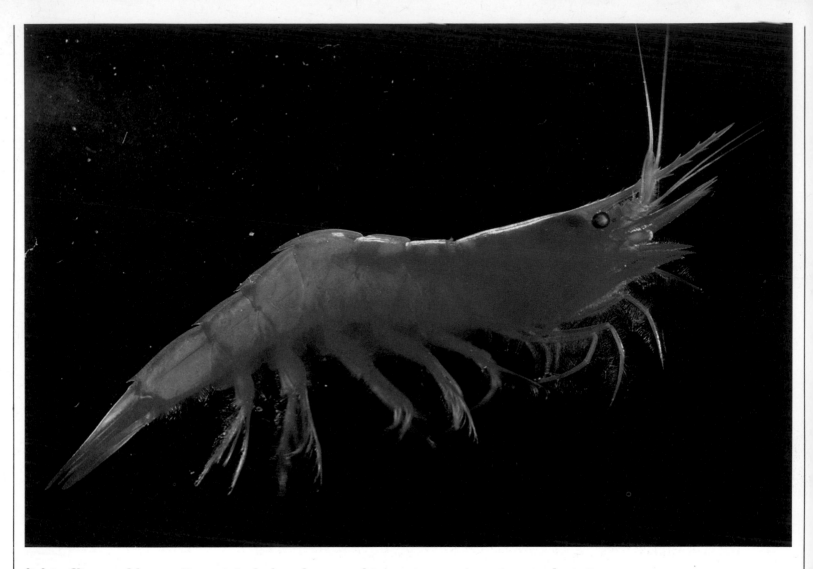

lights, filters and lenses. Its back is dark and the silvering on the sides is the result of an arrangement of small plates which, like a perfect front-surfaced mirror, reflects back any light falling on it. The arrangement of light-producing organs on the fish's belly is magnificent; arranged in two rows they produce light to balance exactly the intensity of the downwelling light. The filters in each light organ appear magenta in colour but back in the deep sea transmit light only in the blue-green part of the spectrum.

The hatchet fish is by no means unique in its use of light for camouflage. But fish also use light for display and species recognition. Some have lures to entice and capture prey while others use especially large light organs on the front of their heads as headlamps for searching out prey. An extreme adaptation of this type is found in a group of midwater rat-trap fish. These have light organs on their cheeks which produce red light. Using a red light and having eyes that are responsive to reflected red light, they can hunt in this dingy world searching out those succulent crustaceans, such as red prawns, euphausids and copepods, their prey unaware that its deceit was overcome — a cunning and underhand method of searching out prey.

Almost every group of deep sea animal has members that luminesce. Clouds of decoy light squirted out by copepods, prawns and squid allow them to escape from hunters. Rows of hundreds of spots of light along the sides of black fishes make them appear larger than they really are, and flashes from the

The first thing which is apparent about a deep sea trawl sample is the limited range of colours. The animals are black, muddy brown, transparent or vivid red. The prawns are the most striking of the red animals since they are large and are usually still alive despite being hauled from a depth of 500 m. This *Acanthephyra* was 7 cm long, but some deeper-living species reach 18 cm.

huge colonial salps, *Pyrosoma*, may act as signals of recognition between individuals. With all this light being produced by the animals themselves, one could easily get the impression that it is not a dark world at all.

The size for survival

In the upper layers of the oceans, the minute algae or phytoplankton provide ample food, and even the carnivore can course through fields of plenty. But below this lush harvest the animals have to survive on less. They are either carnivores or scavengers, or both — feeders of opportunity. Although large creatures do exist, the majority of animals are relatively small. Even the monsters of the deep are no longer than twenty five centimetres. The average viper fish, *Chauliodus*, is only eighteen to twenty centimetres long, rat-trap fish are only ten to thirteen centimetres and the amazing black angler fish are rarely over ten centimetres in length. But their common names seem menacing and perpetuate the myth that deep sea animals

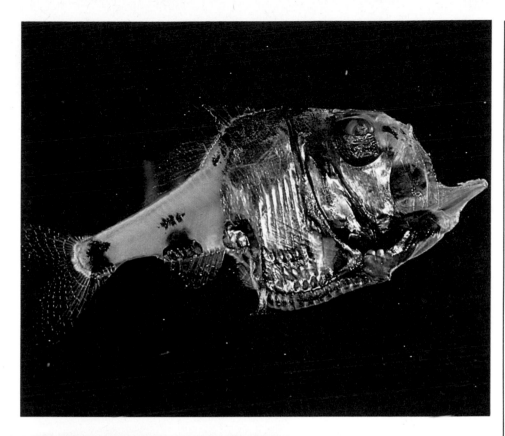

This peculiarly shaped fish is probably the most described deep sea species because of its strategy for camouflage.

ABOVE A side view of the hatchet fish shows its silvered flanks which act like mirrors and reflect any light thereby rendering the fish invisible.

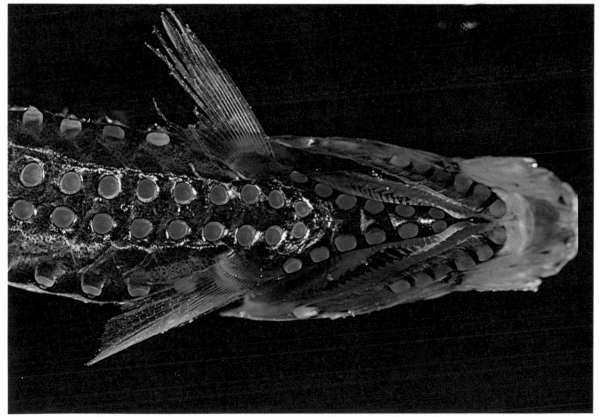

LEFT On the underside of the hatchet fish is an arrangement of light-producing organs, and the intensity of their emission is controlled by a feedback system. The upward-looking eyes detect the intensity of the remnants of daylight filtering from above and match the amount of light its body produces. Thus the silhouette against the light is destroyed. Only blue-green light passes through the magenta filters to the outside.

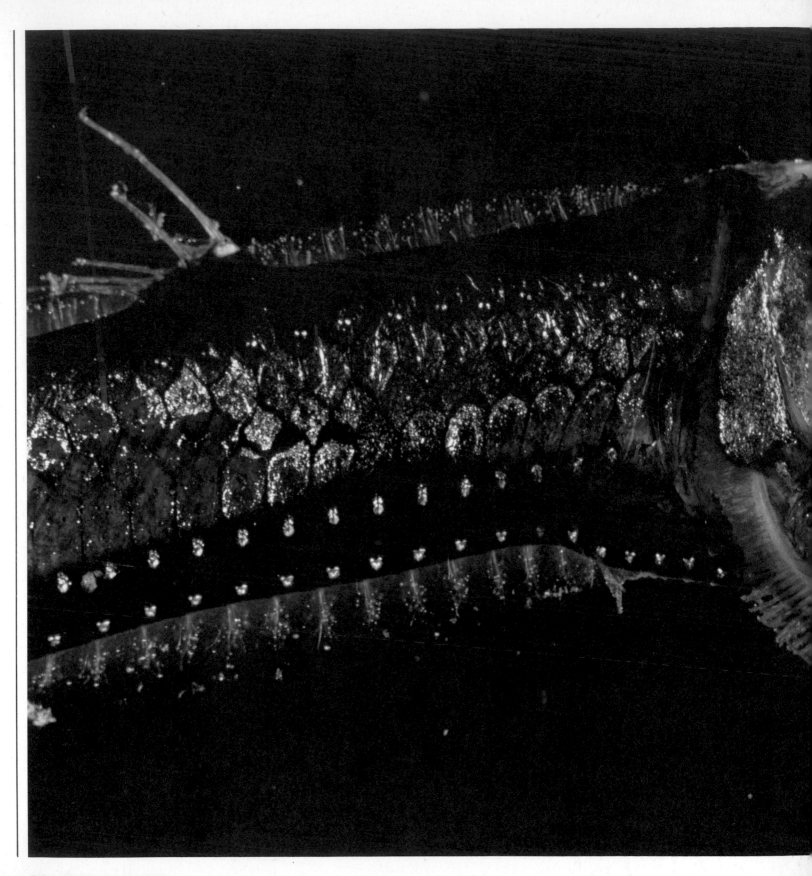

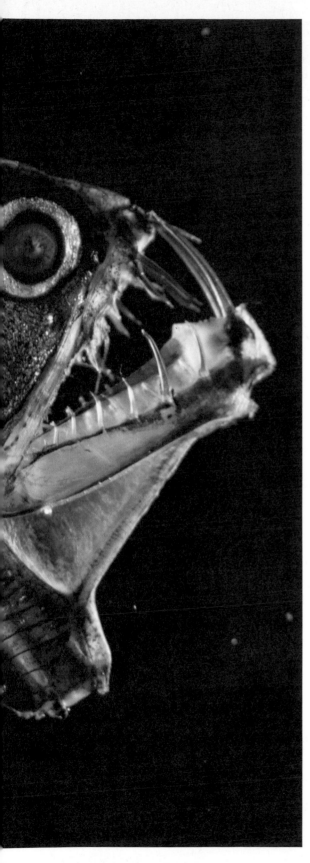

are large. The huge, needle-like recurved teeth and protrusile jaws are adaptations for survival. To eat is to survive, and to have the means to grasp and hang on to something, possibly larger than yourself, means that you can survive. These animals are not active, dashing about after food, wasting energy and valuable resources, especially since food is scarce. They probably just sit and wait. From a depth of five hundred metres the quantity of animals filtered by a net eight metres square would fill the average washing-up bowl, from one thousand metres there would be enough animals to fill a large jam jar and from three thousand metres hardly enough to fill a teacup. Distribute those animals in a volume the size of an aircraft hangar and it is easy to see how difficult it would be to find your next meal, communicate or mate.

The amazing array of organisms and their adaptations, many so bizarre that their functioning has only recently been understood, is hard to relate, especially in an area of biology that is only at a juvenile stage. If work is to be carried out first hand at sea, it has to be done on research vessels, such as RRS *Discovery*. To finance this type of research and keep vessels at sea is extremely expensive and can only be done with governmental assistance. Since costs are so high, there are no signs of expansion. Therefore the opportunity remains limited to a lucky few like myself, as an ex-member of the Institute of Oceanographical Studies, and Peter Parks as a guest on two cruises. The responsibility then falls on us to record these amazing animals on film, as Peter Parks goes on to describe.

Filming at sea

From a single deep-sea sample comes a host of extraordinary animals, so our work is cut out just recording the sample, let alone trying to do it photographic justice. One minute we may be trying to film an animal as black as the ace of spades, and the next, a creature positively 'dripping' in sequin-like reflective scales or so red that a postbox seems anaemic. The most challenging of all fish are those, like the amazing *Stomias*, that are bedecked with rows of beautiful light

The viper fish *Chauliodus* is a mere 30 cm long but is a formidable predator. Part of its dorsal fin is modified as a luminous lure which dangles in front of its mouth and attracts its prey. Food is rare, and so are the chances of escape. The upper jaw is protrusible and the lower jaw, armed with recurved fang-like teeth, can be dislocated to accommodate the largest meal.

organs. So once again the photographer and film maker have to be opportunists and to this end everything we prepared for the two filming trips on board *Discovery* was geared to coping with the unexpected.

It was for the first of the two trips that the first sophisticated version of the optical bench was prepared. The whole assembly was fitted with special cleats and bolts so that it could be lashed securely to the deck, and constructed in stainless steel and aluminium alloy to reduce to a minimum the eternal salt-water corrosion that takes place on any metallic surface at sea. We assembled a peculiar collection of glassware for use upon the bench: flat-bottomed dishes and curious perspex support podia that would make un- usual lighting approaches possible. To keep water temperatures below air temperatures, we constructed photographic tanks with accessory lateral chambers for ice storage.

Both trips entailed their own technical efforts. On the first we struggled to portray on 35 mm motion-picture film some of the amazing animals, such as the crustaceans *Phronima* and *Parapandulus*, we collected. It was the first time I had handled this particu- lar camera, and since I had no-one to refer to for advice, I suffered many a nerve-wracking hour trying to determine how to load it. Since a 120 metre roll of this film, which only runs for four and a half minutes, cost a great deal of money, both to buy and to process, I went to a lot of trouble not to use it carelessly. The second trip carried with it the challenge of filming bioluminescence, and this merits rather more attention.

Lights in the dark

David Shale has described how many oceanic creatures generate their own light. Biolumin- escence is an odd phenomenon, and it needs to be viewed in dark surroundings to get the best effect. So while my eyes were accommodating for low intensities by open- ing their irises, Dr Peter Herring, an expert marine biologist, was coaxing the animals to luminesce. By the time they were performing I would be convinced that the brilliance of emission was much greater than in reality it was. I just could not believe that the brilliantly

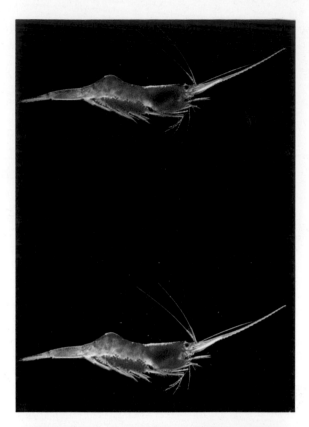
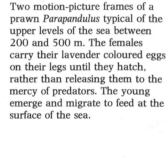

Two motion-picture frames of a prawn *Parapandulus* typical of the upper levels of the sea between 200 and 500 m. The females carry their lavender coloured eggs on their legs until they hatch, rather than releasing them to the mercy of predators. The young emerge and migrate to feed at the surface of the sea.

Bioluminescence in a bottom- living coral. The light produced by this Atlantic coral is emphasized by an image intensifier. The light may act as a warning to animals that brush against it.

glowing creature in front of me was not even able to lift the exposure meter needle off the zero point on its scale. I would shake the meter and wave it about in disbelief. But the fact is that most bioluminescent creatures produce very low intensity illumination.

To overcome this lack of light I used an 'Owl-Eye' image intensifier, a clever piece of electronic equipment that takes an image

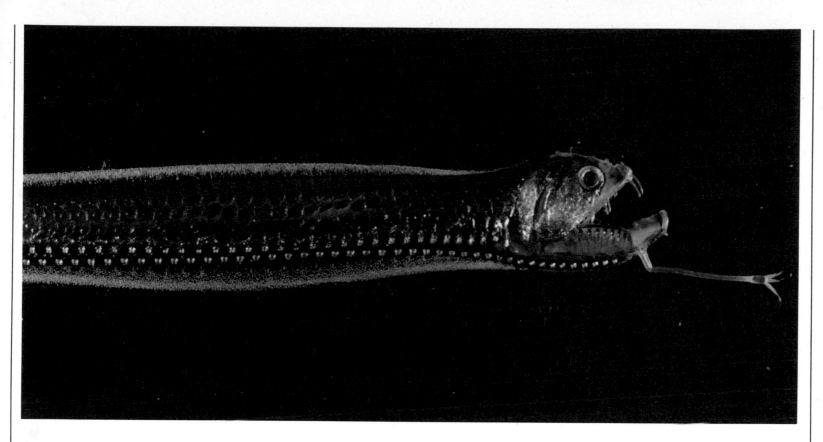

from a conventional lens and enhances it up to twenty thousand times. The 'Owl-Eye' does this in two stages: in so doing it conducts an intermediate image down fibre light guides to display it, further enhanced, ultimately upon a small 'television' screen from which it can be photographed by conventional means. For this reason, the resultant image is a mosaic picture. But even a poor-quality image was useful and interesting to me especially when I knew I was seeing light production behaviour otherwise invisible to the naked eye.

Thus we successfully filmed the beautiful light organ activity of the hatchet fish, *Argyropelecus*, luminescent brittlestars, glowing deep water corals, the ridiculous fish *Opisthoproctus* and the spectacular euphausid shrimp swarms that we frequently encountered setting alight the ship's wash.

But the majority of animals we encountered did not supply their own light. For these we used light sources that produced as little heat as possible. For this reason the lamps were low wattage, high intensity quartz iodide units which we had designed and built

a couple of years before with this sort of project in mind. The lighting systems were designed for attachment to the optical bench upon infinitely flexible yet rigid suspension arms (once flexed they could be locked into position). This meant that as long as the optical bench was lashed to the deck the lampheads would remain secure. Also, the light source could be introduced to the subject at peculiar angles and with such odd creatures as we encountered those angles of lighting were frequently unusual. Not even gales prevented our filming at high magnification when vibration problems are always at their most apparent. I should add that nothing makes one feel more sick than trying to look down a camera eyepiece while fighting to balance against all the instability that mother nature can muster, all in the stuffy bowels of an unstable research vessel. There was, though, one small bonus of working in rough weather: however free the camera system was from vibration, gravity always acted upon the water in the filming tank, so as the ship heeled and plunged, ripples would pass across the tank's surface. By angling one

The dragon fish *Stomias* is one of the more common fish living between 700 and 1,000 m. Very few deep sea fish are red, but their dark skins absorb the remaining blue-green light anyway. This fish's body is covered with a clear gelatinous tissue in which thousands of light-producing organs are embedded. By switching these on and off rapidly it can appear suddenly enlarged and haloed and so deter would-be predators.

The neuston net trawled ahead of the bow wave of RRS *Discovery*. The net slices off the top 10 cm of the ocean and during the day is used exclusively to sample that unique tropical oceanic fauna which is specially adapted to life on or under the air/sea interface. At night the composition of the surface fauna changes. Large numbers of deep-living animals migrate up to the surface, and we then use the neuston net to sample the riches of the deep.

BELOW The red-brown pigmentation of *Atolla* is typical of the colouring of deep water jellyfish. The luminescence, which is demonstrated by mechanical stimulation, may last up to two seconds, appears from the inner white ring and is directed upwards.

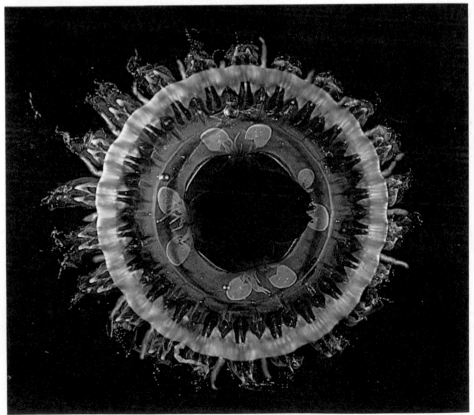

dominant lighting source through the top of the tank, the ripples on the water's surface produced an attractive dappled lighting effect. Even though no such dappling would occur at the depth that most of these animals live, it did enhance the feeling of their aquatic realm.

The most restricting factor in the filming of many deep-sea species is that, once caught within the trawl or even separated into filming tanks, their life expectancy is short. Some animals were dead by the time I had staggered from the sorting laboratory to the filming quarters. Others succumbed as soon as the fresh sea water warmed beneath the lights of the bench. And there were others that breathed their last while still three hundred metres beneath the waves.

Speed was therefore vital. Before each haul arrived on deck, all glassware had to be completely cleaned, set up and repaired. Cameras were always loaded, clerical records updated, mechanics lubricated, spent bulbs replaced and deck lashings checked, well before the call went out that the trawl was being brought on board. In spite of this concerted and con-

sistent preparation from day one to day twenty one of the cruises, I returned from each fully aware of just how much I had missed. Trawl damage had rendered many species useless; surface conditions had killed others; photographic inadequacies had failed to record several; lack of time and the inability to cope physically with others had wrested even more from the emulsions of permanent record. There would be times when I was all set to film animals less than eighteen centimetres long, and then I would try to cope with a sixty six centimetre snipe eel or a ninety centimetre squid. And just what was I supposed to do with four washing-up bowls brim full of jellyfish?

Deep-sea research in future years will certainly go some way towards overcoming these inadequacies. Both David Shale and I are sure though that it will be many years before we will really do photographic justice to these extraordinary creatures of the deeps. Only then will we start to appreciate just how they live and die in that most intangible of habitats.

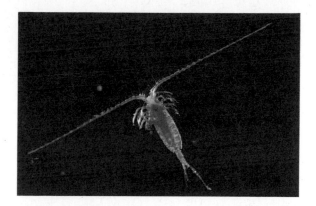

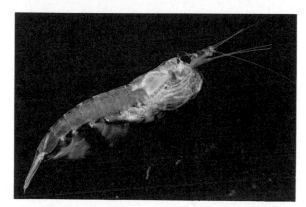

Copepods belong to a group of crustaceans which numerically may dominate trawl samples from 500 to 1,000 m. *Megacalanus* (*top*) is one of the larger forms, reaching 9 mm. The long antennae are extended outwards and probably prevent the animal from sinking too far by increasing its surface area. They are also covered with sensory hairs and help seek out food.
Euphausids are shrimp-like crustaceans and an important component of the food of baleen whales. *Meganyctiphanes* (*left*) is common in northern waters, and blue whales will dive to 300m to feed on them.

The deep-living snipe eel *Nemichthys* has peculiar jaws which diverge towards their tips. The many minute teeth along the sides may entangle the very long antennae of prawns. Unlike other deep-living fish, they are pale and have large eyes. What advantage this might have over being black and having light organs is not known.

7 Expeditions to the tropics

SEAN MORRIS and GERALD THOMPSON

When we mention to our friends that Oxford Scientific Films is off on its travels to the tropics, it is immediately obvious from the look of envy on their faces that their minds are filled with images of bronzed and smiling OSF cameramen relaxing in idyllic holiday brochure surroundings – palm-fringed, tropical beaches bedecked with scantly clad dusky maidens, or cool and verdant glades dripping with decorative butterflies and iridescent tropical birds, and redolent with the heavy scent of frangipani.

In reality nothing could be further from the truth. Many aspects of filming overseas are thoroughly unpleasant – the separation from home and family for months on end, the wear and tear of travel, the inevitable struggles with foreign bureaucracy over customs and work permits, and, particularly in the tropics, the risks to health from various diseases and parasites, and the occupational hazards conferred on the visitor by suicidal taxi-drivers, poisonous snakes and jungle fires. Moreover, so precious are the moments spent in the luxuriant embrace of the tropical environment, that we tend to work day and night from the first day to the last, returning to England suntanned but exhausted shadows of the band of film makers that first set forth.

That said, for a biologist the tropics hold an irresistible attraction. The sheer variety and concentrated density of life is breathtaking. Standing in a tropical rain forest you can actually feel the primeval forces of growth and decay at work, and almost hear the relentless throb of life itself.

The atmosphere is cathedral-like, lofty and serene, the silence broken by the occasional call of a bird or the rustle of a falling leaf. Ground vegetation is sparse because of lack of light. Some trees have great buttresses emerging from the bole near ground level to help prop up their bulk. Lianes hang down like ropes from high overhead, and peering upwards you can see that a host of epiphytic plants, such as bromeliads, orchids and ferns, adorn the branches in the tree crowns. It is high in the canopy, near the light, and where man has scarcely penetrated that the life of the tropical forest is most abundant. But this is not to say that there are no living things on the ground. Ants of various kinds are everywhere. Among the leaf litter cockroaches, crickets, millipedes and other denizens of the dark dampness are abundant. Here, the dead wood decays rapidly and provides food for various beetles and shelter for snakes.

Although the forest is green and dramatic in its signs of life and growth, there is a constant patter of falling leaves, fruits and seeds from the canopy above, as old life gives way to new. The tropical forest has its more tempestuous moods as well. During violent storms, the wind and rain can batter the vegetation to shreds, sending a torrent of whirling leaves and branches crashing to the forest floor. Trees groan and shudder, and the occasional giant, finally too old and infirm to withstand the cruel forces of nature, goes down before the wind, crushing an area of forest the size of two tennis courts.

The tropics are also full of surprises. Many of the creatures are unusual, bizarre or even rare, and every now and again it is possible to unearth an entirely new species, an event that gives a special thrill of its own.

In Jamaica, we were keen to film a group of rare and rather interesting creatures called velvet worms. At first glance, velvet worms are hardly crowd-pullers, but to the scientist they hold a peculiar fascination because their group has been described as the evolutionary 'missing link' between the annelid worms and the arthropods, the group to which

OPPOSITE The cloud forests of northern Venezuela are a naturalist's paradise. Humid but relatively cool, they teem with an indescribable profusion of wildlife. The tall forest trees, competing for light, strain ever upwards and are covered in lichens, orchids and epiphytic bromeliads. Their crowns, sewn together by a tangle of lianes and creepers, form a continuous green canopy like a cathedral roof high above the forest floor. It is in this strange aerial canopy that the greatest abundance of forest plants and animals occur, but it is a habitat seldom visited by man.

spiders, insects and crustaceans all belong.

The first velvet worm was discovered in Jamaica in 1825, but very few had since come to light despite the vigorous efforts of various learned scientists. The chances of our discovering any specimens seemed, therefore, extremely slight but that only made the challenge all the more irresistible.

Following advice from the resident zoologists, we searched for velvet worms in the forests of the Blue Mountains, turning over dead logs and rummaging through leaf litter. But these efforts were in vain. At a council of war, we decided on an unconventional approach which would take us to the John Crow Mountains, a wetter and wilder region at the eastern end of Jamaica. Although it was not 'recommended' velvet worm country we had a hunch that the trip would be successful. Anyway, we wanted an excuse to visit the John Crows.

One morning, John Cooke and I [Sean Morris] set off in the expedition jeep. Three hours later we arrived at the John Crows, sunburnt, covered in dust and sweat, and tingling

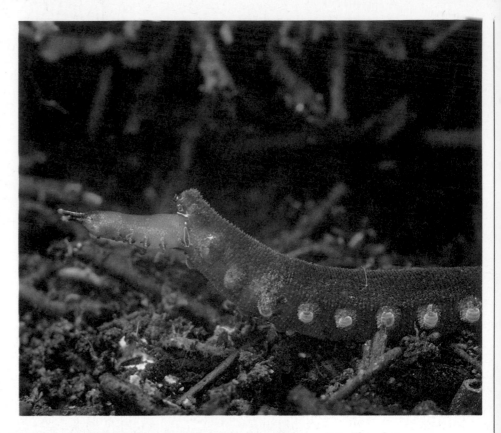

ABOVE The velvet worms or Onychophora have long fascinated zoologists because they combine the characteristics of both worms and arthropods and have been regarded by some as an evolutionary missing link. This female *Macroperipatus insularis* from Jamaica is in the process of giving birth to live young. This occurs regularly at intervals of several days. Velvet worms are widely distributed in the tropics and the southern hemisphere. Although usually associated with warm moist habitats, some species occur in areas which are covered by snow for four or five months of the year.

Although the majority of crabs live in the sea, a number of species have invaded freshwater habitats. In Jamaica, freshwater grapsid crabs live in mountain streams, in caves and even in little pools of water collected within the leaves of epiphytic bromeliads. During our searches for velvet worms, we discovered an unknown species beneath a boulder high in the John Crow Mountains of eastern Jamaica. In honour of its discoverer, it was eventually described under the name *Sesarma cookei*.

with anticipation. After two hours of fruitless searching we were beginning to feel despondent. It seemed that perhaps we should try a change of tactics, and so we began dismantling the rotting stumps of dead tree ferns. Both of us worked enthusiastically, each one wishing to be the first to find our prize. I was in luck because my third stump yielded a small velvet worm of the species *Peripatus jamaicensis*. Delighted and triumphant, I yelled the news to John. Spurred on by the smell of success, we continued our search, and by mid-afternoon we had gathered nine of these rare and elusive creatures — five *P. jamaicensis* and four *Macroperipatus insularis*. We were both filthy, worn out and covered in insect bites, but we glowed with pride. Although I had the pleasure of making the first discovery of the day, John eventually made the second and even more exciting one. On our way back to the jeep, John's natural curiosity, so vital a character for a good field naturalist, tempted him to lever up a large boulder on the edge of the forest. Under it he found a crab. How strange, since we were twenty five kilometres from the sea and several kilometres from the nearest fresh water. John photographed it and eventually brought it back to England preserved in formalin. The British Museum confirmed his suspicions that it was a species new to science and called it *Sesarma cookei* in honour of its collector.

Base camp

Whenever possible, OSF sets up its filming base or camp in the bush. With a mountain of equipment that ranges from balls of string and lumps of plasticine to delicate tape-recorders and cameras, the ideal accommodation is an enormous building which is not only dry, well-ventilated, with a reliable supply of electricity, running water, cooking and washing facilities, but also surrounded by rich tropical forest and as far from the destructive influence of other human habitation as possible.

We were to find just such an unlikely combination of features in Simla, our headquarters in Trinidad, though at night the electricity supply was apt to be interrupted

without warning and at frequent intervals. Each blackout would result in a wave of chaos spreading through the building as various members of the team were cut short in the crucial phase of filming a pair of spiders mating, or recording the courtship song of a tree-frog, or while attending to an equally important but less photogenic call of nature. Perhaps a more sinister disadvantage of Simla, and one we discovered only in the final days of our fourteen week visit, was a serious defect in its water supply. While investigating the settling tank for leaks and

LEFT After three weeks in the Trinidad customs, our 36 crates finally arrived at Simla, our jungle headquarters, under an armed guard! Although we are all biologists, our unique approach to wildlife photography is largely based upon specialized equipment which must travel with us on our expeditions.
During this frustrating period, we explored Trinidad for suitable locations and subjects for photography.

BELOW The sitting room soon became crammed with filming sets and animals. A ginger flower sits behind the bench seat. Behind and to the right is John Cooke's stills set, while beyond is a section of tonka bean tree on which lived one of our tarantulas. Gerald looks for an escaped lizard!

blockages after an interruption in the supply, we found a colony of bats roosting in the roof covering the tank. The water supply was supposedly protected by a fine metal screen from invasion by all forms of organic matter, dead or alive, but the bats had discovered a ten centimetre gash made, perhaps, by a falling branch one storm-lashed night, and had established a sizeable roost directly over the main tank. Unknown to us, our drinking water had been contaminated by liberal quantities of bat faeces and urine, carrying with it the serious risk of rabies and various unpleasant and possibly fatal infections of the liver and blood. I am pleased to report however, that at the time of writing, my colleagues and I are in excellent health.

I doubt whether even a foreknowledge of this slight flaw in the facilities would have deterred us from accepting the offer of Simla from its owners. Situated on the southern slopes of Trinidad's Northern Range, at an elevation of 300 metres, Simla is a biologist's paradise compared to the sultry and oppressive bustle of Port of Spain, Trinidad's capital.

Formerly a well-equipped and industrious tropical research station, Simla had been standing empty for three years before our arrival in 1974. Built earlier in the century as a cool, forest retreat for the colonial governor of the day, it had in its three years of solitude been over-run by the surrounding jungle. The protective fly screens had become rotten and torn, affording access to bats, snakes, lizards, rodents and an army of insects and spiders. Vines and roots had grown into the building through the gaps under the doors. The floors were a tangle of vegetation, living on a mulch of dead leaves and bat droppings. The baths and lavatories were cluttered with the corpses of intruders. Outside, the fabric of the main building and various insect cages, orchid houses and animal pens had been engulfed by the destructive appetite of termites, lichens and moulds. The ponds and water-tanks were clogged with plants and rotting leaves, the garden paths lost in a tangle of vines and seedling trees. The panoramic views of the forest-clad Northern Range and the more arid central plain had been blotted out by a solid wall of vegetation. Not a description to excite the hearts of the average home-seeker. But to OSF, Simla was close to heaven.

We have not always been so fortunate. In Jamaica, our headquarters were on the university campus, more civilized and nearer to laboratory facilities, but a long and tortuous drive from the cloud forests that capped the Blue Mountains. In Costa Rica we stayed in various cheap and cheerful hotels, the very baseline of existence for the biologist-cameraman.

Whatever the status of the home comforts, it is the filming that counts, and the problems of filming are much the same wherever you are in the tropics: rain, humidity, high temperatures and the particular problems associated with night photography.

Coping with the rain

Most tropical locations have marked wet and dry seasons, though the exact timing is apt to vary from year to year by a few weeks, and a wet dry season may be indistinguishable from a normal wet season, and vice versa. You have to trust to luck. Our visit to Trinidad, timed to coincide with the dry season, turned out to be one of the wettest dry seasons on record, with rain on ninety five of the one hundred days we were in residence in Simla.

While filming indoors on sets, rain presents no problem, though collecting animals and background vegetation can be a soggy business. But for those sitting out in the open with a heavy load of delicate camera gear, a sudden storm can bring instant and total confusion. In the tropics, storms arrive suddenly. The sky may be predominantly blue, with white puffy clouds scudding by before the wind — pleasant filming conditions and no cause for concern. The only warning of bedlam is a faint and distant rumbling, accompanied by a cessation of the normal chorus of chirrups and bleeps as birds and insects head for cover, then a rapidly rising crescendo culminating in a crashing roar as the rain storm strikes. Water flies in all directions. As much comes upwards, in ricochet from ground and vegetation, as downwards. Anything caught in the open through ineptitude or misfortune is soaked

within seconds. From the first subliminal hint of misfortune to total immersion may take as little as thirty seconds.

This occurrence was part of my daily routine in Trinidad. I was filming an émerald hummingbird which had decided to build a nest on the end of a slender bamboo shoot overhanging the Guanapo river. The river was clear and shallow, and ran between banks of tangled secondary forest and abandoned plantation high up in the foothills of the Northern Range. The river, which swelled to a raging brown torrent during the wet season, had thrown up pleasant shingled banks and it was on one of these banks that I chose to set up my camera. The surroundings could hardly have been more pleasant. Butterflies flitted from flower to flower,

LEFT The Jamaican tody is one of five species of a family found exclusively in the West Indies. This wren-sized bird catches insects on the wing; its peculiarly flattened bill has fine serrations along the edges, a special adaptation for insect gathering. This one was taking food to its nestlings in a roadside nest high up in the Blue Mountains. Days later we found its nest empty and in chaos — the work of small boys.

BELOW Two fledgling common emerald hummingbirds bulge out of a nest the size of an egg cup carefully woven and held together with spiders' webs and camouflaged with tiny flakes of lichen. The young are fed on a soup of regurgitated nectar and half-digested insects, and are fully fledged at 20 days.

dragonflies and damselflies hawked up and down over the water's surface, colourful tanagers and manakins hopped about in search of insects, while the occasional turkey vulture circled lazily above on the warm currents of rising air. The only drawback was the army of blackflies intent on extracting the last drop of blood from every square centimetre of exposed human flesh.

The female emerald hummingbird had chosen an exposed site for her nest. Visible from all sides and from above, its only concession to camouflage was a construction of spiders' webs and flakes of lichen that blended into the mottled background. Had it been any other type of bird I would have been forced to build a hide or blind from which to film the bird at her nest. But for hummingbirds, no such subtleties are required. They are blessed with such a brazen, self-confident and aggressive nature that a cautious and stealthy observer can stand within a metre of a nest without interrupting the bird's activities. Accordingly, my camera was set up in the open on a shingled bank

about a metre from the nest, surrounded by the usual photographer's impedimenta — camera-cases, spare lenses, filters, magazines, boxes of film, tubes of insect repellent, a vacuum flask and a cutlass. I was standing with my eye to the camera, intent and motionless, when the first storm struck. For a moment I stood in disarray wondering which of the several pieces of precious equipment around me should be saved first. During those four seconds of deliberation everything was drenched. For two minutes I splashed about in frantic confusion, dismantling camera gear and shoving it into aluminium cases. As the last battery cable was being poked into safety, the storm ended as abruptly as it had begun. The sun shone with a sudden, piercing brilliance, and I was left standing, bedraggled and steaming, to collect my thoughts.

During the next few weeks, I learned to gauge the onset of a storm from slight changes in the air temperature, from the behaviour of the birds and from the faint roar of its approach. I constructed banana-leaf umbrellas for my camera and myself, and in the

This Trinidadian tree frog, *Hyla crepitans*, is found along the foothills of the Northern Range, on low bushes and trees in open country. Most frogs prefer damp shaded habitats but *H. crepitans* is remarkable for its ability to resist desiccation even in the direct heat of the sun. Associated with this is the ability to change colour. At night the active frogs are golden brown but by day they may be found lying fully exposed on plants and a pale greyish white.

end I lost count of the number of times I dismantled and set up my equipment. Throughout this protracted comedy, the hummingbird remained unperturbed, sitting tight on her two raisin-sized eggs through the storms and keeping them shaded during the blistering intervals. For two weeks we shared the changing fortunes of the Guanapo river, and eventually my camera was a finger's length from her nest without causing her concern.

One morning I splashed up the river to resume my daily vigil to find the nest battered and empty. I shook my fist at the tyrant flycatcher sitting on his perch atop the tallest bamboo stem. He and his mate had a nest in the vicinity and he knew this stretch of the Guanapo even better than I. Perhaps he had spotted the emerald's nest days ago and had been waiting for the eggs to hatch before taking his rightful share of nature's bounty. I found myself angry and frustrated that the emerald and I had toiled so resolutely, only to have our prizes snatched from us – from the emerald her precious brood and from me the complete sequence of nest-building, egg-laying and fledging of the young. Then, putting my emotions aside, I realized I had been witness to a vital but tiny chapter in nature's endless saga, in which the sharp eye of the predator punishes the unwary or foolhardy victim, thus ensuring that only the most fitting individuals succeed in the struggle for survival.

I turned my attentions to other film topics and managed to complete my story by filming the fledging of young from another nest. Not ideal, but the film survived its setback. The emerald hummingbird was more fortunate: she built another nest without delay, this time cunningly concealed on a citrus branch not ten metres from the ill-fated bamboo tenement, and successfully raised her second brood.

High humidity

Even when it is not actually raining, the tropics tend to be hot and sticky. Of general discomfort to the human body, somewhat relieved by wearing lightweight or scanty clothing, high humidity can wreak havoc

with cameras, lenses and electronic equipment. The water vapour finds its way between the elements of complex zoom lenses and there forms condensation on the glass surfaces. The view through a lens in this condition can be most attractively surrealistic, the whole scene being suffused with a romantic misty quality, the sort of effect that cameramen sometimes go to great lengths to achieve with filters and greased plates of glass. But to have a lens suddenly steam up in the middle of filming a sequence of tarantulas mating is a real nuisance and brings the operation to a temporary halt while the afflicted lens is warmed over a fire to drive off the condensation.

The problem may be more serious than a few droplets of moisture. If lenses are left in warm damp conditions for long enough, microscopic fungal spores find their way into the airgaps between the glass elements, germinate and start to grow on the lens surfaces, devouring the coating chemicals and even etching into the glass itself. A lens invaded in this way is useless.

But you learn not to be too hasty with your diagnosis. One evening in Trinidad we were filming an extraordinary net-throwing spider, *Dinopis*, when Gerald Thompson complained that his lens was suffering from condensation. Gerald is by some years the most senior member of the group, and his diagnosis drew from

Cook's tree boa, or cascabel as it is called in Trinidad, spends the day coiled up on a tree branch overhanging water. It becomes active in late afternoon, feeding on birds and small mammals. It is often thought to be poisonous because of its fierce disposition and readiness to bite but, like other boas, it is harmless. Nevertheless, the bite is deep and painful because the cascabel has exceptionally long teeth – an adaptation that enables it to bite through feathers.

the rest of us the usual ribald and light-hearted comments about senility, and insinuations about the sharpness of his eyesight. Gerald protested loudly but to no avail. Our good-natured banter continued. The lens was duly inspected, and the back element found to be completely clouded over. Feeling somewhat contrite, John Cooke offered to dry the lens, an appropriate act as it turned out, John being one of the world's leading authorities on spiders. He found that the culprit was not condensation at all, but a minute spider that had woven a delicate web of silk across the back of Gerald's lens. I often think of that tiny spider, resolutely spinning its web in the hope of catching a midge, not realizing that its efforts would bring a £50,000 expedition to a complete standstill.

Too hot to handle

The incessant and untimely rain that dogged our dry season visit to Trinidad can sometimes fail to appear in the wet season when it is supposed to fall. The results can be equally catastrophic, as we found during our expedition to Jamaica in 1967. Again we had timed our arrival to coincide with the beginning of the dry season. On arrival we found the land to be parched and brown, the streams and rivers dry, the lakes great pans of baked mud, the insect life virtually absent. We were horrified. The rains had totally failed in the wet season and now with the onset of the really hot weather the countryside was facing disaster. Far from suffering from rainfall and humidity as we had feared, our band of pink-fleshed biologists from Oxford had to contend with searing heat. Cameras, finished in the usual matt black paint, became too hot to touch if exposed to the sun and, fearful that the film would be damaged, we constructed makeshift sunshades when filming in the field.

The hottest place in Jamaica was the old cemetery outside Port Royal which was covered in sand that by midday became unbearably hot to exposed knees and bare hands. The gravestones were mostly to the memory of British soldiers from the Port Royal Garrison and some wives, who had died of yellow fever in the nineteenth century. Carpenter

bees nested in a dead tree; the huge violet-black females flew in and out of entrance holes two and a half centimetres in diameter. Inside the tunnels, the occasional ginger-coloured male could be glimpsed. Now and then a male would back partway out of an entrance and squirt excreta into space. The solitary spreading shade tree contained a large round termite nest and on the shaded ground beneath, innumerable ant lion larvae waited in their pits to catch unwary ants. Apart from these signs of life the cemetery seemed deserted as it baked under the pitiless sun. Gerald Thompson and I were walking among the graves reading the inscriptions when suddenly a bird rose and flew swiftly away on scimitar wings. The white wing bars showed that it was the common nighthawk, a species of nightjar. Suspecting that it was nesting somewhere on the ground, we retired behind the perimeter wall and kept watch. Without delay the bird returned, landed on the ground and ran forward about three metres before squatting down in the centre of a grave. The exact position was noted; the

This nightjar sat in the blazing tropical sun, shading its solitary egg, which would have cooked if left unattended. To cool itself, the bird panted like a dog, fanning its throat membrane continuously to draw air in and out of its mouth. Nightjars are also known as goatsuckers, a name derived from the erroneous belief that these birds sucked milk from goats' udders. This stems from the birds' habit of sitting on the ground with their cavernous mouths agape. Actually the gape and the 'bristles' around their faces help them to catch flying insects such as beetles and moths as they hawk at dusk. The Jamaican name for them is 'gimme-me-bit' after the call they make while hunting on the wing.

bird had settled down just in front of the shadow of the cross. We walked slowly to within two metres of the grave before the bird flew off again. The grave had a scattering of small stones, and it was only after some hard looking that we saw that one of the stones was in fact a solitary egg. Knowing that the egg would be killed by the heat if the bird was not allowed to return, we decided to come back next day, equipped with still and motion-picture cameras. On the next visit Gerald took the precaution of wearing long trousers, ready for a long crawl on the burning sand. Before entering the cemetery we inspected the grave from a distance of twenty metres. There was no sign of the bird. Had she deserted? But through binoculars we could see that the nightjar was indeed sitting on her egg. The camouflage was so perfect that if we looked away and then back at the bird we would again be unable to see her. With cameras at the ready we moved slowly over the sand, keeping as low a profile as possible thereby reducing the likelihood of alarming the bird. At intervals we exposed

film to obtain various field sizes. Eventually I approached to within two metres, and at that distance the nightjar's head filled the screen. The bird watched us all the time but through eyes reduced to a narrow slit. An animal's eye attracts attention when the body is camouflaged and the nightjar reduces this hazard to a minimum. In the hope of filming the baby we returned two weeks later but there was neither egg nor young; a predator had passed that way.

The drought made our task of making three wildlife films for the BBC *The World About Us* series that much harder, as many of the colourful and dramatic insects we had hoped to find had become so scarce that we never even found them. Our moth-trap, which would normally have produced a feast of moths and beetles each night, was hardly worth putting up so paltry was its catch.

The drought in Jamaica did bring its benefits in terms of dramatic situations that would normally not have occured. In an arid, limestone region between Spanish Town and the coast, there was a wide, shallow lake,

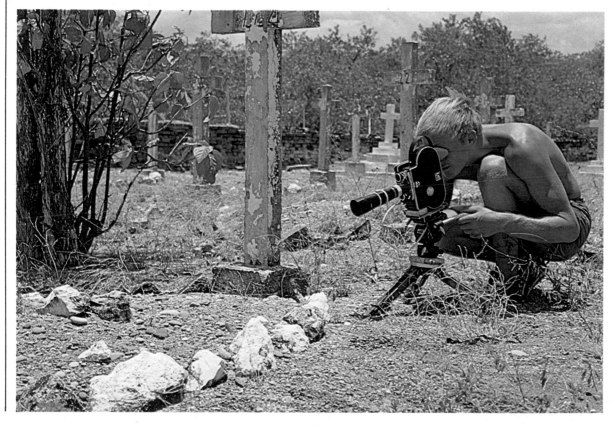

Not many birds would have sat tight while this blatantly uncamouflaged photographer, Sean Morris, inched his way over open ground to within one metre of the nest. But the nightjar's prime defence is in its beautifully camouflaged plumage, and so effectively does it blend with its surroundings that you can walk within centimetres of a sitting bird and never spot it. But the bird must also remain motionless. Its camouflage is therefore a combination of structure and behaviour.

perhaps two square kilometres in area and normally about a metre in depth. Fed by streams from the surrounding cattle-ranching area, the water was rich in organic materials and normally supported a teeming population of fish. The failure of the wet-season rains had robbed the lake of its annual input of water and, towards the end of our visit, word reached us that the lake was drying up. We decided to investigate. The scene that unfolded as we approached the lake was dramatic. The aroma of rotting fish was evident from a couple of kilometres away. As we drove nearer the stench became over-powering. Save for a small area at the far end, the lake had dried up completely. Innumer-able tilapia, the most abundant fish, had perished. Their bleached and rotting remains carpeted the dried and cracked mud. As we crunched over the lake bed, millions of fishy eyeballs stared up at us from their dusty sockets and the noise of our progress, as if walking on a layer of crisp breakfast cereal, echoed from the limestone hills that shim-mered in the heat around the margins of the lake. Turkey vultures hopped awkwardly about, searching for remains fresh enough and large enough to be worth eating, while others circled lazily above, their broad brown wings stretched wide to catch the currents of hot and putrid air that welled upwards.

At the far end of the lake, the last few litres of water were seething with desperate tilapia gulping air from the frothy surface. Flocks of egrets and a scattering of herons were making an easy meal, standing shank-deep in a muddy broth of dead and dying fish.

We squelched through the shallows and set up our cameras in the mouth of a cavern that sloped up from the lakeside into the limestone bluff; from this angle we had a good view of the egrets when they returned to feed. A slight ripple on the water attracted our attention. The ripple moved slowly across the entrance to the cavern, gradually becom-ing transformed into a long, ridged, log-like structure as the back of a four and a half metre alligator broke the surface. The alligator made its way to a patch of shaded water where it lay for the rest of the afternoon, occasionally munching freshwater turtles with the noise of someone smashing coconuts with a mallet.

Thoroughly shaken by our narrow escape we gingerly threaded our way out into the evening light and back to the van. On return-ing to the spot a week later we found that the last of the water and all signs of life had dis-appeared. No fish. No birds. No alligator — its massive frame destined for the pot, no doubt, and its hide for the tourist markets of Kingston.

Night work

To catch the forest in its most fascinating mood, the biologist must venture out at night, because it is then that the forest comes alive. It is as if a curtain is raised to reveal a new and thronging cast on a stage that rapidly dims to blackness.

The air is filled with the shrill song of bush-crickets and the bleeps and croaks of assorted frogs. Moths and bats are on the wing, and snakes and larger animals leave their shelter to search for food. The torchlight is reflected in a pair of eyes as an opossum looks up from its meal. Bushes, which in the daytime appeared empty, are seen to be alive with leaf-eating insects. To walk in a tropical forest at night is one of the most exhilarating experiences on earth.

RIGHT Spiders, like insects, have a tough external cuticle which serves both as skeleton and as protection. When the spider grows, however, the cuticle must be shed periodically, leaving its owner temporarily helpless and vulnerable. By moulting under cover of darkness this huntsman or giant crab spider is less likely to be attacked by predators as it hangs motionless on a silken thread beneath its cast cuticle, waiting for its new skin to harden and darken.

BELOW As soon as darkness falls the forest comes alive. The raucous calls of *Hyla maxima*, the largest of Trinidad's tree frogs, whose females grow to 115 mm, contribute to the deafening night chorus. In this picture, the throat is inflated during the call.

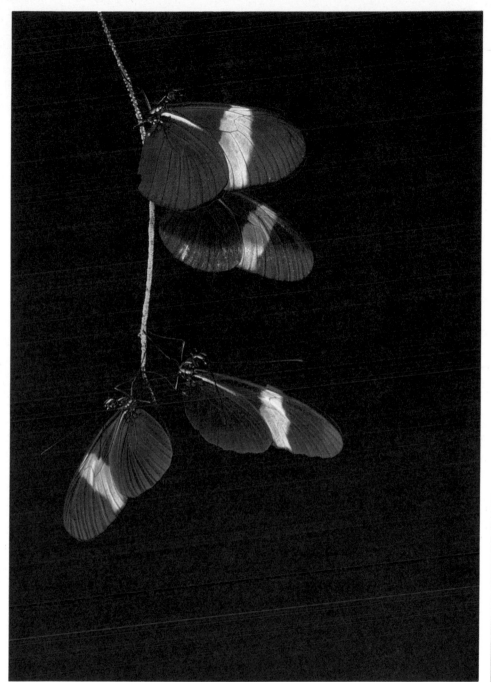

Attractive as they are, the tourist beaches and the down-town night-spots are no match for the teeming life of the rain forest, where the night music has, to me, a more subtle and irresistible texture than even the most sensual and provocative of calypsos. But after a hard day's slog in the tropical sun it is not always easy to spring eagerly from your wicker chair, leave the iced cocktail behind, and tramp out into the gloaming weighed down with lights, generator, cables, cameras and all the peculiar equipment needed for filming in the tropics at night.

For night filming brings with it its own particular problems. Animals that are active in the dark do not always take kindly to two thousand watts of sudden illumination, let alone to the throbbing of a generator and the general disturbance caused by a team of biologists blundering about by torchlight. Frogs, which make up the most voluble component of the night chorus, can usually be relied upon to shut up shop at the slightest disturbance. They produce their bleeps and whistles in a most dramatic manner, by inflating air sacs under the throat or along the flanks. Great stealth on the part of the photographer, and a fair degree of cooperation by the subject itself, are needed to capture the display on film.

Animals with good eyesight, like frogs and small mammals, are most readily disturbed by lights, but there are other denizens of the dark which rely more on their senses of smell and touch, and have poorly developed eyes.

ABOVE By day the Trinidadian butterfly, *Heliconius erato*, is strongly territorial and relies on its bright coloration and distastefulness to deter predators. At night they change their strategy. By clustering on a single thin stem, often beneath an overhanging bank, they gain mutual protection from potential predators.

Many ants fall into this category. Indeed, some species are completely blind and I always find myself astounded by the complex and ordered activities of a colony of army ants, *Eciton burchelli*, with not a seeing eye amongst them. They live in a world of total blackness and carry out all their functions of communication, feeding, hunting, brood rearing and navigation by means of a tapestry of scents. Apart from the very real risk of falling victim to the colony's insatiable appetite for animal food, filming army ants presents no particular problem.

Leaf-cutter ants, on the other hand, have well-developed eyes, though they are active day or night. The long trails of workers returning home each carrying a segment of leaf or flower above their heads, is one of the forest's most dramatic scenes and an obvious target for our cameras. To film a nest it was necessary to find one within easy access because this was a project where the petrol-driven generator, which weighs a hundred kilograms, would be required to power the lamps. Luckily the Trinidadians knew of a nest only

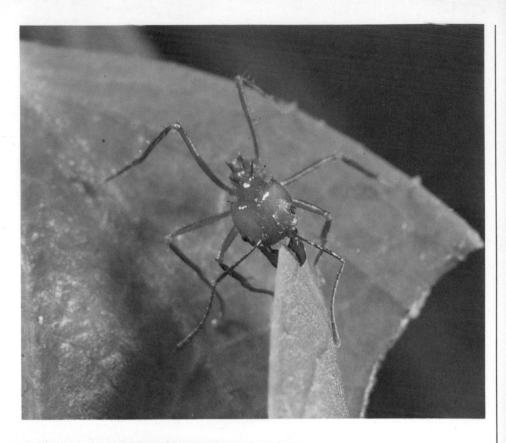

ABOVE Leaf-cutter or parasol ants are common in the forests of the New World tropics, where they defoliate many kinds of tree and shrub. This *Atta cephalotes* has just cut a disc of leaf with its sharp, powerful jaws and is about to carry it back to the nest. In fact this individual belonged to a captive colony and was photographed going about its business in the comfort of the studio.

These New World army ants, *Eciton burchelli*, are less formidable than their African cousins and confine their diet to arthropods. Raiding parties fan out across the forest floor, attacking every insect and spider encountered. The ants in this picture are returning to the temporary nest site or bivouac bearing fragments of prey. A large soldier ant is carrying the back end of a cricket whose prominent ovipositor resembles a steel pin.

100 metres off a road from which it was completely screened by trees. A daytime visit showed an area of bare ground about eight metres square with several entrance holes from which radiated well-beaten trails twelve centimetres wide leading into the surrounding forest. Nothing stirred; not an ant was to be seen. Each nest is a diffuse structure of cells and connecting passages extending down several metres beneath the ground. In hard ground a large nest requires a bulldozer to reveal its underground structure. We decided that activity above ground would be filmed in the forest, and the more intimate underground shots of the queen and workers, larvae and fungus gardens would be filmed at Simla using a very young nest sandwiched between plates of glass. The queen, at twenty five millimetres long, is vast compared to her workers, which themselves vary a lot in size down to minute individuals, some only three millimetres long. The soldiers are about half the size of the queen with very large heads and jaws; their duty is to guard the workers when they leave the nest and to inspect arrivals at the entrance.

Returning soon after dark the generator was started and the lamps revealed to us a scene of phrenetic activity. Thousands of ants were leaving the nest and many were already returning with their leafy loads. By following the main trails which radiated out from the nest, we discovered that they divided into small trails that travelled as far as two hundred metres into the forest. Many ants were ascending into the crowns of large trees. Others were attacking the leaves of shrubs, and these were within photographic range. The fragments of foliage are not eaten but are instead carried down into the nest where other workers lick them thoroughly before reducing them to a pulp which forms a compost on which fungus is grown in special chambers. The ants feed themselves and their larvae on fungus from the gardens. Since leaf-cutters attack orchard as well as forest trees they can be serious pests.

Filming ants on the trail had to be done in short bursts because the heat from the lamps soon stopped the leaders, causing a back up and resulting in chaos. It took ten nights' work at the nest before everything had been filmed.

The lamps attracted numerous other insects, including a nocturnal wasp, *Apoica pallida*. Wasps and mosquitoes are always a distraction to the cameraman who is trying to focus a big close-up. And a sharp lookout had to be kept for snakes, which were common in the area. Trinidad has thirty six species of snake including the very poisonous fer-de-lance and the bushmaster. Twice in one evening while David Thompson was kneeling behind the camera, his father Gerald, who was holding a lamp nearby, noticed a snake lying on a shrub half a metre above David's head. Not trusting to a long-range diagnosis of whether or not the snake might be poisonous, he assumed the worst, and David was told to 'freeze' while the situation was explained to him. He then crawled forward out of range.

On several occasions when filming and collecting at night, we came upon a fer-de-lance. A close relative of the infamous rattlesnake, a bite from the metre long fer-de-lance

We were able to film both army ants and leaf-cutter ants at night. Although army ants send out raiding parties 24 hours a day, there are certain activities that usually occur only at night. The ants have nomadic phases interspersed with resident phases when they send out foraging parties from temporary homes to scour the forest for prey. Once an area has been exhausted, the ants move their brood — eggs, larvae, pupae and queen — to another site. This mass nocturnal exodus, a seething trail of ants perhaps half a mile long and numbering up to a million individuals, was one of the dramatic scenes that Gerald and David Thompson chose to film. Huge sickle-jawed soldier ants guarded the trail at intervals, and any disturbance brought them into instant action.

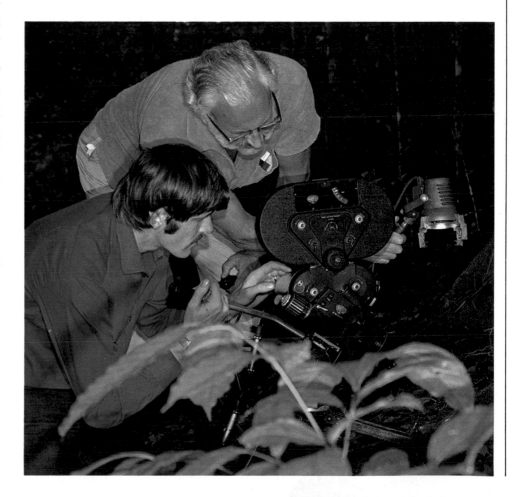

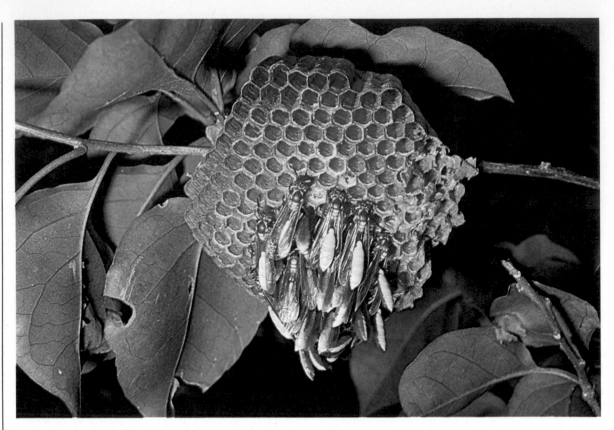

Filming in the dense forests of Trinidad's Northern Range at night was always exciting because an unending stream of new creatures would continue to materialize out of the darkness. But one nocturnal visitor, the wasp *Apoica pallida*, was unwelcome. By day *Apoica* rests on its nest, as seen in this picture, but at night it is active and was attracted to our filming lights. It has a powerful sting.

will land anyone in hospital, and if antivenom serum is not administered within an hour or so the unfortunate victim is likely to be dead. Small wonder we kept our eyes peeled when out at night and held a good supply of spare torch batteries in our pockets. The locals had their own methods of avoiding snake bites. They wore gum boots, which we found intolerable in the sticky heat, and they coated their trousers liberally with ammonia! They also soaked their unfortunate dogs in the stuff, though I can hardly imagine that a hound treated in this way would have much of a nose for the hunt.

In fact it was the locals, with their wild nocturnal hunting forays, who were our greatest danger. They employed three methods of hunting, two of which could have proved fatal to any innocent bystander caught unawares in the rain forest at night. The method least risky to third parties, and the most spectacular to watch, consisted of crashing wildly about in the forest with torches and an ill-trained rabble of dogs (all liberally wetted with ammonia) in the hope of immobilizing the quarry through sheer terror,

whereupon it would be despatched with a few well-aimed swipes with a cutlass. An essential ingredient in the strategy was noise. The dogs barked and yelped in wild abandon, the men hallooed and shouted, and the forest rang with the crashing of undergrowth. From our secluded base at Simla, a well-attended hunt in full song could be heard several kilometres away across the valley. Personally, I cannot conceive of a method more guaranteed to fail than this, and even in the unlikely event of an animal being stupid enough to be cornered, I was convinced that the energy expended in the hunt would far outweigh the nutritional intake from the quarry. Conversations with Trinidadian hunters whom we met on the trail proved me wrong. We were assured that this method of hunting was more refined and polished than it appeared, though it would take a hardened expert to distinguish one from a frenzied ballyhoo. The almost total extinction of deer and the rarity of agouti, paca and wild pigs from Trinidad's Northern Range led me to agree that there was more to these hunting parties than met the ear.

It could be that the other two methods, which caused us great concern for the integrity of our hides, were more effective. One method was to quarter the forest at night with an acetylene lantern and a blunderbuss. Eyes reflected in the lantern's glare provided the target. As it is difficult to identify a distant animal just from the reflection in its eyes, this method gave the hunter the additional thrill of not knowing quite what it was he was shooting at until after he had shot it. The awareness of this fact made our night collecting trips nerve-wracking affairs. Many a hunter, waiting intently in the dark for the rustle of agouti, has been dazzled by the sudden glare from a lantern only to have his brains blown out a second later by the blast from a home-made shotgun. Our only defence was to shout loudly from time to time to make our presence well and truly known to any hunters creeping about in our vicinity.

The other method employed was designed specifically to kill the unwary creeper, though other hunters were not the intended quarry. A trip-wire was stretched taught across a trail or an animal track and attached to the trigger of what can best be described as a miniature cannon concealed in the undergrowth. An animal, or a human for that matter, unfortunate enough to blunder into such a device was literally mown down in its tracks by a hail of assorted hardware — nails, stones and bits of glass. The wounds inflicted on the victims were horrific and the fortunate ones were those that perished instantly. Many did not, hunters and agouti included.

Faced with these very real dangers, together with the physical problems of transporting and setting up camera equipment and lights in the dark, we brought our subjects indoors whenever possible, and filmed them in the relative comfort of our headquarters. Of course, the filmstars still had to be collected and in the case of nocturnal animals this meant frequent torchlight forays up stream beds or through dense undergrowth. Despite the hazards we found these trips exciting because of the wealth of animal life that our torches revealed. I have always been amazed at how effective a torch beam is in focusing the attention. With the field of view black and featureless except for the small patch illuminated by the torch, your concentration is directed with utmost intensity on a small area. There is no dilution of attention by peripheral information. Despite the paltry amount of light available to the eyes, the minutest details that would escape notice in daytime spring to view.

Mind you, some of our most treasured finds have come to light in the most unexpected circumstances. Eager to find specimens of an extraordinary net-throwing spider, *Dinopis*, John Cooke spent night after night in a centimetre-by-centimetre inspection of the garden and walls of Simla and its outbuildings, but in vain. It was while in the lavatory, his mind exploring the reasons for his failure to find *Dinopis* in the most obvious places, that John noticed what looked like a small twig fixed to the tiled wall. Anyone else would probably not have given it a second glance, but John knew better.

It was a female *Dinopis*. He wasted no time in setting the spider up in a glass cage among suitable vegetation. In the daytime the spider stretches out its long legs fore and aft and presses its thin body against a twig so that it is extremely difficult to detect. Well after dark, the spider becomes active and spins a number of lines down to the ground to provide a framework to which it can cling while it spins a small, intricate net about one centimetre square. When finished, the spider tests the net by stretching it out; it is very elastic and can extend to about five centimetres. The *Dinopis* now descends until it can just touch the ground with one leg extended; this measures the distance for the lying-in-wait position. The spider hangs head down from its framework holding the corners of the net parallel to the ground. *Dinopis* has two large forward-pointing eyes, hence its name, the ogre-faced spider, and unlike many web-spinning spiders it can see rather well. When an insect crawls across the ground within reach, the spider lunges downwards with lightning speed and drops the net over the prey. The flocculent silk entangles the insect and the more it struggles the more enmeshed it becomes. The spider jerks up the net and prey and wraps some silk around it before settling down to feed.

The ogre-faced spiders, *Dinopis*, are widespread throughout the tropics but are not often seen. They are active only at night, passing the day exquisitely camouflaged. The spider in this picture is lying stretched out along a twig and is almost invisible. The ogre-faced spiders are so named because of their large, well-developed eyes, which are very sensitive and play a vital role in the capture of prey.

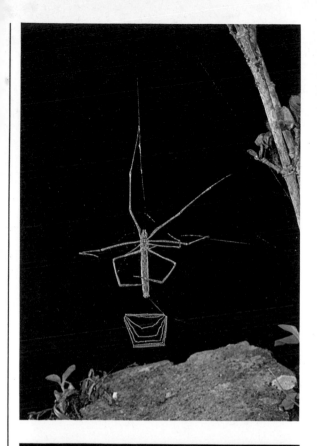

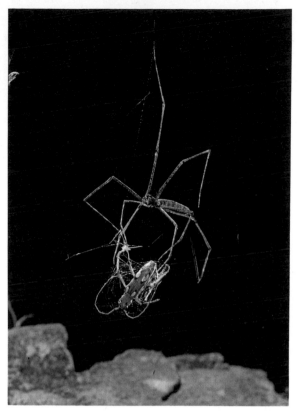

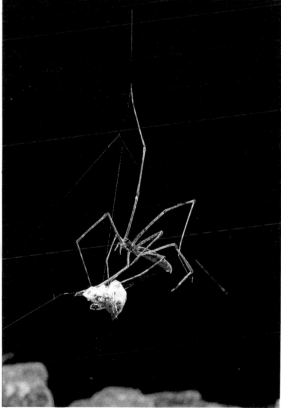

TOP LEFT After dark, *Dinopis* lays down a light scaffolding of silk and begins to weave its snare. This consists of a postage stamp-sized net made of special flocculent silk. This silk is not sticky but is highly elastic and acts by entangling the spider's victim.

TOP RIGHT After the net has been spun, the spider holds it by the corners, hanging upside down some 5 cm above the ground. As an insect walks by underneath, the spider spreads the net over it. In this picture a beetle has just been jerked off its feet and is struggling hard.

BOTTOM Soon after capture the prey is quickly bitten by the spider to subdue its struggles. Before the venom has had time to act, the spider begins to wrap its victim in swathes of silk, as seen in this picture. When the beetle has ceased to struggle within its silken shroud, the spider carries its neatly packaged meal up to a convenient twig and slowly begins to feed.

These pictures were taken on a small set in our studio at Simla in Trinidad. Each evening for several weeks the spider would emerge at about 10 o'clock and build its web, waiting for us to provide prey that was both palatable and visually attractive.

If the prey happens to be a heavy beetle, a prolonged battle ensues. The beetle clings grimly to the soil and attempts to drag itself clear of the net. The spider heaves upwards on its scaffold-lines from above in an effort to lift the beetle clear of the ground, or to reduce its purchase on the soil. From time to time, the spider lunges downwards and rapidly throws skeins of the silk over its adversary. If the beetle is too powerful for *Dinopis* to subdue, the spider eventually cuts it free and it blunders off with the spider's net festooned about it. With laborious precision, and that dedication to detail for which spiders are renowned, *Dinopis* then sets about the task of constructing another net. At dawn, whether she has been successful or not, *Dinopis* dismantles her apparatus and eats it. The silk is recycled to be used again the following night – nature cannot afford the prodigality of our throw-away culture. *Dinopis* spends the daytime in a twig-like posture, its long thin legs and body pressed against a branch or rock.

Eager to film mating and egg-laying, we kept our eyes peeled for a male, but despite

intensive searching in the building we never found another *Dinopis* at Simla.

We then turned our attentions to another spectacular nocturnal spider, the magnificent tarantula, *Avicularia avicularia*. *Avicularia* is one of the so-called bird-eating spiders, jet-black and furry, with delicate pink feet and a leg-span of up to twelve centimetres. 'Bird-eating' is a misnomer since it feeds at night on large insects and small lizards. It might well accept a small bird if the opportunity were offered, but its way of life makes this unlikely.

The spider spins a retreat on the bole of a fairly large tree. To make detailed photography possible John Cooke decided to set up the spiders and their appropriate habitat in the living room at Simla. With the help of Dave Stradling, who was studying the spider, he heard of two tonka bean trees, each with a resident spider, that were going to be felled as part of a housing development. Our only chance was to fell the trees, each about a metre in girth, before the contractor got to them. We set off armed with saw, axe and ropes. The first task was to remove the spiders and place them in containers, a dangerous-looking operation which John performed with the nonchalance of a veteran spider-hunter. Only when we began to saw the trunks did we realize that tonka bean is an extremely hard wood; we later discovered that it is also very heavy. Our object was to remove a metre long section of bole with the spiders' shelters more or less in the middle. Two cuts had therefore to be made on each tree, and to prevent the required piece crashing to the ground it had to be braced with rope before the lower cut was made. The whole operation was fraught with difficulty because the trees were standing on the edge of a small precipice. But by the end of the second day the two lengths of bole were safely back at Simla where they were stood vertically on a table with wire braces running up at angles to the ceiling.

The spiders were now returned to their shelters. One settled down immediately but the other left its retreat during the first night and was eventually found next day in the furthest recess of the ceiling. After sulking in their retreats for two days the spiders resumed

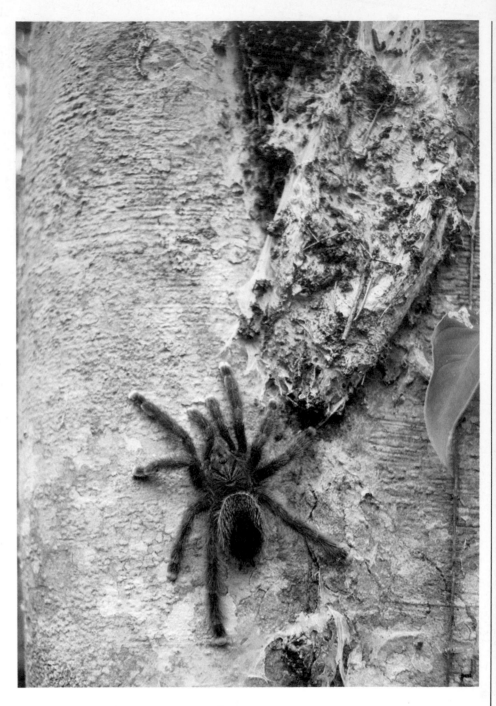

their normal behaviour. In the daytime they stayed at home but after dark they left their retreats and waited around on their tree trunks for food to arrive. Bush-crickets and other insects were supplied as well as the occasional small gecko lizard. The usual gait of *Avicularia* is slow and deliberate but the pounce on prey is almost faster than the eye can follow. The spiders attracted a certain

This large arboreal tarantula, sometimes misleadingly called a bird-eating spider, passes the day inside a silken cocoon, visible here, which it spins on the trunk of a suitable tree. The cocoon is protected against possible attackers by impregnation with barbed irritant hairs rubbed from the spider's body.

amount of attention. The servants steered well clear of them and several people made the pilgrimage from Port of Spain to see them. Evening visitors, ignorant of the spiders' presence, were somewhat startled when we pointed out the large hairy shapes waiting quietly on the boles. Unlike some tarantulas, *Avicularia* is fairly amiable and does not readily use its large fangs. The poison is not toxic to man but the sheer size of the bite would be unpleasant.

After filming the spiders feeding, we set about arranging a mating, which had never been filmed in this species before. Dave Stradling came again to our help. Our specimens were both females, but he had a male which had recently moulted to maturity, and it was arranged that John could borrow George, as the spider was nicknamed, to try for a mating. So George was brought to Simla one evening, and with lights in position and two cameras at the ready, George was released at the base of one of the logs. George knew what to do: unerringly he slowly approached one of the shelters where the female was lurking, tapping the bark furiously with his front legs, thereby signalling that he was a prospective mate and not a meal. Cautiously approaching the entrance he ventured a little way inside only to shoot back like a bullet out of a gun as the female lunged forward. It soon became evident that this female was not interested in a mate; she was, as became apparent later, getting ready to moult.

George was removed from the first bole and given a short rest, while the assembly had coffee. He was then placed on the second log. This time the female responded to George's overtures by slowly emerging from her shelter and tapping on the bark. After an interplay of legs George moved beneath her head, and with his front legs held her fangs up to prevent her from killing him with a downward lunge while he inserted his sperm-charged palps. Mating lasted only about a minute and then the spiders parted quietly. The female returned to her shelter and George was replaced in his cage ready for his journey back to Port of Spain — a fascinating evening for everyone, and possibly for George as well.

The *Avicularia* episode epitomizes the essence of our tropical expeditions — a glorious mixture of excitement, patient endeavour, hilarity, danger, discomfort and sheer hard graft. And at the end of each trip, as we take home with us a wealth of biological images, some held in our memory, some, we hope, on film, we sometimes lose sight of the most enduring influence of all. These are the human contacts, the unforgettable characters that crop up on all continents and among all races. To describe them would be a diversion, and would, in any case, fill a volume. As we plot our course to England, to our studios and homes in the Oxford countryside, our thoughts are quite rightly with the families and friends we have not seen for so long.

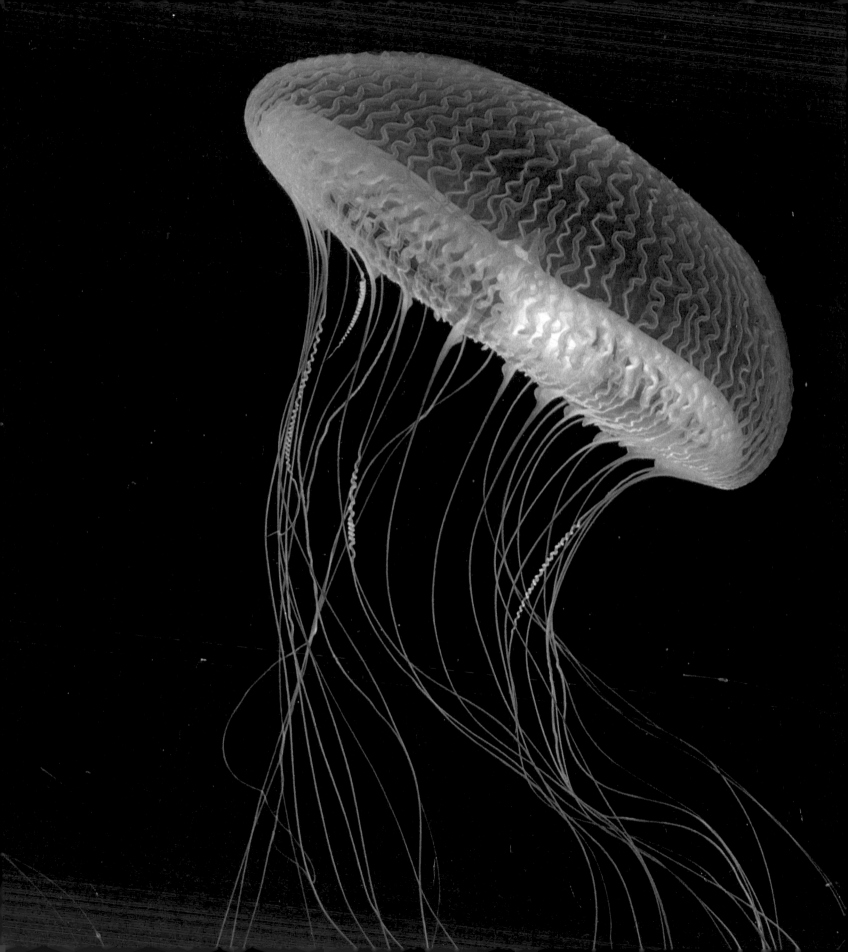

8 The Great Barrier Reef

PETER PARKS

Few marine environments offer such a wealth of life form, behaviour and adaptation as a coral reef. The very first glimpse of a reef, from beneath the water's surface, presents the viewer with a wildlife extravaganza second to none. By far the biggest and most spectacular coral massif is the Great Barrier Reef of Australia. It is so big that its 2,500 kilometres of sinuous, shore-hugging length was clearly seen by astronauts from the surface of the moon as a white line on the faraway earth.

For all of us at Oxford Scientific Films, and for me in particular, the Reef had been regarded as a Mecca for many years, but for logistical and financial reasons it seemed to be beyond our grasp to mount a photographic expedition there. I was therefore delighted when Chris Parsons asked me to represent OSF and join forces with the BBC Natural History Unit to help complete a huge thirteen-part series of films on the evolution of life to be called *Life on Earth*, to be masterminded by David Attenborough and, always too modestly, Chris himself. Programmes one and two of that series were concerned with the origins of life within the oceans, and between us we decided that a combined expedition to the Great Barrier Reef and to the gulf stream coast of Bermuda was most likely to supply us with the film required. In both these areas, there is a fabulous diversity of animals, among them small marine organisms that may resemble the first life forms to develop on the Earth. Two years later, David Shale and I undertook a similar three month trip to the Reef to shoot sequences for a Paramount feature film called *Land Between Two Rivers*. But on this occasion we were after somewhat larger animals.

My experience and interest in filming marine micro-life and some of the lesser known marine invertebrates were perhaps what Chris Parsons was seeking when he turned to OSF. To cut a long story short, a year later I found myself on the Reef. It was an extremely complicated expedition to mount because of the numbers of people involved, its duration and the inaccessibility of its location. These factors were further complicated by the two tons of equipment that had to accompany me in thirty five crates.

Lizard Island

The location chosen for the work on the Reef was Lizard Island, about forty eight kilometres off the coast of north-east Queensland and nearly sixteen kilometres within the protective ramparts of the northern Barrier. This six and a half by six and a half kilometre continental island pokes its three hundred metre granitic peak above the waves. All

OPPOSITE This is not a true jellyfish but the medusoid phase in the life history of a hydra-like polyp, *Aequoria*, which lives on the sea shore. It swims around the lagoon adjoining the research station on Lizard Island along with a host of similarly transparent and gelatinous creatures. Only flash photography and dark field illumination seem able to do justice to such a diaphanous animal, picking out the corrugated sex organs in the umbrella and the long trailing tentacles which paralyse salps, copepods and other planktonic forms.

BELOW A plankton haul off Lizard Island at sunset.

islands in these waters are fringed with extensive reefs and Lizard Island enjoys a truly tropical climate. The weather is ideal for diving and, of course, most work on the Reef involved some diving even if only for collecting animals. But, as luck would have it, by choosing the season of calms we had to put up with quite frequent cyclone interference. Cyclones or typhoons may be mild or furious. To a small and isolated research station like Lizard Island they can cause untold damage and considerable delays to research programmes and filming schedules. So in general, this sort of expedition tends to run flat-out, day and night, until the 'goods are in the can' or 'bad weather stops play'. Since there is always some bad weather on every trip, and because the filming is never ahead of schedule, life is hectic. Achievements and successes can be rewarding; failures and disasters are both depressing and very frustrating.

The equipment we take on an expedition of this sort depends very much upon what we imagine we will need. And what we take at the outset is not necessarily what we feel we should have taken by the time we come home. Experience is of some help, but seldom do we satisfactorily prepare for all eventualities. Before departing on the trip I had made enquiries direct to the research station, read articles and used a certain amount of tropical know-how gleaned from past trips. How was I to know, though, that sinus troubles were going to flare up within a three-hour period, when normally they always creep up on me slowly and usually in winter? How were we to know that Customs and Excise in Cairns, Queensland, were going to impound the film for four weeks and charge us nearly one thousand dollars before releasing it, when normally a 'press pass' bypasses the event? And how could we know that one species of jellyfish would occur in numbers exceeding a million for only thirty six hours of the four month trip? It is this very element of uncertainty, of being prepared for the unknown, of being equipped to improvise under almost all conditions, that makes such an expedition difficult to plan. The ability to

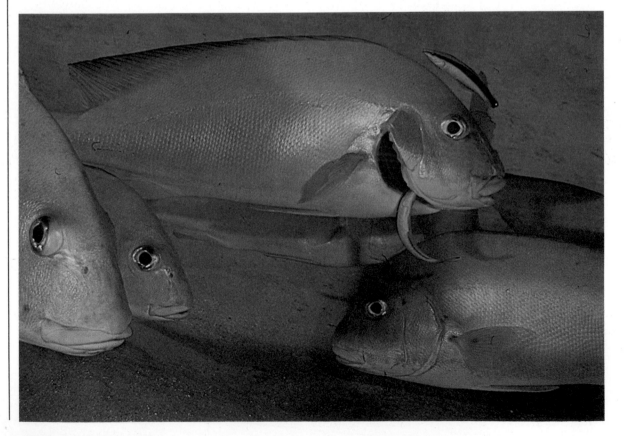

Painted sweet lips being cleaned by the small wrasse *Labroides* at a cleaning station I found only 40 m from the station mooring. Many larger fish must visit such cleaning territories to keep their skin, teeth, mouth and gills in good condition and free of fungi and parasites. This particular group of cleaners became so used to my presence that I too could queue and be cleaned. This was taken with twin flash heads and a 55 mm macro-lens — and a deep breath.

meet and cope with the unexpected automatically necessitates carrying excess equipment; nearly 200 kilograms taken on that trip were never actually used, but the remaining 1,800 kilograms almost glowed red hot from constant use. The heaviest equipment of all, the optical bench, was that used for filming the very smallest creatures. These were the single-celled animals and plants that make up the vast drifting communities of the upper layers in the oceans. It is upon these small plankton that the larger planktonic organisms feed, and, in turn, the larger denizens of the oceans ultimately browse, feed and filter.

We all imagine clear blue tropical waters, continual blazing sun, idyllic boat trips over azure shallows, fruits of indescribable juiciness hanging from laden boughs and marlin, sailfish and mackerel leaping from the sea's surface every time we nudge the boat clear of the station moorings. Accordingly, besides the considerable mass of filming equipment we also took complete diving assemblies, less tanks, about thirteen litres of Sherpa Tensing sun-cream, a four and a

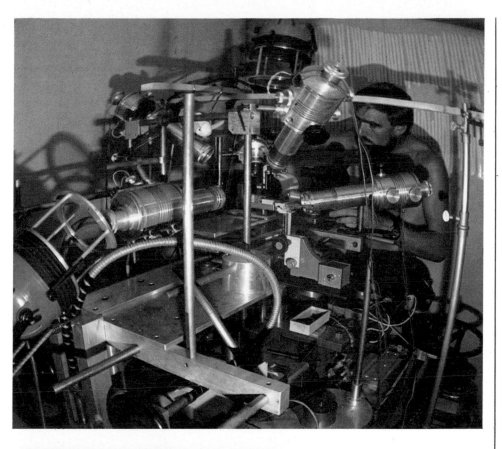

On one of my dives I captured some sea squirt larvae (*left*), minute, bright green, tadpole-like organisms which flickered before my face mask. Under the lights of the optical bench (*above*), the brilliance of the green pigment excited me further, and once back at Oxford, I was thrilled to discover that these were the larvae of some rather uninteresting sea squirts I had seen and photographed (*far left*) in the lagoon. The flaccid, sessile adults have chlorophyll-containing tissue within their vases, but it was the first time that its presence had been recorded in their larvae.

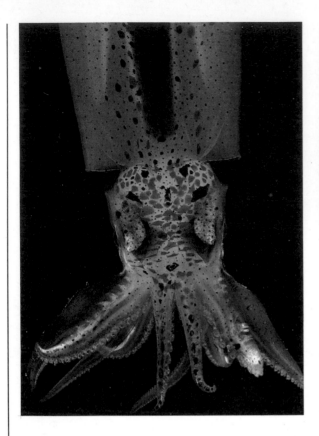

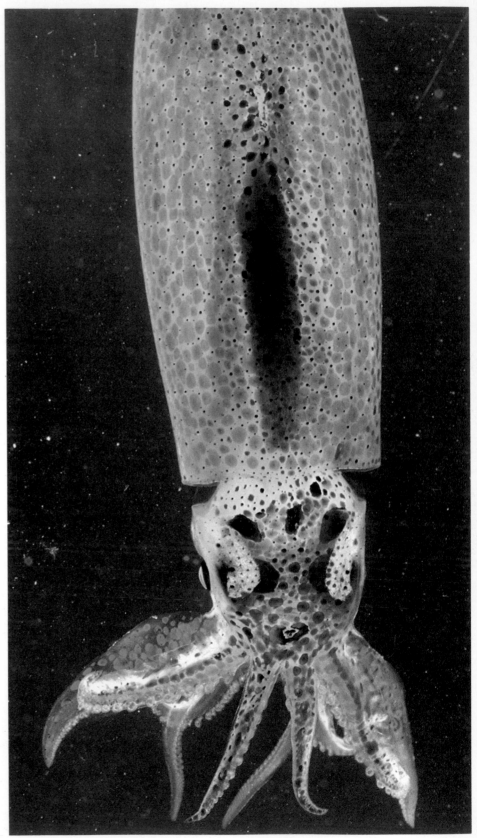

half and a twenty horse power Mercury outboard engine, a five metre Avon inflatable dinghy, a three metre Avon redcrest inflatable dinghy, a complete repair and tool kit capable of serving a police launch, books on what not to eat or be eaten by in Australia and enough fishing tackle to land the star of the film *Jaws*. Added to that were my children's buckets, spades and frisbees, eyeless teddy bears and moth-eaten monkeys, antibiotics, bent wire shaving adaptors, tubes of cream against athlete's foot, four kilometres of sticky silver tape, a stainless steel vegetable collander from the Dorchester hotel for catching large jellyfish, and four boxes of electrical bulbs – to say nothing of a bag full of elastic bands. You can see how it mounts up! This and the optical bench accounted for ten crates – there were a further twenty five!

Three and a half months after first starting to pack, and more than £10,000 into our budget, all thirty five crates arrived in Cairns, but not without incident. Six weeks earlier we had been informed, almost casually, while we were kicking our heels for the second week running in Gippsland,

Victoria, where we had two months' work to do before travelling north to the Reef, that ten crates were in Manila, twenty three were still in Luxembourg and two were in Kuala Lumpur.

The hop from Cairns to Lizard Island is 240 kilometres of spectacular and bumpy flight in a Cessna or Trilander. The first impression of a coral island is always memorable, if weather permits a good view from the air. Lizard's turquoise fringe of coral reefs and dark blue lagoon waters were spectacular – even though it poured with rain on our approach. As if to order, as we taxied back down the iron-rich, almost maroon-coloured airstrip, a metre long Goannid monitor lizard scuttled across our path. We knew then why the island had been given its name by Captain Cook two hundred years before. It was in fact to the summit of what is now called 'Cook's Look' on the island that the famous British mariner clambered to spy out his escape route through and beyond the Outer Barrier fourteen kilometres to his east. Despite the rain it was a memorable arrival and within thirty minutes, a dirty, dusty, bumpy tractor ride had conveyed us to the marine station and conditioned us to what lay ahead.

It took us nearly two weeks to assemble all the equipment, and then a further two weeks for Australian customs to extort six hundred and fifty dollars against the release of our precious film. Although that sort of delay is terribly frustrating, it is a good plan to avoid rushing into filming. It never does harm to learn about the environment and its occupants first. But we did miss the opportunity to put on motion-picture film an exquisite species of squid. Those squid were a bonus.

Camera failure nearly caused us a severe loss of time on the first trip. An entire and worrying day was spent trying to rectify a fault with the guts of my camera laid out all over a bench. Eventually, Barry Goldman, the station director, and I devised a solution – we bent part of it, and it has never failed me to this day.

Although from above the surface you may imagine what it will be like beneath the waves, you invariably fail to appreciate the extraordinary three-dimensional complexity and range of colour and diversity that hits you like a thunderbolt on the first cautious dive.

On our second trip our first dives were associated with disaster. The first dive landed us eight kilometres from base with a faulty engine and we had to paddle home. The next dive, made to establish the buoyancy of the 35 mm underwater camera we had hired in Sydney, taught us first that it was firing only intermittently and secondly that it was so negatively buoyant we could scarcely get it off the bottom. It took nearly six weeks to iron out those faults and cost us valuable footage.

We soon settled into a well-tried routine. Days were spent coping with the dreadfully tedious and often wasteful business of camera maintenance, film logging, despatching and recording and, of course, with the more pleasurable pursuits of locating, tracking and collecting life forms for subsequent tank filming. Most exciting of all were the dives associated with live underwater photography and collecting. Sunset, without fail, was always spent completing a careful plankton haul. Only if the weather had boiled the sea so badly for several days that the detritus content rendered all sampling a waste of

OPPOSITE Returning from a plankton haul at sunset, a colleague scooped up three of these beautiful 4 cm long squid in his bare hands. Imagine my frustration when I remembered that my motion-picture filmstock was still 200 km away in customs! At least I had the pleasure of tackling them on stills. These are two of a series of shots which show the squid's remarkable ability to change colour. Colour cells are opened and closed by minute muscles displaying or hiding their contents very rapidly.

BELOW The value of a diving partner is in the extra pair of eyes. My wife spotted this Bedford's flatworm swimming 15 m from me. After a frantic dash through the water, this graceful flatworm was captured on motion-picture film and stills.

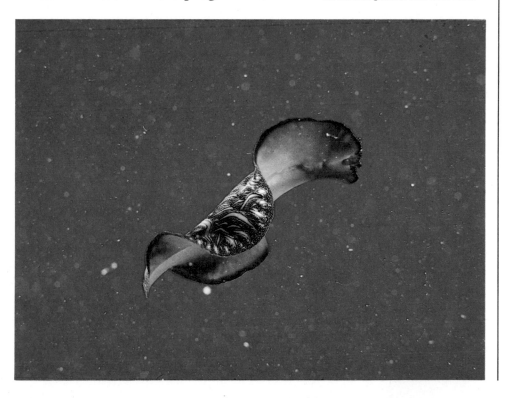

ANTICLOCKWISE FROM TOP LEFT A sea cucumber auricularia larva (5 mm), a sea slug *Phylliroe bucephala* (4 cm), a copepod *Sapphirina angusta* (3 mm), a comb jelly *Beroë* (10 cm), medusa of a hydrozoan *Aequoria* (20 cm), a hydrozoan *Porpita* (5 cm), a sea slug *Glaucus* (5 cm), and a phyllosoma larva (5 cm) of a lobster associated with a jellyfish. The planktonic community is comprised of a wide variety of creatures. Some, like *Beroë* and *Aequoria* are predators, others are prey. Some are adults, others, like the auricularia, are larvae. Some cling to the surface film like *Glaucus*, others, like *Phylliroe*, descend into deeper water. Although capable of limited independent swimming, all are at the mercy of the great ocean currents and their eddies. Most are small, some, like the auricularia, so small that they cannot be seen with the naked eye, while others, like the jellyfishes, may measure 2 m across the umbrella.

Transparency is a feature common to many planktonic creatures, but intense blue pigment characterizes surface-dwellers like *Porpita* and *Glaucus*. The flash of blue in *Sapphirina*, a parasite of salps, can be seen 10 m away beneath the surface as the animal's segments catch the light and split it into a rainbow of colours.

As in any community some individuals are dependent upon others. The leaf-like and bioluminescent sea slug *Phylliroe* is said to associate with medusae and jellyfish. The phyllosoma larva of a lobster seems to have a relationship with certain jellyfish.

time, did we vary this occupation. It is because planktonic organisms tend to migrate to the surface each night and descend by day that samples are collected as late into the evening as is practical. A haul was a one hour operation, sometimes seven or eight kilometres from the station. It can be a glorious time of the day: the setting sun mirrored in a flat calm sea, a pair of ospreys returning to Prince Charles Island, mewing to one another as they go, the noddy terns crossing their path en route to Bird Island and the echo of cicadas bouncing across from Palfrey Island, clearly audible even above the drone of the trolling outboard. In contrast, it can be a God-forsaken and a tempestuous time, with engine failure promising a miserable and frightening night adrift and a howling gale to chill every centimetre of bare wet flesh. But the rewards of a plankton haul are seldom lacking, especially when the haul is your first in tropical Pacific waters.

Planktonic creatures are, to my mind, the most beautiful on Earth. They beat even the insects for sheer beauty, delicacy, extravagance and audacity. Some of the plates in this chapter will help you to share a view of those electric moments, when, perhaps for the first time, we see not only the superb design and contour of a creature, but also the intricacy of its organs — heart, gills, liver and even brain. All the while, the little animal is swimming free — in a single drop of water. Imagine the exhilaration of tracking it in three dimensions on the optical bench as it continues on its way, illuminated by a system that does it no harm and which is designed to do justice to its beauty.

Return to base after the haul was invariably spent diluting the collected sample, snatching a hasty meal and settling down to a long night of peering down a microscope, selection and filming. When viewing a plankton sample beneath the dissection microscope or down the camera, I am always amazed by the incredible activity of the organisms. It is like watching a battle from the air, but it is soundless battle, raging without a whisper, murmur or groan. Yet in that small dish there is death and destruction, blood and guts, and every night the participants are different and the photographic demands vary. Because time on such an expedition is at a premium, we used every available hour and each night's filming continued way past midnight. But we have one golden rule on these trips: whatever the hour, we always try to return all our subjects to the sea before finally collapsing to bed. It is really a way of reminding ourselves of priorities. Life is precious, however small and fragile. We are privileged to film and study it, and it is the least we can do to remember its sanctity and prevent raw commercialism tarnishing that unique quality with which all nature is endowed.

An average day on Lizard Island, therefore, presented a wide variety of activities, problems and challenges. In fact there was no such thing as an average day. A couple of excerpts from my working diary will illustrate what I mean.

8 January 1978 . . . departed with rubbish bin to the deep water channel. En route spotted a beautiful purple jellyfish. Turned about and immediately entered a windrow of several hundred more. There I was, with a stinking dustbin, no camera, no diving gear and surrounded by a species of animal I had come nineteen thousand kilometres specifically to film.

31 December 1977 . . . with Susi and children . . . made night trip to the lodge. As we rounded the point west of third beach we suddenly became aware of beautiful glowing lights in the water. Each area of light was in a regular pattern and remarkably bright and curiously did not seem to move away as we approached. Our trip was so urgent we couldn't even dip with a bucket to find out what was producing the light!

It was New Year's Eve, and I had made a solemn promise to the family that I would forget work that evening. You might be tempted to ask why I did not dip a bucket into the water just to find out what it was that was producing this light. But if it had turned out to be what I think it was, there would have been no way of guaranteeing that I could have resisted the temptation to film it. I think the creatures were bioluminescing siphonophores.

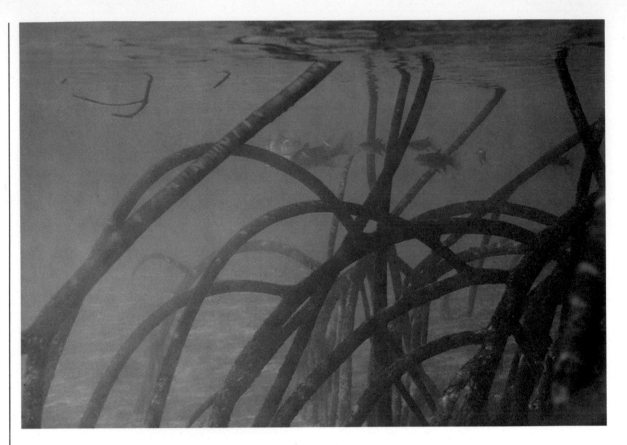

The waters of warm shallow mangrove swamps are always murky, but among the down-turned aerial roots that form an underwater forest, an extra-ordinary assortment of animals adapted specifically to this environment spawn, live, fight and die. The atmosphere can only be conveyed in a picture. Imagine ten-foot long sting rays in fours and fives approaching from beyond the roots and 30 cm lobsters capable of delivering a painful slash with their spiny limbs, rising from chimneys within the sand.

The eagle ray adventure

Not all experiences are disasters. Every now and then one is rewarded with a bonus. One morning, late in December 1979, the family and I were spending a morning in the lagoon, which on one shore is fringed by red man-grove. Red mangrove is a curious plant that grows along particularly sheltered stretches of sandy shoreline. Its roots lie in salt water and the waves lap gently around its multitude of stems. From these stems and the lower branches emerge aerial roots that grow downwards through the water until they reach the sandy bottom. There they root and shoot. A few years of this gentle and insidious growth results in a jungle of stems and aerial roots that is impenetrable to man. Such an aquatic jungle forms a unique environment for animal colonization, and the mangrove area on Lizard Island is no exception. Almost anything you find there is unusual and intriguing, from three-metre-long coachwhip rays and extraordinary shovel-nosed rays to forty centimetre mantid lobsters that live in

vertical burrows in the sand. These lobsters produce slime and sand curtains across the eight centimetre opening to their burrows, from which they peer with stalked eyes, each endowed with bifocal vision.

As we approached the warm, murky shallows, a large dark-coloured ray flew away beneath our bow. Partly to attempt some close-up stills photography and partly to show the children, we decided to try tiring out the ray by gently chugging along behind it. Ten minutes later it was well into the shallowest water and, just as we were won-dering whether we would be able to follow it or not, it drifted to a standstill and then suddenly up-ended itself. It literally stood on its head with its rear body and all of its tail completely clear of the water. There, for us all to see and heed the warning, were three ten-centimetre-long poison spines projecting from the dorsal surface of the tail base. In a state of near exhaustion the ray struggled in among the aerial roots of the nearby man-grove. This was the moment to follow under-water. Half thrown and half pushed by my

family, I splashed in and, with camera in tow, made my way towards the panting ray. The visibility was dreadful — it always is in mangrove areas. As I approached the ray it struggled desperately to free itself from the roots. Only then could I see enough of the animal for certain identification. It was a beautiful spotted eagle ray. To cut a long and arduous swim short, I just about managed to keep up with the animal as it slowly flapped away. Every now and then it would turn and again raise those fearsome spines, just to warn me of its aggressive attitude. I did not really need this warning. Everytime I got to within one to one and a half metres of it, I was painfully aware of how close my bare chest and stomach were to this lethal weapon. Using natural light and a shutter speed of 1/125 second, I was fortunate to gain ten or more useful shots. In those conditions the use of flash does little more than show up the particles suspended in the water. Eagle rays in dirty mangrove shallows are acceptable, in 'snow storms' they are not.

The Great Barrier Reef

To a very large extent the Great Barrier Reef is an unexplored habitat. True, many thousands of people have dived, fished and sported over it, but only a handful have researched or studied its biology in any depth. Some of those who are employed with such continuing research were our colleagues and close friends on Lizard Island. Their advice, stories and experience helped us enormously. They collected for us, dived with us and helped us film. It is through their work that it becomes evident that, in spite of these isolated research efforts, so little is still understood about the reef. One researcher asked me whether I ever caught mosquito larvae in our plankton hauls. I had, and it had often occurred to me that their appearance was too frequent to be explained by accidental run-off from freshwater pools. Apart from a water-skater called *Halobates*, everyone has been taught that there are no truly marine insects. Yet here, time and time again, we were catching these mosquito larvae, pupae and adults in our hauls.

A year or two ago, a couple of research

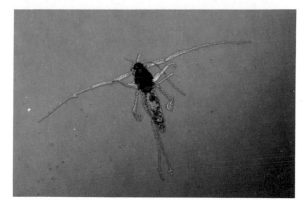

This was one of the many mosquitoes that kept turning up in our plankton hauls from the lagoon and which so baffled us until we read that a number of Australian and Japanese researchers were also finding them. Very few insects are known to live or breed in the sea, but this *Pontomyia* seems to do both. It does not fly, but instead its wings are modified into paddles.

biologists reported finding a species of mosquito in shoreline, but distinctly saline, environments. It turned out that the adult insects we were collecting were indeed of the same species, *Pontomyia*. Because we found some in the act of emerging from their pupae, we were able to link the pupae we were catching to this species. What particularly interested us was the life style of this extraordinary insect. How does a flimsy mosquito survive the rigours of the sea? Upon what does the larva feed? How do larvae and pupae, which breathe air at the surface, manage under such turbulent conditions? The research paper that we have read upon the subject does not fully answer these questions and so the biology of this species still remains, for us, a mystery.

BELOW Semaeostome jellyfish were one of my main quarries on my first trip to the reef. Invariably I seemed to meet them en route back to the boat when my arms were full of spent cameras. This occasion was no exception. To get this picture I had to catch and maintain the jellyfish while redeploying the camera — at least 4 hours work for one shot.

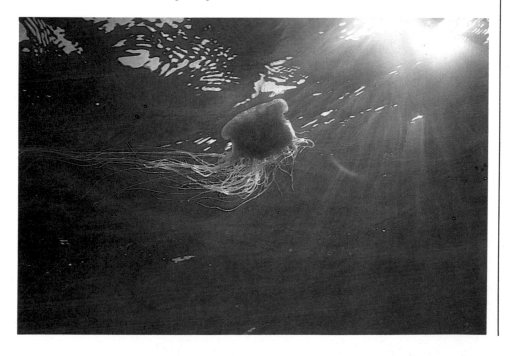

Expeditions of this sort are always eventful. Occasionally dramatic events occur which, as often as not, are over before they begin. On our last trip nothing was more memorable for me than the incident a week before our departure from the island in February. Dave Shale and I were on our way to the deep-water channel six and a half kilometres from the research station. It was one of those fabulous flat calm days. The sea was like a millpond and the state of the water was further emphasized by long drifting wind-rows of the scum-like alga, *Trichodesmium*. We had cut the engine briefly and were standing gazing into the blue void beneath us, searching for pelagic coelenterates or drifting jellyfishes. There were hundreds and thousands of salps, comb jellies and hydro-medusae. A slight disturbance about 50 metres away alerted us both and we saw a dorsal fin cresting a large swollen hillock of water and making relentless progress straight for us. We instantly thought of those memor-able approach shots in *Jaws*. Spellbound we waited and watched, and without looking

fumbled at our feet for the Nikonos camera, a face mask and fins. I dearly wished I had had time to strap on a diving knife. When the creature was about 30 metres from us, we simultaneously exclaimed 'manta'. It was a big brute of a ray. We estimated that it must have been three metres across the wings, which made it a three-quarter-ton fish and not a little awe-inspiring. Once again I found myself more or less pushed over the side with a camera, this time with only a face mask for company. When the bubbles cleared I peered into the water and could only just make out the manta, now steering a slightly altered course and slowly diving. Three remoras looked like insignificant parasites though each must have been a metre long. A shoal of young pilot fish in front of the cavernous mouth looked like fish fry. As it passed ever deeper into the gloom, I swam the fifteen metres back to the boat and Dave handed down my fins. Suitably clad, I then enquired the whereabouts of the manta. His expression was enough to tell me, but his words 'under the boat' galvanized me to

One of those rare and alarming moments when instinct alone captures the action on film. This three-quarter ton manta ray hit me full tilt across the chest less than a second after this shot was taken. In front of its huge mouth was a small shoal of pilot fish which were able to maintain their position despite the frightening speed at which this great creature was moving.

rather rapid action. I submerged, and to this day a clear image lingers in my mind of nearly a ton of ray turning on a sixpence and heading straight at me. At the apex of its turn the manta was on its beam ends and I was looking straight on to its back. I managed to fire one shot with the Nikonos when through the viewfinder I realized the animal was really heading for me. One second later it made contact. It hit me full in the chest and I was driven back and up as if I were a feather. Its enormous mouth was against my rib cage and its flap-like buccal palps were almost round my shoulder blades but situated well out to either side at about elbow distance. There was little time to be frightened. As I broke the water's surface I must have slewed up and to one side because, judging by the graze on my right thigh, one wing must have rasped beneath that leg. As suddenly as it began it ended, and there I was, fifteen metres from the boat, floundering in the water and wondering what was going to hit me next. My progress to the boat was rapid and to his eternal credit Dave grabbed me by the swimming trunks and an arm and lifted me bodily into the boat in one mighty heave.

There is not a lot more to that story except to say that ten minutes later my hands were trembling quite violently. Manta 'attacks' must be rare. They are docile and beautiful creatures and usually not even rough with people. We think this manta must have been frightened when it suddenly realized the boat was above it and its reaction was simply one of fright — I just happened to be in its way. Dave did not escape the assault either. As the ray turned, a metre of flailing wing broke the surface and half drowned him.

We saw the manta again the same evening and still the sea was exceptionally calm. It was swimming towards us, but this time it was the two wing tips that broke the surface. At first they looked like two marlin approaching us in line abreast. As the manta swerved to avoid the boat we had a wonderful view of him and a fitting farewell to an exciting day and a dramatic encounter.

One of the many amusing incidents from the last trip again involved Dave Shale and myself. Mainly because of a splitting head-

ache, I was anxious to complete the dive and head for home, so I was first in the water. Hanging three metres down I adjusted camera, weight belt and the air demand valve and suddenly felt a flap of loose rubber come into my mouth. I spat it back into the valve, and breathing shallowly rose to the surface. There I tried to be funny by saying a large and poisonous centipede had crawled into my mouth. I put the mouthpiece back into my mouth, submerged and gasped. The flap of rubber entered my mouth, completely this time, and I spluttered and spat it free. Away swam a four centimetre live cockroach!

So much of what OSF films is either very small or is difficult to record on film. So any expedition is accompanied by its own peculiar specialist equipment. I have mentioned the optical bench. This versatile but heavy equipment enables the cameraman to film the very smallest animals and plants. In the sea most planktonic creatures are small, no bigger than a full stop on this page, but some are very, very small. These are the protists, or single-celled organisms, almost invisible to the naked eye. The beautiful and often brilliantly coloured Radiolaria, the pastel-shaded Foraminifera and the glass-like diatoms and dinoflagellates are examples of such protists. On both trips we payed particular attention

Gem-like in colour and design, these single-celled diatoms (left), radiolarians (middle) and dinoflagellates (right) represent the lower links in the chain of life which leads from sunlight up to the largest predator. As in all food webs, it is the lower levels that occur in the greatest quantities. Being so small, at under a tenth of a millimetre, these organisms present photographic problems which the optical bench is designed to overcome. The complex camera and sophisticated lighting systems bring these life forms to us in their natural beauty.

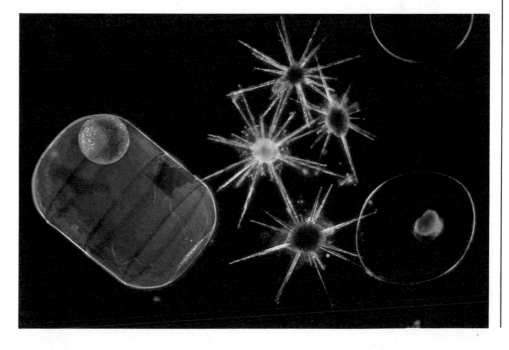

to these creatures. Normally organisms of this sort would be filmed through a microscope, but we find this much too inflexible a device. Our optical benches have been designed to give us as many degrees of freedom as possible. We can pan, tilt, roll, track, corkscrew, rotate, spiral, crane and zoom. So, when filming a static starlike radiolarian the last thing we would do is simply to film it static. We might spiral in towards it, eventually letting it 'thunder' overhead and out of sight. Optical benches, though, are not designed for filming only the very small. The whole system has been constructed in such a way that relatively large subjects can be placed upon the subject stage. A tank of water weighing two kilograms or more can be accepted, so we can make remarkable

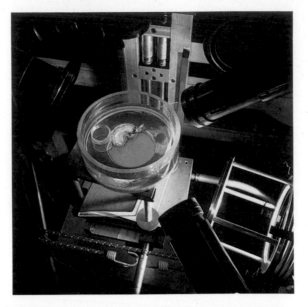

Late at night, two potential stars wait for photographic attention on the vertical end of the optical bench (*left*). They are the bubble raft snail *Janthina* and its hapless victim Jack-sail-by-the-wind *Velella*. Both live on or just beneath the surface and by filming them from above we displayed the snail's extraordinarily savage attack on this gentle, floating siphonophore (*below*). But a sequence of this sort is normally filmed from many angles. Viewed from below, *Velella*'s shrubbery of tentacles would be seen to be stripped from beneath the transparent sail, and a shower of eggs might rain down on the camera lens.

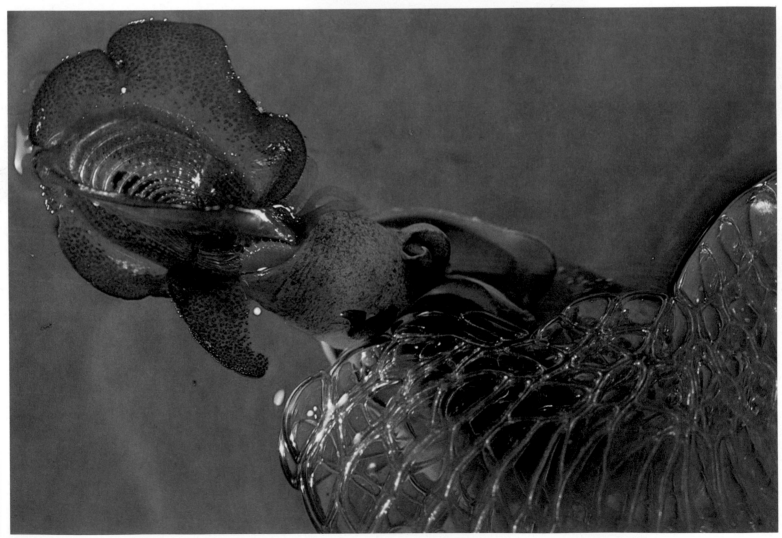

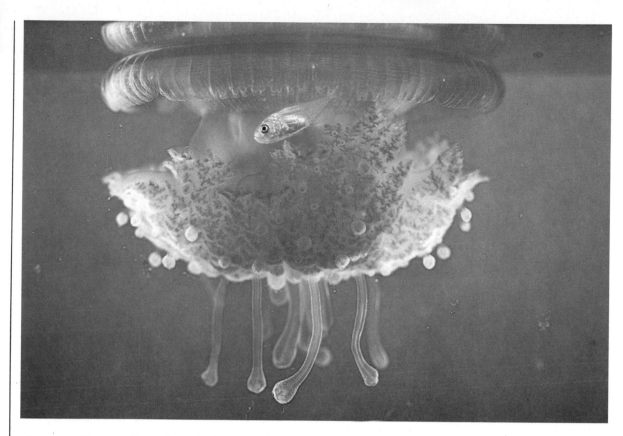

This jellyfish was found associated with a young carangid fish. When wishing to film such a partnership it is vital to treat both gently and not cause distress. This was especially important for the fish which might have lost vital mucus from its body and with it its protection from the fatal stings.

close-up film studies of quite large animals. We might wish to look in detail at the extraordinary tube feet of a starfish or those rows of tripartite pincers that adorn the surface of sea urchins and are said to remove settling spores and larvae of other organisms. We might wish to film a parasitic louse on the fin web of a twenty five centimetre fish or the blood flowing within the gills of a sea squirt. All are possible on the optical bench.

One major ingredient of all marine environments, and so part and parcel of any inhabitant of the sea, is the fundamental ebb and flow of the water. This is perhaps one of the most difficult things to re-create in the studio, but in recent years we have expended a great deal of effort to achieve this effect. One method was a large ten litre spherical flask, modified into a flow-tank system. Like most devices that work well, the principle is very simple. Water is caused to circulate in a direction dictated by four moveable nozzles and at a velocity determined by the head provided by a tap-controlled reservoir. An optical window is inserted into the side of the tank and this provides a wide-angle view of the entire contents of the flask. The slowly swirling, tumbling and spiralling water current gives a wonderfully life-like character to all the pelagic coelentcrates, or drifting-jellies, which comprise such a major proportion of life in the open sea.

It was with such a system that we succeeded in doing justice to an amazing assemblage of jellies we encountered on this last trip. Surfacing with spent cameras from a one and a half hour, fifteen metre dive with a cameraman colleague, Roger Steene, we found ourselves among an incredibly diverse assortment of pelagic salps, which are animals related to sea squirts. It was our experience that these swarms of salps often brought with them numerous predacious coelenterates. This occasion was no exception. I have never seen anything like it: gently drifting wind-rows of hydromedusae so thick that a bucket scooped over the side of the boat came to the surface choked with life forms. More than twenty coelenterate species were recorded in the melée, amid which were some fascinating deeper-water species like the sea slug, *Phylliroe*, the

amphipod crustacean, *Phronima*, in its salp house with its incredible compound eyes glinting in the light, and what seemed to me to be a larval oar fish – a rarity indeed. Our problem was not what to collect but what not to collect. With eight full buckets we returned home at six o'clock in the evening. This night's haul kept us going to four o'clock the next morning. By introducing selected organisms into the flash system, and suitably back- and side-lighting them, we achieved some memorable shots, which, because they were filmed in wide angle, retained that enhanced element of perspective. It is important to obtain this perspective when attempting to convey the third dimension, which all film inherently lacks, and which in this case was part of the magic of that wonderful scene.

Problems with the Portuguese man-of-war

One of the special assignments on both trips was to film the Portuguese man-of-war, *Physalia*, and its very odd relatives, all of which are called siphonophores. The Portuguese man-of-war is famous for its near-lethal sting. Though many of its relatives are quite small, *Physalia* has tentacles up to sixty metres long and if this figure raises an eyebrow or two among biologists let me say that I have measured such a beast. Obviously a creature of these proportions poses particular problems for the cameraman. If the eighteen-centimetre-long floating bladder that bobs at the surface of the sea is wrested from the water the results are usually disastrous. Invariably the captor is badly stung by trailing tentacles. The tentacles are usually left draped over the gunwale of the boat or the edge of the bucket or net, or the tender shin of a leg. By touching the float, the animal or colony is usually stimulated into withdrawing the tentacles but seldom fast enough to recoil the entire length. So damage always results. This sort of damage is unacceptable if further detailed filming is to be conducted. Apart from this, *Physalia* also has an intriguing associate, the nomeid man-of-war fish which, in numbers varying from one to ten, lives among and closely alongside the deadly battery of tentacles hanging from beneath the float. Whenever the man-of-war is disturbed and removed

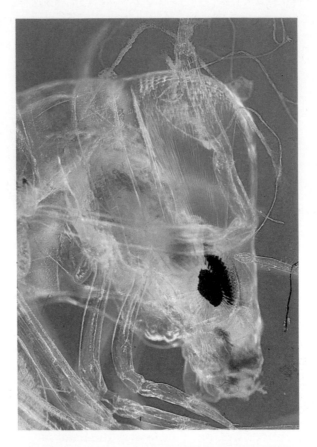

This 1 cm long amphipod crustacean is commonly found inhabiting the middle depths around 300 m and was a common constituent in our deep sea hauls on RRS *Discovery*. So we were surprised when we collected specimens on the Reef and in Bermuda.

They seek out and crawl into the exhalent orifice of floating salps. Once within (*below*), *Phronima* eats away the soft tissues. Whether it shapes the barrel or actually manufactures it we do not know. Its eyes (*left*) are also fascinating. It has four: the two outer ones look in all directions, while the inner pair, by subtending crystal-like lenses high up on top of its head, look upwards through the barrel. In the picture, the inner pair looks like an insect's compound eyes and the black retinas are behind the outer pair.

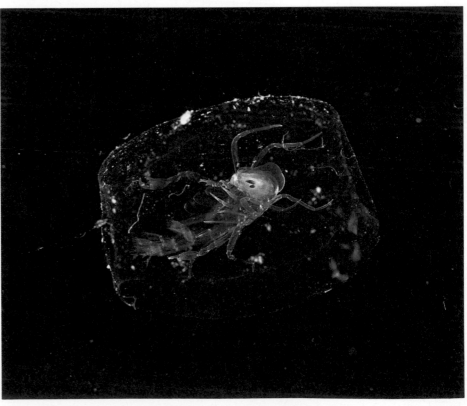

Peter Parks filming the wetting behaviour of the large gas-filled float of a Portuguese man-of-war. Exposed to the tropical sun, the float's outer surface rapidly dries, and so it must dunk first one side and then the other beneath the water every three or four minutes. Wading around bare-legged in shallow water where there are tentacles up to 60 m long, was a risky business that could have laid the photographer up in bed for a week's painful convalescence.

from the water these fish are either lost or badly frightened and consequently damaged. So, how were we going to film these creatures?

Before we departed on the trip we constructed a double outrigger system that consisted of a framework on board our five metre Avon inflatable dinghy, attached solidly to our deckboards. From this frame we suspended four drop-arms attached to gimbal-mounted rectangular floats. In the event of finding men-of-war we were able to lower a rectangular float over the animal's float and thereby prevent it drifting away from the boat and our underwater filming equipment. Where the healthy man-of-war was, so too were the nomeid fish and they too were captured. The design of the outrigger floats was such that as the boat rose and fell on waves the float still remained on the surface of the water and conformed to the surface beneath it. Unless the sea was very rough this system would operate satisfactorily. I say 'would' because although we built the equipment and took it all the way to the reef we never used it. Animals and time just did not permit me to use it on the first trip, and in Bermuda where I could have used it I was single-handed and it requires two men. We feel sure, though, that it will work well, albeit with modifications in the light of experience, and have kept it in pre-fabricated form for future use.

So, photographically, an expedition of this sort is always a mixture of techniques, laboratory, studio and field. Logistically, it is also a mixture of experiences, failures and successes, dramas and comedies.

9 Sand and salt in Iran

JOHN COOKE, JOHN PALING and IAN MOAR

It was late in April 1977. I [John Cooke] lay cocooned in my sleeping bag on a small patch of sand watching the first light of a cold, still dawn creep over the ridge above me. Not everyone would have envied my situation, utterly alone half way up a desolate mountain in the Great Salt Desert of central Iran, but I reflected with pleasure upon the events that had brought me to this remote paradise and was exhilarated by the prospect of the weeks ahead.

This was an expedition with many differences from the ones in which Oxford Scientific Films had previously been involved. Because none of us at OSF had any first-hand knowledge of Iran, we had first to make a reconnaissance trip to establish good relations with the various government departments and officials who we hoped would be helping us, and then decide upon the most suitable filming locations and subjects. Accompanied by John Heminway, an American film maker working with Anglia television on the *Survival* programmes and who had previous experience of Iran, I flew out in January to make a quick tour of the country.

At that time Iran was extremely well provided with game reserves and national parks. Their 77,000 square kilometres amounted to almost five per cent of the country. However, it came as something of a surprise to learn that, unlike other countries I had visited, the Iranian national parks were closed to the public. Their prime purpose was to provide hunting for the late Shah's younger brother, Prince Abdorezza. In fact, the wildlife did very well from this arrangement because the Prince was interested only in the animals of exceptional size or with abnormally large horns, so the majority survived peacefully. Our journey took us from the Caspian Sea in the north to the shores of the Persian Gulf in

the south and, from a wealth of locations and story ideas, we proposed to OSF just three possible half-hour programmes.

I was particularly taken by the prospect of making a film on the ecology of the Caspian Sea and its associated wetlands, and spent some time researching the theme at Sheelat, the Fisheries Research Institute at Bandar Pahlavi (now Bandar Anzali). I must admit that my enthusiasm for this particular topic was not entirely altruistic but more than a little influenced by thought of the benefits to be derived from filming the sturgeon fisheries. Caviar can become terribly addictive! In the event we decided to tackle the other two alternatives. I was to film in the Dasht-e-Kavir, the Great Salt Desert, while John Paling was to work on the island of Hormuz at the mouth of the Persian Gulf. Ian Moar, our third member of the team, was to spend the first part of the trip working with John on Hormuz and then join me in the Kavir for the remainder.

The Great Salt Desert

There was never any doubt in my mind that this expedition was going to be different, but in spite of the many problems that had to be overcome it also proved one of the most enjoyable of our many overseas trips.

My home for three months was to be the remote, incredibly beautiful and romantic caravanserai of Shah Abbas, which was built in the early seventeenth century. This magnificent stone fortress lies on the lower slopes of the Black Mountain, Siah Kuh, and looks north across barren wastes to the distant snow-capped peak of Mt Demavand, jewel of the Elburz range. The caravanserai is fed from a mountain spring, Cheshmeh Shah, by an eleven kilometre stone aquaduct,

OPPOSITE An aerial view of the serried ranks of crescentic dunes formed by wind-blown sand in Iran's Dasht-e-Kavir desert. Much of the Kavir is rocky desert with extensive salt pans and only a small area is covered by shifting dunes. The sparse vegetation is able to establish itself only in the valleys between the highly unstable dune crests.

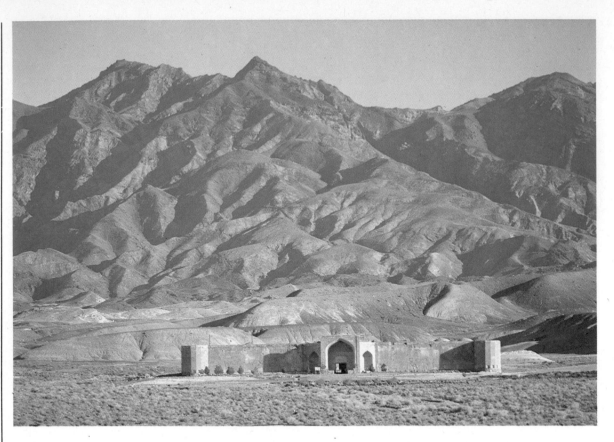

This massive fortress nestles at the foot of the Black Mountain, Siah Kuh. It was built in the early seventeenth century to guard a nearby spring and to protect the desert trade routes. The importance of this magnificent building is indicated by the fact that it is built of stone. Most other caravanserais were constructed of mud bricks and have decayed badly with age. Most damage at the Shah Abbas caravanserai has been caused by earthquakes and the ravages of the army who at one time used it for target practice!

and stands as a proud monument to the merchant warriors of bygone years who rested here on their journeys to the trade centres of Herat, Bokhara and Samarkand. Today it serves as a base for the Game Department's scouts in their operations against poachers and, from time to time, as a field laboratory for research scientists. Facilities, although not quite of five-star quality, were more than adequate. Water, albeit rather brackish, was plentiful. For my benefit a generator had been installed so that, with my lone Farsi-speaking game scout, we periodically enjoyed the mixed blessings of electrical power — mechanical devices in Iran being somewhat temperamental. From time to time we also enjoyed the sporadic luxury of an oil-powered refrigerator. A five-hour drive to the nearest town was all that was needed to fill it with fresh meat, fruit and vegetables. From this comfortable, if somewhat isolated, base my brief was to build up a motion-picture documentary showing the diversity of desert plants and animals and the way in which

they made a living in what at first sight appears a barren and lifeless waste.

Like many of the desert animals, I would be particularly active at night and therefore my first priority was to familiarize myself with the surrounding countryside so that I could navigate back to the caravanserai in total darkness. I also needed to know the location of all the small springs, as these were likely to be centres of animal activity.

In the course of these early exploratory journeys I made a special point of filming a lot of general introductory scenes. There were two reasons for this. First, the desert was beginning to flower after the spring rains and the contrast with the later desolation of summer would be striking. Also important is the fact that after living in an area for some while it is easy to take the scenery for granted. It is always sound policy to capture something striking on film when you first see it.

Some stories cannot be anticipated and must be filmed when you stumble across them. One such case was the female potter wasp I chanced upon one day. I had gone

out to film an impressive deposit of fine fossilized sand-dollars in order to make the point that at one time the Dasht-e-Kavir had been the bed of an ancient sea. Stopping by an old ruin, however, I spotted a large orange wasp carrying a ball of mud. Following her, I found her just starting to construct a cell in which to lay her egg, and which I knew she would first provision with a supply of paralysed caterpillars. Reflecting light on to the site with a piece of aluminium foil and balancing my camera and tripod precariously on boulders and camera boxes, it was just possible to get close enough to film by straining on tip-toe. In the course of a long day I managed to record the whole story, waiting for up to two hours between caterpillars. Once the mud cell had been provisioned and sealed, the wasp immediately began to build another one. After some careful sleuthing I eventually found the wasp was collecting its building material by visiting an area of dry silt about two hundred metres away, forming the ball of mud with its own saliva. Sadly, when engrossed in a filming marathon of this sort it is quite impractical to try to take still photographs as well. Bitter experience has shown that in the end both enterprises will suffer.

A few days later, while studying the social behaviour of some heavily armoured desert woodlice near the ruined caravanserai of Eynor Rashid, I noticed a large, black wasp running hither and thither over the ground,

apparently searching for something. Knowing the woodlice could wait, I decided to follow the wasp. From time to time, it would pause, tap the ground with its antennae and start to dig. Then, seemingly changing its mind, it would move on. But on one occasion it unearthed a large, plump caterpillar, which it carried for more than a hundred metres. Then, putting the caterpillar down, it began searching again but this time examined the dried gazelle droppings that littered the ground. (Gazelles defaecate at specific spots near water holes and their droppings accumulate undecayed in the dry air over many years.) After a few false attempts the wasp found the dropping it had used as a bung to stop up the entrance to a burrow. Pushing the caterpillar down the hole, the wasp then went down after it, laid an egg and proceeded to fill the burrow stone by stone until it was totally concealed. In due course the egg would hatch and the wasp grub could feed on the supply of fresh caterpillar. From the simple observation of a single searching wasp it was possible to build up a full film sequence, all shot in the open, which even included the wasps mating.

In this kind of filming the equipment tends to be subjected to stresses and hardships that would make the studio photographer wince and shake his head in disbelief. Bounding over

LEFT In the distant geological past, the central Iranian plateau was the bed of an ancient sea. In a remote valley of the Dasht-e-Kavir, the smooth rock floor is composed almost entirely of beautifully fossilized sand dollars about 8 cm in diameter. These flattened burrowing relatives of the familiar sea urchins bear witness to this history.

For much of the year, the Dasht-e-Kavir is dry and barren. However, on the rare occasions that rain does fall, long-dormant seeds spring to life carpeting the desert with flowers. *Aegopordon* is one of many species whose short-lived exuberance provides food for a multitude of insects and, in turn, their attendant predators.

the rocky desert in the back of a vehicle, screws shake loose and electrical connections snap. Precisely positioned optical elements shift and grit gets into every moving part. It is not neglect or carelessness but simply an occupational hazard of expedition filming. What it means is that in addition to being scientist and creative film-maker, the expedition cameraman must also be an enterprising mechanic. Not surprisingly we often face appalling repair bills after expeditions to foreign parts. But we have so far managed to escape one of the classic catastrophes of desert photography. A camera left lying on its back in strong sunlight for a few minutes can

Beneath one of the majestic archways of the Shah Abbas caravanserai we constructed a high-sided enclosure in which to film some of the desert's smaller, more agile inhabitants. Simulated scenes of sand and rock were carefully recreated from the surrounding desert and brightly lit with filming lights powered by a portable generator. Many animals become active after the sun has set and the temperature has fallen. Fortunately, most are not unduly worried by the cameras and brilliant lighting.

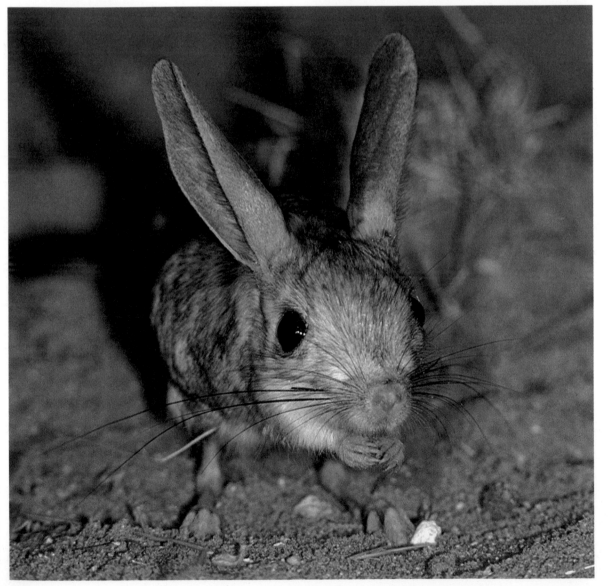

Among the most attractive of the desert's nocturnal creatures that I photographed on the set were the jerboas. These delightful seed-eaters come out on dark moonless nights. This large-eared jerboa, *Allactaga hotsoni*, is generally thought to be extremely rare and very few specimens are to be found in museum collections. However, we found it quite abundant in some parts of the Kavir. Individuals brought back for filming on the set became very tame and made excellent pets.

suffer extraordinarily expensive damage. The camera lens efficiently collects and focuses the sun's rays and it takes only a short while for a neat hole to be burned through the shutter. The effects of this are not immediately obvious and can be very costly in wasted film. At home, the photographer is used to having his film processed within only a few days, and sometimes even overnight. Should a fault develop in the camera or light meter the effects are soon spotted and the necessary steps taken. On expeditions it is very rare to get any feedback at all and you have to rely on meticulous maintenance and checking, coupled with an indefinable sixth sense that occasionally alerts the experienced film-maker to impending calamity.

A vital component of the desert story was the role of the small mammals which feed on seeds and leaves and in turn provide food for birds of prey, snakes and lizards. As they are very shy, very active and totally nocturnal there was no possibility of filming them in the wild. Apart from anything else, the throb of the generator would drive everything within a kilometre or more underground. The answer was to construct a 'set'. With the help of Ray Robinson, an expatriate American, and his wife, who worked for the Game Department, we constructed a two-and-a-half-metre-square box with high sides in which were filming ports. With innumerable loads of sand and boulders a very life-like desert was reconstructed. The first occupants were jerboas, which could be collected quite easily with a bit of agility and a large net on moonless nights when they were stopped by the headlights of the car. Surprisingly it took very little time for them to settle down and begin feeding and burrowing. Over the following weeks jirds, gerbils, hedgehogs, sun spiders, lizards, snakes and scorpions all performed on our small desert set and contributed to the final drama. Looking at the film now it is hard to recall which shots were obtained in these controlled conditions and which sequences were taken in the wild.

Although the caravanserai was somewhat inaccessible, it was amazing how often we had visitors. From time to time, Fred Harrington, an American mammalogist working for the Game Department, would fly out in his

Piper Navajo plane. This was always a welcome event, not only for the pleasure of Fred's company and his wonderful knowledge of the desert fauna and flora, but because it gave me the chance to fly. Low-level contour flying in the still early morning is not only a memorable experience in its own right but provides a valuable understanding of the structure of the desert. With a skilled pilot like Fred, it was possible to locate isolated groups of onagers, the Iranian wild ass, or herds of gazelles and, by throttling back and sideslipping in slowly, get good pictures seemingly only a few metres off the ground.

Towards the end of the expedition, as the shade temperatures daily edged close to 45°C with the advent of summer, I was joined by Ian Moar. Ian had been working with John Paling on Hormuz Island for most of the trip where conditions were expected to be harder than in the desert. Now it was my turn to have some help. The trip to Tehran to pick Ian up at the airport also provided the opportunity to send off a large consignment of film for processing in England and visit the supermarket for supplies. Ian appreciates the better things of life and it seemed cruel to deny him a few luxuries. Besides, I had acquired quite a taste for 'Chateau Sardasht' and some of the other local wines. With Ian's

One of the fiercest and most formidable of the desert's nocturnal hunters is *Galeodes*, a sun spider or solifuge. Growing to about 10 cm in length, these fast-moving relatives of the spiders and scorpions possess jaws that are, for their size, probably the most powerful in the animal kingdom. These solifuges appear during the summer months and are usually seen only as a fleeting shadow rushing into the pool of light from a lantern to seize some luckless insect, in this picture a locust. On a still night an experienced ear can detect the characteristic splintering sound as heavily armoured beetles are crushed by the solifuge's jaws.

arrival the pace of life suddenly quickened and a new sense of urgency became apparent as film flowed through the cameras at an ever-increasing rate. Each evening we would tick off as complete further subjects from our list of projected stories.

Even the weather reacted to the excitement. We were out on the crest of some dunes filming the curious sidewinding movement of a horned viper when we became aware of a black wall of cloud sweeping up from the southwest. As it drew nearer, the air was filled with continual rolling crashes of thunder which seemed to echo off the surrounding hills. Jagged bolts of lightning struck the ground along the advancing wall of blackness. I was ecstatic. Such a storm was vital to the theme of the film I had envisaged – the sudden life-giving downpour that would briefly convert the desert into a lush pasture and so ensure the continued existence of a multitude of animals. As the wall of rain and lightning approached, it seemed to reach out on either side to envelop us. High on the ridge I was ideally positioned to film

ABOVE Many insects in the desert time their emergence to coincide with the brief flowering season that follows rain. This is an unpredictable event and in many years no rain at all falls in a particular location. These large buprestid beetles, here photographed by electronic flash, fly noisily from flower to flower, feeding on nectar. This pair are mating.

Lizards are perhaps the desert's most conspicuous inhabitants for they are almost the only creatures that are active during the day. The monitor lizard *Varanus* grows to about 1.5 m in length and is a fast runner. But, as I discovered, they cannot maintain this speed for more than a few hundred metres. When cornered they not only bite fiercely but lash wildly with their scaly tails. This picture was taken with a wide-angle lens as I lay on the ground regaining my breath.

the advancing storm, but Ian, being of a practical turn of mind was more conscious of the risk of being struck by the ubiquitous lightning. He also realized that the floods that were bound to follow might well isolate us from our base and, more important, from food and drink. As the first massive raindrops struck I thrust the camera into the car, but before we had gone more than a few metres visibility was reduced to almost nothing.

As we fought our way back, the desert became a maze of roaring, muddy torrents threatening to sweep us away at any moment. Then, quite suddenly, a curious orange sun burst through the clouds to reveal a scene of unforgettable beauty. From our vantage point on a low hill we looked across towards the old caravanserai of Shah Abbas. A shaft of sunlight glanced off the old stone-work, isolating it from the black mountains behind which merged into the storm clouds rent by lightning. And overhead, dominating the scene, was a brilliant double rainbow. Every expedition deserves a bonus shot of this kind, and we had several.

The gates of Hell

While I was enjoying solitude and adventure up in the Kavir, John Paling was facing different problems, 1,300 kilometres to the south. The island of Hormuz is only a 29 kilometre journey by dhow from the mainland port of Bandar Abbas, and yet the visitor feels he could be on another planet. Strategically placed at the narrow entrance to the Persian Gulf, Hormuz has for centuries lain at a major crossroads of maritime commerce and travel. Yet no-one stays there from choice because it is a land of extremes, stretching the very limits of human endurance. It has been aptly called 'The Gates of Hell'. When Marco Polo passed by in the late thirteenth century it had a substantial population and, despite its torrid and unhealthy climate, was an important mercantile centre. Nevertheless, he clearly thought very little of it. In the intervening six and a half centuries it has declined markedly and today is home only to a small community of fishermen and iron-ore miners many of them

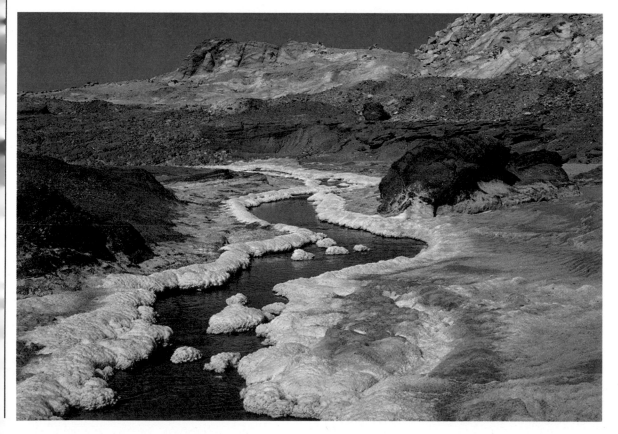

This scene is not the arctic but a scorching blistering desert. The 'ice' is salt crystals that have been produced by evaporation of the supersaturated stream water. The red colour of the river bed is due to the iron salts that make up some of the rocks of Hormuz Island. The streams flow non-stop all year round although there is very little rainfall on the island.

blinded by the disease trachoma. Only the crumbling walls of a large and impressive fort erected by the Portuguese to safeguard their spice trade with the orient in the sixteenth century, remain as a reminder of the days of relative prosperity.

There can be few areas of comparable size that are so dramatic, impressive and totally unexpected. Hormuz is a fairy tale land of technicolor hues and jagged peaks. The island, some eight kilometres in diameter, consists of a huge salt plug forced up from the Earth's inner cauldron through a crack in the crust. It should be remembered that this is one of the world's major earthquake zones where the drifting continents fret and buffet one another. (Only days before our expedition, Bandar Abbas was devastated by a quake that lifted the solid ground in a series of wave-like ripples a metre high.) As the hot salt was forced to the surface it carried with it a bewildering assortment of rocks and minerals that would make any geologist's mouth water. These have imparted to the jagged and eroded salt every colour of the rainbow. Large crystals of pyrites, also known as fool's gold, litter the ground in places, while shining crystals of haematite make the shore glitter like sequins in moonlight. In other areas red ochre, rich in iron ore, colours the sea like blood, while deposits of magnetite can deflect a compass needle thirty degrees. Hormuz is not only beautiful, it is also very mysterious.

The expedition's purpose was not just to marvel at the physical features of the island but to explore its wildlife and try to discover how anything can survive. Indeed the very first problem to overcome was how the expedition itself was to survive. The assurances made in Tehran of accommodation, transport and all manner of assistance proved groundless. Separated from Tehran by both distance and considerable ill-will, the officials in Bandar Abbas delighted in obstructing all the arrangements so generously made back in the capital. The result was a seemingly endless catalogue of difficulties, but none so great as those apparently experienced by the fauna and flora in their struggle to survive. John Paling takes up the story.

Most of the mountains of Hormuz are composed of ordinary salt which sucks in moisture from the humid air and deposits it as drops inside caves in the mountains. As more and more water oozes through, these stalactites grow. Like ice, salt crystals require a little extra care to film. An automatic exposure camera will tend to render them too dark, and similarly an uncorrected manual exposure reading will give a picture of a salt crystal that is less vivid and white than in reality. Slight overexposure on the salt is the answer.

What little we had been able to read about the island left us full of curiosity. The temperature seldom fell below 38°C and often exceeded 45°C. The humidity in summer was close to 100 per cent yet, despite the eroded appearance of the salt pinnacles, rain usually fell for no more than two days in the year. There was no fresh water and the human population depended on daily tanker deliveries. How could anything survive in such conditions? It was reported that Hormuz had its own endemic species of gazelle, which the locals believed was able to drink sea water after sifting it through its feet. On this island of paradoxes almost anything could be true.

Our first exploratory excursions showed that Hormuz supported little plant life, most of it being stubby succulents like those found on spray-blown rocky shores. However, there was, we were told, an area of climax forest that we felt would be interesting. It was. Every four hundred metres or so a stunted crown of thorns tree provided a rare patch of shade and a cluster of blossom that attracted small but interesting varieties of insects and lizards. Below the crown of thorn trees there were ant lions which dug conical depressions in the sandy ground. The insect lies in the base of each cone waiting for an unsuspecting creature, a beetle perhaps, to stumble into its pitfall trap. Then the ant lion flicks a hail of sand particles up at the prey so that it will become dislodged and fall into

the eager jaws of its well-adapted predator.

Another bold hunter associated with the trees is the praying mantis. This well-camouflaged insect about seven and a half centimetres long sits stock still until its prey comes within reach. Then, it creeps forward stealthily until it can grab its prey with dramatic backward-furling front legs. Food is so scarce that the mantids are commonly hungry. They will eat each other and, on two occasions, one had a go at me, the combination of its appetite and my passing hand apparently having sparked off an attack.

Another habitat to be investigated were the streams, which were both unexpected and remarkably beautiful. These we found in several parts of the island and, despite the lack of rain, they were well filled and flowed strongly from the two-hundred-metre-high mountains down to the sea. In this wonder-land, the base of the shallow streams is coloured a vivid rust red and the edges are white like icy snaking borders of a glacier. Yet in this scorching world, the white is far from being ice. It represents crystallized masses of salt crystals. Like stalagmites and stalactites in caves, the sight of endlessly varied white crystal formations extending between two and fifty metres at the borders of each stream was eerily unreal. Yet, like ice, it was dangerous as well. The surface of these salty edges was often thin, and below the apparent solid might be nothing but treacherous water. On one occasion Ian walked a short way from the track and went through the salt up to his waist before he hit the solid stream bottom. Had it been deeper, it would have been an impossible task for him to clamber out on to the crumbling crystalline edge.

Any hopes that the streams might contain wildlife for our film were quickly dispelled. Nothing whatsoever lived in them. They were, we discovered, ten times saltier than the sea. You could see that the surface of the water had a raised meniscus, like mercury, it was so concentrated. If we put our hands into the warm, sticky water and brought them out to dry in the air, within a few minutes the salt would cake and crack from our hands like wax.

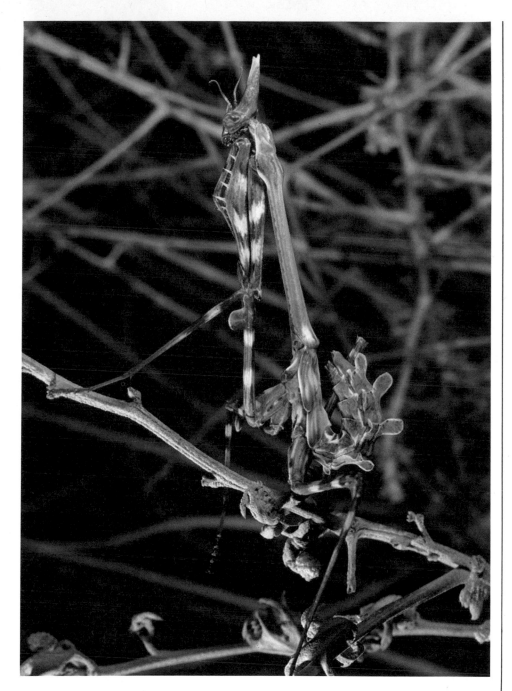

Because few, if any, scientists had explored the island, almost everything we found was likely to be new. But we had not bargained on finding a frog. It was in fact dead, mummi-fied in the crystalline salt of a stream. But it immediately raised questions that our film had to explore. All frogs need to keep their skin moist with fresh water. They also need fresh water for their tadpoles to develop. So although no frog could exist in the salt-soaked

In an environment as harsh and sparsely populated as Hormuz, predators are apt to have a hard time. To improve their chances they must combine agility and ferocity with subterfuge. This praying mantis is extremely well camouflaged as it lurks amongst the desert shrubs waiting for visiting insects. Using its large eyes to identify its victim, the mantis seizes it with the specially modified and barbed front legs.

streams, it did seem likely that there was an unknown supply of fresh water somewhere on the island. If there were, say, a large underground reservoir high in the hills, it would not only explain the frogs but also the water for the gazelle and the apparently endless supply for the streams that never seemed to run dry, despite the minute yearly rainfall.

Obviously our initial plan of investigation was to follow the streams back up towards their sources. Well away from the shore line now, we were encouraged by glimpses of more gazelle the higher we climbed. Finally each stream disappeared into a crack at the base of a mountain of salt. There was no sign of any change in the character of the streams from the point where the waters mixed in hazy patterns into the sea to where they had emerged from the hillsides above.

To pursue them further would require following their course inside the apparently solid hillside. There must be a gigantic cave system inside the mountains but we did not know how to explore it. Then by chance we came across a vertical crack in a sheer face of salt just large enough for a man to enter. Peering inside, we could see by the light of a torch another dream-like world of huge vivid white stalactites. It was so narrow that only one person could enter at a time, and quite soon the cave system narrowed to become impenetrable. Although so starkly and simply visual like a giant wedding cake in the cool moist darkness it was all rather frightening. There was no way of knowing how solid the salt was above us. Stalactites friably crashed to the ground at the merest touch. It was no place to be buried and we felt forced to retreat without, for the time-being, finding the source of our rivers.

Before leaving, we explored several small cave systems and were rewarded by finding and filming the wax colonies of the bees that feed on the crown of thorns' flowers, as well as seeing some strange wasps stocking their nests in the salt stalactites with paralysed insects for their grubs to feed upon. Sadly our filming lights kept disturbing the wasps so we were never able to film a complete sequence of what may well be a new species.

But it was down by the sea that we found the greatest diversity of wildlife. Rather than studying the open water animals, such as whales, sharks and turtles, which were not particularly associated with Hormuz, we concentrated on the creatures of the shore-line. As well as the storks and herons that hunted the margins of the beach, there were constantly moving, hypnotic, white blurs that we could not at first focus upon. Then, with patience, we identified them as hundreds of tiny fiddler crabs. The males of these species have one claw considerably enlarged – either the left or the right – with which they signal their dominance of a small patch of sand. Each builds a hole in the sand and waves furiously at males and females alike once he is in possession of his territory. The

One small area of the shore-line of Hormuz Island is made up of muddy sand and serves as the home for thousands of fiddler crabs. Unlike the females, the males have one claw – right or left – which is greatly enlarged and serves for signalling. The crab waves its large claw in a circular motion to draw to the attention of other males that he is in control of a small area of territory based on a hole in the sand.

With small creatures of about a centimetre across it is a good idea to take a low camera angle to dramatize their appearance. Such pictures are usually created in an artificial set.

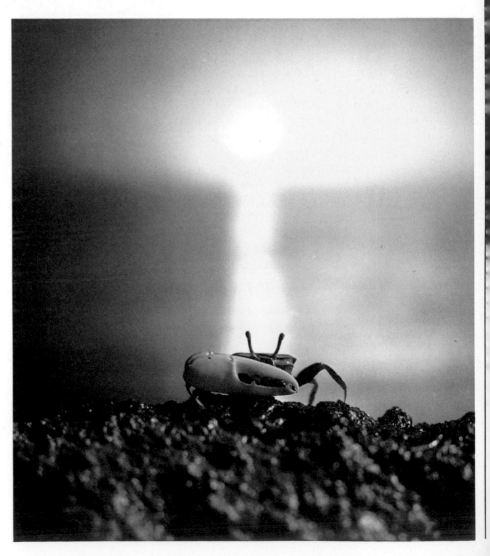

females may be encouraged to mate, treating his advances as a courtship, while the males may wrestle using their enlarged claws to throw their opponents to the ground.

Another comical character of the shoreline was the mud-skipper. Although a true fish, this seven-and-a-half-centimetre-long creature can stay in the air on the mud flats for considerable periods. Using its broad front fins like legs it can haul its body rapidly along the sand. It feeds on the fiddler crabs if it can catch them, and sometimes a battle is evidenced by a mud-skipper still gripped in the jaw by the disembodied claw of a crab, like an ichthyological punk rocker!

It was towards the end of the trip that, by chance, we finally found the source of all the stream water and solved the problem of the island's water balance. We had been collecting samples of many of Hormuz's remarkable rock types to take back to England. On one occasion I had brought the tip of one of the salt stalactites that had impressed me in the caves. I left it on a crate overnight, and when I came to move it next morning the crate beneath it was wet. The solution was suddenly blindingly obvious. Hormuz is like a gigantic block of kitchen salt; every night in the almost 100 per cent humidity it takes in water from the air and immediately absorbs it as a salt solution, which drops down inside the hollow hillsides and starts the streams. By a strange quirk of chance, Hormuz is probably the most efficient natural producer of water in the world. Yet every drop is biologically unusable. The hot air soon concentrates it by evaporation producing the salt-caked margins that had initially impressed us.

And the frogs? Well, it turned out that they had in fact given a false clue. They

were to be found under the leaking holding tanks for the population's freshwater stores! How they first got to the island we may never know, but it is clear that they must now survive and breed in the primitive drains below the houses. They do need freshwater but, like the human population, they get it from the mainland.

And the gazelle? Perhaps they do drink salt water through their feet.

The mudskipper is just 7 cm long and lives mid-way between the water and the land. The eyes are placed high on the top of the head so that it can keep a lookout while its body is still submerged. The front fins have muscular bases and serve as efficient legs which the mudskipper uses to crawl rapidly over the mud. It is able to breathe atmospheric air but it needs to keep its body and gill cavity moist.

10 Australian gums and billabongs

JOHN COOKE

Our first opportunity to visit Australia came through an invitation to do some specialist marine filming for a joint BBC–ABC programme on Westernport Bay near Melbourne. Peter Parks' contact with the Australian Broadcasting Commission's Natural History Unit through this project resulted in our being approached again the following year to participate in two further ABC films.

This was an opportunity too good to be missed. Not only is Australia a 'must' for the enquiring biologist but we were also interested in shooting some Australian sequences for a long-term project on pollination mechanisms.

The first programme on which ABC wanted us to collaborate was a study of freshwater life in the state of Victoria called *Creek and Billabong*. The second was a look at the wildlife associated with the river red gum, the most widespread of Australia's eucalypts. The expedition was to be organized as two two-man trips.

Creek and billabong

John Paling and David Thompson went out first and established themselves in a house at the Snobs Creek fish hatchery near Lake Eildon, in the very attractive and well-wooded hill country a few hours' drive north of Melbourne.

From this comfortable and well-appointed base, John made a number of excursions to film specific subjects, most notably the Murray river cod. This large fish was once widespread in the waterways of southeastern Australia but modern methods of river management have destroyed many of its former haunts. In order to film it, a special filming tank of steel and plate glass had to be constructed and then transported with considerable difficulty to a site in northeast Victoria. Eventually, when John had returned to England, the tank was taken to Snobs Creek in readiness for the second expedition which involved Gerald Thompson and myself. We went out at the beginning of 1976, a month or two after John and David had returned.

Although John had completed much of the work, which included some striking high-speed shots of dragonfly larvae catching prey with their prehensile jaws or 'mask', and some fascinating sequences of caddisfly larvae building their underwater houses, there still remained some key shots for Gerald and I to take. We had with us one of the smaller optical benches, which was kept very busy filming protists, rotifers, and the microscopic algae which are the starting point of any freshwater food chain. For the first time we could be confident about our exposures, particularly when using dark field illumination which is notoriously difficult to judge, because we had just been given for testing a new Bolex H16 camera with automatic through-the-lens light metering.

We also wished to film the life history of a mosquito, and in particular show the emergence of the adult from the aquatic pupal stage through the surface of the pond into the air above. Part of this sequence required time-lapse photography, but the interval between frames was only about one second so we had to use continuous light rather than the strobe lights we usually use, which take several seconds to recycle. In order to avoid accidental disturbance — our house-cum-studio was liable to be rocked nightly by a wombat scratching its back against the floor timbers — we set up the time-lapse gear in a garage at the bottom of the garden. By watching dishes of wriggling pupae carefully, we

OPPOSITE The black swan *Cygnus atratus* is widespread in Australia but is particularly common in the southeast on permanent bodies of water. These birds were photographed on a small lake near Eildon in Victoria by holding the camera at water level while hanging head downwards over the bank. I enhanced the low angle effect by using a wide-angle (35 mm) perspective control lens. Finally, I had to arouse the swans' curiosity and lure them in very close without provoking an attack.

could predict which individual was about to emerge by the way its body began to straighten out. From our experience with British mosquitoes, we expected an interval of several minutes between a pupa straightening out and the start of the actual emergence – quite long enough to get the subject set up under the time-lapse camera. But these Australian mosquitoes were no sluggards and I found there was only just time before the emergence began to pick out a pupa in a teaspoon and sprint down the garden with it. Visitors, most of whom were unfamiliar with the ways of film-makers, would look somewhat startled as I interrupted the conversation with a sudden shout of glee and then vanished through the window in what appeared to be some kind of demented egg-and-spoon race.

Australian mosquitoes may emerge fast but this is not true of Australian dragonflies. We had filmed dragonfly nymphs before as they climb up a reed stem out of the water and then split open to allow the adult insect to emerge and dry its wings. Although in England you might wait some time for the sequence to start, once underway the whole process was steady and predictable. Not so in Australia. Time after time our spirits would rise as a nymph climbed slowly out of the water, only to return again to the water after keeping us guessing for several hours.

Meanwhile there were other calls on our time. In collaboration with an ABC crew that had come to join us, we set up John's giant tank to film water rats and the duck-billed platypus. This was both time-consuming and extremely hazardous. In order to get sufficient light into the tank we needed lamps drawing about twelve kilowatts. These were fed from a very antiquated electrical supply in which the insulation was rotten and the fuses had been replaced by more substantial pieces of wire because they kept on blowing. As the whole set up was dripping wet it was a miracle that nobody was killed. I certainly kept as far away as possible from the shed housing this potentially lethal contraption.

However, the platypus is far too interesting to be ignored. Besides, there were, I discovered, some unexpected benefits to be derived from its study. Although the platypus

is remarkably poorly known biologically, it is nevertheless quite common. Since it was known to live in the streams running down from the mountains and feeding the fish hatchery, we decided to try setting nets at night. Because platypuses have to come up to the surface at regular intervals to breathe, we had to check the nets at twenty minute

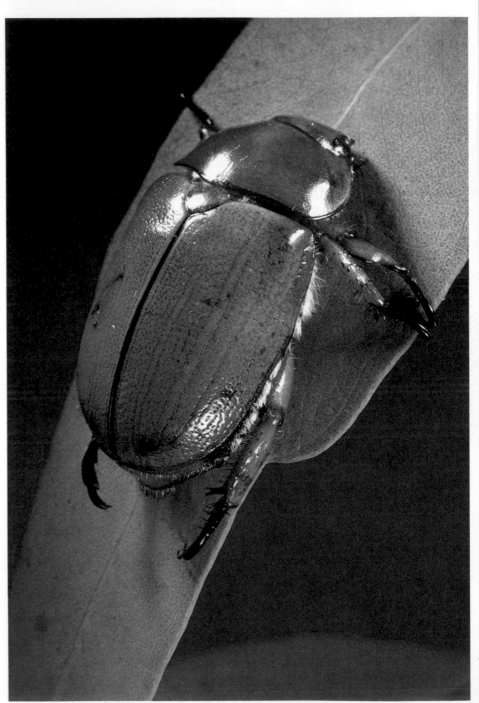

The Christmas beetle, *Anoplognathus*, is a large metallic scarab which feeds voraciously on eucalyptus leaves. The beetles mate during the Australian summer, hence their name, and lay their eggs in the ground. This is a studio 'portrait' shot.

intervals to prevent an unfortunate captive being drowned. Of course, on most visits there was no platypus, but invariably there were trout. For a brief but glorious spell we lived like lords, discarding trout more than twenty minutes old as too stale to be worth cooking.

The river red gum story

The red gum tree programme was not so far advanced as *Creek and Billabong*, and one of our first problems was to decide what subjects to include, which meant spending quite some time studying the trees and their inhabitants.

This entailed not only reading all the scientific literature we could find, but actually examining trees in a variety of locations as we travelled about collecting specific material. In essence, the film was to consist of a series of separate biological stories of particular interest linked together around the common theme of the river red gum.

An astounding number of animals live in close association with the red gum. These range from mammals, birds and reptiles down to a multitude of insects. Some of these insects are obscure or secretive but others, such as the Christmas beetle, are large and familiar. Quite the most striking of the red gum insects are the caterpillars of the emperor gum moth. Beloved by succeeding generations of entomologically minded children, these large and multicoloured creatures live well in captivity, consuming extraordinary quantities of greenery. Eventually they reach thirteen to fifteen centimetres in length and are the thickness of a human thumb. They then spin a cocoon of yellow silk in which to pupate, and camouflage themselves by incorporating into it some of the surrounding leaves. After the garish exuberance of the caterpillar, the adult moth is a disappointingly dull brown colour.

Another insect that fascinated us was the sawfly, *Perga*. Although related to bees and wasps, sawflies have larvae that superficially resemble the caterpillars of butterflies and moths. Known locally as 'spitfires', the *Perga* larvae emit an evil-smelling fluid when dis-

The caterpillars of the emperor gum moth *Antheraea eucalypti* also feed voraciously on eucalyptus leaves, growing to 14 cm. Shortly before pupation, they hang limply from a twig and rapidly change colour from green to reddish brown. At the same time, masses of clear liquid pour out of their bodies. When first we noticed this extraordinary behaviour, we thought our caterpillar was dying of a virus infection. Fortunately, curiosity prevented us discarding it, and after half an hour we watched, amazed, as it raised its abdomen and walked away, ready at last to pupate.

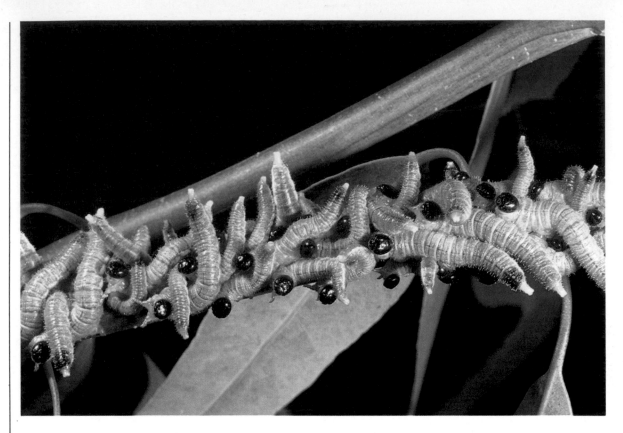

Sawflies belong to the same order of insects as the bees, ants and wasps but their larvae superficially resemble caterpillars. Species of *Perga* have larvae known locally as 'spitfires' from their ability to spray noxious fluid if attacked. They live on various species of eucalypt, feeding together in compact aggregations. At rest they align themselves head outwards and tap their bodies together when alarmed. They pupate underground, the adults emerging from their burrows in early summer.

turbed. The effect is greatly heightened by their habit of living together in tight aggregations and acting in unison. The name 'sawfly' comes from the way in which the adult female lays her eggs. Her ovipositor is a great scimitar-like blade which is inserted at an acute angle into the thickness of the host plant's leaves. By working the serrated parts of the ovipositor back and forth the sawfly gradually cuts a longitudinal slit and deposits a neat row of eggs within the thickness of the leaf.

Perhaps the most remarkable of the red gum stories involved the genoveva azure butterfly, part of which David had filmed and which we hoped to finish. This butterfly belongs to the family Lycaenidae – the Blues – many of which are closely associated with ants. The caterpillars of the genoveva azure spend the day underground in the nests of aggressive ants belonging to the genus *Camponotus*, who guard them against predators. In return, the ants collect a honey-like secretion that the caterpillars produce from special glands on top of their seventh body segment. At nightfall, the caterpillars leave the nest, accompanied by attendant ants, and climb to the topmost branches of the gum tree beneath which the ants have nested. Here, often more than fifteen metres from their daytime sanctuary and herded like cattle by the ants, the caterpillers feed on the mistletoe, *Amyema*.

To film the caterpillars and their ants at night was extremely tricky and took all the skill and patience that David could muster. The slightest vibration was sufficient to interrupt the action and once the lights were turned up all activity ceased after a few seconds. Nevertheless, the story was gradually pieced together over several weeks. David Thompson had even photographed the formation of the chrysalis and by the time we arrived there were three, each held to the inside of a piece of bark by a fine girdle of silk spun by the caterpillar and guarded by a few dedicated ants. Gerald and I hoped that we might shoot the emergence of the adult butterflies, but in fact only one chrysalis was still alive when we reached Australia and even that one died before the emerging butterfly could finish splitting the pupal skin.

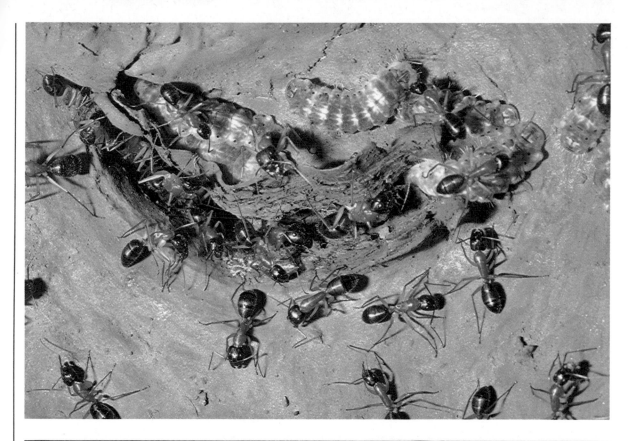

The genoveva azure *Ogyris genoveva* belongs to the Blues or Lycaenidae, many of whose members have evolved close associations with ants. *Ogyris* lays its eggs at the entrance to an ants' nest at the foot of a gum tree. The ants carry the eggs into their nest, where they hatch into caterpillars. The caterpillars produce a secretion for the ants which in return provide protection from predators and parasites. The *Ogyris* caterpillars feed only on a particular kind of mistletoe and each night the ants escort them like cattle to browse in the tree tops.

When the caterpillars of *Ogyris* are fully grown they pupate in the outermost parts of the ants' nest, often beneath the bark of the gum tree upon which the mistletoe has been growing. Even though the ants no longer derive any benefits in the form of sweet secretion, they still mount guard over the pupa and protect it from predators. The pupa is held in place by a silken girdle spun by the caterpillar.

LEFT The imperial blue *Jalmenus evagoras* belongs to the same family as the genoveva azure. The adult butterfly lays its eggs on wattle trees which are inhabited by ants. This is a close-up taken to show the egg being extruded from the tip of the abdomen. BELOW In this close-up view, one of the ants is stimulating the special gland on the dorsal surface of the caterpillar's seventh body segment causing it to release its sweet secretion. This is the caterpillar's contribution to the partnership in return for which it gains protection. This picture and the previous one were taken in the studio using electronic flash.

Although we were defeated by one blue butterfly, we made up for it, at least in part, by success with another. We came upon the imperial blue by chance only a couple of hundred metres from our home at Snobs Creek. Although not part of the red gum story, it was of such interest that we took a few hours off, spread over several days, to get a full coverage in stills. This blue lives on black wattle bushes – not all or any bushes but just certain ones year after year. The caterpillars, which live communally in silk nests, spread out daily to feed on the wattle leaves, always accompanied by numerous small black ants of the genus *Iridomyrmex*, which have underground nests close to the bushes. There are many similarities to the genoveva azure association; the ants gather special secretions from glands on the caterpillar's back and in return apparently ward off predators and parasites. Also, after the caterpillar has pupated, the ants continue to stand guard even though they now receive nothing for their pains. But unlike the genoveva azure, the imperial blue proved a highly amenable

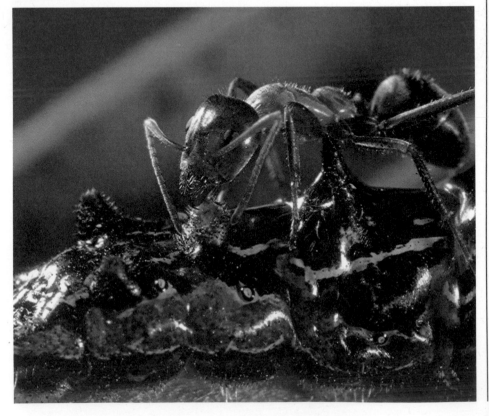

The sugar glider *Petaurus breviceps* is the best known of the five gliders found in Australia. It is widely distributed throughout the eastern forests. It nests in hollow branches and feeds at night on a variety of insects as well as on blossom and sap which it gets by stripping the bark. Sugar glider colonies have a well organized social structure in which both scent and vocal communication play important roles.

subject and we managed to photograph not only the emergence of the adult but even mating and egg-laying. Much of the photography was done in situ, but the constant wind blew the lightly built wattle about and made focusing very difficult. It is an indication of how good a subject the imperial blue was that we were able to snip off bits of wattle complete with ants and carry them both unperturbed to our studios for detailed work under controlled conditions.

But to return to the red gum filming. As with *Creek and Billabong*, not all the shooting was possible at Snobs Creek and we had to make a number of other trips. In order to get some of the nocturnal tree-living marsupials, such as sugar gliders and ringtailed opossums, we had to work in the animal house at Monash University in Melbourne where research into their biology was being carried out. In the time available, there was no question of trying to shoot completely wild individuals out of doors. Not only were the Monash animals used to human presence but they were kept in rooms in which day and night were reversed, so that they were active during the real day — a great help to the researchers and to us. Our brief was to

film the animals as if by moonlight. This we now know is seldom effective; it is far better to film with proper lighting and then let the processing laboratories introduce a blue tint and darken the scene to an acceptable degree. But on this occasion, the producer was present and so we did as we were instructed. The rooms were hung with black cloth and foliage of red gum was brought in from some distance away to create a life-like scene. The lamps were turned to moonlight with blue filters and the general level of illumination reduced still further by the introduction of a neutral-density filter in the camera. To the extent that the animals were scarcely visible, the sets could be said to have been extremely life-like. But the producer was apparently happy and so for several days Gerald and I

sat in the hot, fetid darkness, crouched behind cameras with almost no room to move. It came as no real surprise to us when, on viewing the first rushes, the producer declared them far too dark and totally unusable. It is very hard to convince people that their cherished ideas are wrong without offending them, and so wearily we returned to the gloom and stink for several more days. It is even harder to explain to an exasperated and short-tempered opossum why he has to be further inconvenienced!

Another trip was to Wyperfeld National Park in the arid northwestern part of Victoria, where we were able to witness a singularly rare but interesting phenomenon of great significance to the red gum story. In order that seeds of the river red gum may germinate

Red gum trees are normally found closely associated with water courses because their seeds can only germinate after submersion by flooding. Isolated individuals often grow to enormous size and are a characteristic and often-painted component of the Australian scenery. At Wyperfeld flooding occurs very infrequently; the trees are therefore in a marginal habitat and relatively stunted. But flood waters more than 2 m deep had submerged these trees in 1976 – and provided, for only the third time this century, suitable conditions for germination.

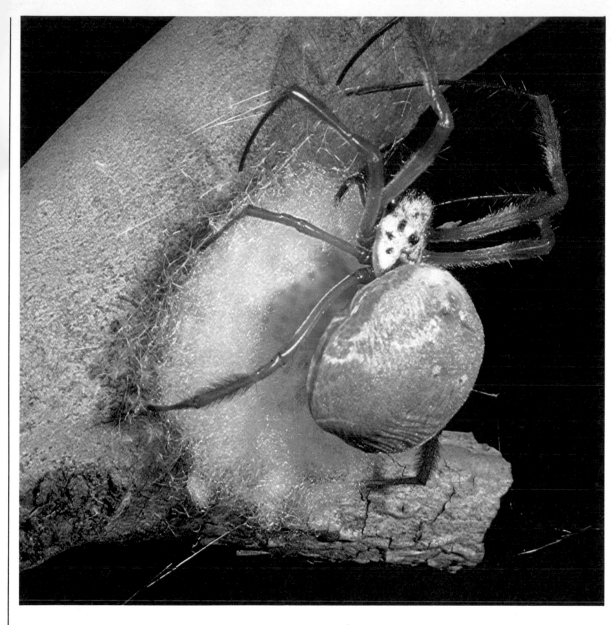

The giant orb weaving spiders belonging to the genus *Nephila* occur throughout the warmer parts of the world. They build very large orbs — often more than a metre in diameter — of a characteristic strong golden silk. Here we see the eggs being laid on a branch at night. They are extruded in a glutinous pink fluid and are then protected from dehydration and parasites by a large cocoon made of flocculent silk. The cocoon is sometimes camouflaged with lichens and fragments of debris.

successfully they need to be immersed in flood waters. As the world's driest continent, Australia cannot regularly provide suitable conditions for germination. Indeed, in many areas new trees can appear only at intervals of several years. Stands of red gum in such places are clearly divided into trees of separate age groupings.

For only the third time this century there was flooding at Wyperfeld and in this very marginal habitat the red gums were to be given another opportunity to regenerate. Rain had not actually fallen at Wyperfeld itself but about 160 kilometres away. How-

ever, the flood water had swelled back into the desert and when we arrived was standing two metres deep or more, giving the trees the appearance of a primeval swamp. Perhaps the most remarkable thing about the floods was the incredible number of insects that accompanied the water. In particular, dragonflies and damselflies, whose eggs must have lain dormant for years, swarmed everywhere. The trunks and lower branches of the trees were festooned with their empty nymphal skins.

Giant orb-web spiders belonging to the genus *Nephila* were also abundant at Wyper-

feld. These spun handsome golden webs amongst the boughs of the red gum. In addition to web spinning and prey capture, Gerald was very keen to film egg-laying, an event he had never seen in spite of having already filmed the courtship and mating behaviour of more than fifty different spider species in Britain. We knew it would involve a lot of waiting and felt that this could most profitably be done back at Snobs Creek while simultaneously filming other creatures. So a dozen large *Nephila* females were collected, driven back to the studio and induced to spin webs on large wooden frames made of red gum branches.

Although we did not know what warning we would have that egg-laying was about to happen, we felt pretty certain it would occur in the small hours of the morning so we decided to take turns at watching throughout the night. This sounds tedious, as indeed it is, but it is one of those things the film-maker simply comes to accept as one of the facts of life. Besides, it is always much easier to be patient when you know you are being paid for it. To cause as little disturbance as possible to the spider the lights were kept very low, even though once something like egg-laying gets underway not even bright filming lights will stop it. Sitting in near darkness, hour after hour, with sagging eyelids even the most dedicated watcher starts to suffer from hallucinations and imagines action when none exists.

This time luck was on our side. At 2 o'clock in the morning of our second night, Gerald watched as the spider moved slowly across its web and began to explore some neighbouring twigs. As he moved his camera into position, convinced that something was about to happen, my alarm clock sounded. It was 3 o'clock. Together we crouched in the half light as the spider started to spin a thick cushion of silk. We had ample time for both motion-picture and stills photography as this stage alone took forty minutes. Then, pressing its abdomen to the pad it had made, the spider exuded a pink stream of eggs in a glutinous fluid. This took only a few minutes, during which time there was frenzied activity as lenses were changed for different magnifications and the lights and cameras shifted for different angles. Eventually, the eggs — probably about one thousand — were all laid and the shrivelled spider began to cover them in layer after layer of silk. For one and a half hours the spider wove back and forth until, as dawn broke, the large spherical cocoon was complete.

Orchid sexuality

In addition to our work for the ABC programmes we also wished to shoot some footage for an OSF production on the sex life of plants, a study of the remarkable means that have evolved for the transfer of pollen from one flower to another. One of the highlights of our trip was a little story for this film.

Our quarry was an insignificant flower, the slipper orchid *Cryptostylis*, which occurs in open woodland a little way to the north of Melbourne. The very existence of this plant depends upon its fooling a male ichneumon wasp, *Lissopimpla*, into thinking that the orchid flower is a potential mate. Visually the resemblance is not particularly striking, at least to our eyes, but the orchid does not rely solely on appearances. Shortly after a bloom appears, it starts to give off a scent that exactly mimics the scent of a female ichneumon. The wasps are not common, so the scent has to be perceived over a wide area — perhaps as far as four kilometres away. Once lured in, the male wasp mounts the flower and tries to copulate with it by forcing his abdomen deep into the trumpet-shaped opening. Within, two little sacs of pollen joined by a blob of adhesive lie in waiting. As the wasp withdraws its abdomen, the pollen sacs come out as well, stuck to the tip of his abdomen but in such a position that, should a real female wasp appear, proper mating can take place without inconvenience. But, later, when the wasp tries to mate with another flower possibly many kilometres away, the sacs burst open covering the inside of the recipient with pollen grains.

In order to film this curious story we made the assumption that the wasp was far more widespread than the orchid. With the help of a local orchid specialist we carefully potted half a dozen plants and moved them back to Snobs Creek, where we could keep

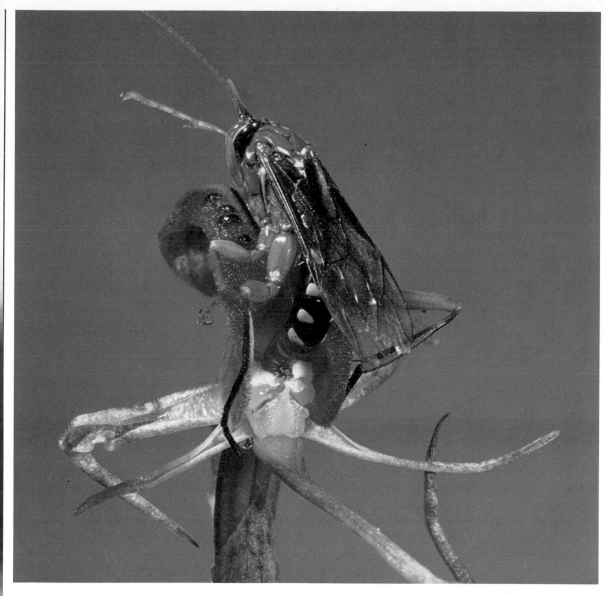

The slipper orchid *Cryptostylis* grows in open woodland in Victoria and depends upon the ichneumon wasp, *Lissopimpla*, for its pollination. The flower emits a scent that mimics the smell of a female *Lissopimpla*. The male wasp is attracted and tries to mate with the flower. In doing so, a pair of pollen sacs are attached to his abdomen. This male wasp, having visited one flower and picked up its pollen, is now attempting to mate with a second flower. The force of his abdomen against the plant ruptures the sacs, spreads their contents and so fertilizes the orchid.

an eye on them. Each orchid was kept under a fine gauze cover on the porch. For the first few days we watched in vain and began to fear that our guess about the abundance of the wasp was wrong. Then suddenly one morning we noticed that on one plant a new flower had opened. As we watched we were aware of a rather persistent insect flying around our heads and then, to our delight, a small orange wasp settled on the gauze searching for a way in. At once all other filming stopped as we set up both our high-speed and normal cameras. When all was ready and we had taken light readings, we removed the gauze covering. Within seconds the action began and, as the sweat poured from us in the heat, Gerald and I were treated to a textbook demonstration of pseudocopulation. Over the ensuing weeks we photographed it extensively in both stills and motion film. When we felt that the story was complete, the orchids were duly returned to their native woodland, unaware that they were destined to become stars of television.

11 America's west and southwest

JOHN COOKE and JOHN PALING

Whenever the word 'expedition' crops up in conversation at Oxford Scientific Films, it immediately conjures up visions of physical hardship and gastronomic deprivation in wild and inaccessible places. True, we have all to varying degrees enjoyed or suffered such trips, but not all expeditions necessarily involve isolation, pain and suffering. There are a few places where it is possible to combine the thrill of wilderness filming with the amenities of modern civilization, and some outstanding examples of this splendid compromise may be found among our American experiences.

Big Bend roadrunners

During the summer of 1975 David Thompson and I [John Cooke] were filming spiders in Arizona for a programme we were making for Anglia's *Survival* series. We were based at the Southwestern Research Station of the American Museum of Natural History near Portal, which is remarkable not only for its richness and diversity of wildlife, but also for the number of biologists who pass through each summer. One of those biologists was Dr Martha Whitson, an expert on roadrunner biology. She gave a fascinating lecture on her work and I was immediately struck by the film potential of the story. Subsequent discussions combined with an impressive field demonstration convinced me it was a project worth following up and little over a year later my film proposal was accepted. Our location was, however, to be Big Bend National Park in southwest Texas rather than Arizona.

Big Bend National Park covers an area of 2,860 square kilometres in the crook of the Rio Grande where it takes a deep swing southwards into Mexico. The heart of the park is the massif of the Chisos Mountains, which rises to 2,396 metres and from which radiates wild and inhospitable desert. A single tarmac road runs through the park which otherwise is accessible only by four-wheel drive vehicles or on foot. Big Bend is, by any standards, tough country and has long had a reputation as one of the last outposts of the wild west.

To biologists, the Big Bend has proved an area of surprising richness. The desert is a northern extension of the Mexican Chihuahuan Desert and is characterized by plants not found in other American deserts. Thus the giant Saguaro cactus, typical of the Sonoran Desert and so beloved by the producers of 'Westerns', is missing from Big Bend. Instead, you find the small dagger-like succulent, lecheguilla, a type of century plant or agave, which when growing densely proves virtually impassable. Between them, the river, the mountains and the desert provide such a wealth of habitats that more than three hundred and eighty species of bird – more than half the total American list – have been reported from the park.

I had visited Big Bend briefly in 1972 and had been entranced by its scenery and uncompromising wildness. Martha Whitson, however, had done a lot of her research into roadrunners there and knew the countryside intimately. Her advice was invaluable but a little perplexing. The biggest concentrations of roadrunners were to be found in the areas of the riverside campgrounds, where the more abundant insects and reptiles provided ample food and the birds could therefore occupy smaller and more tightly packed territories. At the same time these birds were far more used to people and would be much easier to approach and film. But the roadrunner, a ground-living relative of the cuckoo, is more typically a bird of open scenic semi-

OPPOSITE The claret cup *Echinocereus triglochidiatus* is one of the most striking species of cactus in Texas. It grows quite commonly at high elevations and flowers in early summer. This specimen was photographed on the south rim of the Chisos Mountains in Big Bend National Park looking towards Mexico. By using a 20 mm lens stopped down to f/32 it was possible to include both the plant and its setting within the range of focus. Because the exposure was relatively long the camera had to be mounted on a low tripod. Meanwhile, I was lodged precariously half over the cliff edge.

desert terrain and to show it in the sterile artificiality of a campground seemed undesirable. Fortunately we hit upon a perfect compromise. Through Martha's influence, the park authorities made available to us a remote ranch house from which to operate. Even though our food and drink had to be collected in Alpine, the nearest town some 170 kilometres away to the north, at least we had a proper kitchen, piped water and electricity. By basing ourselves in the comfort and convenience of K-bar Ranch we had the wilderness scenery we desired and roadrunners as well. We were also within commuting distance of the campground birds, where we reckoned it would be easier to film nesting behaviour.

Although the expedition ultimately fell victim to the unpredictable biological catastrophes that lie in wait for many wildlife filming ventures, in the early days fortune smiled on us. K-bar Ranch proved to be the centre of a roadrunner's territory and we soon came to know her and her mate's activities intimately.

Most people know roadrunners only as cartoon characters on television, and even those lucky enough to have seen these birds in the wild catch little more than a glimpse as a flustered individual in a cloud of feathers lives up to its name and risks death by sprinting in front of fast-approaching wheels. Authoritative ornithological texts will tell you that the roadrunner is a silent, solitary bird whose behaviour is largely unknown. How wrong books sometimes are! The bird has a rich and varied vocal armoury and Martha brought with her a series of tape-recordings of some of the calls. On our first day we went outside and played a series of dove-like descending coos. Almost at once we received an answering call from Matilda, as we were to call the female, who thought a prospective mate had at last entered her territory, an area we subsequently discovered extended almost two kilometres in each direction. As we periodically exchanged calls, Matilda slowly circled us and from time to time hopped up on a convenient boulder or dead tree to see if she could spot the intruder. Eventually we were within six metres of each other. This became a regular

procedure as the days went by. With experience I found it was possible to move slowly alongside Matilda as she went about her business, often to within only a metre of her.

Observing was one thing. To film was quite another. Camera and tripod, film, light meter, water and other essential items meant carrying between twenty and thirty exceedingly awkward kilograms through quite the most aggressive and unforgiving vegetation I have ever encountered. Almost every Chihuahuan plant possesses spines and prickles of unspeakable ferocity. Added to that was a rough terrain and a burning sun, so it was not surprising that from time to time Matilda and I would lose contact as she took a shortcut through the middle of a large mesquite bush. Once parted, the only way of linking up was to play a recording either of the strange, coyote-like barking call or of the equally curious clacking call, in the hope that she would reply. To film her successfully I had to guess her direction, get in front and set up the camera. Even though this only took a few seconds, the bird moved relentlessly and unpredictably and at best there were seldom more than five or six seconds in which to record any action before some ill-placed shrub or bush obscured the view. Nevertheless, I eventually got what I needed. This included some very attractive foraging

This century plant, *Agave havardiana*, occurs widely in the Chisos Mountains and is related to the fearsome lecheguillas of the surrounding desert. The century plants are so named because of the long period before the plant flowers. In fact the plant's life is between 25 and 55 years, but when it blooms the stalk grows at a rate of half a metre in 24 hours. Like the preceding picture, this was taken using a wide-angle lens placed close to the subject and stopped well down to enhance the depth of field.

behaviour, in which the bird flushes insects from low vegetation by jumping up with outspread wings and then snaps them up with lightning-quick pecks.

As luck would have it, on the occasions I left the camera behind and was cluttered with sound recording gear alone, I witnessed some particularly fascinating behaviour. A roadrunner seldom flies; it will climb by easy stages on to a convenient lookout point and then glide down. The only time I ever saw Matilda's horizontal powered flight, was, needless to say, when armed only with a microphone. We had been walking slowly along the foot of a boulder-strewn escarpment, threading our way carefully between the spiky desert shrubs. As we clambered over a large red boulder, Matilda a few metres in front of me, we suddenly came face to face with a large bobcat. Who was the more startled is difficult to say. I certainly stepped back in surprise as did the bobcat, and Matilda took off on a three hundred metre flight of amazing speed, emitting a call which even Martha had never heard. I hesitate to admit that during that unrepeatable event the tape recorder was switched off!

I was very fortunate in locating Matilda's night-time roost early in the trip. By good luck I was following her just as the sun was setting and was surprised to find her making a determined course apparently straight for the ranch house, where I knew a welcome drink would soon be ready. In fact Matilda nestled down in the middle of a lecheguilla clump on top of a little rocky outcrop only fifty metres from our kitchen door. As a result, I was able to resume watching immediately at dawn each day without having to scour her territory for contact. By being on the spot when Matilda started her day, I was able to observe and film a particularly fascinating piece of behaviour. As the first rays of the rising sun struck the lecheguillas surrounding her sanctuary, Matilda began to stir. Like a person roused from a deep sleep, her movements were slow, numbed by the cool of the desert night. On reaching a suitable rock, she would turn away from the sun and fluff out her feathers, exposing a large patch of heat-absorbing black skin on her back, a sort of natural solar heating panel.

By using sunlight to warm itself up from time to time, a roadrunner conserves about 550 calories an hour, a significant saving in a habitat in which food is often hard to come by.

During my work with roadrunners, I hoped to be able to capture on film the early stages of pair bonding and courtship. Several nests were found through the cooperation of campers, and eventually I was able to film the details of nest building, in which the male collects twigs and grass to present to the female, who does the actual construction. I got several shots of eggs being laid as well as the extraordinary sight of the baby birds being fed metre-long snakes, like oversize spaghetti, by their enthusiastic parents, an operation which often took over half an hour.

But to complete the picture I needed to film roadrunners mating. In this very exciting ritual the male approaches the nest bearing a goodwill offering in the form of a lizard.

The roadrunner *Geococcyx californianus* is a ground-living relative of the cuckoo and occurs widely in the southwestern United States. It is typically found in semi-arid regions with scattered low trees and bushes. On its back the roadrunner has a patch of black skin which is strongly heat absorbent. In the early morning particularly, a roadrunner will turn its back towards the sun, erect its feathers and expose the skin patch. This bird soon grew accustomed to my presence and it became unnecessary for me to use a telephoto lens.

As he gets near, he gives a call which draws the female from the nest, where she may be brooding earlier eggs, and lures her to a nearby open area. Here calls are exchanged, principally whirring sounds but also some growling and beak clacking. This accompanies a visual display in which the male's partly opened tail is wagged from side to side. Eventually the male jumps onto the female from behind and as they mate, passes the lizard to her. Immediately after separating, the birds circle one another, the male bowing appreciatively, flicking his tail and cooing amorously. To capture this story required long hours of observation. The heat and the flies had been very trying and it was late afternoon after a week of watching a pair of birds that had built an accessible nest in a low tamarisk or salt cedar bush. I heard the male call and saw the female jump down from the nest. Eye glued to the camera, I swung towards the direction of the impending action when suddenly all went dark. To my horror, an elderly couple had stepped between me and my quarry and despite my cries of anguish (accompanied, I suspect, by some quite unprofessional language) strenuously tried to engage me in conversation about a hummingbird they had recently seen. Seldom have I harboured less love towards strangers. Not one frame of this long-anticipated and hard-fought encounter was actually recorded on film. But fortunately with this particular event, the experience and watching had paid dividends and within the next two weeks I was able to get all I needed on film at this and other nests.

But although the fates appeared kind and allowed me to win several gratifying battles, the war itself was eventually lost. Key sequences proved too elusive. The hatching, the departure of the young from the nest and the subsequent family hunting as parents and young explored the undergrowth together all eluded me. Still more serious was the failure to get what everyone agreed should have been the supreme moment of drama — the fight between a parent roadrunner and a snake intent on robbing the nest. In such encounters, the roadrunner puts up a magnificent display which invariably ends with the snake's retreat and usually

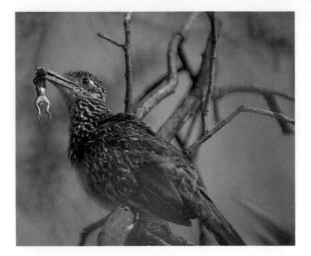

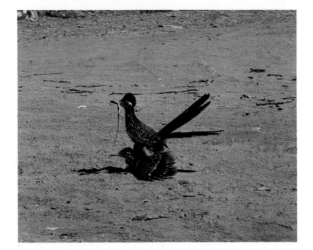

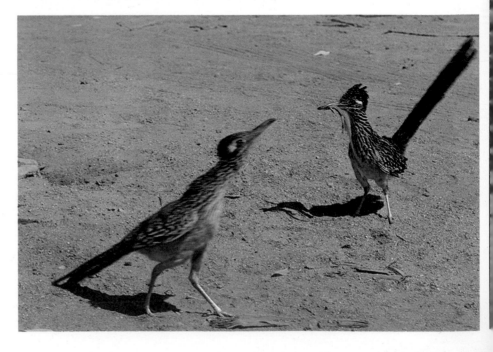

TOP A roadrunner spends much of its day foraging. Its normal diet consists of insects, which it flushes from low bushes. During the mating season it supplements this diet with snakes and lizards, which form the principle food of the nestlings.

CENTRE During nest building the male collects twigs which his mate then arranges. When the nest is completed the male goes in search of a lizard, which will be exchanged with the female during copulation. Having lured the female from the nest to a nearby patch of open ground, there is a brief courtship display before the male, holding the lizard in his beak, jumps onto his mate's back, trampling vigorously. At the climax the female reaches up and seizes the lizard. During courtship and mating the birds raise and lower their crests and periodically display the apteria, brightly coloured patches of skin just behind each eye.

BOTTOM After the female has grasped the lizard in her beak the male dismounts. In a brief post-copulatory display the two birds circle one another rapidly, the male pausing from time to time to bow, lower his head, wings and tail and give a single *coo*. He then flicks his head and tail upwards in a high strutting posture to which the female responds. With each flick, the head crest is erected and the apteria fully exposed.

its demise. But it was ridiculous to suppose that I might be present when such an event took place naturally. Instead I gave nature a little help by making sure there was a suitable snake in the vicinity.

The first problem was to find a snake. Being in a national park and hence a nature reserve I was not allowed to capture any snakes locally. I had to search outside the park boundaries, which itself meant quite a journey each night. The classic way to find snakes in this sort of terrain is to drive slowly until the headlights pick up a tell-tale shadow in the road. But snakes tend to be active only after rain and in 1977 the summer rains failed.

After numerous unsuccessful sorties, I eventually had several suitable snakes and thought that all would be well. I had some days earlier located several convenient nests with eggs or young birds in them. But at each I discovered that catastrophe had struck. Young had been carried off by predators, nests had been destroyed by marauding racoons or coatis, or the parent birds had been killed. Twelve nests in widely scattered parts of the park had all met with some natural disaster. The only nesting bird I was able to film had nothing to protect and showed only marginal interest in my lovingly introduced villain, a large black-tailed rattlesnake. After a few desultory pecks, which caused the snake to bury its head beneath the coils of its body, the bird began a display that looked suspiciously like an early stage of the courtship ritual. Eventually I was forced to concede defeat.

Tinajas and tarantulas

Fortunately, this was not the end of my association with Big Bend, a country and a way of life I had grown to love. During the roadrunner filming I had met a film producer working for the US National Parks Service who was doing the groundwork for a general film on Big Bend that would serve to introduce the uninitiated visitor to its wealth of wildlife. As a result of this chance meeting I made a return visit of several weeks in the autumn of 1979 with a brief to explore whatever habitats I wished and film whichever subjects took my fancy.

We had, of course, drawn up a list of

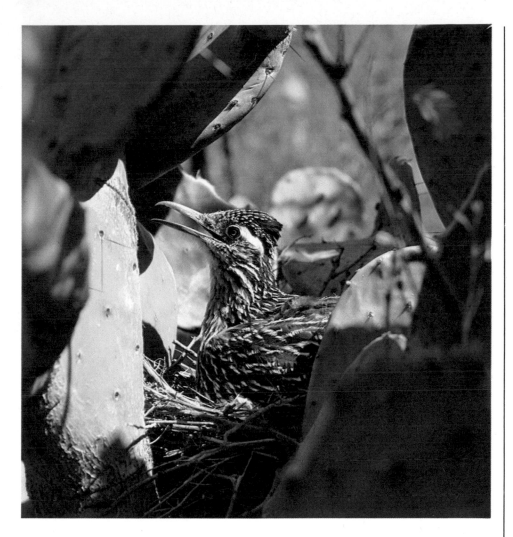

possible targets and made sure that the appropriate equipment was packed. In fact six large crates had to be airfreighted to El Paso. Included in this equipment were a small optical bench for both photomacrography and dark field photomicrography and a complete time-lapse outfit.

One of the first habitats I was to investigate were the tinajas. These are deep rock pools that have been carved out over many thousands of years by the scouring action of hard boulders. Most canyons carry water only during flash floods, perhaps once a year or less, but the tinajas never dry out completely and provide a reservoir of aquatic organisms that are on hand to exploit temporary bodies of water when the storms come. Although they can also provide drinking water for many desert animals, such as mule deer, javelina, mountain lion and pronghorn

Roadrunner nests are built of twigs and are generally constructed low down in dense bushes. The three or so eggs are laid and incubated for 20 days. For the first two weeks after hatching one of the parents remains on the nest, guarding the young against predators and also shading them from the sun. The young birds leave the nest after three weeks but remain with their parents for a further five weeks, hunting and feeding in a family unit before finally separating to lead independent lives.

antelope, most tinajas have smooth vertical sides and act as pitfall traps from which few victims escape. One in particular, in Ernst Canyon, bears tragic testimony to many drownings in the form of deep scratches in the rocks, as year after year hapless animals have struggled to claw their way out. These deep warm green pools are well supplied with nutrients and support a rich variety of life forms, ranging from algae and protists through numerous aquatic insects to frogs and snakes.

But the tinajas were not the only aquatic habitat to attract my attention. Not far from the Rio Grande, in a small spring-fed pool barely fifteen metres across live the entire world population of a small mosquito fish, *Gambusia gaigei*. Endemic fish must surely be the last thing that one would expect to find in the middle of a desert. It was with considerable trepidation that I netted half a dozen specimens, put them into a vacuum flask and rushed them back to my studio in the garage at K-bar ranch. I had hoped to film them feeding and perhaps even spawning, but after a couple of hours it became clear that they did not like the conditions provided. Either the rise in temperature made it hard for them to get sufficient oxygen or the rather brackish water at the ranch house did not agree with them. In any case, I soon decided they were better off in their pond and quickly returned them. But there were plenty of other subjects to occupy my time.

After rain, deserts all over the world spring to life. Spadefoot toads that have been buried all year erupt to the surface in response to thunder before even the first rain drop has fallen. In muddy pools across the desert a reproductive orgy occurs, filling the night air with a deafening chorus of croaks. The resulting tadpoles, as part of their adaptation to this short-lived season of ecstasy, feed voraciously on any meat they can get and develop with surprising rapidity into small toads. As the desert begins to dry out for another year, the toads use the hard pads on their hind feet to dig themselves in for a long, dark fast.

In order to film many of the more active and less predictable of the desert inhabitants, such as lizards, snakes and kangaroo rats, I built a set two and a half metres square and

LEFT In Ernst Canyon a deeply eroded rock pool, known locally by its Spanish name of tinaja, a large water jar, has been carved out of the limestone slabs by storm water flowing irregularly off the Sierra del Carmen. The tinaja never dries out and provides a refuge for freshwater life in the arid wilderness of the surrounding Chihuahuan desert. The canyon was named after Max Ernst who in 1898 established the settlement of La Noria (meaning little well) which was dependent upon this tinaja for its water supply. Max Ernst was murdered in 1908, and La Noria vanished in less than 30 years.

BELOW The set built at K-bar ranch, in which I filmed the nocturnal activities of a wide range of animals from kangaroo rats to scorpions.

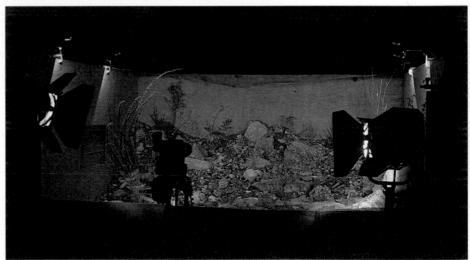

enclosed on all sides by a two metre wall. Here I re-created a section of desert in which, with the aid of filming lights, I witnessed several nocturnal dramas.

But this set was not suitable for one major story. This was the macabre battle between a tarantula and the huge blue and orange wasp, *Pepsis*, that seeks to paralyse the spider and lay an egg on it. This event takes place

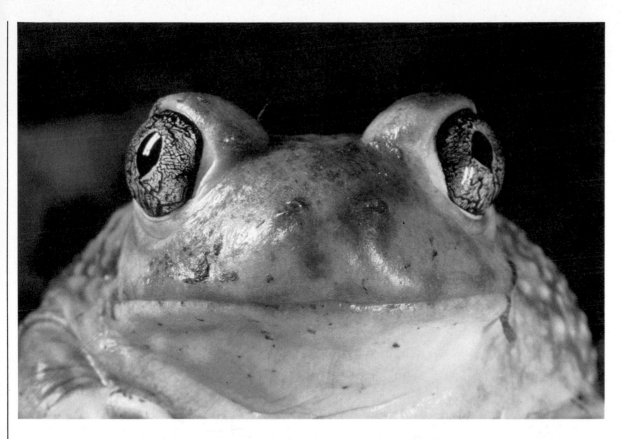

The brilliant cat-like eyes of this spadefoot toad *Scaphiopus couchi* immediately distinguishes it from the true toads, which have horizontal pupils. The spadefoots use special pads on their hind feet to burrow. They remain under ground until summer storms provide pools in which they can breed. This individual, anticipating rain, came to the surface in response to thunder.

LEFT The scorpion *Vejovis spinigera* is common in the American southwest. It spends the day under large stones or in burrows emerging to hunt at night. Most scorpions produce live young which are carried on their mother's back. They remain here without feeding until the first moult two weeks later. These baby scorpions are still quite embryonic and incomplete, and rely on their mother's sting for protection.

only inside a tarantula burrow, a fact that presented immediate problems. The first was actually to find such a burrow and the second was to get light to it. Although I had battery-operated lamps, these could operate only for a maximum of twenty minutes. Fortunately, the Parks Service was able to provide a massive generator which I installed in the back of my truck. Locating suitable burrows was now a matter of patience.

Areas where the ground seemed right I searched meticulously metre by metre, back and forth, hour after hour, in the hot sun. The desert floor is peppered with holes, each the home of a particular species, but very few in Big Bend are the right size and shape to contain the tarantula, *Aphonopelma chalcodes*. Even for the experienced observer, who knows what to look for, there is no short cut. After about a week I found two burrows close to the road on the flats that drain into Tornillo Creek, a major tributary of the Rio Grande. By the time I had located the tarantulas, the summer was past and the wasp season was drawing to a close. I knew that these large, fast-flying wasps needed copious supplies of nectar to meet their energy needs, so I started to search for suitable flowers. I found them in the canyons running down from the Chisos Mountains, where there was still some water. Up in Panther Canyon the Mexican walnuts were still in blossom and attracting a multitude of insects, among them the giant wasps.

Collecting the tarantula hawks, as these wasps are known, required considerable agility. Although it was possible to pluck one from a flower as it fed, these individuals usually proved to be males, and I needed females. These were usually to be seen or heard flying up and down the canyon at great speed just out of reach. There was no time to think. A lunge with the net, accompanied by a leap of olympic proportions would sometimes produce me a very fierce and angry wasp. More often than not, all I achieved were grazed knees.

Because the wasps would perform only when freshly caught, and the collecting site

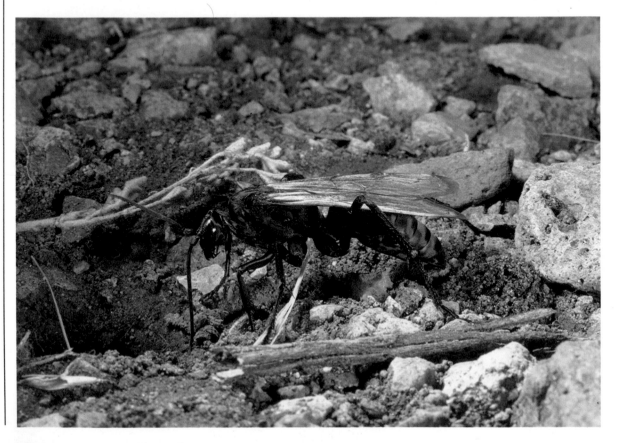

These large ferocious wasps, belonging to the genus *Pepsis*, search for tarantulas which they sting and paralyse. The wasp buries the still-living spider and lays a single egg on it. The wasp larva hatches in a few days and feeds swiftly on the fresh tissues of its immobilized host. This wasp or tarantula hawk as it is also called, has approached a spider's burrow and is about to lure its inhabitant out.

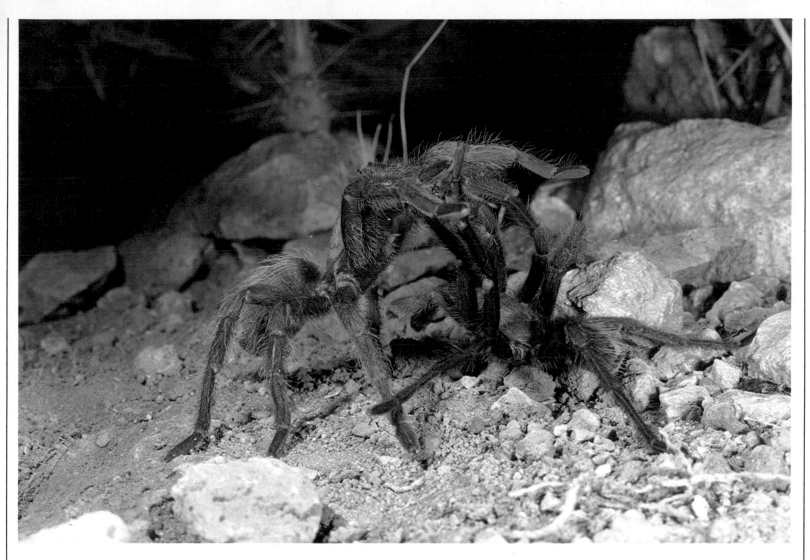

was an hour's hike from the nearest track and several kilometres away from my spiders, not many were available for each evening's filming. Most of my wasps were past their prime and showed no interest in tarantulas. And then I encountered another unexpected problem. Crouched over my camera in a brilliant pool of light in the middle of nowhere, I found at last a wasp that knew what to do. Success seemed assured. But my tarantula was obviously hungry and as soon as the wasp came close to the burrow, the spider rushed out, dragged the wasp underground and ate it – not at all what I had expected to happen. After several wasps had met the same fate I conceded defeat and moved on to the second tarantula.

This time both the wasp and spider knew what to do. As the camera turned, the wasp slowly lured the spider out of its burrow and, after a fierce battle, managed to sting it. Once numbed, the large spider was carefully dragged by the much smaller wasp for a distance of almost fifty metres. In time, the victor brought the vanquished spider back to its own burrow, down which it was unceremoniously dropped. The wasp then climbed down, laid a single large egg on the spider, and clambered out. After a few minutes preening it began to fill in the burrow until, after an hour or more, the hole was completely blocked and invisible. The wasp then vanished into the darkness. Beneath the desert floor a wasp grub would soon hatch and begin to feed on the fresh meat so thoughtfully provided by its mother.

The tarantula *Aphonopelma chalcodes* is widespread throughout the American southwest. Once mature, the male, seen here on the right, lives for only two or three months and wanders great distances in search of a mate. The female may live 30 or more years in her burrow and must be enticed out into the open by the male who taps at her entrance. During mating he uses special spurs on his front legs to engage her fangs and prevent her from killing him in the excitement of the moment.

California and the northern elephant seals

Much of the movie filming by OSF has involved the smaller vertebrates and invertebrates. If it proves impossible to film an animal in the wild, we re-create nature in our studios. Here we can control the environment rather more easily. But large vertebrates, particularly mammals, pose a problem. Filming can be done in zoos, but there is often insufficient habitat and behaviour patterns are either incomplete or abnormal. These difficulties are magnified a hundredfold when the animals are very large and aggressive. The northern elephant seals I filmed off the Californian coast are among the most dangerous animals I have ever encountered.

Elephant seals are the heavyweight wrestlers of the animal world. The males may weigh up to two tons, and in the breeding season they fight each other with unparalleled ferocity. The seals spend most of the year at sea but return annually to small islands off the west coast of America where they haul themselves on to land to breed. So it is there that a biologist-cameraman must go in order to film their life history.

In the early and mid 1970s, attention was focused on the study of animal behaviour as a source of clues and explanations to human behaviour. Several eminent biologists were speculating on the general theme of aggression in animals and man. Was there a parallel between the biology of animal aggression and human aggression, and if so what lessons could we learn from other animals?

The offer of an appointment for three months as a visiting professor at the University of California gave me [John Paling] the chance to film the studies of Professor Burney le Boeuf, a world specialist on elephant seals. Because of the behavioural implications of these studies, I found the prospect of filming the animals fascinating. But how would we get along together stuck on uninhabited islands sharing the beaches with hundreds of dangerous and smelly seals?

Professor Burney le Boeuf was a gentle, delightful man and totally devoted to his research animals. He arranged our teaching commitments at the university to maximize the time we could spend together on the nearby island of Año Nuevo where as many as four hundred seals breed each year between December and March. The island had once been used as a lighthouse station. Although the old house was still standing, it was impossible to use and was overrun by the heavy weight brigade of elephant seals and the smaller, more timid, Californian sealions. Our accommodation on the island consisted of a concrete bunkhouse which was equipped with the bare minimum of cooking facilities and crude metal bed frames, but it was in this environment that Burney le Boeuf's other interest shone. He is a superb gourmet cook and has a wide knowledge of delicious Californian wines. A metal bucket, a bottle of carefully chosen wine and shellfish prized fresh from the rocks provided a typically fitting starter to what were always appetizing meals.

Among the other pleasures of expeditions to film animals in the wild are the sensations not permitted you in urban living. On this occasion there was the clammy, salty feel of putting on cold wetsuits before mounting the tight rubber dinghy that we used to cross the treacherous straits to the island; the spring of the craft through the waves as we lay flat on top of it to minimize the chance of capsizing, with the roar of the outboard in our ears and the cold sea awash around our whole bodies; and the cords securing the equipment and provisions forging white bars across our purple hands as we clung to the bucking craft. Finally, on reaching the sandy beach of Año Nuevo, raucous with the sounds of bull and cow elephant seals roaring their reactions into the wind, we would drop into the water chest high to hold the inflatable from tipping. We would feel the surge of the waves moving the sand below our feet as we manoeuvred the dinghy along the beach to find a safe spot to haul out the boat. Keeping a sea-soaked eye on the many wide-eyed giants bobbing near us in the water, we had to run the boat ashore with military precision to avoid being attacked by any of the seals lining the beach. While wearily portering all our stores and equipment, and picking a way between slumbering seals, we felt a real exhilaration in being part of this natural environment.

Northern elephant seals were once thought to be extinct as a result of wholesale slaughter by whalers. Their home was on the islands off the west coast of California and Mexico. Here, on Guadalupe Island the last six animals were found in 1896. Through international protection, they have restored themselves to their original range and now number well over 30,000. Seen from a vantage point high up a mountainside, these adult elephant seals look like pinheads. A difficult climb up a rock face with all my camera gear was necessary to get this appealing 'establishing' shot.

The male elephant seals are the first to arrive around the middle of December. The largest may be five metres long. All have rolls of fat that wobble like jelly as they thwack their tough yet flabby bodies up the sand. The males' long and prominent noses give the animals their name. This strange protuberance, which serves as a resonator for their powerful bellows, is bigger in the older males and is a visual signal of size and dominance within the colony. The females arrive later in the month. They are smaller than the males, at about three to four metres long, and they have a small nose or trunk. They bear within their bodies one baby, the result of matings the previous year. The females haul themselves out on to the sandy beaches and cluster together in a harem or 'pod'. They scream and yell at anything that disturbs them and, in between times, flick sand over their bodies to keep themselves cool. Any shore bird that ventures too near is snapped at without warning.

As soon as the males arrive the fights begin. First they cry a warning call to advertise their presence (the analysis of sound recordings shows that each animal has a distinct voice, which presumably comes to be recognized by other resident males). If voice alone is not enough to deter one of the challengers then the combatants move in to fight in earnest. Rising on their rear halves they hurl themselves at each other, inflicting bloody chest wounds. Their bulbous eyes show white and they have to turn their heads sideways to get a clear view around the pendulous trunk. The fierce yells and resounding blows make the human observer wince involuntarily. There is no way to stop them. Using peg-like teeth they grip their opponent's chest and throat and shake mercilessly. Yet no elephant seal has ever been known to kill another. Their chests are cushioned by about ten centimetres of blubber, and these battles are the routine means for the males on the breeding ground to assert their position of dominance among those attempting to mate with the females. When one of a battling pair decides he has been beaten, he will pull back his nose to make it appear smaller as a sign

Although smaller than the males, the female elephant seals are no less aggressive. They would rip into any human intruder that got too close and they commonly attack and kill any young seal which is not their own. The difficulty of taking such a picture alone on a crowded beach is not so much the danger from the seals in front but the ones that might be right behind.

of submission. By beating a hasty backwards retreat he keeps his front to the enemy to avoid being bitten on his rear quarters as he moves away. We knew that humans could be similarly treated and I soon learnt the survival tactic of keeping a look out all around and maintaining a safety space to which to flee — a far from easy task with one eye glued to a camera.

These violent confrontations take place mainly at the edge of the colony. The most dominant bull soon takes up residence in the centre. If he can hold his place he has access to mate with virtually all of the three hundred or so cows. To be the master bull on the island requires non-stop vigilance day and night, and about three months of starvation and violence. If an intruder ventures into the colony the dominant bull will lumber over anything and anyone in his way, lunge up and crash his jaws into the body of the upstart. The squealing of the trampled females is apparently ignored in the seemingly brutal world of the elephant seals.

After about seven days on the island the females give birth. There is virtually no sign of parental care. The black 30 kilogram babies have to find their own way to the mother's nipple. Having done so, they are topped up with milk of a tooth-paste-like consistency that is nutritionally among the richest of any mammal. The most surprising thing is the lack of evident attention to the babies from the mother. If they move a few metres away and approach another female, she may well yell at them and is quite likely to snap at their heads, shake them in the air, and kill them. The real mother takes no heed. Twenty five per cent of all the pups on the island die this way before they are four weeks old.

Even if the babies stay close to their inattentive mothers the pups stand little better chance of survival. The dominant bull is seemingly unaware of his responsibilities to the newly born. In his endless task of chasing off all challengers and mating with every female in the crowded pod, he lumbers across the colony treating sand and seal alike. Twenty per cent of the babies die as a result of injuries caused through being crushed.

And there is a further cause of mortality to the hapless pups. Between January and March the stormy Pacific produces exceptionally high tides that crash up the sandy beaches and engulf much of the colony. The bulls spend most of their time fighting and mating and give no heed to the plight of the babies. The mothers could possibly hold their infants against the waves or position their bodies to protect the next generation, but they don't. Many of the pups float helplessly out to sea. Endlessly and plaintively calling, they may get washed up elsewhere on the island or over on the mainland. They simply starve to death or drown.

But all forty per cent of the pups that reach four weeks of age appear to survive, and looked at from this perspective, elephant seals are more successful at breeding than most other mammals.

The moral seems to be this. Because of the harem system, there is strong selective pressure on elephant seals to produce strong and violent males. The strongest males are the fittest evolutionarily because they will be able to control and mate with the largest number of females. Thus there is a pronounced tendency for the offspring to be aggressive, fit and strong. By virtue of his being top of the all-in-wrestling-and-keep-fit league, the dominant bull fathers a new generation of similarly styled animals.

In elephant seals the whole success of the species has been pinned on the strength and aggression of the dominant bull. Everything else has become secondary to ensuring that he holds his position. Crude though it may seem to us, the strategy clearly works well. The species flourishes.

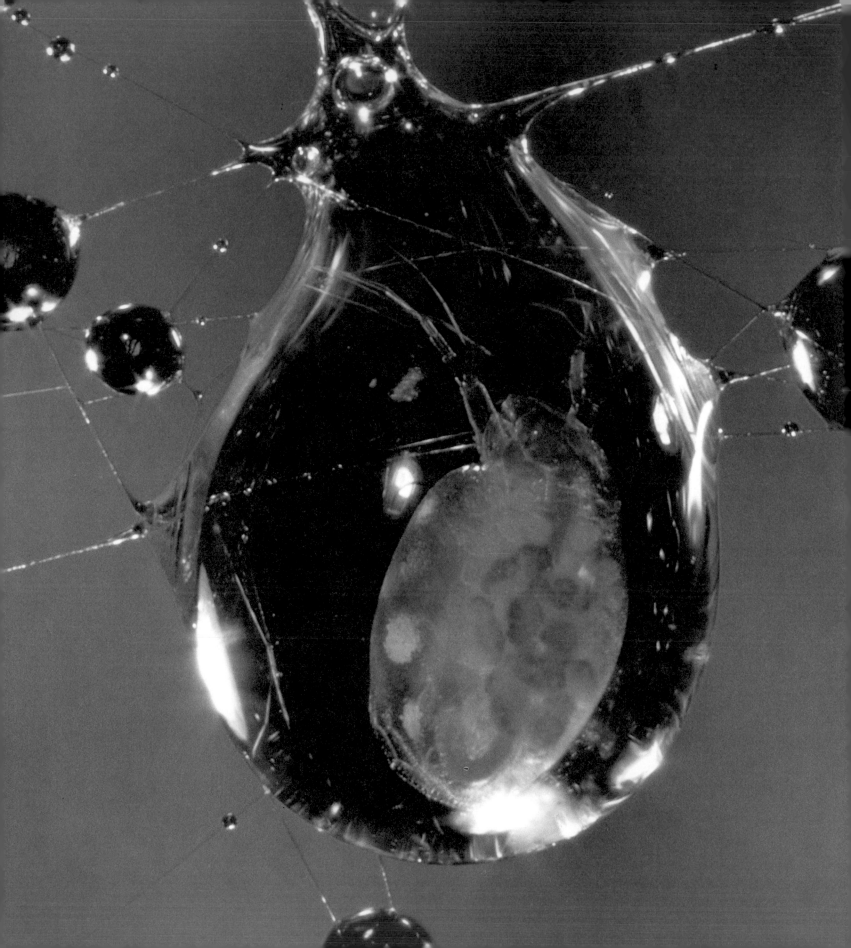

12 Natural magic
PETER PARKS

Everyone has enjoyed lying in a grassy meadow and getting a worm's eye view of life. Many of us have thrilled to the unique sensation of flying low over glorious country-side or drifting silently in crystal clear tropical waters. We have all enjoyed the sensation of turning over a beautiful natural object in the hand while closely scrutinizing it. It was with a combination of these concepts in view that we embarked upon construction of one section of our special-effects equipment, what we now call the Pathfinder, the Cosmoglide and the Stellaglide, each in turn capable of suspending the Cosmoscope and the Galactascope. These may be fancy names, but the equipment is capable of fancy shots, and it was with an eye to the feature and commercial film industries that we named them so.

Like a good fairy story, special effects should contain an element of magic, but the ingredients with which the magic is woven must be as sound as any other photographic technique. Special effects, in any aspect of film-making, rely heavily upon their perpe-trator having a very thorough understand-ing of the problem, a detailed knowledge of the medium in which he meddles and abso-lutely no preconceived ideas about how he should set about deceiving his viewers. He must deceive them or his effects will be far from special. In nature photography the same rules apply, only mixed with the ingredients is an awkward degree of unpredictability.

What really do we mean when we talk of special effects? I think initially we have to admit to failure. We have failed to film the actual event in the way we wish. So we turn to special effects to get us out of the jam and create the effect of the originally conceived event or action. The only thing that is special about it is the fact that, nine times out of ten,

the time and effort involved are prodigious. Answers seldom come quickly and easily, though the most successful effects are often the simpler options. But to complete even the most straightforward special effect it is essential that the cameraman has a very good working knowledge of the camera and lens systems being used to produce the more normal events either side of the intended sequence. For instance, if the preceding work is to be shot in overcast location conditions with a fog filter, there is little point in the effects being shot with front light, clear of all diffusion filter effects.

OPPOSITE A pregnant female water flea tosses and turns within the confines of a dew drop caught in a spider's web.

BELOW John Paling filming what really happens when a spider is flushed down the plughole and the bath is then filled. Contrary to popular belief, the spider is seldom washed down the drain. It is usually trapped in an air lock in the 'S' bend and then scrambles up the overflow pipe, to peer unobserved at the bather, in this case, Carol Naylor.

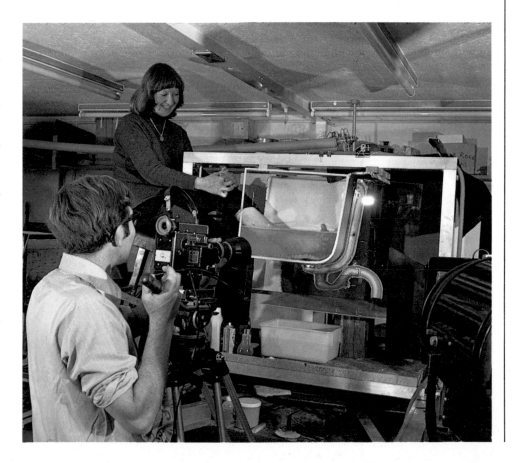

Blue screen or travelling matte

As I write we are waiting for details about a location shoot in Eire. The short but important sequence is for *Knights*, a story about the legendary King Arthur and his mentor, the wizard Merlin. We have been asked to make a branch erupt into blossom as a number of knights on horseback thunder past. The last horseman has then to knock against the branch making it sway violently. On paper this seems a straightforward shot, but there are quite a few problems.

First, we have to act fast before spring beats us and all the blossom is over. In the initial part of the take the flowers must not appear to be developing. So we must shoot at a frame rate of approximately one every forty seconds. (At a speed faster than that we are in danger of burning out the flash head tubes or overloading the controlling circuitry.) In addition, the branch has to look as though it is being blown in the wind. In time-lapse work this is not easy; mimicking a swaying action in slow motion involves moving the branch to left and right realistically, at the same time incorporating the acceleration and deceleration typical of such a movement. Careful thought about this has convinced us that a decreased rate of frames per second with its inherent slight but finite appearance of growth movements may give us the best 'wind' movement, and certainly save a complicated programme of auxiliary drives to move the branch.

In the next part of the take we create the blossoming surge by progressively increasing the interval between each of ten, or so, frames. This gives a less jerky start to the surge of blooming. It is essential that this event is carefully timed to coincide with the actual opening of individual blooms on the branch. Finally, after only three seconds of bloom, a shadow has to pass rapidly over the branch and be followed instantly by a violent knock and the kind of swaying that we would associate with a horseman knocking into the branch in the haste of the gallop. Because the flower is no longer blooming, we have only to show the branch swaying, which gives us the freedom to work again with a forty second interval, and so more easily manipulate and

complete the most complicated phase within a half day's schedule.

The branch sequence which we photograph in our studios has then to be combined with the sequence of the galloping horsemen taken on location in Ireland. But the action on the two strips of film must be combined in such a way that no ghost of the Irish background comes through on to the branch. To prevent this the relevant part of the background picture is blacked out by using a black silhouette of the branch, known as the travelling matte. In this way we can obtain a new negative of the background which fits perfectly round the original foreground. A high-contrast black and white silhouette of our branch can be produced because we have photographed the branch against a pure colour background, a saturated blue in this case. When this image is photographed again in the process camera, the appropriate filter will cut out all the light coming from the background. The background becomes a perfect black frame around the subject and a negative of this will produce the black

For a feature film called *Knights*, currently being directed by John Boorman on location in Eire, we were asked to provide some magical foreground scenes in which vegetation would spring to life as King Arthur's knights thundered across the countryside. The photograph here is an enlarged motion-picture frame from the sequence which was shot by time lapse and which condensed 4 weeks' growth into only 15 seconds. Every plant shows its own peculiar growth style and the scene has an air of reptilian menace. When the composite final scene is made, the horsemen will be superimposed on the blue background.

silhouette of the branch. This account is an over-simplification of what is in fact done, but it relates the main steps of the process known as blue screen travelling matte.

As is often the case in special-effects work, the filming of *Knights* involves several disciplines. Not only have we combined the blue screen, or travelling matte, technique with time-lapse photography but we have also had to work closely with the prime shooting on location so that we could use the same lighting effect. Hence we three-quarter back lit the scene and employed a half fog filter, while on location they used a full fog since their component was the distant, more diffuse scene most affected by atmospheric haze or mist. And finally we had to have a good knowledge of the biology of the plant. It would have been useless to have used a blossom that wilted on cutting or that ceased to open its flowers in the dark.

One of our first assignments using the blue screen system was for another film called *Heretic* (and sometimes called *Exorcist II*). This time we had to combine blue screen, flying locusts and some moderate high-speed work. Blue screen against transparent, rapidly moving wings had probably never been tried by anyone in the film world and there were some doubts as to whether the results would turn out satisfactorily. But they did. We did not even run into one of the main shortcomings of blue screen, where reflected blue highlights on the foreground sometimes appear in the final composite as transparent windows in otherwise solid objects. We had anticipated that the hard shiny plates on the locust's head and shoulders would pick up these reflections.

Snorkel systems

The same film also saw the start of a major development within the unit. We were asked to do a tracking shot through a miniature jungle simulating the point of view of a flying locust. To complete this shot we were to use a very complex system which is in essence nothing more than a snorkel. Like the snorkel of a submarine, the viewing compo-

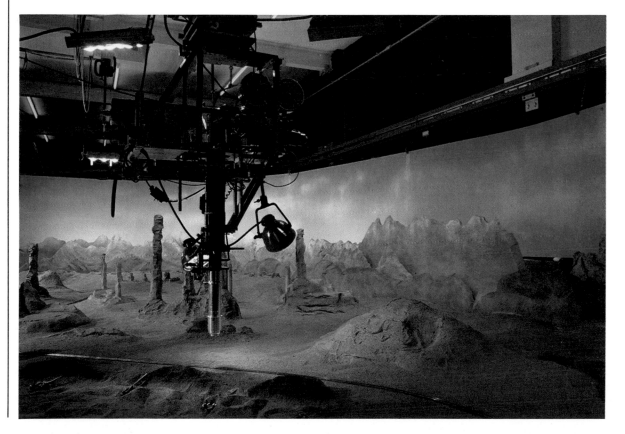

For a recent show reel we created and filmed a dramatic trans-continental train journey. But everything we did was in miniature. To give the impression that distant horizons really were far away, we built the set 15 m long, but our attentions were focused on a model train travelling fast through this landscape of gorges, minute jungles and deserts. Over this sort of scenery, the Galactoscope comes into its own. Suspended freely from the Cosmoglide, we have remote control over its movements and can make it track, twist and turn across the desert plain. It can even film within 3 mm of the sand, so we achieved some very dramatic angles not only from the air and from beside the train, but also by glancing up at it as it hurtled past.

nent is a periscope and exploits what we know as periscope optics. Indeed, we have been told that our system is largely based upon the periscope design of Second World War submarines although we developed it independently and from scratch in our own studios.

You might well ask what this has to do with natural history filming. For some years before 1972 we had come to realize that so much of what we wanted to film would benefit from a camera with three unusual abilities: incredible mobility, the ability to get very low to the ground without the bulk of the camera getting in the way, and an amazingly wide focus range. At that time we had heard of an amazing piece of equipment, designed, built and housed in the United States and called the Kenworthy Snorkel. But by all accounts it was a sophisticated piece of equipment which we had no ability or wish to copy; almost certainly it was made to do a job somewhat different to ours. So we churned over ideas as to how we could get round our problems. Most innovations came

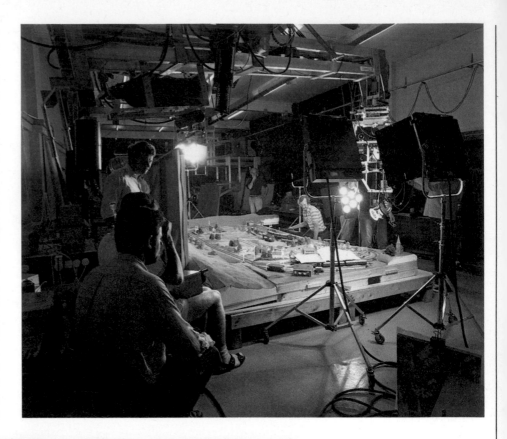

ABOVE Another leg of the same train journey tested further the enormous potential of our Cosmoscope and Galactoscope camera heads. By building lakes, rivers or ponds into the set we could demonstrate our underwater housing. We even endangered the rolling stock by completing the sequence with a high-speed avalanche. As I write this caption, we are about to film a scene in which a live person appears in the shot no taller than the train itself.

LEFT A snorkel view of the train as it passes under the small green bridge at the back and to the right of the set.

as thunderbolts from the sky, but this one arrived while I was having a bath.

Much to the inconvenience of my colleagues I set up a test of my idea on the library table the following afternoon. By tea we had actually taken a photo through the system and were sure it would work. In principle the lens is separated from the camera by a long tube up which the images are relayed. The lens tip therefore can be passed through vegetation, for example, without the bulky camera body getting in the way. The lenses permit a wide-angle view, usually between fifty and seventy degrees, and the focus can be pulled from the setting sun (infinity) to the head and shoulders of a wasp (greater than 1:1). Because of the magnification within the lens assembly, the system loses a certain amount of light but we have reduced this in successive models.

From the start seven years ago, we realized that such a lens was capable of great things only if equivalent design and innovation went into the equipment destined to suspend it. More than the camera head and lens, it was this suspension equipment that occupied most of Ian Moar's and my time for the next five years.

Three such suspension systems now exist, one weighing over a tonne and two approaching the two tonne mark. The first, the Stellaglide, was a floor-mounted pedestal crane and this retains the greatest freedom of vertical movement. The Cosmoglide has a four and a quarter metre jib or arm which resides beneath a steel frame trolley capable of travelling thirteen and a half metres down the length of our big studio. Only the floor and the ceiling limit the movement of the jib. It can rotate through three hundred and sixty degrees, as can the camera head at its tip. The entire jib can glide seventy six centimetres fore and aft and forty centimetres to left and right, and the camera head can describe similar movements. What is more, the camera lens can tilt through three hundred and sixty degrees and can see its own suspension system if we so direct it. In fact, with this combination of axes of movement the Cosmoglide can carry out most

In a special effects sequence for the Anglia *Survival* programme *The Seas must Live*, our cameras drifted through nearly one thousand 'kilometres' of mid-Atlantic rift valley before branching off past the mountain on which stands Bermuda and so on to the Hudson Canyon and New York. The Atlantic ocean floor was a model 14 m long of expanded polystyrene, daubed with plaster and sprayed with paint. Our New York was made of plasticine and our Bermuda of hardboard. The set took 6 weeks to build – 3 of which were spent waiting for the plaster to dry.

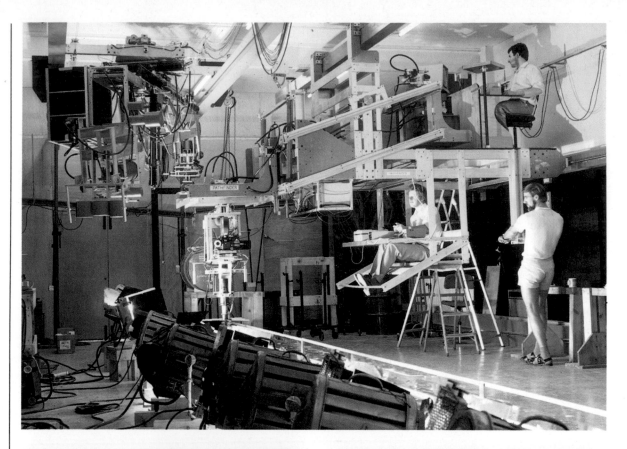

The scene we were to capture was that of a glass-domed spaceship weaving between the meteorites of the rings of Saturn for the feature film *Saturn III*.

TOP We built a tank nearly the length of our large studio and filled it with liquids of different specific gravities and refractive indices. In it we suspended the 'meteorites'. Through the bath and behind our model spacecraft, we flew the Galactoscope, clad in an underwater housing.

BOTTOM LEFT With complex, multiple moves of both the camera and spaceship we simulated rolls, ascents, descents, accelerations and decelerations in, over, through and under the meteorite fields.

BOTTOM RIGHT Some of these shots provided the pilot's view from within the cockpit, and in others the spacecraft and meteorites were combined to produce spectacular space scenes.

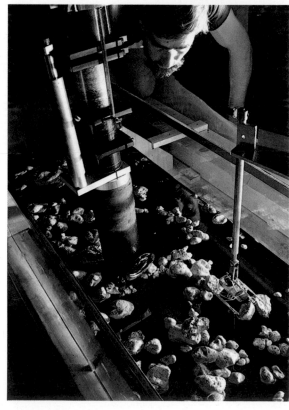

desired moves and combinations. The most recent Pathfinder could track for twenty seven metres, while rotating, tilting and rolling in any combination (in and out of water if necessary), craning (up and down tracking) and dollying (left and right tracking), coming to rest focused at, say, 1:2 upon a plant stem and at the same time describe an ascending spiral round the plant stem. And to crown this final move it could also barrel-roll while ascending! But it is unlikely that we would need this complete repertoire in one go.

Some of the projects upon which we use these three systems have a physical, geophysical or geological bias. In 1978 we were asked to construct and film over a twelve-metre-long model of the floor of the North Atlantic. The same year we simulated a space flight through the ice meteorite zone of the rings of Saturn. To carry out this project we had to construct an underwater housing for the Cosmoscope and Galactoscope snorkel heads. This very successful piece of equipment was also used by Ian Moar and David Thompson when filming for a Paramount feature film *Land Between Two Rivers*, directed by Terry Malick. They set out to film a shoal of fish, by moonlight, in a channel occupied by a mean-tempered alligator snapping turtle capable of clipping fingers from a human hand with ease. Just to complicate the issue, into the channel descended a small but continuous waterfall. Not many feature film cameras are capable of operation in that sort of set, especially as Dave and Ian had built their channel only twenty centimetres deep at the deepest point, ten centimetres at the shallowest and thirty five centimetres wide, and our camera passed right through the waterfall.

That film has involved us in a variety of other biological special effects. Sean Morris and I worked on it for much of the summer of 1979. Sean had to try to film a developing chick embryo from within the egg and to do it in such a way that he could track around and over the embryo at the same time. Terry Malick particularly wanted the stages from fertilization to the sixth day of development, during which period the embryo grows from about one and a half millimetres of static opaque white tissue to fifteen millimetres of

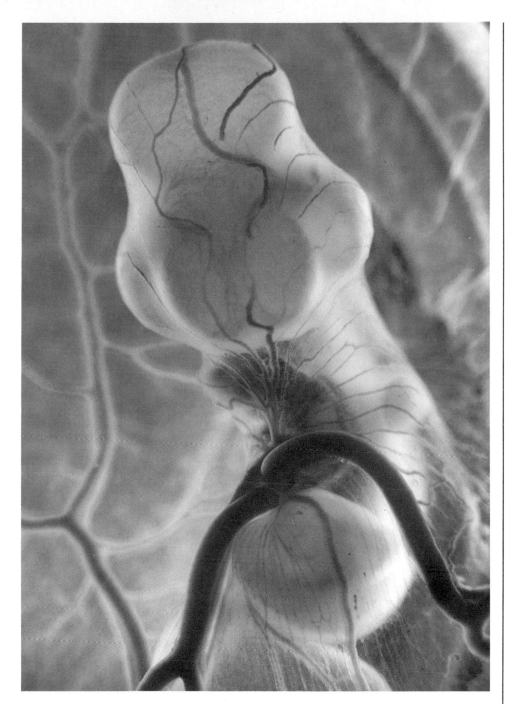

throbbing pink tissue suffused with delicate blood capillaries. Not only had we considerable magnification problems to cope with but we had also to hold those magnifications and the resulting depths of field while tracking around with the camera, or, even more difficult, while double rolling the camera, a manoeuvre which involves rotating the camera or object around the camera axis

In our portrayal of the entire life of a chick within its egg, every shot had to give the observer the feeling of being inside the egg with the chick and being free to move around the developing embryo. To give the free-flight feel about our shots, we had to add to the optical bench's existing axes of movement and experiment with new light sources from unusual directions.

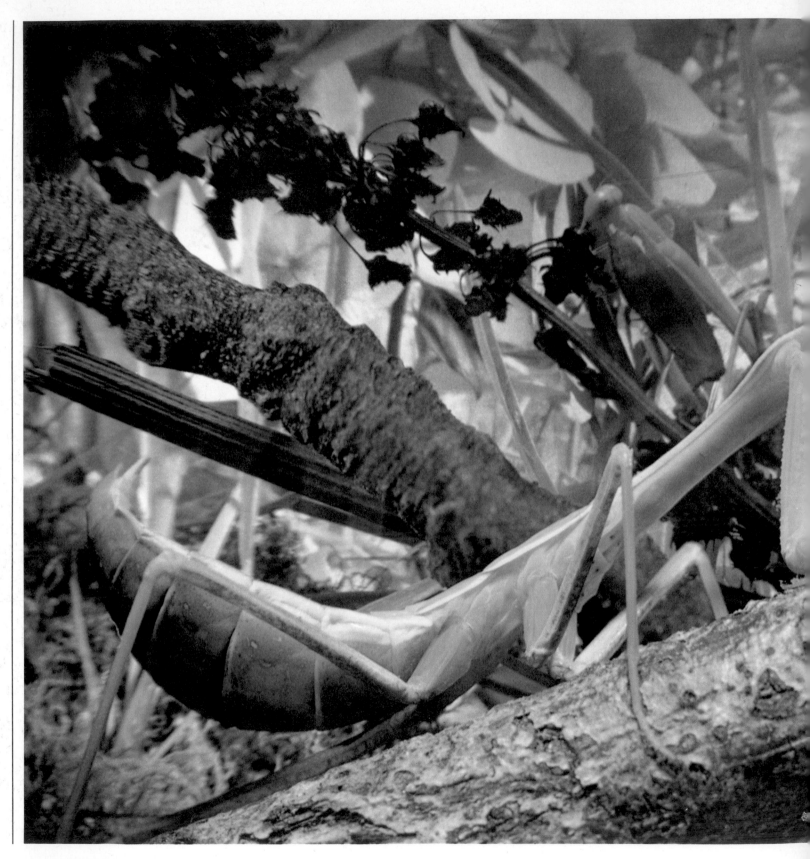

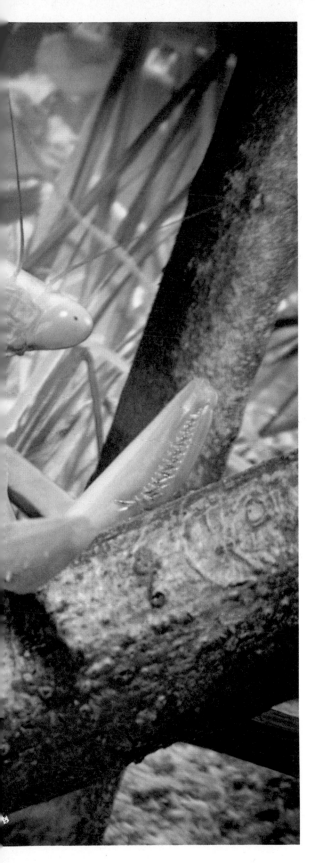

at the same time as turning the object around a vertical axis. Meanwhile we had to illuminate the very delicate embryo with sufficient light to permit our using a T8 microzoom lens system, at the same time producing as little heat as possible. This zoom is a 5:1 system and there is a difference of five stops in the light levels required between one end of the zoom range and the other. Five stops beyond T8 is T45 and it is to this level *at least* that the little embryo had to be lit before we could use the zoom range to its full potential. On top of this is the laborious technique Ian and I developed some years ago to incubate, culture, extricate, suspend and maintain these early embryos outside the egg. But between us we succeeded in achieving some remarkable footage, and I have now only to add some extremely high-power magnification sequences and shots. These shots will entail magnifications up to two hundred times on the film emulsion and will clearly show individual blood corpuscles as they throb through the blood complex of the embryo's amniotic sac. As the book goes to press, I can confirm that we have completed these sequences successfully and have now extended the study to the first seventeen days of a chick's life.

Aerial imagery

Last year I began some work on freshwater micro-organisms with the aim of filming single-celled creatures swimming within a single drop, at the same time placing that drop in a panoramic scene. The challenge was to keep all the components of the scene in pin-sharp focus at one camera-take. It was to achieve just such an example of optical magic that we have designed and built a series of aerial image optical benches over the past six years.

What this system does is to combine foreground, midground and background scenes, as sharply defined as required, with subjects which normally could not be focused upon simultaneously. By the same device, a man can be dramatically reduced and combined with a foreground image which makes him look no bigger than a single drop of water. It was my task to combine a water drop

The aerial image relay system allows us to manipulate backgrounds to bring them all into or out of focus as we will. The second mantis is 60 cm behind the first, and the background is almost as far behind again but we can make them both pin sharp. What we cannot do is to alter the depth of field within one subject. The right fore leg of the front mantis is only half a centimetre in front of the mantis' body but it is already soft.

A single drop of water falls from the roof of a primeval cave. Behind steams a tropical jungle. The cave is only 1 cm across, the roots sticking out of the left hand wall are the fibres of a piece of black paper. The stalactites are extruded rubberoid adhesive. In the motion-picture sequence, the drop repeatedly fills and falls, and each time it does so, a community of microscopic organisms swim within it like goldfish in a bowl. We used aerial image techniques on a very small scale to secure this scene.

forming in the foreground from the stalactite-festooned roof of a cave with a panoramic scene of a primeval steamy jungle clearing beyond, while within the drop had to swim a number of single-celled organisms. The drop had to form and fall repeatedly and each time it filled it had to contain a variety of ciliates and colonial algae.

I constructed the cave of black paper and a rubber-like adhesive called gurasil. The fibres of the torn black paper gave a very good impression of rootlets projecting from the walls of the cave. The black gurasil, suitably 'pulled' before setting, produced a fine range of stalactites. The water drop was filled through a glass tube within the stalactites, in turn fed by a siphoning self-regulating capillary that was superbly regular in its fill and empty cycle. It was possible, with this simple device, to produce a repeating drip falling from the cave roof. The drop was lit conventionally, but in addition some illumination was brought down the glass tube via a flexible light guide, while a second light guide at the side lit the drop for the desired

highlight. Although Terry Malick did not care for the background scene we chose, it proved to us that this technique was successful even when we used magnifications up to 20:1 in the foreground.

As we could photograph that particular set with our microzoom lens system we were able to zoom into the drop until it completely filled the screen —a beautiful bonus. And yet throughout the zoom range we never lost focus on the background scene. This is one of those pleasant byproducts of a system that all too rarely works to your advantage. Normally, as soon as you zoom in on any foreground subject, thereby effectively increasing the focal length of the lens, you rapidly lose *apparent* depth of field and hence focus on the background. In a microzoom lens system you also lose light dramatically. With aerial image relay systems though, if the design and application are correct, there is no loss of focus or *apparent* reduction of depth of field as the prime lens is zoomed. But the light loss factor with the microzoom has, of course, still to be allowed for.

The aerial image technique has now produced some fabulous scenes for us. Not all are applicable to nature photography. But some combine drama and natural history. The combination of a live tarantula and two people, no bigger than the spider, in the same scene still impresses. Yet this particular film sequence was shot four years ago at Shepperton Studios when we combined forces with some colleagues in an attempt to tackle the very real technical problems involved in a production called *Micronauts*.

It is partly as a result of *Micronauts* and the challenge set us by Don Sharpe, the director on our second attempt, that several techniques described in this chapter were developed. And it is as a result of our aspirations for our future projects, which include two feature film fairy stories with a strong natural history emphasis, that the techniques have been perfected and the hardware completed. It is no exaggeration to say that at Oxford Scientific Films more than a quarter of a million pounds worth of hardware has been constructed during our research into aerial image relay techniques and periscope camera technology. The cost of the man hours expended must raise the investment above the million pound mark. We now have ahead of us the challenge of proving that it has all been worthwhile. Initial indications imply that the decision was a wise one, but it is still early days and our fingers are crossed for the future.

Hints for the photographer

Motion-picture photography

The average home movie-maker pays a lot of money for equipment but then makes little or no attempt to learn how to get the best results. The common faults are:
hand-holding the camera, which wobbles like a leaf in the breeze;
swinging the camera around so fast that nothing is seen clearly;
zooming in and out with great frequency.

These faults are compounded in general by a lack of editing, even to the extent of arranging events in chronological order. In professional films the footage shot is usually about 12 times the length of the edited film, although it can exceed 30 times.

The application of some simple rules can improve the product enormously.

— Focus the camera eyepiece.
— Keep the camera clean, paying particular attention to the prism and the gate, which seems to attract hairs that are then in focus on the film.
— Check that the filter holder is fully home.
— Clean lenses (and camera) with compressed air. Never scrub them with a handkerchief, or anything else.
— Check that the camera is loaded before filming.
— Ensure that the film is properly engaged in the take-up spool; if it isn't, the camera will jam.
— Try to avoid high contrast subjects. If they must be filmed, use a neutral grey card for exposure measurements.
— When filming towards the sun, take the meter reading from the ground.
— Use a tripod at all times, except for special effect. (If camera is hand-held overcranking will slow down unwanted shake.)

— Buy the best pan-and-tilt head you can afford.
— Tension the pan-and-tilt head so that it operates smoothly.
— Pan from left to right as a rule. This seems to be more natural for right-handed viewers.
— Pan much more slowly than you think is necessary. In general, half-speed is correct.
— Start and stop a pan on something of interest.
— Run the camera for about 7 seconds before starting and after finishing a pan. This increases the choice of shot.
— Zoom only for a definite reason. Again, hold a shot at the beginning and the end. These parts may be useful.
— Zooms should be smooth and jerkless. A high proportion will be useless.
— Focus a zoom lens in the 'zoomed in' position.
— With a clockwork camera, rewind the motor at *every* opportunity.
— With a battery camera, charge the batteries the evening before use and *carry a spare*.
— Use a long cable release so that stop/start and pan-and-tilt can be operated with one hand, leaving the other hand free to focus.
— Use elastic luggage straps between camera and tripod to counter-weight a top-heavy camera when it is pointed towards the ground.
— Use a front-surfaced mirror for views from below; an ordinary mirror produces ghost images.
— Clapper each roll of film, *i.e.* shoot a few frames of an identifying number.
— Place a piece of paper or other kind of cover over a camera set up in hot sun. Likewise, refrain from placing a loaded camera in the sun in a closed car.
— Protect the camera from rain or blowing sand with a plastic bag.

— Use a polarizing filter to reduce reflections, particularly when filming into water against the sun.
— Make sure exposed film goes into the correct box if more than one stock is in use.
— Put a tape *across* the tin to signify that the roll has been exposed.
— Use a reminder system to ensure that any appropriate filter is not forgotten. If a filter is omitted, tell the processing laboratory; they can apply the necessary correction.
— Use a windbreak to protect a long focus telephoto lens.
— Avoid attempting fades 'in camera'. It is better to let the laboratory insert all such effects.
— If possible prepare a shot list before beginning the film.
— The experienced cameraman thinks like an editor while he films, and changes the angle and magnification every 10 seconds or so unless the action is compelling.
— Avoid 'jump cuts', *i.e.* 2 adjacent shots of the same field size and point of view with a gap in the action between them.
— Avoid filming within 2 hours of sunrise and sunset unless a red cast is wanted or correcting filters are used.
— Do not mix daylight and artificial light. Film is balanced for one or the other.
— Pay attention to continuity.
— Remember it is preferable to do a simple shot well than a difficult shot badly.

Stills photography

Many of the hints given on motion-picture filming also apply to stills photography.

— Whenever possible use a tripod.
— If a picture must be taken with a hand-held camera reduce the chance of camera shake by using as high a shutter speed as possible.
— The longer the focal length of the lens or the higher the magnification, the shorter the exposure time should be. With a 50 mm lens it is unwise to shoot with an exposure longer than 1/50 second.
— If the entire image is slightly but evenly blurred, possibly with double or multiple outlines, suspect camera movement or vibration.
— If the subject itself, particularly a living subject, is evenly blurred, suspect subject movement.
— Be meticulous in getting the best exposure for a particular scene. Under-exposure destroys shadow detail and over-exposure burns out highlights. Incorrect exposure can also upset the colour balance of a picture. Bear in mind that through-the-lens and other reflected light meters provide an average reading over the whole field. So it is necessary to increase the exposure for small dark objects against a light background.
— Back lighting can be very effective but may fool your meter into under-exposure. Professionals often use incident light readings or spot meters in difficult situations.
— Avoid dull flat lighting. Shadows and highlights add interest to a picture but remember that film cannot accommodate too wide a range of brightness. To avoid excessive contrast it is usually necessary to use more than one light source or alternatively to use reflectors.
— Dramatic effects can be obtained by shooting into the sun or other light source. When doing this take exposures above and below the apparent exposure.
— Watch out for flare which can reduce contrast, colour saturation and definition. This can be very difficult when using flash, particularly when there are shiny surfaces either in the picture or just out of it.
— Remember that in any photographic situation filmstock is probably the cheapest component and it is a false economy to be timid or miserly.
— If a picture seems worth taking, experiment with different exposures, magnifications and angles in order to get the best results.

Glossary of natural history terms

Words in *italics* are to be found as separate entries.

Abdomen In *invertebrates*, the posterior part of the body.

Algae Predominantly aquatic unicellular or multicellular plants of comparatively simple organization, lacking a vascular system and containing *chlorophyll*.

Amphipod A freshwater or marine, shrimp-like *crustacean*, characterized by a laterally compressed body.

Annelid A segmented worm. The *phylum* Annelida includes the common earthworm.

Arthropod An *invertebrate* belonging to the phylum Arthropoda which includes *crustaceans*, spiders, insects, millipedes and centipedes. Arthropods are characterized by a tough *exoskeleton* and a large number of jointed appendages in the form of jaws, legs, gills or sense organs.

Bacteria Unicellular microscopic organisms found in soil, water or parasitic on other plants or animals.

Bioluminescence The production of light by living organisms.

Blood corpuscles Cells in the fluid of the blood. In *vertebrates* there are two main types: red, which carry oxygen, and white, which help to prevent disease.

Blubber The thick layer of fat characteristic of marine mammals, such as seals and whales.

Capillary A minute blood vessel, for example one of the network in the body's circulatory system that carry blood to and from the cells.

Carnivore An animal or plant that eats freshly killed animals.

Chlorophyll The green pigment found in plants which absorb light for *photosynthesis*.

Chrysalis The *pupa* of a butterfly or moth.

Cilia Small hair-like filaments on the body surface of ciliate *protozoans* and many other *invertebrates*. They provide locomotory power by synchronous beating.

Cocoon A covering for eggs; a protective silken casing for the *pupa* of an insect.

Coelenterate A freshwater or marine *invertebrate* with a radially symmetrical sac-like body. The single opening is at one end, usually surrounded by a ring of tentacles. The phylum Coelenterata contains sedentary forms called *polyps* and free-swimming gelatinous *medusae*. It includes the corals and sea anemones, jellyfish, *hydroids* and *siphonophores*.

Comb jelly Member of a phylum of marine organisms which superficially resemble jellyfish; comb jellies have conspicuous external rows of *cilia* (comb plates) and some species have trailing sticky tentacles to catch prey.

Copepod A freshwater or marine *crustacean* lacking compound eyes and separate shield covering head and thorax.

Crustaceans A large group of mostly aquatic *invertebrates* including *amphipods*, *copepods*, crabs, lobsters and shrimps.

Diatom A minute *alga* with a highly ornamented cell wall, found principally as part of the freshwater or marine *plankton*.

Dinoflagellate A *protozoan* characterized by two long hair-like filaments (flagella) by which the organism swims. Dinoflagellates are part of the *plankton* and possess both plant and animal features.

Embryo A plant or animal in the very early stages of development.

Epiphyte A plant living on the surface of another plant, but not obtaining nourishment from it.

Endoskeleton A skeletal structure wholly contained within an organism.

Euphausid A small marine shrimp-like *crustacean*, an important component of *krill*.

Exoskeleton A tough supporting structure forming the outer surface of the body.

Genus A *taxonomic* group consisting of closely related *species*.

Guano Excrement, particularly of bats and sea birds.

Habitat The external environment in which a plant or animal lives.

Herbivore A plant-eating animal.

Hormones Substances produced in one part of an organism, which have an effect on another part; chemical messengers within the body.

Host An organism in or on which another organism spends part or whole of its life and from which it derives nourishment or gets protection.

Hydroid A member of the *coelenterate* class *Hydrozoa* in which the *polyps* are usually well-developed and the *medusae* reduced.

Hydromedusa A small, transparent *medusoid* form, the free-swimming stage in the life cycle of a *hydrozoan*.

Hydrozoa One of the three classes of *coelenterates* including the *hydroids* and *siphonophores*.

Invertebrate An animal without a backbone.

Krill Planktonic *crustaceans* that form the food of whales.

Larva A young and often mobile stage in an animal's life cycle, usually very different in appearance to the adult form and incapable of sexual reproduction.

Liverwort The common name for a primitive plant related to mosses found in damp places, which reproduces by means of spores.

Medusa The free-swimming stage in the life cycle of a *coelenterate*. In true jellyfish, the medusa is the dominant and conspicuous stage.

Meganucleus The larger of two *nuclei* found in some *protozoans*, responsible for regulating the normal metabolic functions of the cell.

Metamorphosis The transformation in form and structure from a larval to an adult form.

Micronucleus The smaller *nucleus* of some *protozoans*, responsible for cell division.

Micro-organism A microscopic organism, for example a *bacterium*, *virus* or *protist*.

Mite A small *arthropod* related to spiders, with an unsegmented body and four pairs of legs.

Mollusc A soft-bodied *invertebrate* often possessing a calcareous shell. Included in the *phylum* Mollusca are slugs, snails, squids and octopus.

Mucus A slimy substance secreted by special membranes or glands.

Nectar A sweet viscous fluid produced by plants to attract insects and other pollinators.

Nucleus A compact body present in most plant and animal cells and containing hereditary material essential to life.

Nymph Insect young which hatches out in a state which closely resembles the adult, but has undeveloped wings and reproductive organs.

Ovipositor A specialized external structure adapted for egg-laying.

Palp A sensory appendage, usually near the mouth, in many *invertebrates* (and some *vertebrates*). In male spiders the palps are specially adapted for sperm transfer.

Parasite An organism which lives in or on another organism and derives nutrient from it.

Parturition The process of birth in mammals.

Photosynthesis The manufacture, in green plants, of simple carbohydrates from carbon dioxide and water using sunlight.

Phylum A primary *taxonomic* division, of plants or animals constructed on a similar plan.

Plankton Marine or freshwater plants (phytoplankton) and animals (zooplankton), not necessarily small, that drift with the water.

Pollen The male reproductive bodies produced by the *stamens* of flowering plants.

Pollination The transfer of pollen from *stamens* to *stigma* of a flowering plant.

Polyp A *coelenterate*, with an opening at one end surrounded by a ring of tentacles. Polyps are relatively sessile and may exist as lone individuals or form part of massive colonies, as in corals.

Protist The collective term for the groups of unicellular (acellular) plants and animals.

Protozoa Primitive microscopic unicellular (acellular) animals.

Pseudocopulation In orchids: a process in which the resemblance of an orchid flower to a female insect attracts the male of that species, leading to attempted copulation with and effective *pollination* of the flower.

Pupa The stage in the life cycle of an insect when the tissues of the larval stage are broken down and reorganized into the adult form.

Rotifer A microscopic aquatic *invertebrate* with a circlet of beating *cilia* resembling a wheel.

Salp A free-swimming planktonic *invertebrate* related to a *sea squirt*.

Sea squirt Fixed or open water marine invertebrate whose body contains a tunic of cellulose. May be solitary or colonial.

Siphonophores Free-swimming, passively floating and rarely bottom-living *hydrozoan* colonies consisting of modified *polyps* and *medusae*. The polyp individuals form the tentacles and the digestive units, and the medusoid individuals the swimming bell or float. The Portuguese man-of-war is included in this group.

Species A group of interbreeding animals or plants, possessing similar features. A species cannot usually breed with other species to produce fertile offspring.

Stamens The male reproductive organs of a flower, each consisting of a stalk and a pollen-bearing anther.

Stigma The portion of the female organs of a flower that receives the pollen.

Succulent A fleshy plant of dry regions that stores water in its tissues.

Taxonomy The principles and practice of classification.

Tick A small *arthropod*, closely related to the *mites*, with a rounded unsegmented body, four pairs of legs and piercing mouthparts specially adapted for sucking blood.

Vector A carrier of disease organisms; an agent that transfers a *parasite* to a *host*.

Vertebrate An animal with a backbone and an *endoskeleton* of cartilage or bone.

Virus A submicroscopic *parasitic* organism of plants or animals. They are inert outside the cells of the host. Viruses are responsible for many diseases in man, animals and plants.

Zygote A fertilized egg: a cell formed by the union of the male and female sex cells at conception.

Glossary of photographic terms

Words in *italics* are to be found as separate entries.

Aperture The adjustable opening controlling the amount of light transmitted by a *lens*, measured in settings called *f/stops* or *T/stops*. The larger the f/number, the smaller the aperture. It can be controlled manually, or automatically. Stopping down, or decreasing the size of the aperture, increases the *depth of field* covered sharply by the lens.

Bellows See *extension tubes*

Capacitors An electrical component used to store electric charge; used in *flash* guns.

Colour balance Light from different sources may have different colour characteristics. Daylight has proportionately more blue than light from a normal domestic bulb. The human eye readily adapts to such differences but film cannot. To get natural looking pictures it is necessary to use different filmstock for artificial light and daylight respectively. Electronic *flash* produces light with the same colour characteristics as sunlight. Early morning and late evening light is significantly redder than at other times of the day.

Composite The combination of two or more scenes recorded on separate motion-picture frames.

Condenser An optical system which oncentrates light. A *dark field* condenser has the centre blocked out and therefore produces a hollow cone of light.

Dark field illumination (dark ground illumination) A lighting technique originally devised for the compound microscope. The cone of light transmitted through the *condenser* does not strike the *objective* lens unless scattered by the subject. It gives a brightly back-lit subject against a dark background.

Depth of field A zone extending in front of and behind a subject, where the focus is acceptably sharp.

Depth of focus The range of focusing movement between film and the lens within which an acceptably sharp image is obtained.

Dolly A camera support mounted on wheels for *tracking*.

Electronic flash See *flash*.

Extension tubes (rings) Tubes or rings of specific lengths inserted between camera and lens to give a magnified image on the film. Extension bellows perform the same task but allow a variable amount of extension.

Fibre light guide A flexible bundle of fine glass fibres within a protective sheath used to direct light into confined spaces from a source some distance away.

Film speed A measure of the sensitivity of a film to light. Usually given as an ASA or DIN number.

Flash Conventional flash bulbs, which at OSF are only used for underwater photography, contain magnesium which is ignited to provide a short burst of bright light. Electronic flash, also called strobe light, produces a much shorter but brighter burst. An electronic flash tube contains the gas xenon through which is passed a pulse of high voltage electricity released from condensers. The flash head containing the tube and the reflector, is often well separated from the other electrical components which may be quite bulky and heavy.

f/number The relative *aperture* of a lens at different openings or *stops*. It is the *focal length* of the lens divided by the effective diameter of the lens opening.

Focal length The distance from the lens to the plane in which the lens forms an image of a subject situated at infinity, usually measured in millimetres.

Focal plane The plane on which a lens forms a sharp image. The emulsion surface of the film must be accurately positioned in the focal plane.

Filters Sheets of glass or gelatine generally placed in front of the lens to alter the colour or quality of the light reaching the film. Fog or diffusion filters are used to give the picture an arty softness. Polarizing filters reduce reflection from glass or water surfaces and can also darken blue skies.

Frame A single image in a series on a strip of film; the speed at which the motion-picture camera runs is expressed in the number of frames exposed per second.

Image The representation of an object formed in space by a focusing lens.

Image intensifier An electronic system for making a very faint image brighter.

Iris diaphragm A means of controlling the amount of light which is allowed to pass through a lens achieved by a mechanical iris of overlapping metal plates. The aperture is adjustable and the different settings are called *stops* and are measured in *f/numbers*.

Lens A device which collects light from a subject and focuses an image of it on the film. The speed of a lens is a measure of its light transmitting capacity, a fast lens passing more light than a slow one. Lenses are classified by their speed as measured by *f/numbers* and by their *focal length*. A long focus or telephoto lens has a narrow angle of vision compared with a wide-angle or short focus lens. Wide-angle lenses can record a panoramic view whereas the telephoto lens can be used to isolate a single distant animal or feature by bringing it closer. A camera lens consists of a cylindrical lens barrel containing a number of separate glass lens elements. A prime lens has a fixed focus but this may be modified by the attachment of accessory or supplementary lenses. These are additional glass elements usually used to allow the lens to focus closer than normal to obtain a magnified picture. Macro-lenses are specially designed to allow the camera to work close to the subject. Zoom lenses, which are very complex optically, allow the *focal length* to be varied. Microzoom lenses can change *focal length* at high *magnifications*.

Light meters A device for measuring the brightness of light. An incident light meter measures the brightness of light falling on the subject by gauging the intensity of the source. A reflected light meter measures the amount of light being reflected off the subject towards the camera. Most reflected light meters have attachments for measuring incident light as

well. Some modern cameras incorporate a reflected light meter which are then said to have through-the-lens (TTL) metering. Special flash meters are available for measuring the light output from electronic flash sources. A spot meter has an angle of view of only one or two degrees and can provide an accurate reading of the illumination on any particular part of a scene.

Magnification The relationship between the size of the subject photographed and its *image* formed by the lens. It is usually expressed as a ratio of image size:subject size.

Microzoom See *lens*

Objective The principal lens system of a microscope and used by OSF to obtain high magnification pictures on the optical bench. They are classified by their working distance (distance between the lens and the subject) rather than by *focal length* as are normal camera lenses.

Over-crank To run a motion-picture camera slightly faster than its normal speed of 24 frames per second but not fast enough to be considered high speed photography.

Owl eye A brand of *image intensifier*.

Pan A pivoted movement of the camera in the horizontal plane from a fixed viewpoint.

Photomacrography Photography of small subjects at scales of reproduction between life size (1:1) and 10:1.

Photomicrography Photography of minute subjects at magnifications above 10:1.

Reproduction ratio The relationship between the size of the subject and that of the image reproduced on film.

Resolution A measure of the ability of an optical system to form distinct images of fine, close lines.

Shutter A mechanical system for controlling the length of time light is allowed to fall on the film in the camera. A *focal plane* shutter lies behind the lens and consists of a blind in which is a slit of variable width. As the slit passes across the lens, light falls on the film for a specific time. Depending on the width of the slit, the exposure time or shutter speed will normally be between 1 second and 1/1000

second. Another system, the blade shutter, normally lies within the lens and consists of an *iris diaphragm* which opens and closes for a specified time.

Single lens reflex (SLR) camera A camera incorporating a mirror which permits the image formed by the lens to be seen when the operator looks through the viewfinder. The mirror folds out of the way when the picture is taken.

Stop See *f/number, aperture, iris diaphragm, T/stop.*

Stopping down See *aperture.*

Strobe light See *flash.*

Through-the-lens (TTL) metering See *light meter.*

Tracking Moving a motion-picture camera on a wheeled vehicle (*dolly*) to keep a moving object in view.

T/stop A scale giving the actual rather than theoretical (*f/stop*) light transmitting ability of a lens; used in professional motion-picture photography.

Acknowledgments
It is not feasible to acknowledge individually all those to whom we are indebted for help and advice during the years of our existence. Their number is legion, and to them all we extend our heartfelt gratitude for making our work possible. We wish to extend a special thanks to the following, without whose aid projects mentioned in this book could not have been brought to fruition.
Jan Dawson, Frank Deckert, Derek and Wendy Falconer, Dione and Alistair Gilmour, Lois and Barry Goldman, Prof Ivan Goodbody, Clifford Haines, Prof Sir Alister Hardy, Peter Herring, Pat Hutching, the late Dennis Kempson, Prof Jake Kenny, Brian Lassig, Prof Burney Le Boeuf, Richard Manuel, Nigel Merrit, Prof John Pringle, Peter Rapsey, Sir Peter Scott, David and Helen Stradling, Greg Stroud, Hugh Sweatman and Prof Niko Tinbergen.
It is with great pleasure that we express our special appreciation to Karen Goldie-Morrison who, with much tact and skill, has brought order to the chaos created by ten different authors. Any errors are wholly ours.

Index

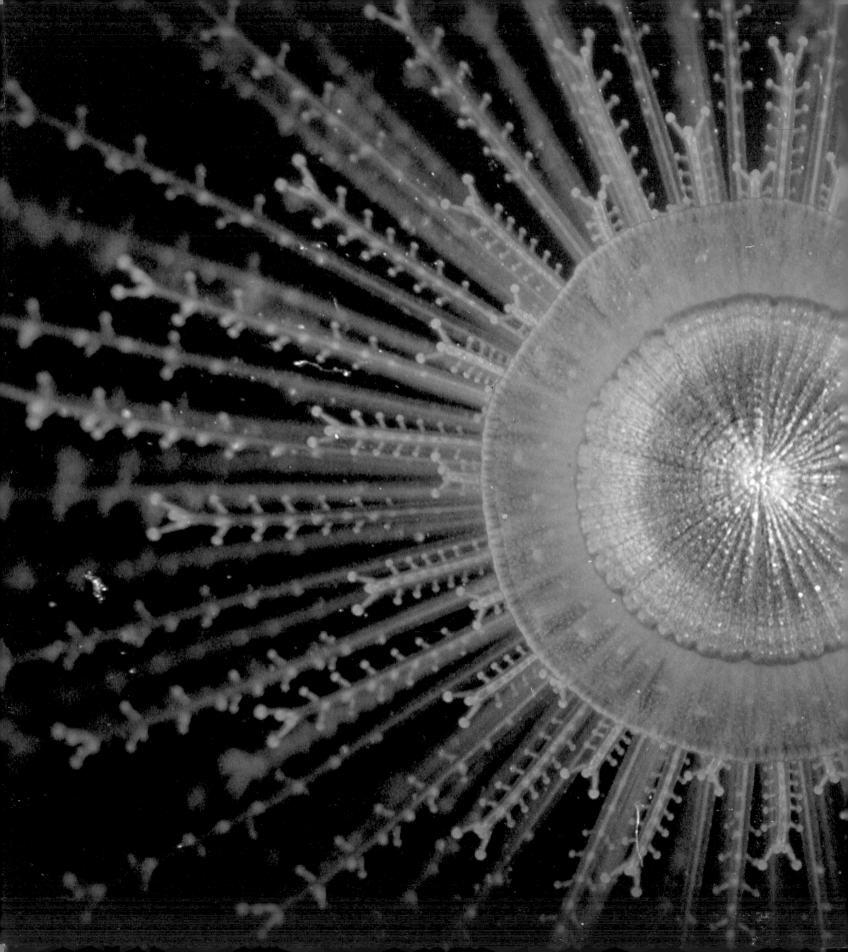